Living Virtually

Steve Jones
General Editor

Vol. 47

PETER LANG
New York • Washington, D.C./Baltimore • Bern
Frankfurt am Main • Berlin • Brussels • Vienna • Oxford

Living Virtually

RESEARCHING NEW WORLDS

Edited by Don Heider

PETER LANG
New York • Washington, D.C./Baltimore • Bern
Frankfurt am Main • Berlin • Brussels • Vienna • Oxford

Library of Congress Cataloging-in-Publication Data

Living virtually: researching new worlds / Don Heider, [editor].
p. cm. — (Digital formations vol. 47)
Includes bibliographical references and index.
1. Entertainment computing. 2. Shared virtual environments.
I. Heider, Don.
QA76.9.E57L59 790.20285—dc22 2008015052
ISBN 978-1-4331-0241-7 (hardcover)
ISBN 978-1-4331-0130-4 (paperback)
ISSN 1526-3169

Bibliographic information published by **Die Deutsche Bibliothek**.
Die Deutsche Bibliothek lists this publication in the "Deutsche
Nationalbibliografie"; detailed bibliographic data is available
on the Internet at http://dnb.ddb.de/.

Cover design by Clear Point Designs

The paper in this book meets the guidelines for permanence and durability
of the Committee on Production Guidelines for Book Longevity
of the Council of Library Resources.

Printed in the United States of America

Contents

Acknowledgments

I'd like to acknowledge the help of:

Cyndi Kernahan of the University of Wisconsin at River Falls for her help in giving me a better understanding of the social psychology that might explain behavior in virtual worlds,

Linda Steiner, a wonderful colleague at the University of Maryland who is a superb editor and good friend,

Mary Savigar, whose careful editing and amazing patience helped this book come to fruition,

And so many of the residents of Second Life, who patiently helped, taught, assisted and let me probe their own virtual worlds.

Contributors

David Beer is Lecturer in Sociology in the Department of Sociology at the University of York, UK.

Mark Bell is a PhD student in the Indiana University Telecommunications Department. He is the co-author of Second Life For Dummies. He studies virtual worlds and social networking with the Synthetic Worlds Intiative.

David Boyns is an Associate Professor of Sociology at California State University, Northridge. His research interests include sociological theory, cultural sociology, media studies, and the sociology of emotions. He is currently pursuing the study of mediated forms of social interaction.

Edward Castronova is an Associate Professor in the Department of Telecommunications at Indiana University, Bloomington. He is an expert on the economies of large-scale online games and has numerous publications on that topic. His latest is a book, Exodus to the Virtual World.

James J. Cummings is a graduate student within the department of Telecommunications at Indiana University. With a background in psychology and anthropology, his research interests pertain to the motivational structure and hedonic value of games and modern media as approached from an evolutionary perspective, as well as how these technologies may be designed and employed for both learning and advocacy.

Jia Dai is a doctoral student at Univeristy of Texas at Austin. Her research interests include new media and society, critical studies and media sociology.

Will Emigh is the co-founder and designer at the game company, Studio Cypher, where he applies all of the tricks he discovered while in the MIME program at IU Bloomington.

Matthew Falk is a PhD student in Telecommunications at Indiana University, working with the Synthetic Words Initiative. His research is focused on

models of gamer behavior and player motivation, and he is interested in the development of virtual worlds for social science research.

Sima Forghani received her B.A. in Sociology from University of California, Irvine and her Master's Degree in Sociology from California State University at Northridge. She is currently working toward a Ph.D. in Sociology from University of California, Irvine. Her interests include immigration and Middle East politics.

Beverly Geesin is currently doing a PhD in the Department of Sociology at the University of York, UK.

Dustin Harp is an Assistant Professor in the School of Journalism at the University of Texas, Austin. Her research is bound by an interest in the various intersections of women and gender, journalism, new media (Internet, blogging, Second Life, social networks), citizenship, and the public sphere.

Don Heider, when not living as one of several dozen avatars in Second Life, is Dean of the School of Communication at Loyola University in Chicago.

Paul Hollins is Deputy Director of the Joint Information Systems Committee Centre for Educational Technology and Interoperability Standards hosted by the University of Bolton in the UK. His research interests include digital games and multi user virtual environments focused on their application in educational settings.

J. Sonia Huang is an assistant professor in the Department of Communication and Technology, National Chiao Tung University, Taiwan. Her research focuses on media economics and strategic management. She holds a MA in Journalism and Mass Communication from the University of Wisconsin at Madison and a PhD from the University of Texas at Austin School of Journalism.

James D. Ivory is an assistant professor in the Department of Communication at Virginia Polytechnic Institute and State University. He holds a Ph.D. in Mass Communication from the University of North Carolina at Chapel Hill. His primary research interests deal with social and psychological dimensions of new media and communication technologies, particularly the content and effects of new entertainment media such as video games and virtual environments.

Aleksandra K. Krotoski is a social psychologist who's been studying virtual worlds since 2003. Her Masters focused on offline identity processes of stigmatised populations who participate in online worlds, and her PhD is concerned with the diffusion of innovations through the social networks of internet communities. Aleks is also a technology journalist with The Guardian newspaper and consults for companies as varied as Linden Lab to Microsoft and the BBC about social media in communication practices.

Jaime Loke is a Ph.D. student in the School of Journalism at the University of Texas. She has a B.A. in journalism and English from Indiana University and a M.A. in journalism from the University of Texas. Her research interests focuses on gender and the media, and the critical and cultural perspectives of gender issues in mass communication.

James Morgan is an artist and an educator. James teaches at the CADRE Laboratory for New Media in San Jose and is the founder and director of Ars Virtua.

Sarah Robbins is a PhD candidate at Ball State University. Her research focuses on the ways digital communities engage with one another via social media such as social networks and virtual worlds.

Travis Ross is a PhD student at Indiana University. His interests include the use of virtual worlds as experimental environments, and applying evolutionary theory to the study of communications.

Marianne Ryan is a Ph.D. candidate in the School of Information at the University of Michigan. She also has a J.D. from Yale Law School. Her research examines the legal, ethical, and policy implications of emerging information technologies.

William Ryan is a Ph.D. student in Human-Computer Interaction at the School of Informatics at Indiana University. He has published articles on machinima, HCI and games, and the process of learning to play games. His current research interests include game interfaces and learnability, mixed reality social interfaces, and embodied computing.

Elena Sosnovskaya is a Master of Arts in Sociology, CSUN and a Ph.D. Graduate Student at the Academy of Science in the Republic of Tatarstan, Russia. Her specific interests in the field are focused on the integration mechanisms within the entertainment communities created by players of MMORPGs. She studies what makes an electronic gathering a community and how sociological theory can be applied to this new phenomenon.

Peter Spangler works as a system administrator, web developer, and instructor and has degrees in computer science and history.

Nan Zheng is a doctoral student in the School of Journalism at the University of Texas at Austin. Her research interests include online public opinion and media framing of public issues.

Introduction

Don Heider

It's a pleasant, new neighborhood. Most of the residents are first time land buyers. They have small plots of land, and they take pride in their homes. There are trees, a stream, and flowers. They are all close to the shoreline, a short walk for most. The new neighbors become acquainted, and even find a gathering spot near one person's home where they often meet and chat. There is a sense of neighborhood, a sense of community.

Then it happens. Someone not from the neighborhood buys a large adjacent tract of land through a land auction. Construction begins almost immediately on a huge, unattractive black box of a building. It's obviously going to be some kind of commercial development, which will bring more traffic to the neighborhood and perhaps even cause the place to lose its sense of a friendly local place. Neighbors are concerned, even angry. A meeting is called, and residents go to the construction site and find the owner, then confront her with their concerns.

The meeting goes like you might expect, people voice their worries, the developer initially seems unconcerned, but then she appears to begin to listen. Someone asks if there might be a compromise worked out. The business owner agrees. Some ideas are kicked around and the owner agrees to move her development on her property so it's a bit farther away from people's homes. The residents aren't completely satisfied, but feel like they have had some voice and impact. This is classic grassroots politics; people voicing their concerns, a discussion and negotiation, and the arrival at some agreement.

But had you been at the meeting that evening, you would have noticed at least one thing that was quite different about this from other meetings of this sort. The residents included a woman dressed in what looked like an exotic belly dancing outfit, complete with veil, there was huge ogre of a man with his hair done up in a topknot with extensive tattoos and wearing a samurai sword. Also present was a blue deer standing upright, complete

with antlers and a sport coat. The meeting didn't take place in the U.S. or the U.K. or anywhere else in the "real world." It took place in a virtual world, on a virtual continent, in a virtual neighborhood. The participants were avatars—realistic cartoonlike representations of people and animals—each one with a real person somewhere in the world operating them through a keyboard at a computer.

Some might think this is a description of a video game. But this place has more characteristics of a world than a game. First, in most games, there are objectives or goals, in other words; a point to the game. In this world that's not the case. It is strictly up to residents to decide what they do or don't do. Games often have a plot which guides players through a certain narrative structure. Here there is no narrative structure, except what people themselves create and abide by.

This world is called *Second Life*. It is a 3-D virtual world created by a company called Linden Labs. The company was founded in 1999 and *Second Life* has been in existence in one form or another since 2003.

Participants, or residents as they are called here, number in the millions and have been steadily growing. Though Linden Labs is a San Francisco-based company and the majority of participants are American, there are also many people in *Second Life* from most of the European countries, as well as from South America, Australia, New Zealand, Japan, China, Taiwan, Korea, and other countries as well.

Second Life represents a new turn in 3-D virtual worlds, sort of. It's considered new because of the qualities that mark it different from a game. But of course very little in the world is ever really new. In many ways *Second Life* and what happens in *Second Life* harkens back to earlier forms of online communication and community. But as new media and the online world continue to developed and morph from one form to the next, *Second Life* and worlds like it offer a chance for researchers to take a look at what's going on and offer a few observations and preliminary conclusions. Definitive work on this emerging area may be years away, but what's needed is a foundation, and this volume seeks to add to a growing literature on virtual worlds.

This collection of essays sets out to present a serious and scholarly look at what is often a fleeting and fast-changing form of media, a set of new technologies which is not always taken seriously or analyzed thus far by researchers. But that's changing. Like me, the group of authors here have found something interesting and worthy of studying. We have found that by studying a virtual world we learn something about ourselves and the larger world. We have found much more than just pixels on a screen.

The chapters you'll find ahead don't deal just with *Second Life*, nor do the lessons of *Second Life* only apply to that one realm. Yet the majority of the work gathered here does take aim at this creation of Linden Labs

because of some of its unique qualities. So for part of this introduction my goal is to give readers an orientation to that one virtual world, and why it may be worthy of the research that follows and much more in the future.

The Kingdom Linden Built

In a nutshell, here's how *Second Life* works. Once you find the *Second Life* (or SL) web page, you can download the software at no charge. In fact playing SL costs nothing as well. So if and when you download and install the software, you will be invited to create a new account. Part of this process involves selecting a name for your character in SL. You get to make up almost any first name you can imagine and then pick from a defined list of last names. The list changes regularly and gives you dozens of last names to choose from, ranging from the somewhat conventional Eliot or Clark to the more unusual such as Birdbrain or Nerd. You must also agree that you are at least 18 years old (for 13–17 year-olds there is teen SL).

Then comes the obligatory agreement to the terms of service. There are also community standards which include what Linden Labs call the big six, covering intolerance, harassment, assault, disclosure, indecency, and disturbing the peace. These are primarily designed to prevent bad behavior between players, their effectiveness is another question.

Once you complete the forms and check the appropriate boxes, you enter *Second Life*. Each person playing the game has an avatar, that is to say a cartoonish looking human figure that walks and moves (and even flies). When you begin SL, you start in an orientation area where a self-tutorial takes you through different steps, like how to alter your appearance, how to chat with others (SL is largely text based, which means you type what you want to say and it appears on the screen), how to view things in the virtual world, and how to interact with objects. There are also players or residents to help new players; these people, known as mentors and greeters, volunteer their time to help new folks in SL. There are some free clothes and free objects available to new players. Eventually when you're ready, you can leave the orientation area and join the larger world of *Second Life*.

In *Second Life* there is a physical world; a land mass, oceans, lakes, rivers, a sun and moon, clouds, and laws of gravity. There is a geography. The world generally consists of several large land masses and thousands of smaller islands. There are buildings, from shacks to palaces, almost all created by residents.

In many ways it resembles the real world in which we live. There are some significant differences, of course. In *Second Life* your avatar can fly. Your avatar can take almost any form, from human to dragon to living as an object.

Because the names for the avatars are created, it is largely an anonymous world. Connected to each avatar is a profile people can look at, where individuals can write something about their avatar or about their lives outside of *Second Life*. The vast majority of residents do not give their real names and many offer no insight into their lives outside of *Second Life*. Those who do may just offer some facts including gender, age, and locale.

Second Life is largely an adult world, with much adult content. Each area of *Second Life* is called a sim. Sims are either designated PG or mature. In PG sims adult activities are supposed to be restricted, such as nudity or the use of obscene language. The vast majority of areas are mature. In a mature sim you might find strong sexual content, ranging from streaming pornographic movies to sadomasochistic practices.

There is an economy in this world. Many things in SL cost money, not U.S. dollars, but Linden dollars. You can spend U.S. dollars to get linden dollars (or lindens as they are known) and you can also sell lindens for real U.S. dollars as well. You can earn lindens by working in SL, though jobs aren't that easy to come by. Some make money by making and selling things, furniture, clothing and such, others by selling their services.

As mentioned above the basic account in *Second Life* is free, you can upgrade to a premium account which costs from around \$72–120, depending on whether you pay in a lump sum or pay across time. The advantage of a premium account is you get a weekly stipend and the opportunity to buy a small piece of land. As people acquire more land, there is a schedule of land fees which also must be paid to Linden Labs, a property tax, more or less.

What Do I Do?

When people create an avatar and enter the world, one of the most commonly asked questions is: "What do I do?" It's a complicated question. Unlike multiplayer games, there are no well-defined set of goals or tasks. People can do what they choose. So the range of activities is quite diverse and wide-ranging. I'd say we could give four broad categories for many of the activities in *Second Life*; people explore, people socialize, people build and create, and people do business. These aren't exclusive categories, many residents do all of these.

Exploring

Most people begin their experience in SL by simply going different places and seeing what the world has to offer. Many sims are unique in the topography and buildings. There are many activities one can participate in as

well, such as sky diving, scuba diving, roller skating, skateboarding, skiing, and more. There are sims full of creatures called furries—animal avatars—and sims that are attempts at historic preservation, including period dress and décor. Each day there are dozens of events from yard sales to bingo games to dance contests to classes. So the act of merely exploring the world and what it has to offer can be a primary and long-standing activity.

Socializing

Since the world is inhabited by many people at once, ranging these days from 20–40,000, you will often encounter others. You speak to people generally though a chat function, which means you type in your comments and people within a certain proximity then can read what you've written/said. Some areas of *Second Life* are voice enabled, so with a headset and microphone you can hear and speak to others, though this function isn't used widely. Dance clubs are popular places to socialize in *Second Life*. Avatars can dance by using some preprogrammed dance animations that make the avatars perform elaborate and fanciful dance moves. You can hear music in *Second Life*, so in these clubs there is either a programmed music stream or someone is streaming music live, which everyone in the club can hear. People talk/type in chat. But instead of a real life club, where you can barely hear someone standing next to you yelling, here you can read everyone's comments. So there is a group conversation that takes place. These kinds of group social activities also happen at other places in *Second Life*. There is also an instant messaging function in the world, so you can select one avatar and send them a private message directly, which they may or may not choose to answer. You can also have these conversations through IM with avatars not in your area.

The social functions in *Second Life* are many, often elaborate and quite complex. Some people come to the world strictly to meet people, make online friends and chat. But others seek other more complex social relations. Many people in world are involved in romantic relationships, including dating, sex, and even marriage. There are detailed role-playing communities, ranging from being part of a mafia family to living in a land of elves. There are also games within *Second Life*, ranging from trivia quizzes to word games to sword play to sports such as golf or soccer.

Building and Creating

Built into SL is the ability for people to build things. A set of building tools allows people to create objects and then manipulate and texture those objects into a wide variety of forms. Residents build everything from belly button rings to massive skyscrapers. Residents also have the ability to create

clothing. People who have graphic art skills can create a number of things outside of SL in programs such as Photoshop, and then import those creations into the world. The result is almost any article of clothing imaginable, from simple blue jeans to period costumes. Residents can also create scripts in world, these scripts allow certain things to happen in the world, whether it is making an avatar sit or lie in a certain position, or even dance. There are also scripts that make objects emit particles or noises. And there are scripts that make objects move and interact in certain ways, allowing for the creation of working vehicles, airplanes, guns, moving wings, etc.

So in SL one is often awed by individual creativity and expression rather than be awed by what a creative team has produced, as one might be in a computer game. There is no one singular vision; instead people's expressiveness comes out in a multiplicity of ways.

Doing Business

One of the most interesting decisions made by Linden Labs was to allow residents to own the intellectual property rights to anything they might create in *Second Life*. What this means is, many people then sell their creations within the world, or in some cases, export what they have created for sale outside of the *Second Life*.

In the world the retail business is quite large and ubiquitous. There are stores, shops, and malls everywhere. The women's clothing business is very, very large and varied. There are clothing stores, shoe stores, gun stores, sword stores, armor stores, animation stores, furniture stores, art dealers, home and garden stores, greeting card stores, to name but a few.

Within *Second Life* you have a set of appearance tools that allow you to manipulate the size and shape of your avatar, the skin color and tone, facial features and hair. Though there is a fairly wide amount of variety found by using the tools, the result is an avatar that still has a fairly cartoonish quality. So artists outside of SL have created skins for avatars that are much more sophisticated in the shading and coloring, that bear a closer resemblance to human skin, or in some cases other whimsical forms such as vampires or drow. These skins are imported into SL and sold. Hair is created with in-world objects, but then made more real looking with textures made outside of *Second Life* and then imported into the world.

But skin, clothing, and hair are not all that is bought and sold. The land itself in *Second Life* is for sale. Residents can buy anything from a very small piece of land to an entire region or as many regions as they like. Some people in SL are real estate developers and speculators, buying and selling land on a regular basis. The best-known among them, an avatar called Anshe Chung, has appeared on the cover of *Business Week* magazine

and is reported to have $1,000,000 worth of holdings in lindens and property in *Second Life*. She has employees and has turned *Second Life* into a full time job.

Residents also sell their services, either as builders, designers, architects, and/or scripters. There are advertising and public relations specialists for hire. Photographers sell their services, as do event planners. As you might have imagined, in this adult environment, you can hire people employed in the oldest known profession—prostitution. People are also hired to host events, dance at clubs, teach classes, or work at other businesses.

What Follows

Second Life is just one of a host of virtual worlds. There's also Entropia, There.com and a couple of dozen other online sites that allow you to visit and explore some type of virtual world. Add to this games such as World of Warcraft, with its 10 million plus subscribers, and it's not difficult to understand why researchers have become interested in this new form of online social behavior.

This anthology brings together research from scholars in sociology, political science, education, information studies, psychology, communication, telecommunication, and journalism. Though most of the research here focuses on *Second Life*, authors also look at other realms and bigger questions about virtual worlds.

This volume begins with a look at the background for 3-D worlds; Jimmy Ivory writes about the ancestry of these places, and Marianne Ryan examines the sociotechnical infrastructure—an element of analysis often overlooked but very important.

Part of the strength of this collection is the varied backgrounds and approaches of the authors, drawing from fields like education, sociology, economics, information studies, communication, and journalism. So not surprisingly, when we begin to examine social aspects of virtual worlds, the approaches range from looking at social networks to how music and geography impact users.

One of the more interesting questions that these worlds raise is that of identity, and Jaime Loke and I both examine some of basic questions about identity creation in these places where forming an identity is a fairly new enterprise, given the anonymity of these places and the flexibility when it comes to appearance.

The popular news media has spent a great deal of time covering the business side of virtual worlds, and we have three important contributions to thoughts about those questions. One could argue that in some ways, money even makes the virtual world go round.

We finish the book with a look at democratic theory, education and journalism in virtual worlds, all of which have an impact on the way people live, act, and interact when participating in these new realms.

Snow Crash author Neal Stephenson wrote "Once a person has all the things they need to live, everything else is entertainment." People who visit these virtual worlds most often have their basic needs met. A very good computer and high speed connection are usually the basic hurdles for participating in these places. It's hard to imagine having those without first having food and shelter. So is it worth studying something that is nothing more than entertainment? First, as you'll read in this volume, there is more than entertainment taking place. Second, how we choose to spend our time, whether it be creating, socializing, or playing, is an important part of understanding who we are. Add technology to that, and studying these places may give us a glimpse of what our future holds.

Part I Underpinnings of Living Virtually

1. Technological Developments and Transitions in Virtual Worlds

James D. Ivory

These days, there are a lot of places to go, people to see, and things to do online. Several million people all over the globe use personalized digital avatars to vicariously socialize, conduct business, attend school, pursue hobbies, and do just about anything else they like in Second Life, a virtual world located on a couple of thousand servers belonging to San Francisco firm Linden Lab (Hogge, 2006; Maney, 2007; Sipress, 2007). Several million more step into the breach as humans, gnomes, orcs, trolls, and a host of other species, girding themselves with everything from swords to magic wands in order to do battle with one another—and hordes of computer-controlled foes—in Azeroth, the fantasy-world setting of Blizzard Entertainment's *World of Warcraft* (Levy, 2006; Hoeger, 2007; Woodman, 2007).

Although real life still remains the default plane of existence for most of us, the popularity of these and other online universes suggest that the physical sphere is no longer the only available venue for playing, fighting, and living in general. For some, this flesh-and-blood world may no longer even be their favored place of residence: Yee's (2006a; 2006b) surveys of MMORPG (Massively Multiplayer Online Role-Playing Games) players from 2000 to 2003 found that 8 percent of respondents typically played for at least 40 hours a week, over 70 percent had on at least one occasion put in a ten-hour uninterrupted shift playing an MMORPG, and half considered themselves addicted to an MMORPG. In Castronova's (2001) survey focusing on players of Everquest, a fantasy MMORPG with a fantasy theme like World of Warcraft, 22 percent of respondents indicated that they would spend all of their time in the game's fictional world of Norrath if they were able to do so. Considering this fervent and widespread attachment to online worlds, along with increasing speculation that virtual environments may someday soon replace the World Wide Web as the primary means for seeking information,

socializing, and conducting business on the Internet (Kirkpatrick, 2007), it appears that living virtually is here to stay.

Things were not always this way, of course. But when did it all begin? At what point did the digital dual citizenship afforded by virtual worlds become an option? The remaining chapters in this volume will explore a number of personal, social, and societal dimensions of virtual worlds, MMORPGs, and the like, but first, this chapter takes a look back. To shed some light on the history and development of virtual worlds like Second Life and World of Warcraft, this chapter will briefly discuss an important family of forerunners to these 3-D online environments: text-based online games and environments. After briefly explicating some defining characteristics of today's virtual worlds, this chapter will explore the inspiration and origins of earlier digital universes with a focus on the text-based predecessors to today's graphical offerings. Finally, this chapter will compare the features, use, and experience of text-based online role-playing games with today's 3-D virtual worlds—and what may lie ahead.

Online Colonization: The First "True" 3-D Virtual Worlds

So myriad are the origins and influences of virtual worlds that it is difficult to pin down a precise point in time when virtual worlds were born.[1] Accounts vary, and identifying the point of nascence for virtual worlds is further complicated by some variation in acknowledgement of what features define a virtual world. Castronova (2001) identifies three criteria that define a virtual world, which he calls "interactivity," "physicality," and "persistence" (pp. 5–6), and conceptualizes these criteria thus: First, a virtual world must allow simultaneous interactivity with and between multiple users in remote locations, with the users' actions impacting the environment and each other. For example, a console video game made to be played alone or with a friend in the same room does not constitute a virtual world, but an online game where players in multiple cities and countries can compete or cooperate simultaneously with each other might. Second, a virtual world's interface must represent an on-screen environment that is "generally ruled by the natural laws of Earth and is characterized by scarcity of resources" (p. 6). Therefore, an online game without a graphical interface, or one that represents a player avatar's physical movement in the game's space inconsistently, or one where multiple players can possess the same item from an environment simultaneously, would not constitute a virtual world. Third, a virtual world must maintain its conditions persistently regardless of whether a player is connected or not. An online game that resets its environment to a consistent set of opening conditions whenever a player starts a new session is not a virtual world.

Other efforts to list the defining characteristics of virtual worlds are similar to Castronova's (2001), though they may use different terms or subdivide one or more of Castronova's three criteria (e.g., Book, 2006; Jakobsson, 2006). Although some maintain that a virtual world can use a text interface exclusively *sans* graphical representations (e.g., Bartle, 2003), others concur that a 3-D graphical interface is a signifying feature of a true virtual world (e.g., Schroeder, Heather, & Lee, 1998; Castronova, 2001). Using these criteria, the first virtual world has typically been identified as *Meridian 59*, a fantasy game commercially released in 1996 (preceded by a 1995 early launch) by the 3DO Company (Castronova, 2001, 2002; Copier, 2005). *Habitat*, a 1985 Lucasfilm release, provided a similar environment to a virtual world, but its graphical interface was only two-dimensional (Robinett, 1994; Castronova, 2002). Despite its retrospective acknowledgment as the "first" virtual world, though, *Meridian 59* did not have the commercial impact that some of its close followers did. While estimates place *Meridian 59*'s peak subscriber base at around 12,000, the 1997 Electronic Arts game *Ultima Online* would eventually surpass 200,000 subscribers and prove to be more commercially successful and influential among early virtual worlds (Castronova, 2001, 2002; Kent, 2003).

Precursors: Early Influences and Inspirations

While painstaking distinctions and classifications may allow us to determine why *Meridian 59* can be recognized as the first virtual world while *Habitat* cannot, the true history of virtual worlds stretches back far beyond the advent of the first game to meet the "true" definition of a virtual world. Just as two-dimensional *Habitat* preceded *Meridian 59* and subsequent virtual worlds, *Habitat* was preceded by technological and conceptual predecessors. Of course, the advent of graphic persistent worlds is closely tied to the thirty-plus year history of arcade, computer, and console video games and the evolution of their graphics, play control, and other technological features (for history of video and computer games, see Wolf, 2002; Lowood, 2006). Similarly, advances in both the technological and economic structure of the Internet have also engendered the development of virtual worlds. A more complete understanding of virtual worlds' roots and inspirations, however, begins with a decidedly more low-tech source: novels.

Many acknowledge Neal Stephenson's (1993) science fiction novel *Snow Crash* as the work that popularized the term "avatar" to describe one's virtual self-representation in virtual reality, though the term may have already been in use online when the book was published (Bailenson & Blascovich, 2004). *Snow Crash* also describes a fictional "metaverse," a virtual world that users can traverse via avatars whose quality depends on the users' financial status and technological savvy. Another science fiction novel, William Gibson's

(1984) *Neuromancer*, coined the term "cyberspace" in describing another imagined virtual world and is credited with far-ranging impact on virtual environments in fact and fiction (Kamioka, 1998; Holland, 1999; Bailenson et al., 2003, Schroeder, 2006; Pontin, 2007). These and other authors imagined online networks where users could extend themselves into amazingly vivid and interactive virtual worlds, but there is another author often cited as an inspiration for virtual worlds—one who never even mentioned computing or online network in his bestselling novels.

J. R. R. Tolkien's (e.g., 1973, 2004a, 2004b) beloved oeuvre charts epic struggle in Middle Earth, a quasi-medieval universe filled with elves, dragons, wizards, men, dwarves, trolls, goblins, and his well-known and short-statured hobbits. *The Lord of the Rings*, Tolkien's best-known work, has sold over 100 million copies in more than 50 languages since its original publication as a 1954–1955 three-volume series (Carpenter, 1977; Sanderson, 2002). Decades after his death in 1973, new published work by Tolkien still continues to be printed via his son's editing of archived material, including a new bestselling tale published in 2007 (Bethune, 2007). Although popular, such fairy-tale subject matter would seem anything but relevant to the advent of virtual universes. The characters in Tolkien's works use magic and maces instead of modems, and even rudimentary mechanical technology is typically reserved for his more abhorrent imagined creatures (Carpenter, 1977)—but the Oxford professor and fantasy author may have had as great an influence on today's virtual worlds as any cyberpunk novelist or Internet visionary (Castronova, 2002; Thompson, 2003; Johnson, 2005; Williams, 2006). Although he never lived to see the virtual worlds of today, a case can be made that a lot of their development stems from attempts to recreate the world of Tolkien's novels—offline and online.

Tolkien's impact on virtual worlds is an indirect one. Although the author was not always glowing with regard to the massive U.S. fan base his work garnered in the 1960s— he famously referred to them as his "deplorable cultus" (Mooney, 2001, p. 38)—the scope of his influence on the fantasy genre transcended the book medium. Tolkien referred to the literary universe created by a storytellers as "a secondary world which your mind can enter" (Rogers, 1999, p. 139), and his work would soon inspire efforts to provide more ways to interact with imagined worlds. The seminal *Dungeons and Dragons* (*D&D*) fantasy role-playing game guides, first published in 1974, include a set of rules, descriptions, and the like outlining how a group of players could congregate and act out adventure scenarios using a combination of role-play and die rolls to determine outcomes (Apperley, 2006). Although the game guide did not explicitly acknowledge Tolkien's work as an influence, the characters, settings, and themes of *D&D* are widely perceived as reminiscent of Tolkien's universe (Castronova, 2002; Turnau, 2004). Thus, what is widely recognized as the first step from Tolkien's

literary "secondary world" to "virtual worlds" was arguably taken on paper via the *D&D* guides.

Worlds of Wordcraft: MUDS and Other Text-Based Online Role-Playing Games

By the time *D&D* was published, Internet technology had advanced enough to allow networked text interaction between remote users (Woolley, 1994). In 1977, the text-based computer game *Zork* allowed players to interact with 211 "objects" in a 191-room universe via text commands (e.g., "GO NORTH," "OPEN THE WINDOW") that elicited text responses (e.g., "You are facing the north side of a white house," "With great effort, you open the window enough to allow entry") (Lebling, Blank, & Anderson, 1979). Given these computing advances, it was not long before the *D&D* fantasy game's mix of creative role-play and calculations from die rolls was transferred online. Between 1978 and 1980 (accounts vary), Roy Trubshaw and Richard Bartle developed *MUD* (for Multi-User Dungeon, later also called *MUD1* to distinguish it from a sequel), which accomplished just that (Kelly & Rheingold, 1993; Rheingold, 1994; Bruckman & Resnick, 1995; Bartle, 1996; Castronova, 2002; Mortensen, 2006). Like *Zork*, *MUD* was a text-based interactive game where players experienced and interacted with their environment via typed commands and computer responses, but *MUD*'s innovative feature was that it allowed multiple users to interact with the world and each other simultaneously via the Internet—and pit their avatars against each other in battle using a server-based incarnation of *D&D*'s die-rolling system.

Despite its lack of graphics, which were readily available in commercial console and computer video games by 1977 (Lowood, 2006), *MUD*'s real-time online environment struck a chord. *MUD* spawned an eponymous genre of followers, as well as an entire taxonomy of variants. Some similar games were called "MUDs," while others with a particular emphasis on narrative role-play aspects or other game dimensions became known by terms like "MUSH" (Multi-User Shared Hallucination) or "MOO" (MUD, Object-Oriented) (McKenna & Bargh, 2000). Despite such fine distinctions in nomenclature, though, all such text-based games are often referred to generally as MUDs (Turkle, 1994), and this chapter will do the same for the sake of simplicity. By the early 1990s, there were hundreds of MUDs online, nearly all of them player-managed and offered free of charge (Rheingold, 1993; Curtis & Nichols, 1994; Kelly & Turkle, 1994).

Compared to the virtual worlds of today, it may be difficult to imagine how text-based MUDs and their ilk would provide a vivid sense of environment, but scholars investigating MUDs have described them with terms like "social virtual realities" (Curtis & Nichols, 1994, p. 193) and "text-based networked virtual worlds" (Schiano, 1999, p. 127). Instead of

high-fidelity graphics, it is the richness of the players' prose that gives a MUD environment its quasi-virtual lucidity. Players may interact with a MUD environment and other players in it with terse commands like "LOOK," "NORTH," "OUT," "ATTACK," and so forth, but on many MUDs, most of the users' keystrokes are dedicated to detailed character descriptions and narrative "poses" that describe their characters' actions in colorful detail (Jacobson, 1996; Turkle, 1994, 1999). For example, Mortensen (2006) provides an example of a possible MUD character description (shown on-screen when another user chooses to use a command to look at the character): "Spiky hair surrounds a round, moonlike face. Two black eyes and a ruby red mouth stand out against the milky pale skin. The short and chubby body is draped in silky, black material" (p. 403). Similarly, Jacobson (1996) shares a typical pose from a role-played wedding scene:

> Victor says, "Irene, through space and time I have found you. In reality, I know you only from a long series of electronic impulses passed from place to place and converging here in this time and this place. In the reality that is my heart, however, I have found a soul-mate, a friend, and a love that is far beyond my ken to explain. I have asked myself: How can such emotions be formed and sustained through this somewhat impersonal medium of electron flow? My answer? I have none. I only know what my heart tells me; and that is that I love you. So, tonight, I stand here with you in front of all these friends, to pledge my undieing [sic] love for you, forever." (p. 472)

Some poses might be accompanied by a command. For example, a medieval-themed MUD might feature a detailed pose describing a character's sword attack on another character, followed by an "attack" command. At this point, the MUD would use data about the characters and one or more simulated die rolls to determine outcomes, such as whether the attack is a hit or a miss and how much the recipient is injured. In turn, the recipient would pose a response consistent with the MUDs combat simulation results, perhaps in conjunction with a retaliatory command. In addition to sharing character actions through poses and commands, players may also provide poses describing the general atmosphere or scene, talk to each other "out-of-character," or even build new rooms, objects, and areas in the MUD if their account has been granted permission. (For a detailed discussion of MUD commands and role-play text with examples, see Kelly & Rheingold, 1993; Turkle, 1995; Jacobson, 1996).

The net result of all users' role-play contributions is something of a collaborative epic novel or play produced session by session, with each player contributing part of the story but not controlling the entire narrative. Given that MUDs allow users such an opportunity to participate in telling favorite stories and acting out a character in a favorite imaginary place, it come as no surprise that beloved fantasy and sci-fi novels and films often

provide the backdrop for MUDs; settings from favorite sagas like *The Chronicles of Narnia, Star Wars, Star Trek,* and, of course, *The Lord of the Rings* abound in the MUD universe.

Do MUDs meet the aforementioned criteria of a virtual world? Not quite, by most standards. Like virtual worlds, MUDs are interactive by way of both their in-character and out-of-character poses and their command systems. Like virtual worlds, MUDs are persistently online as users come and go, and they are bound to some extent by physical laws governing possibilities and probabilities pertaining to travel, combat, and the like. Their text-only interfaces, however, prevent them from being classified as true virtual worlds in many current typologies (e.g., Schroeder, Heather, & Lee, 1998; Castronova, 2001; Book, 2006; Jakobsson, 2006). Like the two-dimensional *Habitat* online game (Robinett, 1994; Castronova, 2002), the MUD genre is therefore all too often relegated to footnote status as a predecessor in the virtual world saga, perhaps an example of what Winston (1998) might call a partial prototype akin to 1920s mechanical televisions and various other "not quite" advances.

The More Things Change: The Legacy of Text-Based Online Role-Playing Games Today

The high-quality graphics, massive environments, and millions-strong subscriber bases that typify virtual worlds like Second Life and World of Warcraft certainly outstrip the no-frills command MUD interfaces. If MUDs are an also-ran in the history of virtual worlds, though, then it stands to reason that they should have gone extinct in the decade or so since the arrival of virtual worlds (Castronova, 2001, 2002; Copier, 2005). Not so. While millions may do their vicarious socializing and swordsmanship in ritzier (and usually pricier) virtual worlds, a computer owner with an Internet connection is still only a free software download and a connection address away from narrative adventure in scores of MUDs available today. Web sites such as *Mud Magic* (http://www.mudmagic.com/), *The Mud Connector* (http://www.mudconnect.com/), and *Top Mud Sites* (http://www.mudconnect.com/) list scores of active MUDs of all types and provide theme details, ratings, rankings, and connection information. Whether or not MUDs can be properly classified as virtual worlds per se, they still endure as a venue for virtual adventure.

Why do MUDs remain despite their seeming technological inferiority? Simple explanations such as price (typically, none) and loyalty come to mind, but there are also potential explanations in findings from empirical research on technological variables and the media experience. For example, a substantial body of research explores the antecedents and consequences of feelings of presence—the feeling of "being there" when using media

(Tamborini & Skalski, 2006, p. 227; see also Lombard & Ditton, 1997, Lee, 2004). On the one hand, there is plenty of evidence that today's virtual worlds should elicit more feelings of presence than MUDs. Technological features in media, such as high definition in television (Bracken, 2005) or technological advancement in arcade-style first-person games (Ivory & Kalyanaraman, 2007) have been found to enhance presence and related measures of experience such as physiological arousal. In addition, the 3-D graphical interfaces of today's virtual worlds means they provide the user with an experience via more sensory channels than do the text-only MUDs. Such an increase in the number of sensory inputs employed is believed to elicit a corresponding increase in feelings of presence (Steuer, 1992). However, Tamborini and Skalski (2006) identify a specific subcategory of presence that MUDs might elicit strongly: social presence, or the feeling of "being with" other players (p. 230). Despite MUDs' technological limitations regarding their ability to maximize feelings of "being there," perhaps it is their focus on sociality via text interaction in lieu of graphic interfaces that allows the text-based games to survive the advent of more advanced virtual worlds. A picture might speak a thousand words, but it doesn't take long to rattle off that much prose in a MUD role-play session—and every word is part of a unique social interaction.

Although their unique opportunities for social interaction and imaginative storytelling have kept MUDs alive to date, the increasing popularity of more technologically advanced virtual worlds will continue to test their mettle. Whether or not MUDs survive in the age of virtual worlds, their legacy is sure to live on in the features that they share with virtual worlds. Mortensen (2006) notes a number of shared characteristics MUDS and the *World of Warcraft* virtual world have in common, ranging from shared thematic roots in literature such as Tolkien's to a shared focus on out-of-character social interaction to a common role-play feature—though *World of Warcraft* does not feature role-play as an integral aspect of its game, a number of its players choose to congregate in server communities where players supplement their 3-D virtual world play with text-based role-play similar to that used in MUDs. Whether MUDs persist or not, then, their legacy is sure to endure as virtual worlds present and future continue to employ similar devices and conventions to place their many players in fantastic places.

It is hard to envision what sorts of evolutionary strides lie ahead for virtual worlds. The surging popularity of Second Life may be a harbinger that in the near future, virtual worlds could become less often like dungeons and castles and more often like malls and suburban cul-de-sacs as fantasy game settings are replaced by vicarious "everyday" interaction. Consistent features and themes throughout virtual worlds' history and pre-history, however, suggest that even as virtual worlds continue to change,

their fundamental principles will continue to include surprisingly consistent threads. An entry in the 2007 virtual world slate offers an apt indicator of this conceptual and thematic stability: the high-profile virtual world *Lord of the Rings Online: Shadows of Angmar*, released by Turbine (Chick, 2007). As this chapter has shown, it can be argued that Tolkien and similar authors played a heavy role in inspiring role-playing guides, MUDs, and virtual worlds to create ways to take users to their literary worlds. Now, you may be able to take your avatar to a nightclub, classroom, or virtual store in Second Life, but there are still well-populated corners of cyberspace where you can battle witches and trolls. The technology of virtual worlds may change, but it seems that at least some of the destinations our imaginations seek often remain the same. What new ways will we create to take us there (albeit virtually) next, and where else will we choose to go? It will be exciting to find out.

Note

1. Even the term "virtual worlds" is not universally accepted, though the phrase has gained some a degree of approval and adoption as a general term for a broad range of interactive, avatar-based online game and community environments (Malaby, 2006). Castronova (2001) also notes that "virtual world" presents a shorter phrase and acronym (VW) than alternative terms such as "massively multiplayer online role-playing game" (MMORPG), "massively multiplayer persistent universe," and "persistent online world."

References

Apperley, T. H. (2006). Genre and game studies: Toward a critical approach to video game genres. *Simulation and Gaming, 37,* 6–23.

Bailenson, J. N., Blascovich, J., Beall, A. C., & Loomis, J. M. (2003). Interpersonal distance in immersive virtual environments. *Personality and Social Psychology Bulletin, 29,* 1–15.

Bailenson, J. N., & Blascovich, J. (2004). Avatars. In W. S. Bainbridge (Ed.), *Encyclopedia of human-computer interaction* (pp. 64–68). Great Barrington, MA: Berkshire Publishing Group.

Bartle, R. (1996). Hearts, clubs, diamonds, spades: Players who suit MUDs. *Journal of MUD Research, 1*(1). Retrieved June 15, 2007, from http://www.brandeis.edu/pubs/jove/HTML/v1/bartle.html

Bartle, R. A. (2003). *Designing virtual worlds.* Indianapolis, IN: New Riders.

Bethune, B. (2007, June 11). MacLean's bestsellers. *MacLean's,* 71.

Book, B. (2006, March). Virtual worlds: Today and in the future. *ITNOW 48*(2), 32–33.

Bracken, C. (2005). Presence and image quality: The case of high-definition television. *Media Psychology, 7,* 191–205.

Bruckman, A., & Resnick, M. (1995). The MediaMOO project: Constructionism and professional community. *Convergence, 1*(1), 94–109.

Carpenter, H. (1977). *J. R. R. Tolkien: A biography*. Boston: Houghton Mifflin.

Castronova, E. (2001, December). *Virtual worlds: A first-hand account of market and society on the cyberian frontier* (CESifo Working Paper No. 618). Retrieved June 10, 2007, from http://ssrn.com/abstract=294828

Castronova, E. (2002, July). *On virtual economies* (CESifo Working Paper No. 752). Retrieved June 10, 2007, from http://ssrn.com/abstract=338500

Chick, T. (2007, May 14–20). A worthy new world in the online "ring." *Variety,* 55.

Copier, M. (2005). Connecting worlds. Fantasy role-playing games, ritual acts, and the magic circle. *Proceedings of DiGRA 2005 Conference: Changing Views — Worlds in Play.* Retrieved June 14, 2007, from http://www.digra.org/dl/db/

Curtis, P., & Nichols, D. (1994). MUDs grow up: Social virtual reality in the real world. *Proceedings of the IEEE Computer Conference,* 193–200.

Gibson, W. (1984). *Neuromancer.* New York: Ace Books.

Hoeger, J. (2007, February 16). Role with it: "World of Warcraft" expansion gives players more room to roam. *Sacramento Bee,* TK30.

Hogge, B. (2006, October 30). Virtually the same as normal: Many are starting to turn to Second Life just as it starts to mirror the real world. *New Statesman,* 50.

Holland, T. (1999, November 22). Nothing will ever be the same again. Or will it? *New Statesman,* 33–35.

Ivory, J. D., & Kalyanaraman, S. (2007). The effects of technological advancement and violent content in video games on players' feelings of presence, involvement, physiological arousal, and aggression. *Journal of Communication, 57,* 532–555.

Jacobson, D. (1996). Contexts and cues in cyberspace: The pragmatics of naming in text-based virtual realities. *Journal of Anthropological Research, 52,* 461–479.

Jakobsson, M. (2006). Virtual worlds and social interaction design. Unpublished doctoral dissertation, Umeå University. Retrieved June 15, 2007, from http://www.diva-portal.org/umu/theses/abstract.xsql?dbid=750

Johnson, S. (2005, July). Your brain on video games: Could they actually be good for you? *Discover,* 38–43.

Kamioka, N. (1998). Cyberpunk revisited: William Gibson's Neuromancer and the "Multimedia Revolution." *The Japanese Journal of American Studies, 9,* 53–68.

Kelly, K., & Rheingold, H. (1993, July/August). The dragon ate my homework. *Wired.* Retrieved June 15, 2007, from http://www.wired.com/wired/archive/1.03/muds_pr.html

Kent, S. L. (2003, September 23). Alternate reality: A history of massively multiplayer online games. *GameSpy.Com—Gaming's Homepage.* Retrieved June 14, 2007, from http://archive.gamespy.com/amdmmog/week1/index.shtml

Kirkpatrick, D. (2007, February 5). It's not a game. *Fortune,* 56–62. Lebling, P. D., Blank, M. S., & Anderson, T. A. (1979, April). Zork: A computerized fantasy simulation game. *IEEE Computers Magazine, 12*(4), 5–59.

Lee, K. M. (2004). Presence, explicated. *Communication Theory, 14,* 27–50.

Levy, S. (2006, December 25). Gaming: Embedded in Azeroth. *Newsweek,* 26.

Lombard, M., & Ditton, T. (1997, September). At the heart of it all: The concept of presence. *Journal of Computer-Mediated Communication.* Retrieved June 15, 2007, from http://jcmc.indiana.edu/vol3/issue2/lombard.html

Lowood, H. E. (2006). A brief biography of computer games. In P. Vorderer & J. Bryant (Eds.), *Playing computer games: Motives, responses, and consequences* (pp. 25–41). Mahwah, NJ: Lawrence Erlbaum Associates.

Malaby, T. (2006). Parlaying value: Capital in and beyond virtual worlds. *Games and Culture,1* (2), 141–162.

Maney, K. (2007, February 5). The king of alter egos is surprisingly humble guy: Creator of Second Life's goal? Just to reach people. *USA Today,* 1B.

McKenna, K. Y. A., & Bargh, J. A. (2000). Plan 9 from cyberspace: The implications of the Internet for personality and social psychology. *Personality and Social Psychology Review, 4,* 57–75.

Mooney, C. (2001, June 4). Kicking the hobbit. *The American Prospect,* 37–39.

Mortensen, T. E. (2006). WoW is the new MUD: Social gaming from text to video. *Games and Culture, 1,* 397–413.

Pontin, J. (2007, March/April). On science fiction: How it influences the imaginations of technologists. *Technology Review,* 12.

Rheingold, H. (1994). The virtual community: Homesteading on the electronic frontier. Retrieved June 15, 2007, from http://www.rheingold.com/vc/book

Robinett, W. (1994). Interactivity and individual viewpoint in shared virtual worlds: The big screen vs. networked personal displays. *Computer Graphics, 28,* 127–130.

Rogers, T. (1999) Literary theory and children's literature: Interpreting ourselves and our worlds. *Theory into Practice, 38,* 138–146.

Sanderson, C. (2002, September 27). A publishing fantasy. *The Bookseller,* 24–26.

Schiano, D. J. (1999). Lessons from LambdaMOO: A social, text-based virtual environment. *Presence: Teleoperators and Virtual Environments, 8,* 127–139.

Schroeder, R. (2006). Being there together and the future of connected presence. *Presence: Teleoperators and Virtual Environments, 15,* 438–454.

Schroeder, R., Heather, N., & Lee, R. M. (1998, December). The sacred and the virtual: Religion in multi-user virtual reality. *Journal of Computer-Mediated Communication, 4*(2). Retrieved June 13, 2007, from http://jcmc.indiana.edu/vol4/issue2/schroeder.html

Sipress, A. (2007, June 2). Does virtual reality need a sheriff? Reach of law enforcement is tested when online fantasy games turn sordid. *The Washington Post,* A1.

Stephenson, N. (1993). *Snow crash.* New York: Bantam Books.

Steuer, J. (1992). Defining virtual reality: Dimensions determining telepresence. *Journal of Communication, 42,* 73–93.

Tamborini, R., & Skalski, P. (2006). The role of presence in the experience of electronic games. In P. Vorderer & J. Bryant (Eds.), *Playing computer games: Motives, responses, and consequences* (pp. 225–240). Mahwah, NJ: Lawrence Erlbaum Associates.

Thompson, K. (2003, Fall). Fantasy, franchises, and Frodo Baggins: The Lord of the Rings and modern Hollywood. *Velvet Light Trap, 52,* 45–63.

Tolkien, J. R. R. (1973). *The hobbit* (Collector's edition). Boston, MA: Houghton Mifflin.

Tolkien, J. R. R. (2004a). *The lord of the rings* (50th anniversary edition). Boston, MA: Houghton Mifflin.

Tolkien, J. R. R. (2004b). *The silmarillion* (2nd edition). Boston, MA: Houghton Mifflin.

Turkle, S. (1994, Summer). Constructions and reconstructions of self in virtual reality: Playing in the MUDs. *Mind, Culture, and Activity, 1*(3). Retrieved June 15, 2007, from http://web.mit.edu/sturkle/www/constructions.html

Turkle, S. (1995). *Life on the screen: Identity in the age of the Internet.* New York: Simon & Schuster.

Turkle, S. (1999). Cyberspace and identity. *Contemporary Sociology, 28,* 643–648.

Turnau, T. A., III. (2004). Inflecting the world: Popular culture and the perception of evil. *Journal of Popular Culture, 38,* 384–396.

Williams, D. (2006). Virtual cultivation: Online worlds, offline perceptions. *Journal of Communication, 56*, 69–87.

Winston, B. (1998). *Media technology and society: A history from the telegraph to the Internet.* London: Routledge.

Wolf, M. J. P. (2002). *The medium of the video game.* Austin, TX: University of Texas Press.

Woodman, T. (2007, January 18). "War" games: Web role-playing competition brings generations together. *The Boston Herald,* O43.

Woolley, D. R. (1994). PLATO: The emergence of on-line community. *Computer-Mediated Communication Magazine, 1*(3). Retrieved June 15, 2007, from http://www.december.com/cmc/mag/1994/jul/plato.html

Yee, N. (2006a). The demographics, motivations, and derived experiences of users of massively multi-user online graphical environments. *Presence: Teleoperators and Virtual Environments, 15*, 309–329.

Yee, N. (2006b). The psychology of massively multi-user online role-playing games: motivations, emotional investment, relationships and problematic usage. In R. Schroeder & A. Axelsson (Eds.), *Avatars at work and play: Collaboration and interaction in shared virtual environments* (pp. 187–207). London: Springer.

2. The Sociotechnical Infrastructures of Virtual Worlds

Marianne Ryan

Introduction

This chapter examines the evolution of virtual world infrastructures. Virtual worlds are immersive online environments in which people interact for non-goal-oriented entertainment purposes. More recently, virtual worlds are becoming arenas for formal and informal education, as well as for diverse commercial transactions. Virtual worlds have real consequences. They are now important sites for investing attentional and financial resources.

Since the evolution of game play can signal important cultural changes in human communities, it can be useful to study how online worlds function. First, this chapter will provide a brief history of virtual worlds juxtaposed against the background of online game development. Then it will describe a new virtual world known as Second Life, which will serve as a case study for applying theories of infrastructure. For example, Second Life can be understood as an infrastructure that supports second-order large technical systems created by residents.

As a boundary object between the real world and the virtual world, Second Life's infrastructural code provides certain constraints and affordances that affect the experience of residents within its world and beyond. At the same time, this analysis reveals how user agency and contingency play an important role in shaping the infrastructure of Second Life. In addition, this agency and contingency can be described further in terms of the capital that is created within Second Life. Finally, the dual role of user/designers in virtual worlds offers important lessons for developing next-generation cyberinfrastructure.

Antecedents of Virtual Worlds

In 1962 MIT hacker Stephen Russell and his colleagues created the Spacewar! program as an early "open-source"-type project that ran on a Digital PDP-1 computer and used 9KB of memory (Graetz, 1981). It involved needle-shaped and wedge-shaped rocket ships that were subject to gravity forces, rotated in a realistic star field, and shot torpedoes in battle. Players used control boxes to maneuver their ships, including acceleration and hyperspace commands. Updated scores appeared in the CRT monitor.

When Russell moved to Stanford's SAIL laboratory to work on artificial intelligence projects with John McCarthy, his fellow SAIL researchers created a version of Spacewar! that could run on a PDP-6 computer in a time-sharing environment (Markoff, 2005). They included an operating system hack that permitted the program to continue to function even as other programs required additional computing cycles. This adaptation, known as "Spacewar mode," soon had numerous real-world applications as well. Markoff identifies this development as "one of the earliest examples of how gaming advanced the state of computing" (p. 103).

In 1969, Rick Blomme created an online version of Spacewar! that could run on the PLATO network (Koster, 2002). In a 1972 *Rolling Stone* article, Stewart Brand reported how Stanford's computer laboratory turned into a veritable video game arcade each night as computer programmers explored and expanded this primitive interactive virtual world within a networked environment (Brand, 1974; see also Turner, 2006). Net.games, rogue, and net.games.frp (fantasy role playing) appeared as some of the first newsgroups in Usenet, which indicates the importance of gaming to early network programmers (Hauben & Hauben, 1997). In this situation, both the network and the game that ran on it (a second-order heterogeneous large technical system) were designed by the same people (King & Borland, 2003). In addition, the network and game *designers* also were the *users* of both the network and the game. This "role hybridization" (Fleischmann, 2006b) is an important theme in the history of computer games and will be discussed further below.

Three-dimensional persistent virtual worlds are online immersive environments populated by interactive avatars. In contrast to videogames, virtual worlds are less goal-oriented; they are experienced as well as performed. King and Borland (2003) suggest that early developers of virtual worlds were influenced by the experience of playing the paper-based Dungeons and Dragons game, first published in 1974 (see also Koster, 2002). The narrative form of Dungeons and Dragons gave a primary role to users, who could change the story (and thus the game) in ways never intended by the game designers. In 1978 Trubshaw and Bartle began to design MUD1, a text-based "multi-user dungeon" in which groups of users

could explore online together by navigating various levels (Koster, 2002; King & Borland, 2003).

Later games could be modified by users who created "mods" that were essentially new versions of major games such as Doom and Half-Life. One such mod, Counter-Strike, became a successful commercial game in its own right (King & Borland, 2003). King and Borland note that "[m]od making is as old as computer gaming itself. Within a few days of the unveiling of Spacewar! at MIT in 1961, other player-programmers had begun adding to the code, making versions with different features, multiplayer play, or changing enough to make the result another game altogether" (p. 211; see also Salen & Zimmerman, 2004).

Design of Virtual Worlds

Today's virtual worlds represent even more complex built environments that are navigable by their residents (Juul, 2005). They consist of persistent ecologies in which people can create and control unique identities represented by avatars. The distinctive aesthetic design and thematic orientation of each virtual world helps to distinguish them in the marketplace. Salen and Zimmerman (2004) describe those unique elements as "*rules*: the organization of the designed system; *play*: the human experience of that system; and *culture*: the larger contexts engaged with and inhabited by the system" (p. 6). However, there are certain technical features common to all virtual world infrastructures.

For example, scripting tools and editors are available in commercial packages for creating virtual worlds and updating them in real time. These virtual worlds then are hosted on multiple servers maintained by their corporate owners. In fact, companies such as the Multiverse Network now offer a self-contained platform for virtual world developers to customize, which includes a common client-server infrastructure (Anonymous, 2007). This represents a move toward more efficient standardization within the industry in terms of objects, attributes, internal system relationships, and external relationships with the greater environment (Feng, 2003).

In order for a given environment to support continued growth in the number of subscribers, companies calculate how many users can be sustained per server at the same time (Mulligan & Patrovsky, 2003). They also determine how many servers are needed to produce a world that refreshes at an acceptable rate to reflect the simultaneous results generated by each new iteration of gameplay from an individual user's perspective. Companies also decide how many processors, how much RAM, and the amount of bandwidth that will be necessary to support an ideal virtual experience that will keep their customers satisfied in terms of reaction times

and latency. Of course, designers often can't control latency that can be introduced when bottlenecks occur on the Internet between the user and the server. Designers also must choose whether to design the world to achieve the best experience provided by the system configuration of an average user, or that of an early adopter with greater horsepower. Then, after significant testing, developers release a client application that customers can use to connect to the new virtual world, create a representative character, and interact with other players.

If a virtual world becomes increasingly successful, the company may plan a further expansion of the world with additional features and activities for players (Mulligan & Patrovsky, 2003). The underlying codebase of the world will determine how much relative freedom individual players possess to make personal or group decisions, create new content, or even to disrupt the delicate balance of the world. For example, some users try to challenge the infrastructural constraints of the world by seeking to exploit newly identified vulnerabilities. One example would be discovering the ability to "clone" in-world objects by the millions, which can overload servers and temporarily shut down regions within the world. The owners of a virtual world may decide to respond by punishing activities that violate the terms of service of the world; altering the rules of the world to accommodate that behavior in the future; or challenging players by increasing the difficulty of gameplay instead (Bartle, 2003).

While providing conceptually rich experiences, at the same time many virtual worlds have a hybrid nature in that their activities sometimes spill over to the physical world. For example, the porous interfaces of the technical infrastructures of virtual worlds can facilitate the trading of virtual currencies in real-world markets (Castronova, 2005). Real-world industries also have developed to support gaming activities such as the acquisition and sale of virtual goods. In fact, in order to advance their progress and acquire virtual goods, users otherwise preoccupied with real-world concerns will pay to outsource gameplay itself to denizens of cyber-sweatshops known as "gold farms" that have emerged as an economic response in underdeveloped nations (Dibbell, 2007). As virtual worlds confront this new reality, they may choose to defer to the consensus of subscribers regarding whether to permit or stigmatize this behavior through the introduction of appropriate incentive structures.

Second Life Case Study

Second Life is an example of a popular virtual world that was established by Linden Lab in 2003 (Rosedale & Ondrejka, 2006). As of June 2007, over 7.2 million residents are members of Second Life (Linden Lab, 2007e).

Membership is free, although a monthly $10 membership fee enables residents to purchase land parcels and island (Linden Lab, 2007e). As of May 2007, almost 60 percent of users range in age from 25 to 44. The population is 43 percent female (as a percentage of time spent in-world) (Linden Lab, 2007d). Linden suggests minimum and recommended system requirements in order for users to enjoy the most vivid sensory experience (Linden Lab, 2007e).

Second Life consists of a scalable grid of computers, each of which is edge-connected to four other machines. Each computer simulates 16 acres of land and accompanying airspace. Representations generated by connected machines support the perception of a seamless and continuous space (Ondrejka, 2004b). Residents have developed a unique sense of place, and convey that sensibility to new members as both explicit and tacit knowledge. For example, while Second Life approximates a complex simulation of the real world, its technical infrastructure also supports avatar actions such as teleportation that would be impossible in the real world. In addition, Second Life's infrastructure explicitly enables residents to engage in economic transactions with other members.

The primary attraction for participants in Second Life is the ability to create and control dynamic objects via Linden Lab's scripting language. In November 2003, Linden Lab changed the terms of service for Second Life to allow residents to retain intellectual property rights to their creations that would be honored in the real world as well under U.S. law (Linden Lab, 2007c). This critical shift in ownership, which distinguishes Second Life from other competitors, has contributed to an explosion of creativity and innovation among entrepreneurial members. Often these transactions represent private commercial exchanges for goods such as clothing and furniture as residents develop their online personas and living quarters (Anonymous, 2006c). Many residents have developed successful commercial businesses in Second Life (Anonymous, 2006c).

As of 2006, ten million user-created and user-owned objects are represented in Second Life. The objects are encoded so that creators can constrain copying or constrain resale of their creations, but cannot constrain both (Rosedale & Ondrejka, 2006). In any given week, 75 percent of Second Life residents create a new object from simple primitives, and 25 percent of those residents create content for use by other residents (Rosedale and Ondrejka, 2006). These virtual goods are exchanged using an in-world currency known as Linden dollars that is tied to the U.S. dollar (Linden Lab, 2007b). As of May 2007, over 12 million economic transactions were conducted each month as virtual goods were bought and sold, including over $6.8 million dollars (U.S.) in monthly economic transactions and almost $500K in daily currency transactions (Linden Lab, 2007d). As of June 2007, one U.S. dollar buys approximately $268 Linden dollars (Linden Lab, 2007b).

Infrastructure of Second Life

The Second Life simulation (known as "the Grid") currently represents the equivalent of 651 square kilometers. Over two thousand servers located in San Francisco are needed to maintain the simulation from the user's perspective, and requires one gigabit per second of bandwidth (Rosedale & Ondrejka, 2006). Simulation data is warehoused in central MySQL databases. As of June 2007, over 1.7 million residents had logged in within the past sixty days (Linden Lab, 2007a).

The servers contain Second Life's codebase software (Bartle, 2003). In terms of Bartle's typology, this includes the *driver*, which addresses most basic operations of data structure and memory management. The *mudlib* defines the physics of Second Life, including mass, movement, and timers. Above the mudlib layer is the *world definition* layer, in which functionality is attached to specific objects. Finally the *instantiation* layer handles the particular incarnation of the virtual world at present.

The functionality of Second Life is encoded in a C-style event-driven scripting language called LSL. It was developed by Linden Lab and enables the designers to code objects with dynamic behaviors. LSL also supports the streaming of live video and music. Second Life runs on Windows and Linux as a client side application (Grimmer, 2006).

In January 2007, Linden Lab publicly released the source code for the SL client to the open-source development community to further foster innovation (Linden Lab, 2007e). A voice-enabled client was publicly released in June 2007 (Linden, 2007). Later in 2007 Linden Lab plans to incorporate the Havok 3 engine, with Mono integrated for script execution as a replacement for LSL (Grimmer, 2006). In addition, it will include an embedded web browser capability (Rosedale & Ondrejka, 2006). Linden Lab asserts that Second Life increasingly is becoming a freestanding operating system in itself (Rosedale and Ondrejka, 2006).

This computer code constitutes the underlying architectural infrastructure of Second Life. It accords with classic definitions of infrastructure because it serves as the foundation for the Second Life system. LSL code is a reliable, ubiquitous, and widely shared large-scale system that operates throughout the Second Life environment. It is embedded within the virtual world and is effectively transparent, since residents are not conscious of it on a regular basis unless a temporary glitch or more systemic failure occurs (Bowker & Star, 1999). Residents learn how to use the infrastructural code to create their own innovative objects within the Second Life community of practice.

Different portions of Second Life's infrastructural code are updated as new versions of the software are released. These code improvements are incremental and often occur in response to resident requests. In addition,

residents vote upon proposals to add new features to the world via code enhancements (Linden Lab, 2007f). In late March 2006 Linden Lab received an $11 million capital infusion from a group of prominent investors that was intended to support further infrastructural improvements (Terdiman, 2006).

Constraints and Affordances of Infrastructural Code

To Farmer and Morningstar (2006), developers of the 1985 Lucasfilm virtual world known as Habitat, the distinction between infrastructural and noninfrastructural code in virtual worlds is clear (pp. 744–745):

> Designers and operators of a cyberspace system must inhabit two levels of virtual world at once. The first we call the "infrastructure level," which is the implementation, where the laws that govern "reality" have their genesis. The second we call the "percipient level," which is what the users see and experience. It is important that there not be "leakage" between these two levels. The first level defines the physics of the world. If its integrity is breached, the consequences can range from aesthetic unpleasantness (the audience catches a glimpse of the scaffolding behind the false front) to psychological disruption (somebody does something "impossible," thereby violating users' expectations and damaging their fantasy) to catastrophic failure (somebody crashes the system). When we exhort you to give control to the users, we mean control at the percipient level. When we say that you can't trust anyone, we mean that you can't trust them with access to the infrastructure level.

However, since residents have access to the same scripting language used by the designers, to a certain extent Second Life problematizes this clear boundary. Sometimes this can present challenges for the smooth functioning of the world. For example, on April 15, 2006, Second Life spent seven hours repelling an infrastructural attack by a nefarious resident. An avatar named Jew Stein used the LSL scripting language to create self-replicating red helixes known as object spam that disrupted the operations of the Second Life Grid (Anonymous, 2006a). Commentators noted that Second Life is uniquely vulnerable to such attacks since it allows residents to create their own content that can overwhelm the Grid's servers (Wallace, 2006).

Engaging in behavior that provokes the wrath of the "gods" (designers) offers another opportunity for the façade of a virtual world to crack. Muramatsu (2004) has investigated several options by which virtual worlds regulate player behavior. On the one hand, human moderators devise, modify, and enforce those rules that govern that world. They also engage in real-time monitoring of game events through encoded surveillance systems embedded in infrastructure which report occurrences of specific types of

problematic events. As a virtual world grows in size and complexity, these infrastructural monitoring systems become increasingly important in maintaining order. Common infrastructural challenges include denial of service attacks, unauthorized access, and disclosing private personal or financial information (Mulligan & Patrovsky, 2003).

At the same time, however, infrastructural code can be used to regulate player behavior through the actual code of the virtual world itself. Delegating enforcement to autonomous code can be an efficient strategy when certain disruptive behaviors occur relatively frequently and are clearly prohibited in the terms of service or community standards (Linden Lab, 2007c). Enforcement via infrastructural code can be preventative by not allowing players to engage in specific behaviors at all, as in a zoning prohibition. Alternatively, when code-based enforcement is a *post hoc* punitive measure, it may not always consider a player's prior history and reputation, and instead treat all violators in the same manner. However, automated punitive infrastructural code is becoming more sophisticated and more frequently can include such variables in its calculus (Muramatsu, 2004).

This discussion provides one example of how infrastructural code can serve as a boundary object across several dimensions (Fleischmann, 2006a). Virtual world infrastructures can be viewed as a *macro-interface* between the virtual world and the larger society, or as a *micro-interface* between the user and the virtual world. By constraining a user who violates the rules of the virtual world, the micro-interface infrastructure exhibits agency in an environment of actors with diverse viewpoints. The infrastructure can be said to "actively reshape relationships within and among these social worlds, shifting alliances, conflicts, and the overall balance of power" (Fleischmann, 2006a, p. 82). Lessig (1999) describes this phenomenon, in which legal controls are embedded within software, as "code is law." At the same time, the macro-interface infrastructure exhibits agency with respect to the user's relationship with society at large. For example, Second Life's infrastructural scripting language provides affordances that enable residents to create objects with real-world value as calculated according to currency exchange rates between Linden dollars and U.S. dollars.

Conversely, this phenomenon also can facilitate a "free culture" movement as well as a "commons" movement (Lessig, 2002, 2005). Free culture refers to those situations in which a software user is freely able to both produce and consume cultural content. The commons refers to the role of the public domain in supporting the production and consumption of cultural content. In fact, Lessig served as a consultant to Second Life during the 2003 tax revolt described below, and encouraged the development of in-world incentives to create new content and make it freely available to others (Au, 2003).

Legal scholar Yochai Benkler's recent book "The Wealth of Networks: How Social Production Transforms Markets and Freedom" (2006) follows

Lessig's call to free content from its technological shackles to advance the goals of a democratic society. However, Benkler contends that this liberation will occur via a system of peer production of "information, knowledge, and culture" (p. 116). He suggests that the asymmetrical power relationships between producers and consumers found in traditional commercial channels of cultural production increasingly are being replaced by a public social production system. In his book, Benkler repeatedly refers to the construction and trade of creative objects by Second Life residents as an example of the new market economy he sees emerging in the real world. He believes that, as now occurs with Second Life's infrastructural scripting language, the affordances of real-world infrastructures eventually will coordinate and leverage user effort for larger creative projects. Benkler's description of the role of technology in social change is evocative of Fleischmann's concept of boundary objects with agency discussed earlier (pp. 17–18):

> Neither deterministic nor wholly malleable, technology sets some parameters of individual and social action. It can make some actions, relationships, organizations, and institutions easier to pursue, and others harder. In a challenging environment—be the challenges natural or human—it can make some behaviors obsolete by increasing the efficacy of directly competitive strategies. However, within the realm of the feasible—uses not rendered impossible by the adoption or rejection of a technology—different patterns of adoption and use can result in very different social relations that emerge around a technology.

Systems and System Builders

Second Life's architectural code functions as a technological "system" around which social relations have developed, as defined by Hughes (1987). It supports the basic scripting functions of a world devoted to encouraging content creation for public and private purposes. The operational boundaries of LSL code are clearly limited to the Second Life environment. Code implementation at the infrastructural level is centrally managed by Linden Lab staff. Although residents can *use* it to create new public works, they do not *control* the underlying code.

Two levels of "system builders" (Hughes, 1987) can be identified in Second Life. At one level, Linden Lab staffers design and implement the code system that enables Second Life to operate effectively. As more and more residents join Second Life and use its features, the LSL code system becomes ubiquitous and develops technological momentum and critical mass (Hughes, 1987). Linden Lab developers also respond to resident complaints regarding infrastructural breakdowns that are aired in town hall meetings and via customer support interfaces. In this sense Linden Lab employees react to sociotechnical reverse salients in the system and design new solutions (Hughes, 1987). A reverse salient is a critical problem

identified within the system, the resolution of which enables the system to function and expand (Hughes, 1987).

In addition, Second Life residents can use the LSL code, as well as the open-source client release, to design second-order heterogeneous large technical systems and networks that function on top of the infrastructural code. In some cases these new second-order systems also are creative responses to specific reverse salients identified in the initial Second Life environment (van der Vleuten, 2004). As Mulligan and Patrovsky (2003, p. 153) caution game designers, "Be prepared to see players playing the game in ways you never expected or intended. They will create their own content with whatever is available." Linden Lab also intentionally created economic incentives for residents to use the LSL scripting language to develop common areas for use by all residents. These public spaces are open to all community members free of charge.

Moreover, residents can collaborate to create complex public works on their properties. As originally designed, the underlying infrastructural code would log visitor traffic to these areas and reward creators with monthly payments called "dwell" or "traffic bonuses" (Linden Lab, 2007f). In response to such systemic incentives, individual residents as well as groups within Second Life created public parks, airport runways, libraries, municipal election systems, museums, and public transportation systems such as subways. Other residents decided to release certain items into the public domain under a Creative Commons license.

Second-Order Large Technical Systems

As one example, the original LSL code enabled resident avatars to teleport across the Second Life Grid. However, residents were required to land at a central Telehub for each region and then traverse overland to reach their final destination (Ondrejka, 2004b). This feature of the system made real estate situated near Telehubs more valuable than distant parcels and introduced an element of scarcity into the economy. In response to resident complaints, the LSL code was revised by Linden Lab designers in early 2006 to enable direct point to point teleportation, which was a more efficient travel mode that rendered the Telehubs obsolete (Linden Lab, 2007f).

Now residents can bid for the right to build teleportation landmarks to replace the Telehub system. These are resident-sponsored and controlled public areas. The new distributed network of landmarks thus constitutes a second-order large technical system that emerged in response to a perceived reverse salient and coordinates heterogeneous sociotechnical and organizational components throughout Second Life.

This layer of integrated, resident-created public works can be understood as constituting independent second-order heterogeneous large technical

systems supported by the underlying code infrastructure (van der Vleuten, 2004). Through a series of public/private partnerships between Linden Lab and Second Life residents, the Second Life environment continues to coevolve in terms of both the underlying code, as well as the social context in which it is subsumed. For example, on April 17, 2006, Linden Labs announced that in order to stabilize the local currency, automated traffic bonuses would be eliminated effective June 13 because incentives were perceived to have become unbalanced (Linden Lab, 2007f). As discussed below, the potential impact of this modification of the underlying infrastructural code upon the amount and nature of subsequent public works development by residents is unknown. Truly, Second Life is a postmodern, decentralized, and self-organizing virtual world.

User Agency and Contingency

Van der Vleuten (2004) critiques two contrasting frameworks for analyzing large technical systems. The first concept, the ideology of circulation, refers to how systems can support the flow of information and ideals necessary for democratic citizenship. The second concept, the ideology of power, evaluates how systems function to reinforce the economic and political goals of dominant elites. Historical accounts of system development that conform to either of these two grand narratives primarily focus on the role of designers rather than users by emphasizing how the sociopolitical agendas of builders are inscribed within their systems. Van der Vleuten suggests that a more multidimensional understanding of the development of large technical systems would reveal the importance of contingency as well as user agency. Both of these elements are important in virtual world environments as described below.

Taylor (2004, p. 261) suggests investigating how "system architectures can act as a powerful shaping force for how life gets lived online." However, other research similarly grounded in principles from the discipline of Science, Technology, and Society Studies demonstrates that "[j]ust as designers configure users, users also configure designers" (Fleischmann, 2006b, p. 88; see also Malaby, 2006). Moreover, Brand describes how the inventors of Spacewar! were *both* designers and users of that second-order system. Fleischmann (2006b) describes the simultaneous occupation of both roles as "role hybridization." The inventors of Spacewar! were both producers and consumers of the game, which destabilizes the traditional power relationship between developers and users and connects both of their social worlds. The design-use interface thus serves as the porous boundary between both social worlds: the real world in which designers operate, and the virtual world in which users adopt and adapt their

creations. In this case, the design-use interface was the Spacewar! program which ran on the PLATO network infrastructure.

As Brand further noted thirty-five years ago, Spacewar! prefigured the rise of Benkler's network culture, Lessig's free culture, and the decentralized, unbundled virtual world of Second Life (pp. 78–79):

> Spacewar as a parable is almost too pat. . . . It was part of no one's grand scheme. It served no grand theory. . . . Yet Spacewar, if anyone cared to notice, was a flawless crystal ball of things to come in computer science and computer use:
>
> 1. It was intensely interactive in real time with the computer.
> 2. It encouraged new programming by the user.
> 3. It bonded human and machine through a responsive broadband interface of live graphics display.
> 4. It served primarily as a communication device between humans.
> 5. It was a game.
> 6. It functioned best on standalone equipment (and disrupted multiple-user equipment).
> 7. It served human interest, not machine. (Spacewar is trivial to a computer).
> 8. It *was* delightful.
>
> In those days of batch processing and passive consumerism (data was something you sent to the manufacturer, like color film), Spacewar was heresy, uninvited and unwelcome. . . . The hackers made Spacewar, not the planners.

Given that historical context, Second Life's resident-driven design model appears less radical. Since Second Life residents also can be both designers as well as users of systems, contingency and user agency played a critical role in a seminal episode in Second Life's history as well. When Second Life was established in 2003, its underlying code facilitated the ability for residents to create and control their own objects. However, the LSL scripting code used by residents also included a module that gathered data about resident-created objects for taxation purposes. Resident taxes were based upon the size and complexity of their objects, which reduced the incentive to design large public works and similar expressions of creativity (Au, 2003). In essence, the original automated system of tax law and policy was a second-order heterogeneous large technical system supported by the first-order infrastructure of LSL code.

Because the tax system favored the interests of the Linden Lab "tax collectors," it could be interpreted as an instantiation of van der Vleuten's ideology of power in Second Life. However, Second Life residents decided to mobilize and stage a revolt against the unfair tax burden imposed on prolific creators by the incumbent system (Ondrejka, 2004c). In a region known as Americana, which included representations of iconic American architecture, residents used LSL code to build a recreation of Boston Harbor. They also built crates of tea and threw them into the harbor in

protest. After some negotiation, Linden Lab decided to completely redesign Second Life's tax system in late 2003, which constituted a victory for van der Vleuten's ideology of circulation (Au, 2003).

Today Second Life's economy is supported by a land-based tax revenue model instead. Taxes are imposed on land parcels, rather than upon user-created objects, through an automated system built into the infrastructural code. User agency and the contingent nature of history was powerfully revealed when residents co-opted the LSL scripting language to create expressive objects in protest against what they perceived to be an unjust political situation. Adopting van der Vleuten's perspective (2004) on agency and contingency demonstrates how the second-order tax policy system ultimately was shaped by consumer choices. As Malaby (2006) recognizes, contingency in the form of improvisation and innovation is a potent countervailing force against structural efforts to control, particularly in unstructured virtual worlds.

Capital in Second Life

However, the revised infrastructural tax system subsequently has become unbalanced as well, due to other contingent forces. As residents created public works and other second-order large technical systems, they invited the community to visit their land to enjoy them. Infrastructural code kept a log of such visits and paid residents a regular subsidy called "dwell" or "traffic bonuses." However, residents soon discovered that they could create and set up "camping chairs" in which other "zombie" residents would sit for hours on their property, even when the person who controlled that avatar no longer was sitting at the computer in the real world. The infrastructural log duly recorded their presence and paid the subsidy to the landowner, even though visitors were not interacting with the public works on their site as the incentive originally was designed to encourage (Au, 2006b).

Eventually, landowners used the scripting language to create new camping chairs that paid automated kickbacks into guests' Second Life bank accounts, in order to persuade guests to remain in these specially designed chairs for longer periods. This was an unexpected consequence of the creativity incentives established by Linden Lab and facilitated by the infrastructural code. As Farmer and Morningstar warned, based on their experience while developing the Habitat virtual world, "Detailed central planning is impossible; don't even try" (2006, p. 739). In response to this contingency, in April 2006 Linden Lab announced the demise of the dwell subsidy program (Anonymous, 2006b). It remains to be seen how innovative residents will react to this shift in capital incentives in the long term.

As previously discussed in the Boston Tea Party incident, residents could not leverage their in-world creations in this manner until private property

was introduced into Second Life. The concept of private property is an ideology that was inscribed in Second Life's technical infrastructure in 2003 (Malaby, 2006). The ability for residents to claim title and ownership of virtual goods made them fungible, and created a market for exchange in both real and virtual worlds (Ondrejka, 2004, 2005). Moreover, Ondrejka (2004a) argues that this connection with the real world, via a porous boundary of infrastructural code, is the real secret to Second Life's success. It creates an element of scarcity in a market of virtual goods, and also enables residents to transfer their creative skills in developing cultural content to the real world (Ondrejka, 2005). Malaby (2006) also contends that such boundaries are effective sites for contestation and negotiation.

Network Effects

In order to recognize positive and negative externalities produced by the operation of a system or network, the boundaries of that system's infrastructure must be evident in order to identify which elements are external to it. For virtual worlds such as Second Life that exemplify what Castells calls a "mind-based economy" (2001, p. 159), that determination has become increasingly complex. The virtual world spills over to the real world when Linden dollars are traded for U.S. dollars in real-world currency exchanges. This suggests that actions that occur solely in virtual worlds potentially may produce network effects (both intended and unintended) within the real world as well.

Alternatively, the real world also spills over to the virtual world when real-world sociopolitical debates are imported into Second Life. For example, in early 2006 a Second Life resident began to buy parcels of land in order to create and erect billboards upon them using the tools of the LSL code infrastructure. These billboards proclaimed "Support Our Troops Impeach Bush" in a clear expression of dissatisfaction with Bush administration policy in the real world. Many residents complained to Linden Lab, either because the billboards blocked their own view, or because they disagreed with the author's sentiments (Au, 2006a).

Although some residents sought a market solution by attempting to purchase these land parcels with billboards, the landowner discouraged that method by charging a market premium. Because the billboards were visible throughout Second Life, his public message exhibited network effects since so many residents could see and comment upon it. When Linden Lab declined to become involved, in the end other enterprising residents used the LSL scripting language to create their own public billboards with counter-messages such as "I Love Bush" which produced network effects as well. This scenario also can be analyzed using an ideology of

circulation model, based on the use of infrastructure to support the free expression of competing ideas within a democratic society (van der Vleuten, 2004).

Of course, the real issue at stake was that structures erected on private land created public externalities within a networked system. The traditional distinction between public and private areas has become more complex in both real and virtual worlds. Recently danah boyd (2006) has suggested that contemporary online environments support the rise of "superpublics" that are less dependent upon established boundaries of time and space, and instead afford new and different dynamics in terms of individual behavior and identity. The network effects represented by such superpublic infrastructures may correspond to Graham and Marvin's notion of glocality discussed further below.

Bundling/Unbundling/Rebundling

Problematizing the notion of public and private space also resonates in the delivery of real-world infrastructural services. Previously these items often were provided on a cross-subsidized, bundled basis by municipalities themselves, or by their appointed representatives within the private sector. Increasingly, however, technological advances have enabled these services to become unbundled and offered on an *ad hoc* basis, or perhaps even not at all in underserved areas. The result is a "splintered" urban environment. A similar evolution of this process within virtual worlds may provide insights for real-world decisionmakers.

In virtual worlds such as Second Life, designers may provide only basic infrastructure such as the underlying scripting language. Any additional infrastructure, such as transportation networks, must be built upon that foundation by residents themselves as second-order heterogeneous large technical systems. This process is decentralized and uncoordinated. Designers may decide to offer incentives to create public works, such as the traffic bonuses in effect in Second Life until June 2006. When such incentives are removed, however, residents may lack a rationale to cooperate and collaborate on large-scale projects. When the exercise of autonomy trumps community interests in both real and virtual worlds, chaos may ensue. As a result, some second-order infrastructure such as school systems may be under- or over-provided in the absence of clear market signals.

Latour and Weibel (2005) emphasize that matters of public concern such as devolution and privatization agendas need to be the focus of public democratic processes of coming to consensus. Civic debates regarding the nature and role of public infrastructure can help efficient coordination emerge. Community deliberation should be a necessary prerequisite to

making decisions regarding whether to unbundle or rebundle privatized public services. A designated space for public deliberation can help facilitate this discussion. Second Life's town halls can perform this role in order to support what Castells (2000, p. 13) refers to in another context as the "public works program of the Information Age." Other effective mechanisms are associated with real-world community planning processes.

Glocal Bypass and Enclave

Second Life exhibits various characteristics that indicate that in different situations it may function as either an enclave or a "glocal bypass" in terms of Graham and Marvin's (2001) conceptual framework. On one level, it may operate as an enclave for technosocial elites far removed from the real world. Sunstein (2002) described the potential risks such isolation poses for society in his book *Republic.com*. As we have seen, however, the porous boundaries of Second Life's infrastructure enable currency transactions as well as political protests to smoothly cross over and back between the real and virtual worlds, which militates against isolation. In addition, residents themselves have demonstrated an impulse to avoid such tendencies by developing new public works, such as a system of common spaces where residents can congregate and share information. So the concern that virtual worlds may represent a new frontier of segregation may be overstated.

At the same time, however, some residents have expressed a desire to develop a subcommunity within the Second Life community. For example, several residents combined their land parcels to create Neualtenburg, a self-contained gated region within Second Life from 2004–2006. It had a separate governance structure, held independent elections, and limited the activities of nonresidents (Linden Lab, 2007f). The geographic boundaries of Neualtenburg may simply have held appeal to those for whom a tangible sense of community is important, and may not imply any negative connotations of exclusivity.

What is more likely is that virtual worlds such as Second Life will serve as a "glocal bypass" to help connect residents from international jurisdictions throughout the real world. Second Life's infrastructural code already lowers the barriers of in-world geographical boundaries by enabling residents to easily teleport from region to region within the confines of the virtual world. Going further, when Second Life's architecture approaches the status of a true operating system with an embedded browser and other functionality, residents will be able to readily incorporate real-world Internet resources within their virtual world. In addition, residents and Linden Lab designers will be able to use the LSL scripting language to create tools

for remote communication and collaboration in both virtual and real contexts.

Public Deliberations on Infrastructure

Ideally, the design, implementation, and modification of infrastructure is a public process in both real and virtual worlds. In the case studies described in this paper, this process takes place at two levels of system-building. In both scenarios, second-order heterogeneous large technical systems are built upon the original foundation of underlying infrastructure. This process involves relatively little technical overhead, but invokes higher costs in terms of social investment in organizing these efforts. As function rather than form usually is determinative at the end-user application level, user agency and contingent factors become important influences upon the ultimate configuration and use of such systems.

As these systems expand, they produce network effects for providers and subscribers alike, and also redefine the boundary between public and private matters and spaces. As systems become unbundled, citizens of both real and virtual worlds need to make informed, consensual decisions regarding the provision of resources and services. Once again, user heuristics and preferences will provide feedback to mold system functionality in order to support community status as either an enclave or "glocal bypass."

In discussing the LambdaMOO community's response to an alleged virtual rape many years ago, Mnookin (2001, p. 278) provides this suggestion: "In an oft-quoted dissenting opinion, Justice Louis Brandeis wrote: 'It is one of the happy incidents of the federal system that a single courageous State may, if its citizens choose, serve as a laboratory; and try novel social and economic experiments without risk to the rest of the country.' Seventy years later, it may be virtual spaces that can best serve as laboratories for experimentation—places in which participants can test creative social, political, and legal arrangements." In addition to providing opportunities to test the validity and fungibility of new forms of capital, virtual worlds such as Second Life also provide opportunities to assess new infrastructural arrangements as well.

Virtual Worlds and Cyberinfrastructure

Ubiquitous, reliable, transparent infrastructure is a vital component of critical public works projects in both real and virtual worlds. It may be efficient to standardize upon a common core infrastructure. However, users inevitably adopt and adapt infrastructure in contingent and unexpected ways according to their needs. The functionality and persistence of Second

Life's infrastructure in the form of its LSL scripting language remains a work in progress. However, it can provide lessons for other real-world infrastructural programs currently under consideration.

For example, the National Science Foundation (NSF) Blue-Ribbon Advisory Panel on Cyberinfrastructure (2003, p. 5) focuses on the role of "enabling hardware, algorithms, software, communications, institutions, and personnel" in making recommendations for cyberinfrastructure development. This is the fundamental layer at which Second Life's scripting language infrastructure operates. Items created by residents using that scripting language operate as an application layer above. Experience in Second Life suggests that second-order large technical systems, such as transportation systems and other public works, can be created within virtual worlds by building upon the initial infrastructure layer. This has important implications for the NSF's cyberinfrastructure initiative, which includes the goal of developing a "national digital data framework" (NSF Cyberinfrastructure Council, 2006, p. 19).

First, Second Life can be used as a testbed to model these and other potential "middleware" projects. Moreover, virtual worlds such as Second Life may in fact soon serve as environments in which future NSF projects, such as scientific collaboratories, actually may be located in order to support avatar-based research collaborations. As Au suggests (2006c),

> [T]he experience of one's alter ego being in an immersive space is experientially different from any other kind of Net-mediated interface that has come before it. Different, and in several key ways, better, than the limited, distanced, largely asynchronous interactivity of the Web as it exists now. An MMO quite literally offers a direct pathway into data, and global collaboration with an international community through avatars that afford each individual a high degree of ano-nymity, and paradoxically, an equally high degree of self-representation. With so much potential, and the technical/commercial infrastructure in place to make it feasible, it's difficult to imagine online worlds not becoming the next real leap in the Internet's evolution.

Graham and Marvin (2001) might concur that Second Life's own infrastructure offers the potential for demonstrating, on a smaller scale, how the unbundling and rebundling of infrastructural components, such as international scientific instrumentation and research practices, might be conducted more efficiently via a "glocal bypass" facilitated by cyberinfra-structure.

Conclusion

Ondrejka (2005) notes that the infrastructures of virtual worlds must remain flexible and responsive to the needs and desires of their residents: "Just as

real-world urban planners must accept change, digital world developers must as well" (p. 3). The culture of participatory design that emphasizes the agency and contingency of infrastructural boundary objects and user/designers indicates that Second Life residents form their world through their choices. The underlying technical architecture of Second Life's infrastructure helps shape social and power relations within that virtual world. However, iterative reinterpretation, reinscription, and transformation of that infrastructure, by users as well as developers, influences subsequent events as well.

This chapter has discussed emergent sociotechnical affordances of virtual worlds and what they may foreshadow in terms of the postmodern decentralization and unbundling of infrastructural services in the physical world. As user needs and virtual world infrastructures continue to coevolve during the Internet era, they offer real-world lessons to help improve the design and maintenance of complex cyberinfrastructure projects, which share several critical features with virtual worlds. Insights gained from studying virtual world environments such as Second Life suggest that they can be productively deployed as experimental testbeds in which to challenge current theories of infrastructural development, and also to incubate new ones.

References

Anonymous. (2006a, April 15). Attack of the red helix: Not so good for the Jew. *Second Life Herald*. Retrieved April 22, 2006, from http://www.secondlifeherald.com/slh/2006/04/attack_of_the_r.html

Anonymous. (2006b, April 18). Linden Lab kills dwell payments. *Second Life Herald*. Retrieved April 17, 2006, from http://www.secondlifeherald.com/slh/2006/04/linden_lab_kill.html

Anonymous. (2006c, May 1). My virtual life. *Business Week*.

Anonymous. (2007, June 9). Online gaming's Netscape moment? *Economist*. Retrieved June 15, 2007, at http://www.economist.com/printedition/displaystory.cfm?story_id=9249157

Au, W. J. (2003). Tax revolt in Americana. *New World Notes*. Retrieved April 2, 2006, from http://nwn.blogs.com/nwn/2003/09/tax_revolt_in_a.html

Au, W. J. (2006a). Unimpeachable offense. *New World Notes*. Retrieved April 2, 2006, from http://nwn.blogs.com/nwn/2006/03/unimpeachable_o.html

Au, W. J. (2006b). Improvise, adapt, oversit. *New World Notes*. Retrieved April 22, 2006, from http://nwn.blogs.com/nwn/2006/04/improvise_adapt.html

Au, W. J. (2006c, September). Taking new world notes: An embedded journalist's rough guide to reporting from inside the Internet's next evolution. *First Monday*, special issue number 5. Retrieved July 31, 2008, from http://www.uic.edu/htbin/cgiwrap/bin/ojs/index.php/fm/article/view/1562/1477

Bartle, R. (2003). *Designing virtual worlds*. Berkeley, CA: New Riders Publishing.

Benkler, Y. (2006). *The wealth of networks: How social production transforms markets and freedom.* New Haven, CT: Yale University Press.

Bowker, G. C., & Star, S. L. (1999). *Sorting things out: Classification and its consequences.* Cambridge, MA: MIT Press.

boyd, d. (2006). Super publics. *Apophenia: Making connections where none previously existed.* Retrieved March 22, 2006, from http://www.zephoria.org/thoughts/archives/2006/03/22/super_publics.html#comments

Brand, S. (1974). *II cybernetic frontiers.* New York: Random House.

Castells, M. (2000, July 15). *Information technology and global development.* Keynote address presented on May 12, 2000 at the Economic and Social Council of the United Nations, New York, NY. Retrieved April 11, 2006, from http://www.un.org/esa/coordination/ecosoc/itforum/castells.pdf

Castells, M. (2001). Information technology and global development. In J. Muller, N. Cloete, & S. Badat (Eds.), *Challenges of globalisation: South African debates with Manuel Castells* (pp. 152–167). Capetown: Maskew Miller Longman.

Castronova, E. (2005). *Synthetic worlds: The business and culture of online games.* Chicago: University of Chicago Press.

Dibbell, J. (2007, June 17). The life of the Chinese gold farmer. *The New York Times Magazine.* Retrieved July 31, 2008, from http://www.nytimes.com/2007/06/17/magazine/17lootfarmers-t.html

Farmer, F. R., & Morningstar, C. (2006). The lessons of Lucasfilm's *Habitat.* In K. Salen & E. Zimmerman (Eds.), *The game design reader: A rules of play anthology* (pp. 728–753). Cambridge, MA: MIT Press.

Feng, P. (2003). Studying standardization: A review of the literature. *IEEE 3rd Conference on Standardization and Innovation in Information Technology,* 99–112.

Fleischmann, K. R. (2006a). Boundary objects with agency: A method for studying the design-use interface. *The Information Society, 22,* 77–87.

Fleischmann, K. R. (2006b). Do-it-yourself information technology: Role hybridization and the design-use interface. *Journal of the American Society for Information Science and Technology, 57*(1), 87–95.

Graetz, J. M. (1981, August). The origin of Spacewar. *Creative Computing.*

Graham, S., & Marvin, S. (2001). *Splintering urbanism: Networked infrastructures, technological mobilities and the urban condition.* New York: Routledge.

Grimmer, L. (2006, February). Interview with Ian Wilkes from Linden Lab. *MySQL developer zone.* Retrieved April 6, 2006, from http://dev.mysql.com/tech-resources/interviews/ian-wilkes-linden-lab.html

Hauben, M., & Hauben, R. (1997). *Netizens: On the history and impact of Usenet and the Internet.* Los Alamitos, CA: IEEE Computer Society Press.

Hughes, T. P. (1987). The evolution of large technological systems. In W. Bijker, T. P. Hughes, & T. Pinch (Eds.), *The social construction of large technological systems* (pp. 51–82). Cambridge, MA: MIT Press.

Juul, J. (2005). *Half-real: Video games between real rules and fictional worlds.* Cambridge, MA: MIT Press.

King, B., & Borland, J. (2003). *Dungeons & dreamers: The rise of computer game culture from geek to chic.* Emeryville, CA: McGraw-Hill Osborne Media.

Koster, R. (2002). *Online world timeline.* Retrieved February 21, 2006, from http://www.raphkoster.com/gaming/mudtimeline.shtml

Latour, B., & Weibel, P. (Eds.) (2005). *Making things public: Atmospheres of democracy.* Cambridge, MA: MIT Press.

Lessig, L. (1999). *Code and other laws of cyberspace.* New York: Basic Books.

Lessig, L. (2002). *The future of ideas: The fate of the commons in a connected world.* New York: Random House.

Lessig, L. (2005). *Free culture: The nature and future of creativity.* New York: Penguin Press.

Linden, J. (2007, June 13). Voice First Look viewer available for the live grid. *Linden Blog.* Retrieved June 15, 2007, from http://blog.secondlife.com/2007/06/13/voice-first-look-viewer-available-for-the-live-grid/

Linden Lab. (2007a). *Second Life economic statistics* (2007). Retrieved June 15, 2007, from http://www.secondlife.com/whatis/economy_stats.php

Linden Lab. (2007b). *Second Life LindeX market data* (2007). Retrieved June 15, 2007, from http://secondlife.com/whatis/economy-market.php

Linden Lab. (2007c). *Second Life terms of service* (2007). Retrieved June 15, 2007, from http://secondlife.com/corporate/tos.php

Linden Lab. (2007d). *Second Life virtual economy key metrics* (2007, May). Retrieved June 15, 2007, from http://s3.amazonaws.com/static-secondlife-com/economy/stat_200706.xls

Linden Lab. (2007e). *Second Life: Your world. Your imagination.* Retrieved June 15, 2007, from http://secondlife.com/

Linden Lab. (2007f). *SL history wiki* (2007). Retrieved June 15, 2007, from http://www.slhistory.org/index.php/Main_Page

Malaby, T. (2006, September). Introduction: Contingency and control online. *First Monday,* special issue number 7. Retrieved July 31, 2008, from http://firstmonday.org/issues/special11_9/intro/index.html

Markoff, J. (2005). *What the dormouse said: How the Sixties counterculture shaped the personal computer industry.* New York: Viking Penguin.

Mnookin, J. L. (2001). Virtual(ly) law: The emergence of law in *LambdaMOO.* In P. Ludlow (Ed.), *Crypto anarchy, cyberstates, and pirate utopias* (pp. 245–301). Cambridge, MA: MIT Press.

Mulligan, J., & Patrovsky, B. (2003). *Developing online games: An insider's guide.* Berkeley, CA: New Riders Publishing.

Muramatsu, J. I. (2004). Social regulation of online multiplayer games. *Dissertation Abstracts International, 65*(10), 5237B. (UMI No. 3149680).

National Science Foundation (NSF) Blue-Ribbon Advisory Panel on Cyberinfrastructure. (2003). *Revolutionizing science and engineering through cyberinfrastructure.* Washington, DC: National Science Foundation.

NSF Cyberinfrastructure Council. (2006). NSF's cyberinfrastructure vision for 21st century discovery. Washington, DC: National Science Foundation.

Ondrejka, C. R. (2004a). Living on the edge: Digital worlds that embrace the real world. *Social Science Research Network.* Retrieved February 21, 2006, from http://ssrn.com/abstract=555661

Ondrejka, C. R. (2004b). A piece of place: Modeling the digital on the real in Second Life. *Social Science Research Network.* Retrieved February 21, 2006, from http://ssrn.com/abstract=555883

Ondrejka, C. R. (2004c). Aviators, moguls, fashionistas and barons: Economics and ownership in Second Life. *Social Science Research Network.* Retrieved February 21, 2006, from http://ssrn.com/abstract=614663

Ondrejka, C. (2004–2005). Escaping the gilded cage: User-created content and building the metaverse. *New York Law School Law Review, 49,* 81–101.

Ondrejka, C. (2005). Changing realities: User creation, communication, and innovation in digital worlds. *Social Science Research Network.* Retrieved February 21, 2006, from http://ssrn.com/abstract=799468

Rosedale, P., & Ondrejka, C. (2006, March). Glimpse inside a metaverse: The virtual world of Second Life. *Google Tech Talk.* Retrieved April 9, 2006, from http://video. google.com/videoplay?docid=-5182759758975402950

Salen, K., & Zimmerman, E. (2004). *Rules of play: Game design fundamentals.* Cambridge, MA: MIT Press.

Sunstein, C. (2002). *Republic.com.* Princeton, NJ: Princeton University Press.

Taylor, T. L. (2004). The social design of virtual worlds: Constructing the user and community through code. In M. Consalvo et al. (Eds.), *Internet research annual vol. 1: Selected papers from the Association of Internet Researchers conferences 2000–2002* (pp. 260–268). New York: Peter Lang.

Terdiman, D. (2006, March 28). Second Life scores $11 million in funding. *News.com.* Retrieved April 9, 2006, from http://news.com.com/Second+Life+scores+11+milli on+in+funding/2100–1043_3–6054598.html

Turner, F. (2006). *From counterculture to cyberculture: Stewart Brand, the Whole Earth network, and the rise of digital utopianism.* Chicago: University of Chicago Press.

van der Vleuten, E. (2004). Infrastructures and societal change: A view from the large technical systems field. *Technology Analysis & Strategic Management, 16*(3), 395–414.

Wallace, M. (2006, April 17). 3pointD security: Will Second Life ever be safe? *3pointD. com: The metaverse and 3D web.* Retrieved April 22, 2006, from http://www.3pointd. com/20060417/3pointd-security-will-second-life-ever-be-safe/

Part II Social Aspects of Living
Virtually

3. The Social Life of Second Life: An Analysis of the Social Networks of a Virtual World

ALEKSANDRA K. KROTOSKI, EVANTHIA LYONS AND JULIE BARNETT

Introduction

Second Life is a social virtual world devised, developed, and maintained by U.S. company Linden Lab. Social virtual worlds are online graphical representations of virtual communities with the aim of bringing people together in a digital environment.

They exist in cyberspace as perpetuating environments, accessible to account holders 24-hours per day and 365 days per year. They are interpersonal in nature, in contrast to other online communities which are functional (e.g., eBay communities or open source forums), or goal-oriented (Massively Multiplayer Online Games like Blizzard's *World of Warcraft*). They establish a conceptual space for their participants who interact with one another socially and collaboratively in a represented physicality. In some cases, social interactions transform into commoditised transactions based upon the needs of virtual residents and the skills of the community members.

Second Life and other spaces like it are collaborative social tools that exist for the purpose of social goals—making friends, interacting across distance, and meeting others with similar interests. What sets them apart from other socially oriented Internet environments like social networking sites (e.g., MySpace, Facebook, Bebo, etc.), Multi-User Dungeons (MUDs; e.g., LambdaMOO), and other online communities (e.g., bulletin board systems, forums, or chatrooms) is that the virtual world component exists in a 3-D representation of space.

Each Second Life account holder has an avatar, or computerised representative, which is the virtual world resident's public face in the online world. The avatars in Second Life are persistent online identities which each resident 'wears' any time s/he is logged into the digital environment. It is through these avatars that the residents of Second Life interact with one another.

The avatars may be close to, the same as, or entirely different from the account holder's actual physical self (or gender). Over time, however, the avatar comes to represent the online identity entirely, and becomes the person which others develop relationships with. Through mutual experiences within the virtual world, the anonymised offline self is replaced with the pseudonymous identity of the resident and his or her avatar. These interactions form the basis of friendships built on the development of trust, which in turn is based on experience via repeated interaction.

This phenomenon has been observed in other online social environments, including chat rooms (Levine, 2000), bulletin boards (Correll, 1995), and MUDs (Kendall, 2002). Online relationships have been exploited with digital ferocity as the Internet's power for social connectedness has been explored and expanded with the social media movement, and articulated through applications like blogs and social networking sites. In these spaces, the connections between people are expressed through publicly accessible profiles and friends' lists which users browse at their leisure, making friendships asynchronously. Relationships in these spaces are usually based on existing friendships or friends of friends.

In contrast, Second Life adopts a more situated networking approach than most modern web-based social media. Residents are co-located in time and space in a synchronous medium that encourages the development of friendships based upon physical-virtual co-proximity. For this reason, research which explores how and why relationships form between people in chat rooms is most useful for examining similar phenomena in a social virtual world like Second Life (e.g., Levine, 2000).

Social Relationships and Social Networks

But why are relationships in the Second Life important to the so-called 'first' one? Critics of online social networks argue that the medium's anonymity contradicts the opportunity to develop interpersonal bonds, yet the social capital bestowed upon online brands, like virtual bookseller Amazon.com, or reputation-based marketplaces like eBay.com, indicates the importance of relationships based upon permanent identity. Indeed, in *Second Life*, residents are welcome to create objects and over time in-world brand identities have emerged (Book, 2004). Further, ethnographers detail

entrance and exit rituals, and the formation of subgroup and hierarchical classifications, which reflect community formation offline (Correll, 1995). Online community designers recognise that reputation in these spaces is an important digital currency (Kollock, 1999; Raymond, 2000; Bergquist & Ljungberg, 2001; Hemetsberger, 2002), and create systems which provide the facilities to establish identifying features (e.g., avatars, home spaces) which help users integrate with permanent virtual social groups.

Social Network Analysis (SNA) argues that by examining the patterns of connections between people, we are able to understand how information, innovation and influence may pass through a social environment. By looking only at the connections between people, network analysts can also identify emergent communities and groups of people who are tightly bonded and, psychologically, are likely to share similar attitudes and norms. Further, it can pinpoint where the breakdown of information may occur, and how best to resolve this when it happens.

Further, developers of online social spaces are keen to encourage relevance for their community members. They hope that by directing individuals to groups in which they can become situated members, they will be less likely to drift away to another space, potentially bringing others with them and eventually undermining the social foundations upon which an online community is based.

Social virtual worlds like Second Life are also the subject of scrutiny in various social sciences, from law to psychology. Researchers observe the relationships to describe the development of social systems in the real world, and to understand how friendships, laws and societies are created and fall apart. Similarly, the networks of friendships in these spaces represent trust bonds made between people over distances, which is important for the speedy diffusion of innovations or information throughout the distributed population.

Diffusion of Innovations

Diffusion research examines how practices, ideas and innovations spread through interpersonal communication networks. It is primarily used as a predictive technique aimed at understanding the potential trajectory of anything from commercial products to the spread of infectious diseases. Unsurprisingly, there are many stakeholders interested in understanding diffusion's processes; marketers and psychologists, community developers, economists, medical researchers, political scientists and sociologists have all examined diffusion for their own purposes.

Diffusion theories recognise that social interaction is a complex and important aspect of how populations work and, rather than assuming targets

passively receive information from sources (e.g., media outlets, public and private organisations or spokespeople), it promotes horizontal rather than vertical approaches to understanding distribution and uptake. In other words, theorists assert that innovations diffuse because of the dynamic communicated experiences of similar others who have already adopted, creating a process of mutual sense-making (Valente, 1995; Valente & Davis, 1999). Thus trends, cultures and practices are passed between members of a community.

The Internet has been described as a 'network of networks' (Garton, Haythornthwaite, & Wellman, 1997) because it explicitly connects groups of people using computer networking technologies. Highly interconnected social software networks like weblogs, forums and other collaborative online entities have challenged traditional notions of information ownership, resulting in a reconsideration of online contributors' involvement in news reporting and other forms of citizen participation. This brings to bear new phenomena relevant to existing approaches to diffusion of innovations through this rapidly changing communication avenue, as physically distributed networks of individuals who engage with one another in virtual communities—from different cultures and perspectives—consider which innovations to adopt or to reject.

While there has been criticism levied against the Internet suggesting that online activities reduce the strength of offline networks (Kraut et al., 1988), substantial evidence suggests that these early findings were due in part to the dearth of people online (McKenna & Bargh, 2000; Kraut et al., 2002). Subsequent study, primarily by Wellman and colleagues (Wellman & Gulia, 1999; Wellman, 2001; Wellman, Boase, & Chen, 2002) and others, has examined the affordances of online interactions, arguing that virtual connectivity extends existing networks, strengthening offline bonds rather than replacing them. Certainly in socially slanted spaces, where interactants meet repeatedly over months and years, research suggests that online social systems form, through which information diffuses (Correll, 1995; Kendall, 2002).

Measuring Diffusion

The most commonly used method for predicting the patterns of diffusion is SNA. Figure 3.1 is a visual representation of an entire system. The dots are individual actors in the network and the lines are the links between them, forged by the criteria defined by the researchers. For example, medical scientists may map links using physical contact data, political scientists may use international trade statistics, organisations may use communication

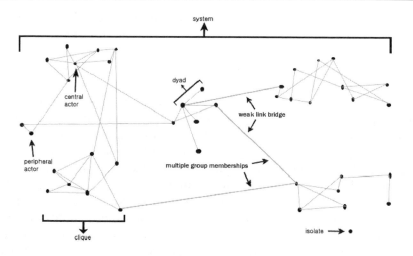

Figure 3.1 A sociogram representation of an entire network.

pathways and market researchers and psychologists may use interpersonal influence factors, like trust, to define the relationships that connect actors together.

Social network analytic strategies have received high-profile attention as the methods have been implemented in public health contexts (Bauman & Ennett, 1996; Montgomery et al., 2001), anti-terrorism operations (Krebs, 2002) and community participation action research (Weenig & Midden, 1991; Weenig, 1993). Risk researchers have adopted social network analysis for public attitude change campaigns (Scherer & Cho, 2003), and market researchers are increasingly relying upon network analysis for effective bottom-up advertising approaches (e.g., Domingos & Richardson, 2001).

Measuring Networks in Second Life

Social Network Analysis data collection emphasises actor-definitions of network principles, using a technique called sociometry to generate connections. In this method, participants are asked to list or select people they are connected with, and may be asked to further define these relationships to assess questions of interpersonal closeness and distance. The resulting matrices of data are imported into an SNA programme (e.g., UCINet, Pajek) which produces a sociogram of the raw data (Figure 3.1), and associated descriptive statistics. By using sociometric surveys, social network researchers allow participants to identify friends and acquaintances,

an approach which has been demonstrated to offer more effective predictive power in describing influence effects than researcher-defined groups (Bauman & Ennett, 1996; Scherer & Cho, 2003).

In Second Life, social relationships can be captured in several different ways. One of the benefits of the online realm for diffusion research is that computer-specific attributes can serve to aid in defining important network factors without researcher intervention. For example, strong ties can be measured by the number of communication modes which network participants use to interact (e.g., in 'public' like in a live chat room, via private messaging facilities, using email or in person; Correll, 1995; Garton et al., 1997). Hyperlinks can be mined from websites and weblogs, providing evidence of the pathways through which information travels in virtual channels. For this reason, it is often easier to follow online innovation as it passes through a system, as data traces can be assessed and user-definitions (e.g., hyper-linking and tagging) often negate the need to query participants directly for their network connections.

In spaces like Second Life, where interaction occurs locally and simultaneously (as in offline environments) there are no accessible persistent records of connectivity or diffusion to mine. Communication is primarily text-based, with typed words exchanged synchronously. While there are several modes of communication (public chat, private group chat and private chat), more traditional methods of SNA must be implemented in order to understand how practices, cultures and trends spread through these online worlds.

Connections in Second Life

Residents have several options for meeting fellow citizens, from the formal to the casual, in private or in public. For example, regular events called by members of the community help to perpetuate a cycle of repeated informal interaction, and formal group structures help establish social bonds based upon similar values and beliefs.

Importantly in the millions-strong virtual world, Residents are able to demarcate people they wish to meet again. The *Friends* list is an indication of a reciprocated formal partnership. It allows players to see which of their contacts is online, when they are online, where they are in the virtual space, and offers unique contact options. In some cases, Residents also allow close friends to manipulate their objects and avatar. Modification rights are rare and must be activated specifically; it has been suggested that such permission indicates a close relationship between pairs.

The bulk of actors in each actor's friendship network are not visible to other avatars, but if Residents choose, they can identify one close friend as

a 'partner' who is visible on their public profiles. It is understood in the community that this pair is closely bonded, and they often celebrate a formal ceremony to highlight the establishment of this public display of connectivity.

So, using traditional sociometric methods, residents may be asked to describe their contacts from the in-world 'Friends' list. This basic network can be represented in a sociogram like that in Figure 3.1. Researchers then apply descriptions to key actors to extract meaningful information about diffusion.

Key Network Descriptions

Position

In SNA, each resident's importance in the diffusion process is defined by the number and quality of ties he or she has. Those who have many strong connections are described as more influential than those who have few or none.

Their positions in the network are defined by their relative importance both overall (globally), and within the groups they are most closely connected with (locally). Individuals who have ties to many others in their clique, network or system are described as central, while those who have fewer ties to others in the network are referred to as peripheral. Social network researchers argue that these delineations have implications for both the amount of information which an actor has access to and how quickly it can be passed through a system (See Figure 3.2).

Central actors have more links to others in the network than peripheral actors and they are able to quickly diffuse information to the people within their groups. Rogers (1995) theorises that opinion leaders are more conservative about adopting innovations than their peripheral counterparts because a socially counter-normative adoption may jeopardise their

This node is the centre actor in a closely-connected group. It is expected to reflect the innovativeness of the group.

This peripheral node is expected to be innovative as it sits on the outskirts of the network.

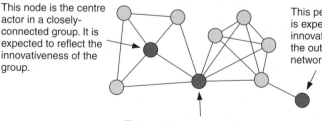

This node is connected to two closely-connected groups. It is a lynchpin, an important pathway for innovation to pass between them.

Figure 3.2 Network positions.

important roles, but their adoption signals to the rest of the group that the new content is socially acceptable. In contrast, peripheral actors may not know what the network knows as quickly as a central actor does but their positions on the outside of the social sphere means that they have connections with other groups who have novel information. Peripheral actors also play an important role in passing information to people in other social groups in the system. These measurements help to pinpoint opinion leaders in a social environment.

However, measuring something like the number of connections in an offline environment can be relatively straightforward. But in a computerised situation like Second Life, where friends on a list may literally reach thousands, the notion of 'central' becomes more difficult to support.

For example, a person with over a thousand friends would be expected to have a huge effect on the diffusion of an innovation. It would be argued that s/he would be able to spread an innovation extremely quickly and to many different people in a system. In reality, this skews the analysis, as it assumes that a simple connection is enough to indicate the pathway along which a diffusion will spread. Yet social psychological research argues that there are reasons for why people choose to adopt or not to adopt an innovation, and these are based on interpersonal elements like strength of relationship, perceived trust in the source, perceived credibility in the source, number of others who are perceived to have adopted in the potential adoptee's self-identified group, and whether the adoption maintains a stable identity or disrupts it. Therefore, one cannot assume that the simple connection indicates the pathway of an innovation. It is important thus to understand more about the connection before predictions about the spread occurs.

One way this is represented in SNA is by describing the direction of the relationship. In practice, this would represent when an individual chooses someone as a contact or friend when the other person doesn't.

In Second Life, the 'friendship' measure described above does not offer this option, as it is assumed to be a 'binary' relationship, or a relationship which automatically assumes both parties are connected if one person indicates a connection. Therefore, it is important to include more information about a relationship than only its direction.

This can be done in several ways. First, sociometric surveys offer the researcher the opportunity to specify how participants should measure the quality or value of a connection. This kind of self-report has a qualitative value, and can be used to assess behavioural features that may indicate a stronger or weaker relationship. An example of such a behavioural feature in Second Life is to ask how residents communicate with one another (e.g.,

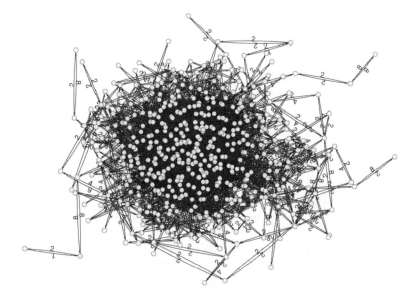

Figure 3.3 A directed network.

public chat, private chat or chat outside the virtual world). As suggested earlier, this has implications for the level of trust between people.

Yet another way to measure connection is to examine the behaviour of the digital population using recording devices or server logs to assess, for example, how many times two people are in contact with one another, or the permissions granted to each of their friends. The network map then begins to look more like the one shown in Figure 3.3, which identifies the strength of a relationship on the lines connecting two people.

Structure

While position and relationship value are important descriptors in SNA, a network is also defined by its shape and density. According to Valente's (1995) Network Theory, examining the structure can also inform the researcher how quickly and in which direction an innovation will diffuse.

Network theory proposes that innovations will flow rapidly through dense networks of cliques which feature many interconnections between them, but that they will stagnate if the system has a low density, or features many discrete groups with few connecting ties. In contrast, novel information will spread quickly through a system which has a greater number of radials than cliques (See Figure 3.4), as actors in radials have more access to both the innovation and to people who do not fall into a single social grouping.

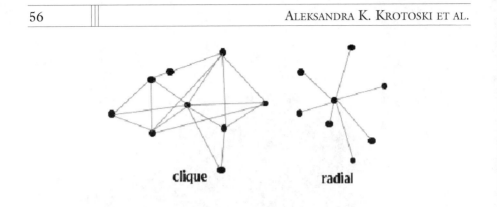

Figure 3.4 Cliques and radials.

Other measures specify weak ties (actors who act as bridges between multiple groups and are considered influential across groups) and network stars (actors with many strong and weak ties through the system). Research on the formation of online relationships (cf. Levine, 2000) and online communities (cf. Kendall, 2002) highlight the importance of similar processes between the two, but (Garton et al., 1997) suggest that there are more weak ties online than offline, and therefore greater interpersonal transience. Yet research which aims to replicate Milgram's (1967) Small-World experiment via the Internet suggests that there is no significant difference in the 'degrees of separation' between a source and an unrelated target (Dodds, Muhamad, & Watts, 2003). The message may spread greater physical distances and arguably the weakly tied networks may generate the need for a greater emphasis on social capital (Hemetsberger, 2002).

Describing Key Actors in Second Life

To assess a baseline understanding of the relationships in Second Life, and the potential for diffusion through this social network, an online survey was made available to the Residents through a virtual research lab built for the purpose of collecting data. After the initial stages, the survey was distributed to over 4,000 Residents using a snowball sampling method, which eventually measured 9,676 connections between 6,767 individuals between April and December 2006.

The survey was divided into 5 sections:

1. **Demographics** included avatar name, age, country of residence, offline gender, online gender, length of time in Second Life and number of hours spent in Second Life per week.
2. **Social Network Items** required participants to list the names of the Second Life avatars with whom they have formed an official

'friendship'. This generator method was chosen because it represented an explicit tie for both parties, and incorporated more actors into the resulting social network, regardless of whether or not they completed the survey. All listed avatars were contacted to inform them of their role in the research, and were invited to contribute or to opt out of the study. Eight avatars who were contacted chose to opt out, and their names were removed from the data set.

3. **Social Psychological Items** assessed each respondent's perceptions of his/her relationship with the avatars generated in the social network items to compare these scores with social network factors. These included scales measuring perceived social psychological trust (SPT), perceived group prototypicality (SPP) and social comparison (SPSP). The trust scale were informed by Poortinga and Pidgeon (2003), Cvetkovich (1999) and Renn and Levine (1991). It incorporated themes of social trust (care, competence, objectivity, consistency, similarity and trustworthiness). The social comparison scale was informed by the Attention to Social Comparison Information Scale (ATSCI; Lennox & Wolfe, 1984). The prototypicality item was generated for this survey.

4. **Own Experience of and attitudes to risk items** assessed Residents' attitudes towards general 'risk' behaviours in Second Life (online identity privacy, 'virus' infection and fraud).

5. **Perceived Experience of and attitudes to risk items** assessed Residents' perceptions of their friends' attitudes towards general 'risk' behaviours in Second Life (online identity privacy, 'virus' infection and fraud).

The global network's density was low, indicating a loosely tied social group, which this is a frequent finding in very large networks (Friedkin, 1991).

In such a large network, it is difficult to identify central actors by looking at a visualisation, and so a centrality measure was calculated which identified 46 Residents who were considered the 'most popular' in this group. They received the highest number of incoming links, or nominations from other people (Costenbader & Valente, 2003). This group is represented in Figure 3.5, which shows that there are 31 actors who are connected to one another, and therefore represent a highly cohesive, or strongly tied, cluster of people. Information which begins at one point in the group has the facility to reach another person on the other side, which makes this a powerful group within the virtual world.

The other 15 actors in Figure 3.5 are what are called 'isolates', or people who don't have any connections with anyone else. However, these actors are not to be discounted as they have important connections within the entire network and can therefore get information to people and Second Life communities which aren't connected to the people in the cohesive group in

Figure 3.5 The opinion leader network in Second Life.

Figure 3.5. The 15 opinion leaders represent alternative information streams, which may overlap further down in their networks.

Definitions of Closeness

The networks defined above have been determined by assessing the number of relationships an actor receives from others in the Second Life network, but what does it mean to be central within this virtual world?

An actor's network centrality has an impact on perceptions of several factors associated with social psychological persuasion processes (elaboration likelihood model of persuasion (ELM), Petty & Cacioppo, 1986; Conflict-Elaboration Theory of social influence, Perez & Mugny, 1996). If central actors in Second Life can be identified using network analysis, it is possible to predict how much others trust them in general, how much others trust them for information about taking risky behaviours inside

Table 3.1 The effect of network centrality on social psychological variables of persuasion

	β_0 (std. error)	β_1 (std. error)	δ_e (std. error)	2cLogLikelihood	N
Social network trust?	0.773 (0.023)	0.432 (0.020)	0.420 (0.013)	6162.35	2786
Trust about business?	0.807 (0.026)	0.191 (0.021)	0.531 (0.018)	6560.19	2651
Trust about sex?	0.809 (0.026)	0.215 (0.021)	0.532 (0.018)	6510.62	2649
Trust about privacy?	0.805 (0.025)	0.240 (0.021)	0.530 (0.017)	6460.3	2649
Social comparison?	0.797 (0.026)	0.312 (0.020)	0.483 (0.016)	6400.24	2685
Prototypicality?	0.803 (0.026)	0.190 (0.022)	0.534 (0.017)	6653.37	2685

Second Life (business, sex[1] and privacy), how much other people compare themselves with them, and how much each central actor is perceived to be a representative of a given group (See Table 3.1).

What this means in practice is that the central actors in Second Life are viewed as highly trustworthy. This has implications for diffusion, as their messages are likely to be attended to, particularly in an online environment, where the immersiveness of the communication context enhances the necessity for a source to be perceived as 'trustworthy' (Guadagno & Cialdini, 2005). They're also highly likely to be considered sources of social comparison. In other words, these highly central, popular actors are looked up to, to inform attitudes about innovations.

This varies slightly according to the information content. People are more likely to trust a central person about issues associated with identity privacy than they are to trust them about sexual risks and activities, but they are more likely to trust them about sex than about business.

Opinion leaders in the Second Life network are more likely to be sources of information because they have access to a broader information pool. If they adopt or transmit an innovation, it is likely to spread through their local networks because they are trusted individuals, viewed as prototypical in the social group, and sources of others' social comparison.

Within the 46-person opinion leader group, there are several demographic features which stand out as significantly different from the rest of the Second Life population[2] (see Table 3.2). From this sub-sample of 46 key opinion leaders in the Second Life network, the majority were older than average and from the United States. Very few 'gender bend', or take

Table 3.2 95% Confidence Intervals for global and local demographics

	Global 95% Confidence interval		Opinion Leaders (N = 47)		Opinion Leaders (N = 31)	
	95% Confidence interval		95% Confidence interval		95% Confidence interval	
	Lower	Upper	Lower	Upper	Lower	Upper
Age[a]	32.90[c]	34.48[c]	32.44[c]	47.56[c]	35.65[c]	50.55[c]
Gender[b]	0.184	0.200	0.773	0.789	0.737	0.754
Avatar Gender[b]	0.000[c]	0.001[c]	1.000	1.000	1.000	1.000
Length of time in Second Life[a]	3.59[c]	3.87[c]	4.58[c]	5.92[c]	4.80[c]	6.00[c]
Hours per week in Second Life[a]	2.29[c]	2.51[c]	3.36[c]	4.14[c]	3.35[c]	4.25[c]
Direct experience of business fraud[b]	0.000[c]	0.000c	0.035[d]	0.042[d]	0.101	0.113
Attitudes to business risk[a]	2.486[c]	2.585[c]	1.519[c]	2.629[c]	1.386[c]	2.614[c]
Direct experience of sexual activity[b]	0.000[c]	0.000[c]	0.172	0.187	0.274	0.292
Attitudes to sexual risk[a]	2.377[c]	2.511[c]	1.794[c]	2.354[c]	1.742[c]	2.258[c]
Direct experience of privacy breach[b]	0.000[c]	0.000[c]	1.000	1.000	1.000	1.000
Attitudes to privacy risk[a]	2.306[c]	2.414[c]	2.223[c]	3.111[c]	2.151[c]	3.183[c]

a: t-test statistic
b: Chi-Square test statistic
c: significant at the p=0.000 level
d: significant at the 0.05 level

on a sexual identity different from their offline selves, and most are female.

Second Life opinion leaders are particularly dedicated to their community. They've been involved with the virtual world for longer and spend more time in-world than the majority of residents.

Conclusions

There is a core of relatively similar actors who control the information in Second Life, although there are also several opinion leaders who are not subject to the social pressures of the core contingent. This indicates the

potential for some distribution of cultures and trends which is not dominated by this core group.

From the perspective of companies and interested third parties who wish to enter this virtual world for social marketing purposes, there are a few core actors in the Second Life network who should be targeted for campaigns. By identifying a small proportion of the entire network, influential messages are likely to spread through the rest of the network.

Yet these actors are very similar, suggesting that Second Life's core contingent is dominated by a relatively controlled subset of less than 50 actors. While the relative centrality of this group means that information diffusion can be exercised rapidly, there may be a danger of ghettoising Residents from other demographic categories. Particularly with relation to the nationality of the opinion leaders identified within this research, it may be important to consider designs which incorporate as many different countries as possible.

This chapter has presented only the surface of the networking possibilities in this virtual world. Future research may wish to follow an innovation through the pathways of communication in order to understand how information diffuses through the networks, and to apply the results learned here. As virtual worlds continue to capture the imaginations of a global population and become more central in the information campaigns of citizen journalists, marketing organisations, psychologists, economists, political scientists and others interested in simulating the social, the power dynamics identified by network analysis are an important step in understanding the potential of this medium for influence.

Ethical Considerations

An important prerequisite of any research conducted using human participants is the assurance of anonymity and confidentiality in order to protect them from any potential harm. In traditional social science, this can be easily assured; for example, attribute information can be collected without the need to know participants' identities.

However, SNA is predicated on the identities of respondents and the identities of those people they list as friends/acquaintances/sources of information, and therefore the conditions of anonymity become problematic. Anonymity is not possible in the network collection paradigm as identifying information is used to facilitate the development of the sociogram analytic tool (Borgatti & Molina, 2003, 2005). As Kadushin (2005) argues, 'the collection of names of either individuals or social units is not incidental to the research but its very point' (p. 141).

Social network analysts argue that the lack of anonymity in data collection should not deter Social Network Research from going forward,

but the onus for establishing the ethical use of sensitive identifying information is on the researcher. Of particular importance is the removal of any identifying features or attributes from the data as soon as possible, and certainly before dissemination of findings. While this has relevance for raw, 'as collected' data in databases, this also has implications for sociograms. As Borgatti and Molina (2003) explain, the sociograms used to deduce important information such as position and structure has 'a 1 to 1 correspondence with that person's filled out questionnaire, completely revealing that person's responses' (p. 341).

The conditions for when to remove identifying features in the process of social network research vary depending upon whether the social network analysis is 'pure' (i.e., the questions of interest relate to how the structure of a network *alone* has an effect on a given independent variable) or feature sociological or psychological leanings (i.e., the questions of interest relate to community, organisation or actor position). Whereas for 'pure' SNA, it is suggested the node names can be replaced by codes almost immediately (Klovdahl, 2005). Kadushin (2005) argues that including actual names on a sociogram assists in the interpretation of the data. He maintains that this applies to all SNA, as knowing which actors are in particular positions provides information that uniquely contributes knowledge for analysts familiar with the network under consideration. Names are removed from sociograms and sociometric lists prior to publication, and untraceable user IDs are used in their stead.

Another important aspect of SNA which situates it in a unique ethical position is that 'participation' is not confined to the primary participants. It is also interested in the named contacts provided by respondents to sociometric surveys. While this information presents valuable information for analysis of who relates to whom, it can be argued that the named parties are now unwitting 'participants' in the research who have not given their informed consent.

Borgatti and Molina (2003) explain that information gleaned about secondary sources is primary respondent's perception of a relationship s/he has with another person, 'which is clearly something respondents have a right to do: every respondent owns their own perceptions' (p. 339).

However, it is plausible to argue that a relationship is comprised of two actors, and neither party can ethically report on it without the consent of the other (Borgatti and Molina, 2003). Further, while the perceptions of a contact are arguably owned by the primary respondent, Klovdahl (2005) argues that the information which may be divulged in the course of sociometric interview or survey may be believed to be private by the secondary source, and so therefore these parties are human subjects under the IRB's Common Rule. It then becomes the researcher's responsibility to obtain consent from all parties included in the analysis (primary respondents and contacts) or to obtain waivers of consent.

While SNA is a valuable tool used by researchers to understand the processes of diffusion through social structures, care must be taken when sociometric analyses are conducted in order to preserve the rights of the participants and other members of the sample community.

Notes

1. People use Second Life for a wide variety of purposes. Sexual activity is just one of the pastimes enjoyed by some residents. The question in the survey was on whether people perceived virtual sex to be a risky activity, and whether they had engaged in it.
2. Only respondents provided demographic information.

References

Bauman, K. E. & Ennett, S. T. (1996). On the importance of peer influence for adolescent drug use: commonly neglected considerations. *Addiction, 91,* 185–198.

Bergquist, M., & Ljungberg, J. (2001). The power of gifts: Organizing social relationships in open source communities. *Information Systems Journal, 11,* 305–320.

Book, B. (2004). "These bodies are FREE, so get one NOW!": Advertising and branding in social virtual worlds. In *2003 Interactive media Forum: Identity & Cultures in Cyberspace.* Miami University, Oxford, Ohio October 27–28, 2003.

Borgatti, S., & Molina, J. L. (2003). Ethical and strategic issues in organisational Social Network Analysis. *The Journal of Applied Behavioral Science, 39,* 337–349.

Borgatti, S., & Molina, J. L. (2005). Towards ethical guidelines for network research in organizations. *Social Networks, 27,* 107–117.

Correll, S. (1995). The ethnography of an electronic bar: The Lesbian Cafe. *Journal of Contemporary Ethnography, 24,* 270–298.

Costenbader, E., & Valente, T. W. (2003). The stability of centrality measures when networks are sampled. *Social Networks, 25,* 283–307.

Cvetkovich, G. (1999). The attribution of social trust. In G. Cvetkovich & R. E. Lofstedt (Eds.), *Social trust and the management of risk* (pp. 53–61). London: Earthscan Publications Ltd.

Dodds, P. S., Muhamad, R., & Watts, D. J. (2003). An experimental study of search in global social networks. *Science, 301,* 827–829.

Domingos, P., & Richardson, M. (2001). Mining the network value of customers. In *Conference on knowledge discovery in data* (pp. 57–66). New York: ACM Press.

Freeman, L. C. (1978). Centrality in social networks: Conceptual clarification. *Social Networks, 1,* 215–239.

Friedkin, N. E. (1991). Theoretical foundations for centrality measures. *The American Journal of Sociology, 96,* 1478–1504.

Garton, L., Haythornthwaite, C., & Wellman, B. (1997). Studying Online Social Networks. *Journal of Computer Mediated Communication, 3–* [Online publication].

Guadagno, R. E., & Cialdini, R. B. (2005). Online persuasion and compliance: social influence on the Internet and beyond. In Y. Amichai-Hamburger (Ed.), *The social net: Understanding human behavior in cyberspace* (pp. 91–113). Oxford: Oxford University Press.

Hemetsberger, A. (2002). Fostering cooperation on the Internet: Social exchange processes in innovative virtual consumer communities. *Advances in Consumer Research, 29,* 354–356.

Kadushin, C. (2005). Who benefits from network analysis: Ethics of social network research. *Social Networks, 27,* 139–153.

Kendall, L. (2002). *Hanging out in the virtual pub: Masculinities and relationships online.* University of California Press, Berkeley, CA.

Klovdahl, A. S. (2005). Social network research and human subjects protection: Towards more effective infectious disease control. *Social Networks, 27,* 119–137.

Kollock, P. (1999). The economies of online cooperation: Gifts and public goods in cyberspace. In M. Smith & P. Kollock (Eds.), *Communities in Cyberspace* (pp. 220–242). London: Routledge.

Kraut, R., Kiesler, S., Boneva, B., Cummings, J., Helgeson, V., & Crawford, A. (2002). Internet Paradox Revisited. *Journal of Social Issues, 58,* 49–74.

Kraut, R., Patterson, M., Lundmark, V., Kiesler, S., Mikopadhyay, T., & Sherlis, W. (1988). Internet paradox: A social technology that reduces social involvement and psychological well-being? *American Psychologist, 53,* 565–573.

Krebs, V. E. (2002). Mapping networks of terrorist cells. *Connections: Bulletin of the International Social Network Analysis Association, 24,* 43–52.

Lennox, R. D., & Wolfe, R. N. (1984). Revision of the self-monitoring scale. *Journal of Personality and Social Psychology, 46,* 1349–1364.

Levine, D. (2000). Virtual attraction: What rocks your boat. *CyberPsychology & Behavior, 3,* 565–573.

McKenna, K. Y. A., & Bargh, J. A. (2000). Plan 9 from cyberspace: The implications of the internet for personality and social psychology. *Personality and Social Psychology Review, 4,* 57–75.

Milgram, S. (1967). The small world problem. *Psychology Today, 2,* 61–67.

Montgomery, M. R., Kiros, G.-E., Agyeman, D., Casterline, J. B., Aglobitse, P., & Hewett, P. C. (2001). *Social networks and contraceptive dynamics in Southern Ghana* (Rep. No. 153). New York: Population Council.

Perez, J. A., & Mugny, G. (1996). The conflict elaboration theory of social influence. In E. H. Witte & J. H. Davis (Eds.), *Understanding group behavior: Small group processes and interpersonal relations* (pp. 191–210). Mahwah, NJ: Lawrence Erlbaum Associates, Inc.

Petty, R. E., & Cacioppo, J. T. (1986). The elaboration likelihood model of persuasion. In L. Berkowitz (Ed.), *Advances in experimental social psychology* (pp. 123–205). Orlando, FL: Academic Press.

Poortinga, W., & Pidgeon, N. F. (2003). Exploring the dimensionality of trust in risk regulation. *Risk Analysis, 23,* 961–972.

Raymond, E. S. (2000). Homesteading on the Noosphere. First Monday [Online]. Retrieved 17 August 2007 from http://www.firstmonday.org/issues/issue3_10/raymond/index.html

Renn, O., & Levine, D. (1991). Credibility and trust in risk communication. In R. E. Kasperson & P. J. M. Stallen (Eds.), *Communicating risks to the public* (pp. 175–218). Netherlands: Kluwer Academic Publishers.

Rogers, E. M. (1995). Diffusion networks. In *Diffusion of Innovations* (4th edition., pp. 281–334). New York: The Free Press none

Scherer, C. W., & Cho, H. (2003). A social network contagion theory of risk perception. *Risk Analysis, 23,* 261–267.

Valente, T. W. (1995). Conclusions and discussion. In *Network models of the diffusion of innovations* (1st edition, pp. 127–139). Cresskill, NJ: Hampton Press, Inc.

Valente, T. W., & Davis, R. L. (1999). Accelerating the diffusion of innovations using opinion leaders. *The Annals of the American Academy of Political and Social Science, 566,* 55–67.

Weenig, M. W. H. (1993). The strength of weak and strong communication ties in a community information program. *Journal of Applied Social Psychology, 23,* 1712–1731.

Weenig, M. W. H., & Midden, C. J. H. (1991). Communication network influences on information diffusion and persuasion. *Journal of Personality and Social Psychology, 61,* 734–742.

Wellman, B. (2001). Computers networks as Social Networks. *Science, 293,* 2031–2034.

Wellman, B., Boase, J., & Chen, W. (2002). The networked nature of community: Online and offline. *IT&Society, 1,* 151–165.

Wellman, B., & Gulia, M. (1999). Virtual communities as communities: Net surfers don't ride alone. In P. Kollock & M. Smith (Eds.), *Communities in cyberspace* (pp. 167–194). New York: Routledge.

4. MMORPG Worlds: On the Construction of Social Reality in World of Warcraft

DAVID BOYNS, SIMA FORGHANI AND ELENA SOSNOVSKAYA

Introduction

Massively Multiplayer Online Role-Playing Games (MMORPGs) are among the most celebrated of contemporary online gaming systems. A unique blend of role-playing games (like Dungeons and Dragons and Traveler) and Multi-User Dungeons (MUDs), MMORPGs allow thousands of individuals to simultaneously inhabit virtual gaming spaces. In these spaces, players undertake adventures, seek out treasures, and slay enemies, all the while interacting, cooperating, and competing with one another. To date, a wide array of MMORPGs have been developed, reflecting dozens of distinct themes (fantasy, science fiction, urban adventure, military, espionage, etc.), and embody a range of game designs.

Launched in November of 2004, and currently boasting over 8 million players[1] worldwide, World of Warcraft (WoW) is perhaps the most popular of these MMORPGs. WoW is a multifaceted, fantasy-themed gaming system, with a rich sociological complexity that provides a fertile ground for the study of online interaction, cooperation, and sociability. Like most MMOR-PGs, WoW is premised upon the design of a complex virtual world that players can endlessly inhabit, explore, and survey. However, WoW is much more than a "gaming space," it is also a sophisticated sociological space where individuals in real life (RL) meet, compete, and collaborate with virtual allies and enemies. It is also a virtual place where relationships that

frequently extend beyond the game and into RL ("real life") are established, cultivated, and nurtured. Within the gaming space of WoW, many levels of social reality are constructed, some through the intent of the game designers, and others by players both inside and outside of the game. It is the sociological complexity of the virtual space of WoW and its melding with RL that is the subject of this study.

This chapter is organized into five primary sections. First, a brief summary of the WoW game is provided. Next, the sparse but growing literature on MMORPGs is reviewed toward providing a scholarly context for our study. Our methodological strategy is then described outlining the multiple, qualitative methods employed in our study. The results of our study are reviewed and we suggest that four distinct but interrelated dimensions of social reality are constructed during WoW game-play. Finally, some concluding thoughts are outlined.

A Brief Synopsis of World of Warcraft

Having celebrated its three-year anniversary, WoW is currently the largest and most popular online role-playing game in the world. For a monthly fee of $15.00, the game allows hundreds of thousands of people across the globe to simultaneously play and interact with one another inside of a virtual gaming space. To date, WoW already boasts 5 million paying customers from North America, Australia, New Zealand, Korea, Europe, and China alone. With the recent announcement that WoW is now available in Russia, Taiwan, Hong Kong, and Macau, the number of WoW players worldwide is sure to grow to even more astonishing heights.

The game is premised upon a fantasy theme where players create avatars (i.e., the characters that they role-play) and explore the rich and nuanced virtual realm of Azeroth. Azeroth is a complex virtual world composed of two primary landmasses: the western regions of Kalimdor and the Eastern Kingdoms. Both of these areas are subdivided into distinct regions, with each having its own unique geography, ecology, culture, and inhabitants. Players move their characters through these "zones" in search of adventure, treasure, fortune, reputation, and conquest. The ostensive goal of WoW is to explore the world of Azeroth while "leveling up" a character, defeating a whole host of monsters, acquiring equipment and rewards, and interacting with other players from around the world. However, as this study demonstrates, the unique design of WoW transforms the game into much more than a "game space," it is also a sociological space that facilitates a complex array of social interactions and opportunities for sociability.

To begin game-play, each player must create a character to explore Azeroth. In developing this character, a player must first select a gender

(either female or male) and choose to become a member of one of two competing, world factions—either the Horde or the Alliance. The choice of faction determines both the race, and subsequently the class, of each character. It also creates an important dimension of game-play because the respective members of the Horde and the Alliance are opponents in the larger game and frequently strive to outwit and slay one another. Horde characters are selected from one of four races (Orc, Tauren, Undead, and Troll); while Alliance characters are made up of four additional races (Human, Night Elf, Dwarf, and Gnome). Each race has particular traits and abilities, some of which are innate to the character and others that only become available as the character advances. Character attributes vary along the lines of strength, stamina, agility, intelligence, and spirit and lay the foundation of a player's success in the game.

The selection of race is accompanied by the selection of a character's class. Many classes are offered to WoW players (e.g., warriors, mages, priests, rogues, druids, paladins, shamans, hunters, and warlocks), but not all classes are available to each race. For example, the Druid class is only open to the Night Elf or Tauren race; only Dwarfs and Humans can become Paladins. As players advance in the game more opportunities, abilities, and resources are made available to enhance their character's attributes and uniqueness. For instance, as levels of experience increase a player can select from a wider range of professions, acquire improved clothing, armor, and weaponry, and learn more powerful spells, abilities, and talents.

A player's primary objective in WoW is to "level up" his or her character. All players begin the game at level one and gradually gain the appropriate amount of "experience" to move from one level to the next. With the initial launch of WoW, players leveled their characters to a maximum level of 60. With the *Burning Crusade* expansion of WoW the maximum level was expanded to 70.[2] Experience is gained through the completion of "quests," the discovery of new territories, and successful combat with the enemies created by the game designers. As a player advances more experience points are required to level up as higher levels make characters more powerful and durable. Quests are frequently the most efficient means of gaining experience and they often provide substantial material rewards such as clothing, magical items, or weapons; although some players prefer to gain their experience primarily through "grinding"—foregoing the quests and slaying as many creatures as possible as quickly as possible. There are over 2,000 quests currently available in the game and they require players to suc-cessfully complete unique tasks. Each of these adventures reflects different types of quest modes: collection quests, for example, require players to investigate Azeroth and collect specific items; delivery quests ask players to act as couriers of messages from one region to another; discovery quests involve seeking out specific territories or locations; killing quests require a

specific number of enemies to be slain; and dungeon quests, or "instances," are composed of a combination of the above.

While leveling up one's individual character is the intrinsic goal of WoW game-play, as characters advance they quickly realize that at higher levels they cannot progress rapidly by themselves; they must rely on the cooperation and coordinated activities of others. In fact, this is an important aspect of the game design; grouping with others, negotiating trades, and seeking membership in guilds are essential components of WoW game-play at the higher levels. The game designers of WoW have intentionally established this social dimension to WoW as a fundamental aspect of the game so that if players seek to advance their characters they must find a way to work together.

Overall, WoW is a game premised on a player's advancement of their role-playing characters through the exploration of the virtual world of Azeroth. However, the game is intrinsically social, cooperative and lends itself to a rich study of the sociology of sociability. Players may engage WoW alone but they are surrounded by others and it is through their collective engagement that the complex nature of WOW game-play emerges.

Sociological Studies of MMORPGs

The study of MMORPGs has only recently become a subject of sociological investigation (Bartle, 2003; Ducheneaut, Moore, & Nickell, 2004). Many of these studies follow in the tradition of Fine's (1983) examination of multiplayer, fantasy role-playing games like Dungeons and Dragons. Like Fine's work, the sociological research on MMORPGs has been specifically guided by the investigation of the mechanisms by which people create meaning, interact, become engrossed, and establish identities in the fantasy worlds they inhabit. Two conflicting groups of gaming studies have emerged; one explores the potentially detrimental (or "addictive") aspects of MMORPGs, while the other examines the prosocial dimensions of this virtual game-play (Jansz and Martens, 2005). For example, some (Turkle, 1985; Griffiths & Hunt, 1998; Roberts, Foehr, Rideout, & Brodie, 1999; Anderson and Bushman, 2001; Sherry, 2001; Anderson, 2004) have considered playing computer and other video games in terms of social isolation, addiction, and violence; while others (Parks and Roberts, 1998; Pasquier, Buzzi, d'Haenens, & Sjoberg, 1998; Durkin & Aisbett 1999; Livingstone and Bovill, 1999; Orleans and Laney, 2000; Durkin & Barber, 2002; Schaap, 2002; Ducheneaut, Moore, & Nickell, 2004; Griffiths Davies and Chappell, 2004; Williams et al., 2006) have studied gaming as a unique form of sociability where social relations are established and cultivated.

The Daedalus Project initiated by Nick Yee (2005) and the *PlayOn* project conducted by researchers at the Palo Alto Research Center (Ducheneaut &

Moore, 2004a, b, c; Ducheneaut, Moore, & Nickell, 2004) are two of the most longstanding and sophisticated research enterprises into the study of MMORPGs. While *Daedalus* is psychologically oriented, investigating issues of emotional investment, immersion, motivation for game-play, relationships, and the demographics of players and their characters; the works of the *PlayOn* team represent one of the most comprehensive attempts to examine the sociology of MMORPGs charting the in-game social networks of characters, opportunities for social interaction, the dynamics of community formation, and the forms of sociability intrinsic to specific game environments.

Perhaps the most interesting sociological element of these social scientific investigations of MMORPGs is the examination of the engrossment and immersion that players experience in these games (Bartle, 2003; Kelly, 2004; Castronova, 2005; Yee, 2005; Taylor, 2006). This immersion is a real and an intentional component of game design (Bartle, 2003; Kelly, 2004) and is perhaps the most controversial aspect of MMORPGs. Because game developers strive to provide vibrant and sophisticated MMORPG game worlds that will facilitate player identification with characters and compel these players to persistently inhabit and explore these virtual gaming spaces, many players frequently find themselves consumed with their game-play. This immersion is frequently labeled as "addiction" by designers, players, and MMORPG detractors (Bartle, 2003; Kelly, 2004). With respect to the cultivation of a rich immersive experience, World of Warcraft is no exception.

The quick, massive, and widespread popularity of WoW is a testament to the success of game developers in their design of an immersive gaming system. While, immersion has been a frequent subject of investigations into MMORPGs—especially those conducted by *The Daedalus Project* and *PlayOn*—fewer studies have explored the means through which players negotiate and construct a social reality within, around, and outside of these games. It is this "reality" within which players become so thoroughly engrossed. Of course, the virtual world created by game designers provides the basis for the social reality constructed by game-players (Bartle, 2003; Ducheneaut, Moore, & Nickell, 2004). However, more flexible and socially oriented MMORPGs allow for entirely new dimensions of sociological reality to be created and experienced by players. Even while game design creates specific opportunities for (and limitations upon) play, exploration, and interaction, WoW players have constructed a rich and thriving world both inside and outside of the confines of the game environment. Players inhabit a virtual world created by game designers, but they use the design features of the virtual reality of the game to modify, and even create, novel dimensions of the special reality of their gaming world. In addition, and as this study reveals, players of WoW have moved their reality construction outside of the game and construct a sociological world that extends into RL.

Research Questions

This study is oriented toward an examination of the dimensions of social reality constructed within WoW game-play and is guided by two central research questions: (1) how is the social reality construction of WoW accomplished? and (2) what levels or dimensions of social reality are created within WoW game-play? To answer these questions two primary components of the social reality of WoW game-play are investigated. On the one side there is the "virtual" reality, which encompasses everything that occurs inside of and through the game. At the other end is the RL dimension of WoW, which encompasses the experiences of players, both during and outside of game-play, and the communities they create external to the game. The juxtaposition of these two components provides an opportunity to explore the rich and varied social reality of WoW players and the means by which the virtual space of WoW interfaces with the sociological dimensions of everyday life.

Methodology

The results of this study are based upon an ethnographic study of World of Warcraft game-playing. The primary methods employed are inductive and directed toward an exploratory examination of the types of social reality construction engaged in by WoW players. Data collection methodologies consisted of field observations of three players during their game-play, structured and unstructured interviews with eighteen WoW players, content analysis of WoW related online forums and websites, and intensive virtual ethnography of game-play over a period of three months. The total data collection process spanned the course of five months and was guided by a method of triangulation (Denzin, 1970) through which multiple methodologies were utilized in order to tap into the multidimensional aspects of the social reality of WoW.

Field Observations of WoW Game-Play: Subjects who were interviewed and observed were selected using a convenience sample and were recruited from personal contacts and from an internet café in the Southern California area—"Computer City Netcafé"—where MMORPGs are the dominant attraction. Observations of players were conducted in thirty-minute segments in order to capture the flow of game-play as it proceeds in real-time. Two simultaneous observers were used in this process, one recording the events of the game itself and another documenting the actions of the player. These observations were broken into roughly five-minute increments, which allowed for a unique juxtaposition to be developed between the dynamics of the game itself and player reactions in RL.

Interviews with Game-Players: Both unstructured and structured interviews were utilized to capture personal accounts of the reality construction of players. The interviews were framed as conversations and ranged in length from twenty-five minutes to one hour and were primarily conducted on site at the Computer City Internet Café.

Content Analysis of Sites Devoted to WoW Play: An analysis of six websites was conducted in order to gauge the real life and real-life social reality of WoW players. A content analysis of online MySpace groups, as well as other online forums devoted to WoW, provides insight into the wider community of players, including their discussions and thoughts about the game outside of actual game-play. Further analysis also revealed substantial RL economic aspects of WoW game-play whereby game currency is converted into RL monies, and *vice versa*. WoW is not simply a game inhabited by a virtual community; it also has real-world economic consequences the proceeds of which are considerable.

Virtual Ethnography of WoW Game-Play: Finally, extensive ethnographic observations were conducted of WoW play. These observations required the acquisition of a WoW account and the creation of a character with which to play. Over 500 hours of ethnographic observations were conducted as complete participants in WoW play. These observations involved the development of a character, the completion of quests, membership in and interaction with guild members, grouping with other players in the accomplishment of specific game tasks, and extensive social interaction with other players through the game's email and instant message systems.

Results

The results of this study suggest that there are four distinctive but interrelated dimensions to the reality construction within and around WoW game-play. WoW is a virtual reality game created by a team of game designers; it is an imaginary space developed for players to explore and within which they can interact. This virtual environment forms the first and most important "baseline" dimension of the social reality of WoW. We refer to this dimension as the *virtual reality* of WoW. Inside of this virtual environment, however, a second dimension of social reality emerges—a *virtual social reality* of player-to-player interaction. While player interaction in the game is intrinsically facilitated by the game design (e.g., through the creation of social spaces, email and instant message systems, "ventilio" or "teamspeak" multimedia interactions, and an array of character "emotes" that allow players to visually illustrate what they mean) it is how the players flexibly utilize and appropriate these interaction channels that allows for the construction of a complex sociological culture within the game.

Whereas the dynamics of the game itself form the basis of game-play, there are two other important dimensions of WoW social reality that extend outside of the game itself. It must be remembered that behind all characters and guiding them through the virtual space of WoW are real people in RL. To MMORPG players, these games are participatory endeavors in which their experiences stem not simply from playing or controlling an avatar but from "being" an artificial persona in a synthetic world (Newman, 1998, 2002). Without the *real-life reality* of WoW there could be no game-play. While players navigate their characters through the complex virtual environments of WoW, interacting with hundreds of other players, in RL, they frequently do so alone in real-time and real-space. While some players do play WoW in RL groups (as our observations in the Computer City Internet Café suggest), game-play is always conducted through an individual's interaction with a computer and, even in groups, social interaction is primarily mediated through the channels available through the WoW game system. However, because players are frequently separated spatially—sometimes by thousands of miles—it is difficult for them to communicate about the game, share strategies, and build relationships. To accommodate for what Giddens (1984) describes as this spatial "disembedding," players use alternative and nongame means for sharing WoW information and experiences. These exchanges create a *real-life social reality* surrounding WoW game-play and are facilitated through frequent face-to-face interactions among friends who play the game, among patrons of netcafés and similar social spaces, and through computer-mediated forums such as blogs, web-forums, and other websites devoted specifically to the development of the WoW community.

Collectively, these four dimensions—*virtual reality, virtual social reality, real-life reality, and real-life social reality*—function to create the social reality of WoW game-play. None of these dimensions operates in isolation from the other and it is through their unified collaboration that the rich sociological space of WoW is created. In the sections that follow, we document the distinct contributions of each of these dimensions to the experience of WoW game-play.

Virtual Reality

The virtual reality created by the WoW game design is multidimensional. On the screen, WoW players are presented with "three dimensional" graphics from the first-person point of view of their character accompanied by live action movement and sound, pop-up windows for character inventory and attributes, world and regional maps, and a real-time instant message chat. With all of these interface capacities, each player has the ability to engage the WoW environment in a multiplicity of ways simultaneously: they can move their character throughout the landscape, assess their character's

attributes and inventory, engage in combat with foes, investigate quests, talk with the nonplayer characters (NPCs) created by game designers, check to see if any of their friends are online, chat with and send email to other players, and trade and barter with both player and nonplayer characters.

In terms of violence, the game is rather subdued. While there is a good deal of killing there is no "blood," and character death typically results in a momentary resurrection. Because of this regenerative "death system," and because characters never technically "die" in the game, one of the more unique features of WoW is that the game never truly ends. Characters can constantly be resurrected and return to the point in the game where they died. This system allows players to be persistently engaged in a seemingly endless game of duels, quests, and explorations.

As an added dimension to game reality, players have the choice between playing in two distinct modes: Player vs. Environment (PvE) and Player vs. Player (PvP). In both modes, players are able to continually interact with one another and explore the virtual world of Azeroth; this is the baseline mode of PvE. The PvP mode, however, creates an added dimension to game-play whereby players from opposing factions are allowed to attack one another onsite, making every player continually vulnerable to attack from the enemy faction. Because of this PvP competition, game-play in PvP mode is often touted as more "exciting" and interactive.

Virtual Social Reality

Although the virtual environment of WoW is essentially set by the game designers, players are able to utilize this space to engage in a flexible set of social interactions within which they build a unique culture—a virtual social reality. Using the components of the game design, players are able to interact with one another in a variety of ways. The game comes equipped with a built-in instant messaging service accompanied by an email system. Individuals can "whisper" messages to specific players, can "yell" out loud to anyone in their immediate virtual vicinity, or they can send private messages and goods to other characters via email. In addition, more advanced players commonly use headsets and microphones which allow players to verbally and instantly communicate with one another during game play through commonly used "ventrilio" or "teamspeak" systems (such systems are especially crucial in complex combat situations involving a multiplicity of players). Most players utilize one or more of these methods of communication during game-play in order to strategize, to negotiate the trade of items, or simply to chat.

WoW game designers have also created a visual system of communication through which players can use their character to send nonverbal messages to other players. Each character has a built-in language of animated

"emotes," slash commands that allow players to quickly and easily communicate during game-play. For example, "/dance" causes a character to begin to dance, "/laugh" causes a character to break out in laughter. These "emotes" are not simply sent as textual messages to other players but are actually performed by the characters themselves. Other "emotes" are common: wave, sleep, bow, roar, kiss, applaud, kneel, sit, etc. Pregenerated voice commands and actions, many of which include animations, can also be activated by these slash commands.

Using this system of communication, players are able to generate a nearly endless array of interactions with one another. One of the more common patterns of nonverbal interaction is for players to instruct their characters to break out into spontaneous dance for other characters. Such dances are commonly done in celebration of a unique victory or the acquisition of a distinctive piece of equipment. However, frequently dance occurs for no special reason at all—it is simply utilized as a means of social interaction. It is common to see "scenes" where characters burst into spontaneous dance with additional characters joining in the dance while onlookers applaud, laugh, and blow kisses. These nonverbal activities can occur anywhere in the WoW realm, but typically occur in the local inns established in most major zones.

The presence of inns is one of the most unique features of the WoW game design. Inns are not only spaces in which many vendors of goods are present but they are also a "safe zone" for "resting" one's character. Character rest is an important aspect of the WoW game as a well-rested character has an increased capacity to gain experience from the enemies they slay. Thus, characters frequently gather at inns in order to trade with vendors and "rest" their characters. Inevitably, players strike up conversations with other players while congregating at inns creating a built-in system of sociability that is absent from many MMORPG gaming systems (Ducheneaut, Moore, & Nickell, 2004).

Amid these systems of social interaction a unique culture has emerged through which much of the virtual social reality of WoW is constructed. One of the most important aspects of this culture is the language that has emerged to describe the various dimensions of the game. The following is a short glossary of common WoW lingo (provided by an interview subject, Howie):

> Noob/Newb: (1) New to the game or (2) Playing for a long time but not very good (sign of disrespect).
> Leet/1337: Variation of elite, meaning good player.
> Uber: Super/good.
> FTW: For the win/say when you get an item.
> Gimp: A character not up to snuff.
> Owned: Defeated/killed/disrespected.

Other terms and abbreviations are common: "atm" = at the moment; "afk" = away from keyboard; "pull" = to draw a monster away from an inopportune location; "tank" = a character that can enter the fray of a melee and sustain a lot of damage, "aggro" = the radius of threat around an enemy that will cause it to become aggressive; "lol" = laughing out loud; "jk" = joking, etc. The use of this language is illustrated in the following in-game excerpt taken from the general instant message chat engaged in by players present in the large world cities.

> Limited: how do you buy a hearthstone [a device that allows teleportation to a home destination]?
> Gerken: u don't
> Simonize: LOL nooob ftw
> Fido: u can't
> Flyswatter: you can't
> Limited: I didn't think so lol
> Archie: NANANANNANANANOOOOOOOOBBBBBB
> Gerken: noob!!!!!!!!!!
> Prophet: talk to an Inn keeper and say this is my home.
> Archie: NEWBCAKE
> Prophet: Noob*
> Simonize: lol here comes the noob cat calls
> Archie: lol
> Fiona: that was funny
> Archie: yes it was
> Prophet: *sniff* sniff* *I smell a nub biscuit
> Limited: well the chatter isn't sheesh
> Gerken: lol
> Gerken: noobish
> Archie: <+++NOOB
> Prophet: nice try noob.
> Archie: lol jk
> Fiona: WTB NOOB Slave
> Archie: yo NewbProphet dont make me hurt you
> Nartin: Aren't noob catcalls a very noob thing to do
> Newman: No, you nOOb!

It is through this language, both verbal and nonverbal, that the virtual social reality of WoW is primarily constructed; however, it forms just the cultural building blocks of WoW culture. More complex relationships emerge in the game as players "group" to cooperate on quests and form more permanent relationships by joining guilds. One of the unique features of WoW game design is that it allows players to temporarily unite their characters into "groups." With a maximum size of five characters, groups emerge as coordinated activities among players to accomplish specific tasks—like completing quests or slaying more powerful enemies. Groups

have special "party" instant message chat lines where they can exchange strategies and information; and they also share in the goods received from specific kills or quests.

Guilds are more permanent groups with charters and membership rosters and, in fact, guild membership is an integral component of advanced play in WoW. A guild can be comprised of various characters with varying levels of advancement. Typical guilds are composed of "newbs," who are defined as players who are new to the game or veteran players who are considered weak or poor players. It can also contain a certain number of intermediary players and a certain number of "leets," or players who are considered to be advanced. A typical guild is also stratified along a status hierarchy, with a self-appointed or elected leader, officers who oversee different classes, and the general body of players. Some guilds may also have treasurers who handle the guild's collective winnings and another representative for miscellaneous activities concerning the guild and its activities.

Players join guilds through a variety of avenues. Some gain membership through a connection with an existing guild member, others complete an application and undergo a trial membership and some even create their own guilds and recruit players by posting open positions on forums, websites, and the general chat log within the game. An analysis of guild websites (like that of the Nugos guild at www.nugos.ru and the Twilight Mourning guild at www.twilightmourning.com) reveals that guild membership is an often serious undertaking, in which members can be expected to abide by a fixed set of rules and regulations. Any deviation from these rules and regulations can result in expulsion from the guild.

Guild membership is an important mechanism by which friendships among WoW players are forged and maintained. The players interviewed for this study consisted of members from five different, relatively advanced, and longstanding guilds. In general, these players expressed satisfaction and pride in their respective guilds, and most exhibited strong loyalty toward these groups. For example, Sara, a twenty-two year old college student who plays only in the netcafé, said that she would never leave her guild because it's made up of so many of her "friends," and Howie, Sara's twenty-three year old boyfriend and the assistant manager of the netcafé, stated that he probably wouldn't leave his current guild because he knows roughly 50 percent of its members and because he "started on this server to play with them." Our access to players with membership in the same guild, such as Sara and Howie who belong to the Computer City guild, also provided insights into the dynamics of guild organization.

For the most part, Computer City guild members speak fondly of their guild. Ron, a twenty-two year old trade school student, described the Computer City dynamic perfectly: "Everyone knows someone. We all work together. It is a 'Friendster' guild." Some Computer City guild members,

however, acknowledge the shortcomings one would expect in any relationship, virtual or otherwise. Steve, a fifteen year old high school student who plays WoW everyday of the week for 6–10 hours a day, recognized that his guild does occasionally have problems concerning cooperation and teamwork. Ron expressed similar sentiments and said that their guild was relatively fair to a majority of its members.

Steve's feelings on teamwork and cooperation were echoed by many of the players interviewed for this study and were often recounted as avenues to successful advancement in the game. To ensure guild success, Ron stated that members should "try to work together and that the game 'is not a race'." Moe, a fifteen year old high school student and committed gamer, recommended that new players should begin by listening and "not pretending" to know everything. Steve himself, perhaps, put it best when he said that players should "stick together, you know, follow the directions of the group leader, I guess, the guild leader. Things go really good if you follow the directions."

As discovered and reinforced time and time again through observation and interviews, guild membership and other forms of interaction can significantly alter and elevate the gaming experience. Most of the players we interviewed expressed positive sentiments about the ability to interact with other people during the game. Players like Steve and Sara described the game as "more exciting" and "not boring" because they could talk to other players, in or outside the game. Steve even said that "if [WoW] was not on the Internet I would probably not be playing it," preferring the social nature of a MMORPG to the isolation of a traditional videogame. Justin, a twenty-one year old recent college graduate, expressed this sentiment nicely suggesting that when one interacts in the game it makes it more fun and it would be "lonely to play hours on end without online friends or real friends to play with. Player interaction is the sole basis of what separates MMORPGs with any other game."

A majority of players stated that during game-play their discussions are a combination of dialog about the game (e.g., sharing information about strategies and experiences) as well as things that could be deemed as "trivial." Both our interviews and observations suggest that frequently guild member interaction is replete with purely sociable conversation: many members logon to WoW just to say "hi" to those on their guild roster, or simply to find out "what's going on," and guild members typically wish one another "g'nite" when logging off. Most players within guilds also appear to restrict a majority of their conversations within the guild, either through strategic or sociable interaction; however, opportunities for interaction with non-guild members abound and are frequent. These more transitory relationships are a fundamental aspect of WoW game-play and typically consist of invites for temporary group participation, special favors and exchanges, or just for ordinary "small-talk."

While interaction is an intrinsic aspect of the game, all of the players interviewed for this study stated that they preferred to play the game rather than just talk about the game. However, both of these dimensions of WoW game-play are complementary: sociable conversation serves to facilitate player interest and involvement and serves to produce solidarity with other players. WoW game-play can proceed without player interaction, but the experience would be drastically altered and progress is likely to be much slower.

As our observations and interviews suggest, WoW game-play is not simply about the engagement of the virtual space created by the game designers. It is also a system in which virtual social relationships are formed among players through the coordinated activities of their characters. In terms of the construction of the social reality of WoW, the social relationships created within the game are paramount. These relationships provide insights not only into a player's experience in the virtual world of the game, but also in their experiences in real life.

Real Life Reality

As Hornsby (2005, p. 61) has pointed out, most Internet activities (like MMORPG game-play) typically "involves an individual sitting alone in front of a computer terminal." This isolation is an intrinsic aspect of the RL baseline experience of WoW. Although simply "sitting alone" is not always the case with all WoW players—like those who gather to play at the Computer City Internet Café—even players who play in the copresence of other players typically create a self-imposed space around them, relying upon the WoW communication channels to convey messages even to those individuals who are within earshot.

The physical (though not necessarily social) isolation that accompanies WoW is a commonly remarked upon aspect of its game-play (Kelly, 2004). Strongly immersed players are known for their intensive participation in WoW, often playing for hours at a time foregoing food, drink, sleep, and bathroom breaks. To capture the lived-reality of this immersion a series of observations were conducted to capture the real-time dynamics of WoW game-play. One of our "leet" interview subjects, Moe, illustrated how he thought he appeared during his consecutive hours of WoW game-play:

> I'll just stay like this the whole time [demonstrates at his desk], my legs up on the computer [hard drive]. My hands will never move from this position [right hand on mouse, left hand on right side of keyboard]. I have my keyboard set up with hot keys so I never have to move my hands from this position. All these buttons serve a purpose. If my buttons got messed up, I would suck. Like, especially in duels you have to get into a rhythm. It's the only way you can, like, win. And you don't realize and stuff, but it'll be like second nature.

When we observed Moe during his play he stayed in the very same position, a position he likely sustains throughout most of his engagements with WoW.

In Table 4.1 below, we have provided side-by-side observations of Moe's game-play (character name, Milkman—a level-60 undead priest) in which we juxtapose the virtual and social realities of WoW game-play with its RL reality. The left-hand column contains observations of the player and is meant to reveal the real world reality of a typical WoW game-play session. The right-hand column provides a running commentary on the action inside the virtual reality of WoW. These juxtapositions are segmented into five-minute increments and are meant to provide an in-depth view of the startlingly different realities that MMORPG interactions can simultaneously produce.

In this thirty-minute excerpt, Milkman and his companions are traveling through one of the WoW regions called the "Western Plaguelands" and into a dungeon known as "Scholomance." "Scholomance" is one of the many unique "instances"[3] that populate WoW and is recognized as one of the more difficult level-60, five-player dungeons provided by the game (at least prior to the release of the *Burning Crusade* expansion). Milkman moves through the plaguelands and "portals" into the Scholomance dungeon where he meets up with the other members of his party who have made a similar journey. Milkman and his party battle the initial monsters they encounter, all the while using the instant message game chat to coordinate their actions.

As the preceding juxtaposition reveals, RL game-play is an often solitary and uneventful experience, at least for an outsider to observe. The virtual experience, on the other hand, provides the player with an inundation of stimuli and action. While the observer may only see a sedentary and unemotional individual—as exemplified by Moe during this game-play session—the player is often participating in a variety of activities, such as talking to other players, planning an assault, traveling through a multitude of environments, or accomplishing an important task. The game is filled with continual, split-second decisions that can create a sophisticated, intense, and emotionally engrossing experience. Such experiences help to explain how WoW players can often invest significant time in game-play; while they may appear unmoved in RL reality they are persistently challenged by a variety of tasks and motivated to complete these tasks in the virtual reality. Furthermore, their motivation is coupled and enhanced by the ability and desire to interact with other players.

Real Life Social Reality

Although there is a stark contrast between the virtual and RL dimensions of WoW game-play, there is an interesting social space in which the virtual and

Table 4.1. Juxtaposition of RL reality with the virtual reality of WoW

"MOE"	"MILKMAN"
Time: 10:55 am	
Moe sits in a chair at his computer desk. He is using both hands to play—his right hand is maneuvering the mouse and his left is placed over the keyboard. He appears very concentrated and involved in the game.	Milkman is traveling through water that is a gold-ish, brown color. No other character is in sight at the moment. On the screen pops up red text stating **"Out of Range."** This message appears three times before disappearing. By this point, Milkman is hopping in and out of the water. He finally walks on land and jumps onto a horse. He has moved from "Darrowmere Lake" and into "The Writhing Haunt." He stops on a mud hill, stares into the lake and then proceeds to jump into the lake (the horse automatically disappears). The perspective changes and now I can see Milkman swimming under the lake. The water is murky and muddy. Gradually, the lake turns a silver color and, again, the perspective is changed for a 360 degree shot of the surroundings. Milkman approaches what appears to be a fortress. The scene is a burnt orange color. Milkman hops onto land and is approached by another character who turns out to be someone in his group.
Time 11:00 am	
Moe sits in the exact same position. The only movement he is showing is the constant movement of his eyes across the screen and his fingers over the keyboard and mouse. The room remains very quiet. There is the occasional sound of a barking dog and the ticks of a desk clock.	Milkman is now inside the fortress, which is made of large stones, and is passing skeletons strewn on the ground. Inside are 4 other characters that make up his group. One character (a.k.a. TheBigGuy, an orc warrior) is huge and is carrying an enormous axe. Player switches screens by closing the game screen briefly and accessing a website entitled "DKP." Player returns to the game. Milkman is standing in front of a spiraling vortex made of blue smoke. All characters are standing around. TEXT BOX: M—**"we gonna use vent"** [the "ventrilio" real-time voice-over system] replies **"sure"** POP-UP: **NOTHING CLEANED.** M—**"wanna just start?"** Milkman leads the way into the vortex. Player changes perspective a number of times. TEXT BOX: M—**"if you get a libram of focus, give it to Doo."** [a "libram of focus" is a unique artifact sought after by Paladin players. Milkman is instructing the party to pass the libram onto the group's Paladin named Doo].

Time 11:05 am

Moe briefly touches his left eye. He places his hands back on the mouse and the keyboard and seems oblivious to those around him. He remains very concentrated on the game and rarely moves his eyes off the monitor. Moe finally changes his position. He bends his knees and puts his feet on a second chair. He moves forward slightly, in order to better observe the monitor. He also starts to periodically move his toes while playing.

Time 11:10 am

Moe sits in the same position- knees bent, his fingers moving on the mouse and keyboard and his toes wriggling.

Time 11:15 am

Moe is in the same position although he does lean back a bit more in his chair. He continues to wriggle his toes. Moe says something to other players through a microphone. He does not move his head or body. His eyes remain focused on the monitor. He continues to type and click without looking down at the keyboard. His movements appear automatic.

Milkman does not do any killing; he leads the group as they take care of the enemies. At this point, creatures are lying dead all over the ground. The group approaches a closed gate, enter, and look around. Player presses a button on the bottom left of screen and opens two separate windows (windows quickly closed). TEXT BOX: M- "anyone need the scourge stones off the bosses?" [Scourge stones are unique items that drop off of the undead creatures that inhabit the plaguelands]. Milkman goes down a flight of stairs and two black and blue creatures approach him. Player opens a window to display the specs on another player (window is closed). Group is in a large hall made of stone and the big guy is battling an enemy. Milkman appears with a large blue ring/ halo around his entire body. He shoots a blue ray at a lamb passing by. Group moves into another room where they are immobilized by spider webs.

Characters free themselves from spider webs. Milkman activates a "Mind Blast" [a damage spell]. Player opens up a window displaying his specs and list of talents which are self-chosen.

The group is now in a huge hall containing boxes of bones. They are working together to attack enemies. Milkman activates a "Flash Heal" for TheBigGuy who has been injured. Milkman activates another "Mind Blast" and then a "Greater Heal." Skeletons in room begin to rise and attack the group. POP-UP on screen: **Spell Is Not Ready Yet.** Milkman stands with three others in the group. Suddenly a huge blast goes off and TheBigGuy runs off to attack. POP-UP: **Spell Is Not Ready Yet. You Are Facing the Wrong Way.**

Continued

Table 4.1. Continued

"MOE"	"MILKMAN"
Time 11:20 am	All group members are in view. Milkman leads the way into another room, which is tinted green. TEXT BOX: M—"**where are the deeds?**" "**it shackle**" "**remove curse.**" TheBigGuy is killing a blue ghost. A huge, voluptuous lady appears. She is provocatively dressed and purple wings. She has large virtual breasts and purple wings. The fighting continues. POP-UP: "**Not Enough Mana**" (**mana is blue "stuff" or juice that gives Milkman his powers**). TEXT BOX: M—"**die in a good spot.**" Players start dying as they have been defeated. Milkman is still alive because he has the ability to heal the other players. TEXT BOX: M—"**cc**" Other player—"**sheep.**" Milkman activates a "Greater Heal," for all but one of the players in his group that have already died. No more enemies around. Milkman and the other players are resting. Milkman is drinking water to replenish his mana [an energy reserve that is consumed by casting spells].
Moe changes his position. He puts one foot on the chair in front of him and the other on his computer's hard drive. His fingers continue to move over the keyboard and the mouse. His eyes remain focused on the monitor. He also continues to move his toes. Moe briefly stretches his legs and then returns to the same position.	

End of the observation

RL bleed into one another. Computer-mediated communication (CMC) allows players to experience what Walther (1996) calls "hyperpersonal" interactions where individuals can cultivate relationships and identities that create, extend, and perhaps enhance those that exist in RL. Walther (1992, 1996; Walther & Parks, 2002) has offered the concept of *hyperpersonal interaction* as significant for the study of mediated social worlds. He has analyzed computer-mediated interaction by measuring the levels of intimacy, solidarity, and attraction via CMC. Walther has conducted an analysis of existing trends, theories, and research findings of previous studies on CMC (Short, Williams, & Christie, 1976; Sproull & Kiesler, 1986; Daft, Lengel, & Trevino, 1987) in order to describe computer-mediated interaction according to the level of intimacy created during the communication process. According to Walther's perspective, CMC might be intentionally impersonal when the depersonalization is advantageous for the users or impersonal because participants restrict time frames for interaction or they do not expect future interaction. CMC is interpersonal under the same conditions as face-to-face (FtF) communication when users possess time for information exchange, build impressions, and create values, but it takes for CMC a longer time than for FtF to become interpersonal. Walther has argued that technology allows us to create *hyperpersonal interaction* based on selective self-presentation, idealization, and reciprocation, an interaction that is more friendly and social than FtF interaction in impression-generating and goal-setting. Therefore, Walther has rejected previous debates in terms of liberal and limiting approaches for CMC. He has concluded that technologies provide us with the opportunities to communicate on different levels of intimacy, either to maximize or minimize our interpersonal effects, but the nature of communication remains inherently human. For example, the instant messaging feature in WoW provides some players with an outlet to behave in ways that they normally would not. Ron described this kind of "hyperpersonal" interaction nicely stating that in WoW interactions "I am pretty comfortable. It is much easier. It is pretty easy to break the barrier if you do not know anyone. You can always say "Hey! What's up?" in the game, but it would not be the same in real life. Face-to-face is harder."

For many players, this type of "hyperpersonal" interaction does not conclude once they leave the computer screen. While "life on the screen" (Turkle, 1995) is the baseline dimension of WoW game-play, for many players like Ron the social reality of WoW extends "beyond the screen" and into RL; and as our study suggests, in some instances RL finds its way into the social reality of WoW. Perhaps the most notable illustration of what we call the "real-life social reality" of WoW is the characteristic, interpersonal conversations and relationships that players cultivate *around* the game (and sometimes not even *about* the game) when they are not playing.

One of our interview subjects, Sara, expressed the fact that like most players at Computer City she spends about the same amount of time talking about the game as she does playing the game. She revealed that "If you don't know what you're doing, it's good to come out here [the front of the café where players frequently hang out] and ask for help." She explained that these kinds of interactions allow players to get away from the game and to have a "break"; however, these "breaks" typically consist of "game-talk" about "game-play." She also said that the game frequently "breaks the silence" when players have nothing else to talk about. Ron also suggested that frequently a typical night of playing could easily transition into a cause for socializing among Internet café patrons. He said, "We eat at Denny's, have dinner, chill, hang out if we do something successful. For example after playing we might have breakfast at 2:00 am."

Many players agreed that WoW had some sort of "hyperpersonal" impact on their real-life relationships. For example, Justin said that many of his friends thought that he was "never around anymore because he was always playing WoW." Others felt that WoW helped to teach lessons that could be applied to RL. For example, when asked to reflect on their goals in playing WoW, Ron stated that one of his main goals was to benefit his guild, "to help the guild to get a high rank" in the game; and Sara expressed a sentiment echoed by many players, that her character's accomplishments not only motivate or inspire her in her real life, but that the game in general can teach her an even greater lesson—that the game "teaches you good morals and to finish what you started."

In addition, we found that the social environment of Computer City Internet Café can foster relationships (both platonic and romantic). As Ron suggested, relationships surrounding game-play can easily bleed into those formed through "conventional" modes of interaction (i.e., hanging out). Of utmost import to the relationships we observed among the Internet café players is the fact that their computer-mediated relationships and their relationships outside of the game serve to reinforce one another in a cyclical fashion. The existence of these hyperpersonal relationships is also reinforced by ethnographic observations made during WoW game-play. During "rest" in safe zones, it is common to see characters "cuddling" as they "/sit" or "/sleep" close to one another. In addition, wedding invitations between characters occasionally circulate on the general chat or guild channels announcing the virtual marriage of two characters in one of the Azeroth cathedrals.

In addition, to these face-to-face interactions, players have moved the discussion of WoW outside of the game through an increasing number of online forums and blogs. Currently there are over 600 World of Warcraft groups on Myspace.com though many others can be found at Blogspot.com and other online venues. These forums have emerged to address a wide

range of WoW concerns, some specific to character classes and professions and others detailing particular strategies for the completion of quests. Perhaps the most extensive of these sites are Thottbot.com and WoWGuru.com where players collectively share specific experiences and suggestions about WoW game-play.

These Internet forums serve a variety of functions for WoW players, allowing players to expand upon those friendships forged during the game outside of the game through the exchange of game-tips, personal information, and even photos of their characters and their RL self. More narrowly focused groups also cater to smaller WoW populations such as female players, players who play on role-playing servers, gay and lesbian players, and players in particular guilds. Many of these web groups are designed to allow for open discussions on whatever matters or issues players may have concerning the game. Some typical topics include specifics about the gaming experience (i.e., what it felt like to accomplish a difficult quest or how a guild went about defeating a boss), the best headset and microphone equipment to use, and debates over the best screen shots taken by players.

Much like MySpace groups, Internet forums—especially those found on the Blizzard Inc. website—allow players to discuss the game and their gaming experience outside of actual game-play. There are a myriad of forums, each devoted to a different aspect of WoW. Many forums cater to particular classes of characters. For example, priests can visit a forum designed for their class to ask other priests about clothing, weaponry, or spells. Guilds also use forums as a way to recruit players for guild membership and may post recruitment notices. In general, the discussions found on WoW forums are wide and varied and, therefore, serve as an invaluable resource for players. Not only can a player post a question about a particular quest or item, but he can also engage in debate over the supremacy of the Alliance faction over the Horde faction. Such discussions reinforce a player's involvement and, perhaps, dedication to the game outside of actual game-play.

Finally, it must be mentioned that outside of the WoW player community is a booming economy that feeds off of the popularity of WoW worldwide (Castronova, 2005). The economy is both internal to the game (where the major currency is exchanged in virtual copper, silver, and gold), and external to WoW (where game currency is converted into RL monies and vise versa). The most prevalent aspect of this growing business is the sale and purchase of virtual goods and money for RL money via such mainstream websites as eBay.com. While Blizzard Inc. frowns upon such activities, many see this as a legitimate means to making money and getting ahead in the game. Others have also managed to turn WoW game-play into part-time and even full-time professions. For example, players known as "farmers" play exclusively in order to accumulate virtual money, which they in turn sell for RL money. Chinese players are perhaps best

known (and perhaps stereotypically known) for having the largest number of "farmers" who not only play to accumulate virtual money but who also level up their characters in order to sell their entire accounts for RL money. Many WoW players and observers see such activities as taking away from the true spirit of the game, yet this booming economy does not appear to be slowing down by any means (Schiesel, Seth: *New York Times*, December 9, 2005, p. 4).

Although WoW's worldwide popularity is impressive there is also a dark side to WoW game-play. Some stories have hinted at the detrimental impact of excessive or unhealthy game-play. A young man in Tianjin China, for example, "committed suicide, apparently in the belief that he could meet his virtual character in the afterlife" (Goff, Peter, 2005, p. 19). Soon after his RL suicide an online cyber-funeral was held in dedication of the young man and his family. Although such unfortunate accounts are far outnumbered by the positive and healthful experiences many WoW players have, they still reveal the possibility for harm and further solidify the connection between the virtual reality and real-life reality. Our interviews also hint at these antisocial (or at least nonsocial) effects. For example, a few of the players we interviewed admitted that WoW had a negative impact on their real life relationships; like Justin who said that many of his friends thought that he was "never around anymore because he was always playing WoW." The intense immersion created around the WoW game-playing experience can produce a frequently discussed RL isolation effect that can disrupt RL relationships.[4] Most notably here are the increasing number of "game widow" forums that have emerged to build a support community around family members affected by the intensive use of MMORPGs like WoW.[5] Even in its antisocial dimensions, MMORPG game-play serves as a basis for the establishment of community in RL.

Conclusion

At the start of this research project we set out to answer two key questions—how is the social reality construction of WoW accomplished and what levels or dimensions of social reality are created within WoW game-play? Our findings, from extensive field and virtual ethnographic observations, content analyses, and in-depth interviews, have provided a wealth of information and reveal an important finding. Game-play in virtual worlds is not accomplished within a self-contained gaming system. Instead, and following the works of Castronova (2005) and Taylor (2006), we suggest game-play bleeds into RL in a complex manner. We argue that four distinctive and interrelated dimensions exist within and around WoW game-play. The first two dimensions—*virtual reality* and *virtual social reality*—speak

to the experiences of players within the virtual world of Azeroth created both by the game designers and by player's own actions and interactions. MMORPGs like WoW are commonly designed with the intention of not only creating a virtual gaming space that is entertaining and engaging (Bartle, 2003), but also constructed to facilitate social relationships and the creative development of a social reality inside the game (Ducheneaut, Moore, & Nickell, 2004; Ducheneaut & Moore, 2005; Ducheneaut, Yee, Nickell, & Moore, 2006; Williams et al., 2006). Within this virtual social reality players create a unique culture and use an esoteric language to communicate with one another and often times forge relationships and undergo experiences comparable to those found in real life.

The next two dimensions—*real-life reality* and *real-life social reality*—reveal both the often isolating nature of WoW game-play and the contrastingly rich social relationships players form outside of game-play. Previous investigations into virtual spaces like WoW have revealed both the alienating (Anderson & Bushman 2001; Anderson, 2004) and the prosocial (Ducheneaut, Yee, Nickell, & Moore, 2007) aspects of MMORPGs. As the side-by-side observations of real-life and virtual realities reveal, during a typical session of WoW game-play players often appear to be unmoving and alienated automatons, emotionlessly engrossed in a life on the screen. Despite appearances, however, such players are often participating in highly engrossing and challenging tasks (Yee, 2005). Using both voice-over technologies (like ventrilio or teamspeak), players often share these experiences with other WoW players and, in so doing, extend their investment and experience of the game beyond the boundaries of the virtual world. The emergence of a sophisticated culture that extends beyond the confines of the game itself—and into website and internet forums, formal and informal communities like guilds and discussion groups—is evidence of the prosocial nature of gaming systems like WoW (Ducheneaut, Yee, Nickell, & Moore, 2007; Sosnovskaya, 2007).

We conclude this chapter with a brief story that reflects the various and intersecting dimensions of the social reality constructed through WoW gameplay. In December of 2005, a young man was killed by a drunk driver. Such an event would have been inconsequential to the WoW community except for the fact that this young man was a well-respected "leet" WoW player. News of this tragedy circulated through the WoW community both within the game's instant message and email systems and on various WoW Internet forums. While players were stunned and expressed their grief in these avenues, their most poignant gesture was the collective decision to hold a virtual memorial service in one of the WoW virtual cathedrals. On a specific day and time, hundreds of characters from both factions traveled to attend this service and knelt to commemorate the life of this young man and reflect upon their collective loss. In an instance where game-life and real-life were brought

together, the complex nature of the social construction of WoW realities was illustrated in a coordinated virtual gesture with real-life consequences.

Notes

1. As of August, 2008.
2. Plans are currently in process to further character progression to level 80 with the release of the *Wrath of the Lich King* expansion planned for future release.
3. An instance is a unique copy of a zone or dungeon that can be only occupied by a specific number of players at one time. Instance parties are typically made up of 5, 10, 15, 20, or 40 players. These parties of players enter these instances in order to accomplish quests and defeat high-level monsters and bosses.
4. For examples see: http://www.wired.com/news/holidays/0,1882,48479,00.html; http://www.selfpsychology.org/_forum/0000014b.htm.
5. For examples, see http://games.groups.yahoo.com/group/spousesagainstever-quest/; http://health.groups.yahoo.com/group/EverQuest-Widows/; http://www.gamerwidow.com/.

References

Anderson, C. A. 2004. An update on the effects of playing violent video games. *Journal of Adolescence, 27*(1), 113–122.

Anderson, C. A., & B. J. Bushman. 2001. Effects of Violent games on aggressive behavior, aggressive cognition, aggressive affect, physiological arousal and prosocial behavior: A meta-analytic review of the scientific literature. *Psychological Science, 12*(5), 353–359.

Bartle, Richard. 2003. *Designing virtual worlds.* Indianapolis, IN: New Riders Publishing.

Castronova, Edward. 2005. *Synthetic worlds: The business and culture of online games.* Chicago: University of Chicago Press.

Daft, R.L., Lengel, R. H., & Treviño, L. K. 1987. "Message equivocality, media selection, and manager performance: Implications for information systems." *MIS Quarterly, 11*(3), 355–368.

Denzin, Norman K. 1970. *The research act in sociology.* Chicago: Aldine.

Ducheneaut, N., & Moore, R. J. 2004a. Let me get my alt: Digital identities in multiplayer games. Presented at the CSCW 2004 workshop on Representation of Digital Identities, November 6, Chicago, IL.

Ducheneaut, N., & Moore, R. J. 2004b. Gaining more than experience points: Learning social behavior in multiplayer computer games. Presented at the CHI 2004 workshop on Social Learning Through Gaming, April 26, Vienna, Austria.

Ducheneaut, N., & Moore, R. J. 2004c. The social side of gaming: a study of interaction patterns in a massively multiplayer online game. pp. 360–369 in *Proceedings of the ACM Conference on Computer-Supported Cooperative work* (CSCW 2004), Chicago, IL. Retrieved January 3, 2006, from http://doi.acm.org/10.1145/1031607.1031667

Ducheneaut, N., R. J. Moore, & Nickell, E. 2004. designing for sociability in massively multiplayer games: an examination of the "third places" of swg. *Proceedings of the*

Other Players conference, J. H. Smith and M. Sicart (Eds.), Denmark, Copenhagen: IT University of Copenhagen. Retrieved January 3, 2006, from http://itu.dk/op/proceedings.htm

Ducheneaut, Nicolas. & Moore, Robert J. 2005. More than just 'XP': Learning social skills in massively multiplayer online games. *Interactive Technology and Smart Education,* 2(2), 89–100.

Ducheneaut, Nicolas, Nick Yee, Eric Nickell, & Robert J. Moore. 2006. Alone together? exploring the social dynamics of massively multiplayer games. Pp. 407–416 in *Conference proceedings on human factors in computing systems CHI2006.* Montreal, PQ, Canada.

Ducheneaut, Nicolas, Nick Yee, Eric Nickell, & Robert J. Moore. 2007. The life and death of online gaming communities: a look at guilds in World of Warcraft. Pp. 839–848 in *Proceedings of CHI 2007.* New York: ACM.

Durkin, K., & K. Aisbett. 1999. *Computer games and Australians today.* Sydney: Office of Film and Literature Classification.

Durkin, K., & B. Barber. 2002. Not so doomed: computer game play and positive adolescent development. *Journal of Applied Developmental Psychology,* 23(4), 372–392.

Fine, Gary Allan. 1983. *Shared fantasy: Role-playing games as social worlds.* Chicago: University of Chicago Press.

Giddens, Anthony. 1984. *The constitution of society: Outline of the theory of structuration.* Berkeley, CA: University of California Press.

Goff, Peter. 2005. Virtual games, real costs. *South China Morning Post,* November 23, p. 19. Retrieved December 27, 2005, from www.lexisnexis.com

Griffiths, M. D., & N. Hunt. 1998. Dependence on computer games by adolescents. *Psychological Reports,* 82(2), 475–480.

Griffiths, M. D., M. N. O. Davies, & D. Chappell. 2004. Online computer gaming: A comparison of adolescent and adult gamers. *Journal of Adolescence,* 27(1), 87–96.

Hornsby, M. Anne. 2005. Surfing the net for community. A Durkheimian analysis of electronic gatherings. In Peter Kivisto (Ed.), *Illuminating social life: Classical and contemporary theory* (3rd edition (pp. 59–91). Thousand Oaks, CA: Sage Publications.

Jansz, Jeroen, & Lonneke Martens. 2005. Gaming at a LAN Event: The social context of playing video games. *New Media & Society,* 7(3), 333–355.

Kelly, R. V. 2004. *Massively multiplayer online role-playing games.* London: McFarland & Company.

Livingstone, S., & M. Bovill. 1999. *Young people, new media.* Report of the research project *Children, young people and the changing media environment.* London: London School of Economics and Political Science.

Newman, James. 1998. *Gameworlds: Videogames, space and experience. Critically examining a player's perspective.* Lancaster University (Edge Hill College). Unpublished manuscript.

Newman, James. 2002. In search of the videogame player. *New Media & Society,* 4(3), 405–422.

Orleans, M., & M. Laney. 2000. Children's computer use in the home. *Social Science Computer Review,* 18(1), 56–72.

Parks, M. R., & L. D. Roberts. 1998. "Making MOOsic." The development of personal relationships online and a comparison to their off-line counterparts. *Journal of Social and Personal Relationships,* 15(4), 517–537.

Pasquier, D., C. Buzzi, L. d'Haenens, & U. Sjoberg. 1998. Family lifestyles and media use patterns: An analysis of domestic media among Flemish, French, Italian and Swedish children and teenagers. *European Journal of Communication, 13*(4), 503–519.

Roberts, D. F., U. G. Foehr, V. G. Rideout, & M. Brodie. 1999. *Kids and media @ the new millennium.* Menlo Park, CA: Kaiser Family Foundation.

Schaap, F. 2002. *The worlds that took us there: Ethnography in a virtual reality.* Amsterdam: Aksant Academic Publishers.

Schiesel, Seth. 2005. Virtual achievement for hire: It's only wrong if you get caught. *The New York Times,* December 9, p. 4. Retrieved December 30, 2005, from www.nytimes.com

Sherry, J. L. 2001. The effects of violent video games on aggression. A meta-analysis. *Human Communication Research, 27*(3), 409–432.

Short, J., Williams, E., & Christie, B. 1976. *The Social Psychology of Telecommunications.* New York: John Wiley and Sons.

Sosnovskaya, Elena. 2007. *"Communities of memory" in the World of Warcraft.* Unpublished Master's Thesis. California State University, Northridge.

Sproull, L. & Kiesler, S. 1986. Reducing social context cues: electronic mail in organizational communication. *Management Science, 32* (11), 1492–1512.

Taylor, T. L. 2006. *Play between worlds: Exploring online game culture.* Cambridge: MIT Press.

Turkle, S. 1985. *The second self.* New York: Simon and Schuster.

Turkle, S. 1995. *Life on the screen: Identity in the Age of the Internet.* New York: Simon and Schuster.

Walther, Joseph. 1996. Computer-mediated communication: Impersonal, interpersonal and hyperpersonal interaction. *Communication Research, 23*(1), 3–43.

Walther, Joseph, & Parks, Malcom R. 2002. Cues filtered out, cues filtered in: Computer-mediated communication and relationships. In M. L. Knapp & J. A. Daly (Eds.), *Handbook of interpersonal communication* (3rd edition, pp. 529–563). Thousand Oaks, CA: Sage.

Williams, Dmitri, Nicolas Ducheneaut, Li Xiong, Yuanyan Zhang, Nick Yee, & Eric Nickell. 2006. From tree houses to barracks: the social life of guilds in World of Warcraft. *Games and Culture, 1*(4), 338–361.

Yee, N. 2005. The psychology of MMORPGs: Emotional investment, motivations, relationship formation, and problematic usage. In R. Schroeder & A. Axelsson (Eds.), *Avatars at work and play: Collaboration and interaction in shared virtual environments.* London: Springer-Verlag. Unpublished manuscript.

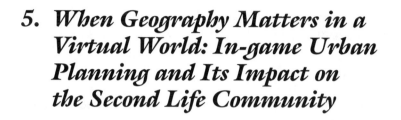

5. When Geography Matters in a Virtual World: In-game Urban Planning and Its Impact on the Second Life Community

NAN ZHENG

Introduction

As it is laid out in Second Life's advertising slogan, "Your World, Your Imagination," you can imagine an entire 3-D world online, complete with Islands, cities, and seas. Now imagine it populated with people from across the globe who gather in shopping malls, casinos, and clubs in this virtual world, gossiping about the most popular players or comparing notes on the best spots to buy a virtual home. Imagine yourself in a car racing with live opponents competing with you. Imagine a place where you can be a vampire, elf, online party organizer, or in-game clothes designer, developing a reputation for yourself that is known all over the world. Now imagine that you could log in and enter that world any day, any time, anywhere. It is Second Life a large online virtual world inhabited with more than five million residents.

One important component of Second Life is for players to meet others and seek companionship.[1] Like-minded players are inclined to form social units such as groups ranging from neighborhood associations to fans of science fiction novels. Players often build a place for group gathering based on real life beliefs (i.e., religions, political affiliations) or create a simulation of imagined place that fulfill their fantasy. Although in cyberspace spatiality

is largely illusory, virtual community can be produced in a socially constructed space (Jones, 1995). In the case of Second Life, players envision the communities based on an online physical place. Using textual analysis to examine player-run newspapers and blogs, this chapter will provide illustrative explanation of how players connect their community experience with the visually represented geographic space in the game world.

Literature Review

Imagined Community

The concept of community is often traced back to Ferdinand Tönnies' (1967) *gemeinschaft* (community), which characterized country village life. Tönnies found that people in rural villages are united by social ties formed within a shared living space, such as family kinships, neighborhood, and friendship. James Beniger (1987) followed Tönnies to argue that "hybrid of interpersonal and mass communication" created a "pseudo-community." Beniger questioned the sincerity of such communities, which are formed through simulated, but not face-to-face interpersonal communications.

According to Benedict Anderson (1983), communities are not necessarily constrained to a geographic location, but rather a social construction created by people's collective imagination. In the same line with Anderson, contemporary theorists argue community less in terms of geographical space, but more in terms of a shared moral standing among community members. For instance, Amitai Etzioni (1996) indicated that communities are social entities that are constituted by a web of affect-laden relationships among a group of individuals and their shared culture.

Anthony Cohen (1985) has approached the community, similarly to Etzioni, as a phenomenon of culture and more specifically explained it as a construction of cultural symbols. In *The Symbolic Construction of Community*, Cohen criticized the structural determinism of community that concentrated on the physical forms of community organization such as a neighborhood or tribal village. He argued that communities need to be studied based on experiences and the meanings people attach to them. According to Cohen, people resort increasingly to symbolic behavior to reconstitute the community boundary. In this sense, community is a boundary-expressing symbol, which depends on its members' symbolic construction and embellishment.

Moving from Tönnies and other scholars who emphasize a common geographical space and face-to-face interpersonal communication as the necessary components of a community, contemporary scholars perceive community less likely confined to a geographical boundary but defined by

people's collective consciousness. As the Internet use flourished in the last decade, the discussion of community has further shifted away from the constraints of the physical domain but more associated with people's online social experience. In one of the earliest studies of online community, Rheingold (1993) defines the virtual communities as social aggregations that emerge from the Internet when enough people carry on public discussion long enough, with sufficient human feeling, to form webs of personal relationships in cyberspace. Paccagnella (1997), for example, defines the "virtual community" as the articulated pattern of relationships, roles, norms, institutions, and languages developed online. Similarly, Scime (1994) argues that the "virtual community" is a group of individuals, who come to have shared values, care for each other, engage in real dialogue, and have a moral voice through online communication.

In the social construction tradition, virtual community is conceptualized as a dynamic social creation of its members. Feenberg and Bakardjieva (2004) argued that online virtual community can be constructed and bent in an infinite number of ways by particular people with contextually social goals. Fernback (1999) indicates that "cybercommunity is not just a thing; it is also a process. It is defined by its inhabitants, its boundaries and meaning are renegotiated, and although virtual communities do possess many of the same essential traits as physical communities, they possess the 'substance' that allows for common experience and common meaning among members" (p. 217). Following this constructivist view, this chapter proposes that virtual community is imagined by people who gather on the Internet and form social relationships based on a variety of goals, practices, and experiences.

Geographies of Cyberspace

The radical time-space compression through new communication technologies has led to the collapse of geographical boundaries (Harvey, 1990). For geographers, the cyberspace creates new social space without the formal qualities of geographic place (Kitchin, 1998). However, the authenticity of online social space is often questioned because of the lack of physical space. For example, virtual communities are criticized by generating a false sense of collectivity because they are based on no more than shared interests (Doheny-Farina, 1996). Compared to the offline communities, they do not involve the deeper community bonds and values that are shared in the places one physically lives.

However, the cyberspace is still considered socially meaningful despite the absence of physical space. As Stone (1991) argued, cyberspace is "social spaces in which people still meet face-to-face, but under different definitions

of 'meet' and 'face'... collections of common beliefs and practices that united people who were physically separated" (p. 85). Moreover, empirical studies have found that online communities demonstrate meaningful social characteristics such as voluntary and meaningful conversations (Rheingold, 1993), established histories (Rheingold, 1993), developed social hierarchies (Dibbell, 1998), and enforced rituals and norms (Baym, 1993).

The online social interactions have also been investigated in the context of the spatiality of cyberspace. In a study of text-based MUD-BlueSky (Kendall, 2002), the online social space is analogous with the social settings described as "third places," which is a quasi-public space for sociability and interconnection among people. A similar approach has been used in a study of social relationships a 3-D online community that replicates the traditional geographically based city (Carter, 2005). The researcher found that people's social practices in the 3-D online community were informed by the online place they occupied.

In different types of online social platforms, the geometric structure and forms are often used either with or without explicit geographic referent (Dodge & Kitchin, 2003). In the text-based MUDs, users mobilize through a conceptualized sense of space, since there is no material map to illustrate the geographic relations between web pages. Differently, in some online game worlds, the graphic display of the landscape and figures of participants can help visualize the spatiality of cyberspace similar to a real-world geographical map.

Defining the virtual reality as media simulated environment, Steuer (1992) suggested that people's sense of presence in a space is determined by "the combination of sensory stimuli employed in the environment and the way in which participants are able to interact with the environment" (p. 80). This definition emphasizes two important properties of a virtual reality: the vividness, which refers to the ability of a technology to present information to human senses; interactivity, which means the extent to which users can modify the form and content of a mediated environment.

Recently, there is an increasing number of publications dedicated to games with a graphical user interface (i.e., Manninen, 2003; Kolo & Baur, 2004). Second Life with its 3-D interface design can present a vivid virtual world. The overall space of Second Life is made by a combination of a large open sea, four big continents, and thousands of small islands. The Landscape of Second Life is characterized with a wide variety of environments. Like the real world, Second Life has tropical islands, coast lines, desert land, snowy mountains, hills covered by trees and grass, etc. Some landscapes in Second Life have a regional theme. For example, Neultenburg is a place in Second Life, which is designed to have a winter theme with medieval German-style architectures built on snow-covered land. Therefore, Second Life provides a graphically rich virtual environment with enough geographic

referent for exploring how community is constructed based on people's sense of space in a virtual world.

Second Life players also enjoy a high degree of interactivity. Players often choose to settle down on a piece of virtual land, which they buy to create a themed social place and engage in a variety of social activities with like-minded people. The results can be anything from imaginary terrain settings from novels to cities based on real-world city plans. For example, a subculture group who choose to appear as elves in-game built an area named ElvenGlen to practice their simplistic and rural way of life. In order to maintain their lifestyle, those players made ElvenGlen an entirely no-fly area[2] and prohibited all modern looking objects inside it. In communities like ElvenGlen, the word "residents" is commonly used by players to refer to themselves as members of online social groups in Second Life.

Method

This chapter investigates how Second Life players' community experience is associated with geographic place in the game world through a close reading of player-run online newspapers and blogs. Analyzing Second Life newspaper leads one to agree with Benedict Anderson (1983)'s indication that mass media is the mediation of people's imagination of community. Since Second Life is a fairly large virtual space with more than 5,000,000 players (by March, 2007), it is impossible for its players to know and imagine the community in a face-to-face manner. As a result, several in-game newspapers have been developed to meet the need of information seeking and in-game issue discussion. Also, many players write blogs about their game experience and reflections on the social phenomena in Second Life. Those players' blogs can provide first-hand evidence concerning community experience on the individual level with their textual analysis.

Researcher starts the sampling[3] with two major in-game newspapers— *Second Life Herald* and *Metaverse Messenger*—which are both designed to cover the events and persona in the Second Life. *Second Life Herald* is one of the earliest publications in Second Life. Self-identified as "always fairly unbalanced," *Second Life Herald* has a highly opinionated writing style and a blog-like layout, which allows readers to post comments on each story. The publisher of the *Second Life Herald*, Peter Ludlow, is a professor in the philosophy department of philosophy and linguistics at the University of Michigan, with research interests in cyberspace, including questions about cyber-rights and the emergence of laws and governance structures in and for virtual communities. *Metaverse Messenger*, which follows the traditional newspaper layout and writing style, has published files in PDF format both through in-game vendor machines and their website every Tuesday since

August 9, 2005. The newspaper is run by Katt Kongo (in-game name), who has seven years of experience in the news profession in real life.

A list of blogs (see Appendix for the list), which appeared in the two newspapers and well-known among Second Life players, are chosen for analysis. Mostly, those blogs are written by players who are actively engaged in discussion of social issues in Second Life. They often provide opinionated reports based on writers' first-person observation or experience of a social issue in Second Life.

In terms of research ethics, there have been concerns about textual harvesting without obtaining the consent of the online social group (i.e., Sharf, 1999). In this chapter, all the texts analyzed are taken from newspapers and blogs, which are intentionally made public as mass media content; therefore this study does not deal with any direct human participants' involvement that requires informed consent. In the following analysis, players' game name[4] are used to identify them as they appeared in the Second Life newspapers and blogs. While reporting facts or expressing opinions in the game, Second Life newspapers and blogs may occasionally use pseudonyms when the issue is relatively sensitive or the sources refuse to release their game names. Also, players sometimes do not use their game name but pseudonyms when they post comments in blogs. In both cases, those pseudonyms will be used to refer to a player.

Analysis

To explore a large virtual world like Second Life, players often use the digital map showing the overall virtual landscape to start with (See Figure 5.1). On the map, one can view the information on upcoming events by clicking the pink stars on the map. The real-time population density within a certain area is represented by the number of green dots. Those functions of the map are designed for players to find a socializing place.

Once an event or a place is selected, players need to use the teleportation system to reach their destinations. Teleporting is the act of going from one location to another instantaneously in Second Life. Originally, all attempts to teleport to a location would send the player to the nearest telehub, which functions as bus stop or airport in the real life public transportation system. After landing at the telehub,[5] players have to reach the exact spot they choose by using walking and flying abilities[6] granted by the game system. In November 2005, the telehub system was abolished. Replacing it are point-to-point teleports, allowing users to teleport directly to any location without using the telehub as the public transit center.

Second Life also has a mature real estate market that connects each geographical space to a market value. Analogous to the real life market, the

Figure 5.1 Map of Second Life.

better a Second Life land is planned and organized, the more valuable it is. Therefore, individual players and Second Life real estate businesses often build planned communities to increase the market price of a land. Real estate is one of the most popular and profitable lines of business in Second Life. Anshe Chung, who sells and rent homesteads to other players, made the cover story on *Business Week* in May, 2006. According to *Business Week*, Chung's firm has virtual land and currency holdings worth about $250,000 in real U.S. dollars.

In Second Life, players' sense of place is highly determined by the mechanism of teleportation system, which they use on daily basis for traveling the virtual landscape. Also, real estate market often has impact on the shape of the community where players own a home or have a social life. Thus, two incidents—the reformation of the teleportation system and the community plan projects in Second Life—are investigated to show how players' community experience is associated with geographical space in Second Life.

The Reformation of Teleportation System

Linden Lab is the parent company of Second Life, which maintains the group of servers and regularly updates the game software that sustains the virtual environment of Second Life. In December 2005, Linden Lab introduced the point-to-point teleportation, which is an in-game transportation system that allows players to travel directly to their destinations without using the public transit centers—telehubs.[7] Robin Linden, the vice president

of the Linden Lab, explained that the point-to-point teleportation is designed to offer a more efficient way of traveling in the game, since lots of players have complained the telehub system, which cause confusion when they can not go directly to their destinations. In her blog entry "Formerly Known as Telehubs," Robin Linden wrote,

> I see it [the removal of telehub] as an opportunity to move away from an organizational system based on forcing people to stop somewhere other than their planned destination, and instead to create a new one, in the same places, where we really think about why someone might want to be there. (*Official Linden Blog*, November 27, 2005)

The original intention of building telehubs was to provide meeting areas for players and facilitate social interactions. Philip Linden (CEO of Linden Lab) once articulated telehubs' social meaning by comparing it with the subway system in New York City, in which the travelers are always sent to a stop near their destinations, and walk the rest of the way. Scholars of urban planning argued that the most fundamental of urban activities is people walking along streets (Boddy, 1992). The function of the city street is for different sectors of society to mix and mingle. In Second Life, telehubs function as the subway stops in New York City, which provide players with public space and pedestrian experience. On players' way to the destination, they can explore the community nearby and perhaps meet new people.

Some players worried that the elimination of telehubs will lead to the decline of community experience in the Second Life. For example, Gwyneth Llewelyn argued in her blog,

> people will not care what is "in-between" ... what will be important is the ultimate destination, not how and why you get there ... The only thing that will happen is that Second Life won't be a "virtual country" any more ... It will be a collection of snapshots linked together by teleports. ("It`s a country?" *Gwyn's Home*, November 27, 2005)

According to Llewelyn, the reduction of players' unintended exploration of Second Life neighborhoods will cause the missing of "in-between," which would eventually lead the players to lose the sense of wholeness in Second Life. Moreover, according to Forseti Svarog's blog post, the point-to-point teleportation would result in increasing restriction on land accessibility. Before the removal of telehub, traveling activities are mediated through public transportation centers—telehubs. In the system of point-to-point teleportation, travelers to a particular place are automatically transferred to the middle of their destination area which may happen to be someone's private property. The absence of telehub area as a public place is leading more players to put restrictions on their private land in order to avoid

intrusion from random travelers. This increasing restriction on land can undermine the social experience of players who enjoy the online world as an open and public space.

Responding to the concerns of community decline and increasing segmentation in Second Life, Philip Linden (CEO of Linden Lab) pointed out that before seeing the landscape of Second Life as isolated places linked by teleports, one needs to take the size of those fragmented places and the overlapping parts of them into consideration. He wrote that

> we crave complexity and scale, meaning that there will always be a motivation for a like minded group of people to establish the largest contiguous space they can equitably inhabit together … The "country" part of SL[Second Life] will have become plural—each large community will be it's own country in a universe that at the highest level is an open technology platform … Specific communities will be embedded in other more general ones. (*Philip's Blog*, December 06, 2005)

This argument highlights the complexity of the community structure, which may overcome the isolation effect caused by the point-to-point teleportation. Investigating large metropolitan communities, Etzioni (1993) proposed the idea of "new community," which indicates that people have choices to belong to divergent sub-communities but still maintain common bonds to a larger community. In this sense, the mainland areas and large islands in Second Life can be seen as large communities that contains multiple distinct sub-communities. Also, some sub-communities are connected together by their shared community services or zoning rules.[8] Therefore, the overall landscape of Second Life exhibits the multilayer layout with embedded geographic connection.

Taking a further step to retain the sense of locality and neighborhood, Linden Lab converted the former telehub land into "infohubs," which serve as the places for local social activities and business uses. However, the infohubs are not visited as much as telehubs; even Linden Lab has arranged activities such as contest of artistic display to attract players. The myth of telehub's success, as Gwyneth Llewelyn indicated, is based on "the importance of the distribution of space." As the telehubs no longer serve as transportation centers where people have to go through on their way, their role as the social aggregators in a geographic area has been lost.

The dramatic reduction of traffic on the land near the telehubs has a direct impact on the business located in those areas. Due to the heavy traffic, most of the land near telehubs were valuable for business use and developed into shopping districts. Since Linden Lab announced the enabling of point-to-point teleporting, commercial value of the telehub land has been diminished in the Second Life real estate market. With sharply devalued land investments, a group of property owners sent a petition for compensation of their telehub lands. Responding to land owners'

dissatisfaction, Linden Lab offered to buy back the land near the telehub with a price of 10 Linden dollars per square meter. However, some of the land owners found the compensation unacceptable since the telehub land was selling at 50 Linden dollars per square meter in some areas. Anshe Chung, who runs one of the largest real estate businesses, has estimated the size of her losses as equivalent to 25,000 U.S. dollars, because of telehub changes.

Despite the direct influence on the real estate market, the removal of the telehub also shifts the overall Second Life commerce from a geographically based model to a mainly reputation-oriented one. Prokofy Neva argued in his blog entry that "point to point [teleportation] rewards closed, sophisticated, elitist networks. It's a blow against the democratic access and freedom for the market we had with telehubs." He predicted that the future market place in Second Life would be largely based on a "word-of-mouth" system in which only elite players and business owners would benefit from an established information circle, consequently making it difficult for newcomers to build a reputation. In a discussion panel on point-to-point teleportation, counterarguments indicated that telehubs with an artificially raised value are actually a less democratic system, since it prevents people from getting noticed because they cannot afford higher-priced land.

Before the transportation change, telehubs were not the only social hubs in Second Life. Clubs and places that hold regular events are also popular social places in the Second Life. After the telehubs are abolished, players are more likely to go to those places for social gathering. But the ability of those places to generate meaningful social interaction is still questionable.

In an editorial article of *Second Life Herald*, the increasing number of clubs has been accused of undermining the diversity of game experience. Providing players, especially newcomers with money and work opportunities, clubs attracted a lot of players to stay for most of their game time. Angeltk Beckenbauer, who used to work as a dancer in Club Elite, confessed that since the club required its dancers to spend 75 per cent of their in-game time dancing for the club, she felt she was exploited because she never had a chance to explore Second Life and develop other interests. Counterarguments from the club owners suggested that clubs help new players to facilitate in-game social networks and give them opportunities to earn Linden dollars. The club owners held that those are fundamental requirements for survival before players can explore other opportunities.

Similarly accused of damaging the players' social experience, the game called Tringo[9] is a creation that property owners use to attract large masses of people to their territories. However, even land owners complained about its negative impact on socializing among players. Eboni Khan, owner of a resort area with a Tringo game in it, explained, "Sim [simulation] owners

have Tringo to attract people to the sims [but] Tringo players rarely look at the sims. They just go from game to game … And they don't chat, because they are too into the game. So it's not even social, which I don't like." Some Tringo players disagreed with Khan and argued that the Tringo game did encourage players to be socially active because it generated groups among Tringo players based on their common interest in the game.

The preceding evidence shows that the removal of telehubs not only changed the way of traveling but also altered players' social experience in Second Life. The shift from telehub system to point-to-point system has changed people's traveling into a more private experience, restricted their accessibility to some geographical places, and eventually affected their social life in the game.

The salience of market place in the discussion of teleportation suggests an important role of commerce in players' public life. Telehubs were perceived as high-value lands and ideal places to build shopping center because of its public nature. The commodification of public space has long been documented in the urban planning literature. In North American cities, the urban areas are often organized with the consumption culture, in which the streets are dominated by shops and measured by the profit per square foot (Crawford, 1992). However, scholars, who treat people as active users of space, suggested that consumption site such as shopping mall has a communal function for socializing (e.g., Fiske, 1989). In Second Life, while telehub is mostly used as a place for selling and advertising, it still creates space for togetherness and interactions among players. Also, it is hard to deny that social activities can take place in commercially oriented events or places such as clubs and Tringo games. Thus, community and commerce are not mutually exclusive in Second Life, and sometimes they even depend on each other to flourish.

Community Planning

Community was traditionally viewed as a concept generated and connected to a physical space. In *The Spirit of Community,* Etzioni (1993) suggested several ways to design the physical environment in a more community-friendly way. For example, shared spaces such as public parks and community tennis courts, he argued, should be provided for people to mingle. In Second Life, it is not very difficult to find material design carried out to create themed areas for players to have a community experience. However, the question remains whether a designed communal space can generate community within it.

Linden Lab, the game company that created Second Life, was involved in several community planning programs. One of the projects "Second Life Surrealty," gives players a house in a preplanned community—Blumfield— when they upgrade from a basic account to a premium account.[10] Later, Linden Lab reported that Blumfield has added to the perceived value of

Figure 5.2 Blumfield and Levittown.

land by allowing direct access to a house and community; and it also encouraged basic account users to update to premium accounts.

Although Blumfield achieved success as a business experiment, it received criticism from players, who doubted its ability to create a community with sufficient social interaction among players. After interviewing several new players in Blumfield, Satchmo Prototype reported in his blog that players' experiences in Blumfield were more about skill development rather than building social relationships within the neighborhood. For example, one of the interviewees, Rhinohorn Axon, said, "[Blumfield is] a sanctuary from which I can learn the basics ... If I ever spend enough time to determine a way to make an income, I probably will move out of Blumfield."

The lack of community experience among Blumfield residents can be explained by its failure to include public places. Blumfield, resembling the design of Levittown,[11] is a neighborhood constituted by similarly designed houses being put together into a chessboard-like layout (see Figure 5.2). Commenting on the design of Blumfield, Forseti Svarog wrote, "I didn't see any effort put forth towards encouraging community through gather spots and street layout." Therefore, in Svarog's mind, this preplanned neighborhood would not create a community for new players who often arrive in Second Life for social purposes.

In December 2005, a Blumfield Residents Association was formed to enforce their will on the appearance of Blumfield community. The founder of Blumfield Residents Association, Patch Lamington, started this

community group with the fear that players who live in Blumfield will change the look of their property as far as they leave the place in a chaotic development. He said in an interview with *Second Life Herald* that "It [Blumfield Residents Association] has helped some of the residents value the area more, which has helped maintain the area better." Not only the property owners in Blumfield, but also others who are residents of places that do not have regulations for community development have demand for land organizing. The publisher of *Metaverse Messenger* complained in her column that a "visually unattractive" casino was built right next to her home, but since the area she lived in does not have zoning rules that inhibit commercial construction, she could not do anything to change the situation. Therefore, she demanded Linden Lab to divide Second Life into either "residential" or "commercial" areas or even distinct areas for different types of architecture designs.

Influenced by players' initiatives to regulate their community, in January 2006, Linden Lab started to envision a system that allows landowners to create a "covenant" document that would be visible to all prospective land buyers in an area. The zoning conditions would be created through voting among existing landowners. To enforce the covenant, land owners will be granted the control over land use or alter terrain.

Real estate businesses in Second Life have long been engaged in land planning by building themed communities with predesigned homes for players. Although players can own and sell their land in those communities for profit, the developer maintained the control of what is allowed and what is not in terms of changing the appearance and purpose of the properties. Anshe Chung, one of the biggest real estate business owners in Second Life is quite successful in designing and selling preplanned lands with architecture fitting into the environment.

However, the preplanned community projects and players' voluntary effort in building community can contradict with each other. Anshe Cheng once bought a simulation called Briarcliff—a small-town style shopping area—and turned it into Friesland, a German and Dutch community. In an interview with *Second Life Herald*, she explained this plan as a market strategy to target the increasing population of European players. Ironically, as she was trying to set up a themed community, she was accused by the former Briarcliff residents of breaking a preexisting one. One former Briarcliff resident, Ack Mendicant, described her attachment to the community as follows:

> What made Briarcliff was the community. It was a place where you knew everybody, and you'd hang around and chat with your friends while you watched them work on their latest project ... It is equivalent to a ring of close friends you hang out with during school, or a neighborhood restaurant where you know the

owner's name, and all the people who usually stop by after work. (A comment to
"Anshe at the Gates," *New World Note*, March 02, 2005)

For Ack Mendicant, Briarcliff is equivalent to an offline neighborhood,
which has people's shared memory and social practices attached with a
geographical space. However, for commercial developers, community is no
more than unified architectural design selling for profit.

Both the cases of Blumfield and Briarcliff have shown the relationship
between space and community in Second Life, which explains Lefebvre's
(1991) distinction between "spaces of representation" and "representations
of space." The former indicated an appropriated, lived space, which is in use
by people; the latter suggested a planned, controlled, and ordered space
enforced by the economic and social power. In the case of Blumfield, not
until the Blumfield Residents Association formed, the preplanned physical
structure by Linden Lab had become a community. With their further
demand for land organizing, players started to take control over the space
and turned it into a "space of representation." For Briarcliff's residents, a
commercially planned project has taken over the physical location where they
used to form shared experience with like-minded people. The space that rep-
resents community experience has turned into a presentation of commercial
profit. Like Cohen's (1985) view, community is member's experience and not
a structure of institutions. Therefore, in Second Life, players' social experi-
ence and a shared geographic place must converge to form meaningful
communities.

Conclusion

Bringing the sense of spatiality back into the concept of online community,
this chapter explored how people's community experiences are associated
with the virtual geographic places. The findings suggest that Second Life
players assign social meanings to virtual places and imagine the commu-
nity based on those socially shared spaces. The manifest of geographic
structures in Second Life with maps and transportation systems has con-
nected players' community experience with the sense of place. Further,
virtual geographical places in Second Life are social constructs, in which
social meaning and market values are attached to particular landscapes.
Therefore, cyberspace is no longer constituted with only spatial metaphors
like text-based virtual communities, but real physical online territories
that are bound with people's online social interaction. It responds to "the
lack of a shared physical space" argument that has long been used to

question the authenticity of the virtual community (e.g., Doheny-Farina, 1996).

Since the virtual commerce is an important theme in Second Life, the market place for exchanging virtual goods and service is often the public space where people engage in social interaction and form online social relationships. Moreover, the convergence of public and market place may suggest a trend in the commercialization of virtual community. As found in this chapter, players' community experience may get damaged through the money-driven economy in Second Life, which makes the online world more like a business to serve consumers rather than a public place to facilitate meaningful social interaction. However, no decisive claim can be made on the effect of commercialization in Second Life, since players' social interaction often takes place in commercial settings such as clubs and Tringo games.

Second Life is a technologically created world by real people behind the keyboards, who do not strictly separate their lives into online and offline portions. However, using textual analysis of game newspaper and blogs, findings of this chapter are mainly limited to players' experience in Second Life. Future research must be done to understand how Second Life players immerse their online space with their physical space. For example, Aime Weber, a fashion designer in Second Life, describes her typical night with her Second Life friends in a virtual pub as follows:

> It feels like OUR pub. Exclusive designer work area and drunkening zone. Actually, you will frequently find us here in the bar sitting silently … we are all busy on Photoshop and Illustrator. We use [an external IM/file sharing program] a lot, exchange textures, help each other. It's a great environment, totally … So normally, I keep Second Life open with the dialog in the lower left hand side of the screen … the rest is covered with Photoshop, etc., and I respond when someone talks to me.

Thus, for veteran players like Aime Weber and her friends, to be in companionship is only to open another window on their computer screen. The boundaries of real and virtual space blur since being in Second Life and real life is simultaneous. Nicholas Negroponte (1995), Director of MIT Media Lab, once predicted that "digital living will include less and less dependence upon being in a specific place at a specific time, and the transmission of place itself will start to become possible (p. 165)." More than a decade has passed; now the virtual world such as Second Life has made the transmission of place real by taking individuals to new communal social places on the Internet.

Appendix

List of Player Blogs and Player-run Newspapers

Newspapers/ Blogs	Publisher/Blogger (In-game name)	URL
Second Life Herald	Urizenus Sklar	http://www.secondlifeherald.com/
Metaverse Messenger	Katt Kongo	http://www.metaversemessenger.com/
New World Note	Hamlet Linden	http://secondlife.blogs.com/nwn/
Second Thoughts	Prokofy Neva	http://secondthoughts.typepad.com/second_thoughts/
Wu-had	Jauani Wu	http://wu-had.blogspot.com/
Gwyn's Home	Gwyneth Llewelyn	http://secondlife.game-host.org/
Philip's Blog	Philip Linden	http://secondlife.blogs.com/philip/
The Official Blog of Linden Lab	Linden Lab Stuff	http://blog.secondlife.com/

Notes

1. see http://secondlife.com/whatis/meet.php
2. In Second Life, the game system grants players with power to fly. However, the land owners can make no-fly area by manipulating the technical settings of the land, which prohibit players from flying.
3. This research is based on a sample collected from August 2005 to March 2007.
4. When players create their Second Life account, they are asked to take a game name by choosing from a list of predesigned last names such as Mcluhan, Ming, etc. All the Linden Lab staff use "Linden" as the last name. Players' first names are created by themselves.
5. Teleportation could also be done directly between two distant players. When accepting a teleport offer, players will arrive near where the offer is made.
6. In Second Life, the game environment offers players the ability to fly. It is a popular way to travel in Second Life, since it gives players a better view of the landscape, which helps them to explore and discover new things on their way to their destinations.
7. Telehubs still exist in many private islands, in which the owner can make visitors begin their visit from a single place of their choosing. Mainland telehubs have became Infohubs since point-to-point teleportation was introduced.
8. Zoning rules are contract terms created by the game company, Linden Lab, land owners, or residents to regulate land use. For example, land is often rated as Parental Guidance or Mature level. Only on the Mature rated land, can one show sexually explicit content or run adult business. Zoning rules are taken into account when considering prices for buying, selling, and renting land.

9. Tringo is a game created by Second Life player Kermitt Quirk. It consists of a display board, to track scores and pieces in play, and game cards, for the players. After players place their bets in a winner-take-all pot, they compete with each other to fit their pieces together onto their cards. When the pieces show up, players click their card for where they want to place the pieces. The game goal is to make solid blocks of 2x2, 2x3, or 3x3, then the scores are 5, 10, 15 points, respectively. Players have 10 seconds for each piece, and lose 7 points if they fail to place one in time.

10. People join Second Life with either a basic account or a premium account. Land owning is one of the advantages that the premium account holders have. Owning land allows players to build, display, and store their virtual creations, as well as host events and businesses. Every premium account holder is granted a 512-square meter land plot. Any additional land requires a monthly fee. The fee is tiered, and discounted as one acquires more land.

11. Levittown is a planned suburban neighborhood 30 miles from New York City created between 1947 and 1951.

12. Simulation, also called sim, is a technical term which refers to an area on the server. In Second Life, it is often used to describe a geographical place which is usually built on a theme. For example, subtropical sim, is a Hawaiian-like area with a big volcano in the middle of it.

References

Anderson, B. (1983). *Imagined communities: Reflections on the origin and spread of nationalism.* London: Verso.

Baym, N. (1993). Interpreting soap operas and creating community: Inside a computer-mediated fan culture. *Journal of Folklore Research, 30,* 143–176.

Beniger, J. (1987). Personalization of mass media and the growth of pseudo-community. *Communication Research, 14*(3), 352–371.

Boddy, T. (1992). Underground and overhead: Building the analogous city. In M. Sorkin (Ed.), *variations on a theme park: The new American city and the end of public space.* New York: Hill and Wang.

Carter, D. (2005). Living in virtual communities: An ethnography of human relationships in cyberspace. *Information, Communication and Society, 8*(2), 148–167.

Cohen, A. (1985). *The symbolic construction of community.* New York: Tavistock Publications.

Crawford, M. (1992). The world in a shopping mall. In M. Sorkin (Ed.), *Variations on a theme park: The new American city and the end of public space* New York: Hill and Wang.

Dibbell, J. (1998). *My tiny life: Crime and passion in a virtual world.* New York: Henry Holt.

Dodge, M. & Kitchin, R. (2003). *Mapping cyberspace.* New York: Taylor & Francis.

Doheny-Farina, S. (1996). *The wired neighborhood.* New Haven: Yale University Press.

Etzioni, A. (1993) *The spirit of community: Right, responsibilities, and the communitarian Agenda.* New York: Crown Publishers.

Etzioni, A. (1996). *The new golden rule.* New York: Basic Books.

Feenberg, A. & Bakardjieva, M. (2004). Consumers or citizens? The online community debate. In A. Feenberg & D. Barney (Eds.), *Community in the digital age: Philosophy and practice.* New York: Rowman & Littlefield Publishers.

Fernback, J. (1999). There is a There There: Notes toward a definition of cybercommunity. In S.Jones (Eds.), *Doing Internet research: Critical issues and methods for examining the net* (pp. 203–220). California: Thousand Oaks.

Fiske, J. (1989). *Reading the Popular.* London: Unwin Hyman.

Harvey, D. (1990). Between space and time: Reflections on the geographical imagination. *Annals of the Association of American Geographers, 80*(3), 418–434.

Jones, S. (1995). Understanding community in information age. In S. Jones, (Ed.), *Cybersociety: Computer-mediated communication and community* (pp. 10–35). Thousand Oaks: Sage.

Kendall, L.(2002). *Hanging out in the virtual pub: Masculinities and relationships online.* Berkeley, LA and London: University of California Press.

Kitchin, R. M. (1998). Towards geographies of cyberspace. *Progress in Human Geography, 22*(3), 385–406.

Kolo, C. & Baur, T. (2004). Living a virtual life: Social dynamics of online gaming. *The International Journal of Computer Game Research, 4*(1). Retrieved September 5, 2006 from http://www.gamestudies.org/0401/kolo/

Lefebvre, H.(1991). *The production of space.* Oxford: Basil Blackwell.

Manninen, T. (2003). Interaction forms and communicative actions in multiplayer games. *The International Journal of Computer Game Research, 3*(1). Retrieved September 27, 2006 from http://www.gamestudies.org/0301/manninen/

Negroponte, N. (1995). *Being Digital.* London: Hodder & Stoughton.

Paccagnella, L. (1997). Getting the seats of your pants dirty: Strategies for ethnographic research on virtual communities. *Journal of Computer-Mediated Communication, 3.* Retrieved November 20, 2006 from http://jcmc.indiana.edu/vol3/issue1/paccagnella.html

Rheingold, H. (1993) The virtual community: Homesteading on the electronic frontier. MA: Addison-Wesley Publishing Co.

Scime, R. (1994). Cyberville and the spirit of the community: Howard Rheingold meets Amitai Erzioni. Retrieved February 17, 2007 from http://imagination.org/cyberville/cyberville.html

Sharf, F. (1999). Beyond netiquette: The ethics of doing naturalistic discourse research on the Internet. In S. Jones (Ed.), *Doing Internet research* (pp. 243–256). Thousand Oaks, CA: Sage.

Steuer, J. (1992). Defining virtual reality: Dimensions determining telepresence. *Journal of Communication, 42*(4), 73–93.

Stone, R. (1991). Will the real body please stand up? Boundary stories about virtual cultures. In M. Benedikt (Ed.), *Cyberspace* (pp. 81–118). Cambridge: MIT Press.

Tönnies, F. (1967). *Community and society.* Lansing: Michigan State University Press.

6. Rockin' with the Avatars: "Live" Music and the Virtual Spaces of Second Life

David Beer and Beverly Geesin

Introduction

It would seem that social networking sites such as MySpace, Facebook, and Bebo are radically reworking a range of social relations through the development of vast and complex online communities. These user-generated networks enable online "friends" to meet up and interact through flexible profile-based sites incorporating personal information, photographs, thought journals, music uploads, status reports, and so on. One of the most radical and widely referenced (in the popular press) of these social networking sites is the 3-D virtual world of *Second Life* (http://secondlife.com/).

Second Life describes itself as "a 3-D online digital world imagined, created, and owned by its residents." The tag line "Your world. Your Imagination." found on the homepage illustrates the eagerness of this application to attach itself to the online democratic ideal of interactivity and the general movement in online cultures toward (a rhetoric of) social participation. In relation to the broader emergence of what is often referred to as Web 2.0 (O'Reilly, 2005; Beer & Burrows, 2007), a movement defined by the shift to user-generated content and software that operates at the level of the webtop rather than the desktop, the coverage this site has received is somewhat disproportionate in terms of its number of members or "residents." In June 2007, at the time of putting the final version of this

chapter together, this number of residents stands at 7,036,186 with 1,767,200 of these having logged in during the last 60 days—although, of course, this is a constantly changing figure (see the postscript that concludes this chapter). This number of users is significantly lower than some of the other web applications associated with the emergence of Web 2.0; MySpace for instance has a reported 130 million registered users (Robinson, 2006). This disproportionate coverage in relation to a range of other widely used Web 2.0 applications is most probably a consequence of the startling spectacle of *Second Life*'s 3-D spaces, and the interest shown in the development of its own virtual economy (more on this below). However, *Second Life*'s potential to drastically reconfigure virtual culture—and for that matter, cultural arti-facts, events, and practices in more general terms—means that it is worth critical reflection in its own right, despite this relatively low number of users. The growth of this form of application means that it is more than likely that this will be an area of cultural expansion in the coming years, and for this reason we need to begin to think out how we are going to deal analytically and conceptually with 3-D virtual worlds such as this. We also suggest here that *Second Life* needs to be understood in relation to a range of other appli-cations that form the *Web 2.0 context*—that is in relation to other user-gener-ated spaces that are now defining web cultures.

With this in mind this chapter takes as its focus the now common practice of hosting musical events and performances in *Second Life*. This practice has seen music festivals and individual gigs occurring as "live" cul-tural events in this virtual world. We see here the beginning of a problem for cultural analysis, and even for vernacular understandings, as "live" music becomes software mediated. This is where popular music performances occurring in the "live" arena are experienced as 3-D virtualized perfor-mances. Currently we simply do not have the terminology or strategies at hand for dealing with this shift. To begin to move forward with cultural analysis in this Web 2.0 context this chapter seeks to explore the possible ongoing cultural and spatial implications of the digital virtualization of the "live" musical event. We consider here how we might approach this type of uncharted cultural happening as we explore the potential for this type of 3-D social networking site to radically transform experiences and understandings of "live" or "shared" events and experiences.

Musicians in Second Life

To take a step back, *Second Life* can be described as a user-generated 3-D virtual online world. Users register and create an avatar, a virtual body that they use when in *Second Life*. It is possible to sign up for three different pack-ages with varying "benefits," the basic plan is free with the others costing

around $9.95 per month. All allow for the custom design of the avatar and opportunities to construct buildings; the key difference between these enrollment options is the amount of Linden dollars you get to spend and the rights given to the ownership of land (for which an extra land use fee is also required).

The *Second Life* home page maintains a range of ongoing statistics about the site. For example, the page tells us that at 3pm on the 7th of June 2007 $1,340,929 had been spent during the previous 24 hours. This is a converted figure from *Second Life's* own economy based on the Linden dollar. It is possible to convert Linden Dollars into U.S. Dollars through the usual currency exchange processes. In fact *Second Life's* internal economy has an estimated Gross Domestic Product of $64 million dollars (Adams, 2006). It has even been reported that more than 3,000 residents earn an average of $20,000 per year from the site (Adams, 2006). These avatars literally "animate the markets of the global culture industry" (Lash & Lury, 2007, p. 19).

Considering its growing economy, its substantial number of users, and, most importantly, the media attention it has received, it is not surprising that a number of high-profile performers, as well as those seeking record contracts and audience recognition, have now used *Second Life* as a venue for "live" music performances. Indeed, musicians using *Second Life* may be separated into three distinct groups: *established bands, tribute bands* and *amateur musicians*. First, there is the increasing presence of "real-world" pop stars in *Second Life*. Pop stars such as Suzanne Vega, Duran Duran, and Regina Spektor have been testing the waters of *Second Life* as a promotional tool (Andrews, 2006). Here *Second Life* is used either to make direct connections with new audiences or for generating publicity in more conventional media forms through the attention these novelty 3-D gigs receive (particularly in the popular press). Visits by pop stars into *Second Life* can be incorporated into promotional packages and some record labels are investing substantial amounts of money into this new venture. These packages include the design of sophisticated avatars for the artists thus creating a need for real/virtual world companies like *Millions of Us*. Illustrating the kind of commodification of knowledge that Nigel Thrift (2005) has described, the website for *Millions of US* lists services such as "Conceptualization and Project Design," "Scripting," "In-world Launches and PR," and "Machinima and Film-making" (http://www.millionsofus.com). The emergence and success of such virtual world specialist design companies is evidence that record labels and other businesses are beginning to recognize the commercial and promotional potential of *Second Life*. It offers a kind of intermediary space where business can be conducted and where a particular niche market can be communicated with. However, it also raises some questions with regard to the quality of the experience for the "music fan" in *Second Life*. This then may lead future work into such web applications to look in more detail at

the experiences of audiences who visit these online spectacles. We are yet to find out from those who frequent gigs in *Second Life* what the experience is like, why they go, how it fits into their cultural consumption patterns, and so on.

This virtual world and the development of avatars originated as a form of self-expression, an artistic endeavor, a creative redesigning of the self for the virtual world. Residents are able to design new virtual identities that allow greater freedoms than their real-world identities. This tool for self-expression can also, as we know from experiences of early web applications, be deceptive. For example, in this instance, there is little way to be sure that the real-world pop stars are actually controlling their avatars in *Second Life* (or if indeed this matters). In a Q&A session in *Second Life* with a music group such as Duran Duran how can the user be sure that the avatars' responses are coming from the actual members of the band and not from a record industry intern? While at the moment there is still "space" for the two worlds to coexist there is the possibility that an increased presence from more established acts may disrupt the open and creative potential of independent musical performances in *Second Life*. It would contradict the overwhelming rhetoric of "democratization" and "communal ownership" if amateur artists began to find it more difficult to find venues or more probably audiences for their performances. Mainstream acts can always find a place in the virtual or real world to perform (at least while they carry some cultural capital), yet it is not so easy for musicians just starting out who may be looking to this 3-D world to provide them with opportunities to get heard. Already, there is an increasing backlash against commercialization in *Second Life* by residents who prefer their virtual world to be defined by users rather than corporate interests (Semuels, 2007). A backlash that is likely to be futile as the commercial opportunities become more apparent, as user-generated applications become part of a "global culture industry" (Lash & Lury, 2007) and as the economies of the virtual world continues to expand.

Tribute bands comprise the second category of musicians in *Second Life*. The most popular example of this would be the U2 tribute band U2 in SL. The group's performances consist of synchronizing the movements of avatars designed to look like the members of U2 with live recordings of the original U2. There is great attention paid to the visual detail and to exploiting the marketing and branding potentials of the virtual space—the venue is complete with a concession stand, T-shirt booth, bar, and two porta-toilets (Totilo, 2006). The avatars are carefully synched to the music. The fake Bono claims, "I rehearse steady for about a week" (Totilo, 2006).

U2 in SL illustrates a shift in the idea of the tribute band from a predominantly musical imitation, with some adherence to the basic visual signifiers of the band, to an entirely visual simulation (where the music is a

recording of the actual band). In some ways, this shift is rather disappointing. U2 in SL's choices of what makes this virtual setting more "real" are questionable. In an attempt to uncover the essential elements of the live experience they found programming the ability to eat virtual hotdogs a vital element. After that, perhaps it is best not to ponder the perplexing inclusion of porta-toilets. Other choices demand deeper reflection. When criticized for plastering the virtual concession booth with corporate logos (Coke, Pepsi, and Evian) one of the U2 in SL creators explained that they were "intended to make the concert seem more real" (www.secretlair.com). U2 in SL's focus on replicating perfectly the experiences of the live mega-event from U2's well-known corporate stadium rock gatherings seems to draw attention to the inherent capitalist splendor of the pop spectacle. While trying hard to recreate the spectacular aspects of the live experience in *Second Life* they have instead drawn attention to the commercial interests that underpin such events—interests that are inevitably replicated where the brands are promoted as part of these U2 in SL events. The result is that through the reimagining of the mega-gig in a 3-D virtual world possibilities emerge for noticing the details of such events in the physical world. For instance, reflecting on Graham and Thrifts recent collaborative work that considers "all the processes of maintenance and repair that keep modern societies going" (Graham & Thrift, 2007, p. 1), we could ask how the repair and maintenance processes and procedures of the venue hosting the U2 in SL show vary from those at the U2 show.

In broader terms, to return to the music performance itself, these avatars represent pop stars who themselves are the "spectacular representations of human beings, distilling the essence of the spectacle's banality into images" (Debord, 2004, p. 38). Watching the live video montage that the group posted on YouTube (see References for a link) the motions of the band seem banal or even comical, yet with an underlying accuracy at the same time. The rough approximations of the avatar, as they try to capture the complex movements of the human body, produce something close to the band's performance, yet they inevitably fall short and caricature. The Bono avatar simply cannot be fully appreciated or even understood without reference or knowledge of Bono's actual stage persona. Traditionally, tribute bands are imagined as a group trying to perfectly replicate songs of their favorite band as a "labor of love"—although in some cases, as we have seen with bands like the Bootleg Beatles, it can be a profitable and sustainable venture. With U2 in SL's simulation of the images of their favorite band and concert setting it appears that their efforts are more a labor of love for *Second Life,* and their desire to make music work in the 3-D world, rather than a tribute to the music of U2.

The third and final group of musicians in *Second Life* includes the independent or amateur artists who turn to *Second Life* as a new method for

reaching audiences and promoting their work. Like a range of other Web 2.0 applications, such as MySpace and YouTube, *Second Life* supposedly operates here as a way of bypassing the obstacle of the recording industry so that musicians can get directly to their audiences. In the past, fledgling musicians would go on tour, traveling from town to town performing in a different city every night (the second-named author has first-hand experiences of the physical rigors of touring). Chris Dahlen from *Pitchfork* describes this as "a creaky, 19th century business model—and a grueling way for new acts to reach new audiences" (Dahlen, 2006). Compare that to Melanie Fudge who performs from the comfort of her home almost every night: "There's no equipment to lug around, she doesn't have to drive and she can mind her son while performing" (Andrews, 2006). Not only is it more pleasant, comfortable, and convenient—it is also surprisingly effective. Fudge states, "There's a crowd of 30 to 45 that show up to every online event (and) I have sold many more CDs through *Second Life* than I did previously" (Andrews, 2006). As a result musicians are, it would seem, increasingly interested in performing in *Second Life* and the virtual venues are proliferating to meet the demand. Amateurs appreciate the opportunity to perform from the comfort of their home to audiences around the world—and it is likely that audiences too appreciate this convenience.

Roland Barthes once claimed that the "amateur, a role defined much more by a style than by a technical imperfection, is no longer anywhere to be found" (Barthes, 1977, p. 150). The amateur is certainly alive, well, and even flourishing in Web 2.0—at least at the level of production if not of necessarily of dissemination. Indeed, amateur production practices—of literature, art, music, cultural critique, and so on—is one of the driving forces behind the user-generated content proliferating across the web. Transformations in attitudes toward the amateur can perhaps be traced back to the punk movement of the mid to late 70s (and further if we so wished). This was a movement defined by the values of the amateur over the virtuoso and an independent spirit in music (with the emergence of independent record labels, distribution networks, fanzines, and the like) where bands flaunted their lack of technical proficiency as a political statement. The changes to the music business model resulting from the challenges of the Internet has ushered in another explosion of the amateur, this time in the form of the wikizen (a term used to describe those creating content in Web 2.0 terminology). This more recent rise of the amateur, or "cult of the amateur" (Keen, 2007), is equally open to exploitation by the culture industry looking to commodify the next *en vogue* cultural movement. However, this is not to say that the new Internet cultures have not presented challenges for or resistances against social order. Illegal music downloading continues to undermine copyright laws and bands are increasingly looking to ancillary profits for making money rather than depending upon record sales.

Although the power of social networking sites may often be overstated, there is no doubt that such sites are having a profound effect on how bands promote themselves. There are already examples where bands have gathered huge followings from their MySpace presences and others have made it to the Top 40 purely from downloads and even without a recording contract (Gibson, 2007). Musical performances in *Second Life* are yet another addition to this trend.

The amateur musicians performing in *Second Life*, the third of the categories described here, seem to fall into two further subcategories. There are those who perform in *Second Life* exclusively and those who combine performances in *Second Life* with performances at venues in the "real world." The latter group appear to use *Second Life* as one promotional tool among many to advance the band, while the former is the classic amateur, performing in *Second Life* purely for the enjoyment, novelty, and feedback from others.

Many in the independent music community are exploring ways that *Second Life* can help new bands. Record labels such as Multiverse Records have popped up in *Second Life* organizing events, promoting musicians, and helping them sell their music. Multiverse has also organized events that were performed in *Second Life* simultaneously with performances at small clubs in the real world (Cadioli, 2006). Multiverse owner, Mike Prevost, also runs Muse Island in *Second Life,* which is solely dedicated to musical performances. He takes his new business venture seriously and hopes "to find sustainability, and perhaps in the process, prototyping and developing the record industry of tomorrow—one that works better than the industry of today" (Cadioli, 2006). Already there is the potential to make money as artists are able to charge admission with digital tickets, sell their music, and pass around a tip jar for donations (Dahlen, 2006).

Although there are many hoping that musical performances in *Second Life* will prove to be profitable and have an impact on the music industry, there are still disadvantages and limitations for the independent artist performing in *Second Life*. There are, for instance, technical limitations: audience numbers must remain small as greater numbers will crash the system, the interactions remain awkward as audience members must "text message" the musicians, and the animations of avatars performing still appear rigid and lack spontaneity as actions must be programmed beforehand (Dahlen, 2006). The very notion of preprogramming brings the question of whether these can indeed be thought of as "live" events.

In addition, as the *Second Life* landscape grows and more residents move in and participate in these musical performances there is an inevitability that there will be a mass of competing voices where artists will find it difficult to distinguish themselves from the countless others—particularly as the performance of the avatar is so limited in its scope. In a world without spatial limitations there could be countless live venues with countless

performers. The novelty of the musical event which ensures at least a small audience for most events will be gone as these become more mundane parts of the digital repertoire of cultural events, or will at least mean that audiences are spread more thinly across a larger number of events. Although there is a democratic idealism of a world where anyone can broadcast their music the question is who will get heard. In the "sped-up" cultures of Web 2.0 only a small few will take the time to search out for something that is not marketed to them. As a result of too many choices, users may flock to virtual venues and artists that have a stamp of approval from a large real-world corporation such as MTV, the BBC, or Warner Brothers thus replicating in *Second Life* the difficulties that independent musicians must contend with in the real world. Here we will begin to see the importance of record industry backing in getting heard over the cacophony of rocking avatars. Our suspicion is that rather than empowering or democratizing we will instead see the divisions and hierarchies of contemporary popular culture replicated in *Second Life*.

Second Life as Interactive Radio?

It is tempting to compare live musical events in *Second Life* with those occurring in the "real world." This virtual world has cafés, bars, large "outdoor" venues for festivals, and the musicians themselves encourage this interpretation by putting a good deal of effort into making their avatars do the part of performing by playing the instruments, synchronizing dance moves and so on. And we have already discussed bands using brandings and merchandising and food stores to promote this reading of the "virtual" gig as being as close as possible to the "real-world" gig. By comparing *Second Life* musical events in this way, it is difficult not to conclude that there is still a lot missing in the virtual—the smells, the discomfort, the heat, the damp, amongst other sensory experiences are not replicated here. The virtual world is thus relegated to being an inferior imitation of the real, at least for the moment. Unless, of course, the audience prefers the sanitized, convenient, and comfortable gigs found in *Second Life* (which would be entirely understandable). However, there is a different way to think of these musical events in *Second Life*. The fact that *Second Life* musical events incorporate simulations of elements of the live musical performance does not mean that this is the extent of possible comparisons. It is also possible to compare these musical events with other more conventional media.

For example, rather than inferior versions of live performances, the musical events in *Second Life* have the potential to add a new dimension to radio. Here we can see the virtual world as a form of remediation rather than something entirely new. Bertolt Brecht, in 1932, referred to radio as

"a substitute for theatre, opera, concerts, lectures, café music, local newspapers, and so forth" (Brecht, 1932). Today, radio, particularly with the recent emergence of digital radio, continues to be a popular medium broadcasting across the same types of areas that Brecht mentioned. Radio is frequently used as a medium for broadcasting live performances. As Walter Benjamin famously contended in relation to film, radio, as a form of mechanical reproduction, enables those who can't physically be present at the original event to experience at least some aspects of the musical moment. Adorno (2002), of course, was far more cynical about the consequences of radio and other reproductive media for the music that it broadcasts. It would, of course, be difficult to confuse listening to a radio broadcast with actually being at a live concert. However, this does not mean that it is not an enjoyable and convenient experience for the listener. It is simply a different and more convenient way to access and experience the live event.

In considering the issue of live music, there is an ambiguity of time and place that accompanies these more mediated experiences of musical performance. The live performance may be broadcast simultaneously with the live event or it may have been recorded at any time in the past, there is also the possibility that broadcasts we consider to be live are in fact transmitted with a delay (often to enable unpredicted material to be excluded from the broadcast if necessary). The "live" label in the later case merely suggests that the performance occurred in front of a live audience rather than suggesting that the performance is occurring in "real time"—this definition of "live" is very fuzzy as there is often a lot of postproduction tinkering on so-called "live" recordings.

Of course, radio has its inevitable drawbacks. Terrestrial radio is limited by bandwidth with a finite number of stations available. As a result, radio as a medium has generally been highly regulated with strict government control. In the United States, for instance, the government administers the issuing of licenses for permission to broadcast. Radio stations are increasingly consolidated and controlled by large parent companies. The influence of independent and college radio stations is small. Satellite radio and the Internet have opened up this closed network by offering a potentially infinite number of stations outside the domain of government regulation. Both satellite radio and Internet radio broadcasts and podcasts have revitalized the medium. Here we see radio moving away from the broadcast model, operating from the few to the many, toward more decentralized models (Poster, 1995; Beer, 2006).

Satellite and Internet radio maintain the traditional model of radio—individuals locate a station and listen to the audio broadcast—operating as "substitute" in the sense that Brecht intended. In addition to increased decentralization, the simulation of *Second Life* has the potential for providing an even richer experience of mediated "live" events. *Second Life* offers a

way to bring a visual and spatial dimension to radio listening (in a different form to that provided by television). One can wander from place to place picking up different streams rather than flipping through a set of radio channels. It would be interesting to see users developing sophisticated and inventive acoustic landscapes in *Second Life* creating interactive multimedia installations. Here wandering in *Second Life* is not merely a visual experience, but an auditory and interactive one as well.

There remains however some scope for the playful qualities of *Second Life* to be embraced; venues and avatars could be tailored to fit the mood of the music (as a opposed to mimicking the real-world gig). Rather than *scanning the dial* residents could *scan the virtual landscape* finding Goth clubs adorned with gargoyles or retro 60s venues decorated in psychedelic colors. Visual elements could aid the reinforcement of the musical subcultures identity in ways that are not possible with traditional radio. Musical performances in *Second Life* have the potential to go beyond mere substitutions of live performances in the real by creating a simulation that is a broader sensory experience than that made possible by radio.

In addition, *Second Life* has the potential to bring to fruition Bertolt Brechts aspiration for the future of radio. In "The Radio as an Apparatus of Communication" Brecht expressed the desire that radio move from a medium of distribution to one of communication. In this he claimed that the "radio would be the finest possible communication apparatus in public life, a vast network of pipes" (Brecht, 1932). This would be so if "it knew how to receive as well as to transmit, how to let the listener speak as well as hear, how to bring him into the relationship instead of isolating him" (Brecht, 1932). Here, changing our perspective a little, we see Brecht's vision for radio realized as *Second Life*. The most promising facet of musical performances in *Second Life* is not the presence of mainstream pop stars but the proliferation of amateur musicians and the dialogue between these artists and the audience. *Second Life* enables artists to transmit their music being played in their bedroom around the world. More importantly, it enables instant feedback from listening avatars worldwide who have come together in the *Second Life* café or bar. Anyone is able to perform; there are no barriers to getting a show booked, as there would be in the real. If one owns a plot of land on which to link the music stream there isn't even a need to be booked at one of the *Second Life* music venues. The wide gap between listener and performer is erased, as anyone is able to produce content and share it with others. The listener is no longer isolated but brought into the creative process with great potentials for interaction and cooperation. In this sense it is a response to Brecht's "call for a kind of resistance by the listener, and for his mobilization and redrafting as a producer" (Brecht, 1932). Consumers, as is common across Web 2.0 applications, become involved in acts of production. But we would like to add a note of caution at

this point, this is an example of what has been described as the "rhetoric of democratisation' (Beer & Burrows, 2007) that has ushered in Web 2.0. This, we suggest needs critical reflection as these sites expand into the mainstream.

One example of the inevitable relationship between *Second Life* and radio is the investment of BBC Radio 1 in *Second Life* where the BBC has set up a virtual tropical island as a venue for music festivals and parties (Fildes, 2006). The island will be used for mainstream performers as well as unsigned acts. Last year, the island hosted a virtual event mirroring BBC's One Big Weekend held in Dundee. Audiences did not see avatars of the performers but were able to watch and listen to streaming video of the event. In addition, participants were given virtual digital radios to keep, which would enable them to tune into Radio 1 anytime. The interactive editor of Radio 1 described the venture as "providing interaction between our listeners" and hopes to use the space to bring audiences and artists closer together (Fildes, 2006). It seems too early to tell if such an incorporation of a terrestrial radio station into *Second Life's* virtual world will be successful. Perhaps residents of *Second Life* will embrace this enmeshing of real-world organizational structures and virtual world spaces, or perhaps it will be shunned as yet another commercial intrusion as residents prefer what they perceive to be more user-defined spaces.

The Future of Music in Second Life

As we have suggested, one of the more surprising characteristics of *Second Life* is its preoccupation with replicating the real. A virtual world is created with limitless possibilities, yet its users appear to take this as an opportunity to design a world that looks a lot like the real world. This seems particularly to be the case when analyzing the musical offerings in *Second Life*. Again, we find that most of the effort of residents is spent on creating simulations of the real rather than pushing the boundaries of what is possible in *Second Life*. There are cafes that look like cafes, bars that look like bars, stadiums that look like stadiums—all with merely inconsequential quirky flourishes to distinguish it from reality. Bands struggle to design avatars that look like they are playing guitar or drums. There are live performances, record listening parties, and Q&A sessions with musicians. Unfortunately, there is a lack of truly creative explorations of how music and sound could be incorporated in an inventive and new way in this virtual world, as residents prefer to remain within the confines of the traditional music model.

Interaction and collaboration could be maximized taking advantage of the musical production and communication tools available. DJs in *Second Life* should be able to take the live stream of a musician performing on

guitar in a virtual bar and create a remix almost simultaneously that could then be broadcast in an adjacent virtual nightclub. Or, perhaps, audience members at a venue would be able to select from a number of versions of the same performance at the same time. Likewise bloggers and journalists should be able to post reviews of the performance while it is being broadcast and attach to their avatar a link to the review thereby eliminating the lag time between performance and public feedback.

Artists could also explore the relationship between music and space in a virtual setting. There are so many possibilities for art projects involving sound and movement in *Second Life* where avatars moving through a location would experience changes in the sounds rather than merely connecting into one static feed of sound—we can imagine here the simulation of the acoustics of the venue. Amid the obsession with replicating the real with musical performances in *Second Life*, acoustics have been largely ignored. For inevitable architectural reasons, a musician performing in his or her bedroom does not have the same acoustic sound as when a musician performs in a bar or a cavernous nightclub. We have not come across artists should playing with or confounding expectations of acoustic space; with, for instance, huge cathedrals broadcasting sounds that appear to emit from a small confined room and vice versa. Such projects could challenge our assumptions about acoustics and space and demonstrate how easily these perceptions can be manipulated. There may well even already exist a software plug-in that can perform this manipulation of acoustics.

The potential for sharing music may also be expanded in *Second Life*. Residents could develop podcasts or playlists that could be attached to their avatar or to a particular place in *Second Life* to be shared with others. Thus generating new series of connections between music and urban spaces as these playlists become attached to virtual buildings, streets and other city spaces (Whiteley, Bennett, & Hawkins, 2004; Beer, 2007). The sense of interacting with others is limited if individuals are sitting at their computers in the real world each with a different soundtrack to the virtual experience. Music is a central component to how we interpret our space and can have profound effects on one's mood and responses (DeNora, 2003) or even one's sense of belonging (Savage, Bagnall, & Longhurst, 2005).

Lastly, *Second Life* could change the way that music is written, performed, and recorded. Musical collaborations between individuals separated by physical space are not new with established methods in place for composing at a distance (ranging from sending four-track tapes through the mail to e-mailing mp3 files). However, it is conceivable that at some point musicians would be able to collaboratively work on a project at the same time rather than passing the tracks back and forth. Recording studios could be developed in *Second Life* where musicians could work on a piece simultaneously and collectively.

All of this is dependent upon residents in *Second Life* pushing the virtual world's creative potentials and testing the limits of what's possible in the virtual. It is too early to predict if future developments within *Second Life* will be driven by investment from large commercial corporations who have the money to research and develop new ideas for *Second Life*, or if the future of *Second Life* will be dominated by the independent users who tinker and play with the virtual world purely for the fulfillment of turning ideas into virtual reality. Likely, it will be a combination of both with some tensions existing between the two. *Second Life* is at a peculiar and nascent stage in its development. Real-world corporations are increasingly interested in getting involved with the developments of virtual worlds, with corporate heavyweights such as AOL, CBS Corp, NBC Universal, and Sony BMG moving in to the territory (Wallenstein, 2007). At the same time this has created a tension between those adamantly against a corporate presence in *Second Life* and those who recognize that more investment in *Second Life* will allow the virtual world to grow and develop technologically as well as in terms of the geographies of its virtual space. So for example, we see acts of protest occurring illustrated by the members of the *Second Life* Liberation Army who detonated an atomic bomb inside an American Apparel store and shot customers outside of a Reebok store in *Second Life* (though this doesn't exactly cause any damage) demanding more influence for users in defining *Second Life*'s future.

The art collective *Second Front* seems to have a quite revolutionary agenda for challenging the status quo. At a recent "performance" they infected their unsuspecting *Second Life* audience with bad code labeled "Code Deforma" which "produced elongated arms, inverted heads and contorted limbs" (www.slfront.blogspot.com, February 19, 2007). Later they returned the infected avatars back to their original state. They engaged in this act to draw attention to the fact that many feel compelled to design their avatars reflecting ideas of physical beauty from the real rather than to use *Second Life* as a place to escape the pressures to conform to one dominant ideal. Again, this example should serve as a reminder that *Second Life* is a gameworld and is different to the focus on the mundane aspects of people's lives that appears to underpin its rival social networking sites).

Some Conclusions

John Urry recently wrote that

> "new" organizations have developed that are globally mediated. People imagine themselves as members (or supporters) of such organizations through purchases, wearing the T-shirt, hearing the CD, surfing the organization's page on the Web, participating in computerized jamming and so on. However, for all the power of

global fluids, "members" of organizations will intermittently come together to "be with" others in the present, in moments of intensely *localized* fellow-feeling. These moments, involving what has been called the "compulsion to proximity," include festivals, business conferences, holidays, camps, training camps for terrorists, seminars and, of course, sites of global protest. (Urry, 2003, p. 90)

Urry's vision of this "compulsion to proximity," the desire to be where the physicality of the action is and to see and experience it, may now need to be rethought if or when the world of *Second Life* expands into the mainstream of cultural life. The draw may not be the physicality of the experience of the gig but of attending events as the imagined avatar rocking-out with fellow avatars—moshing, pogoing, or foot-tapping. It may be that rather than a compulsion to proximity these events instead reveal an opportunity to attend live musical happenings without the risks and discomforts of "being there" at a live musical event—the crushing and pushing, the flailing hands, elbows and feet, the smell, crowd surfers, the unwanted physical contact, the unwelcome advances, the damp, the dirt, and, especially, the heat.

It is this wider sensory experience that is lost at the *Second Life* gig, although the audio and visual aspects are simulated (with some inevitable differences around acoustics and the graphic potentials of the existing system) there are properties of the "live" music experience that simply are not there in the virtual world. We can't then go down the route of suggesting that the gig experienced in *Second Life* is indistinguishable from the physical attendance of the gig. This is clearly not the case. Rather the understanding of and even the motivation to attend musical events will be changed as these virtual world opportunities proliferate and spawn new cultural movements of their own. What then might happen to live music when the material and spatial dimensions are opened up to reworking as the boundaries and practicalities of the "real" world are removed? Again, we cannot conclude that this type of virtual world gig or festival threatens real-world events, this is simply not the case given the ongoing popularity of events such as Glastonbury, Reading/Leeds, and the numerous other rock music festivals.

We are not suggesting then that the virtual spaces of *Second Life* are endangering live music; nor are we saying that they are saving live music by opening it up to a global audience. Rather we are suggesting that the early forays into virtual gigging in a 3-D virtual world suggest a cultural movement that requires some attention in order for us to build upon and keep fresh the type of cultural studies accounts of past movements. In other words, what we need now is a form of cultural studies or cultural sociology that engages with how youth or (sub)cultural movements are organized and operationalized through Web 2.0 applications. It is here that we have a chance of unpicking the details of the fragmentary and complex music cultures that exist in the post-generic age of a "knowing capitalism" (Thrift, 2005).

In cultural studies and cultural sociology, youth movements, and the ubiquitous image of the subculture, have defined how music culture has been understood. The study of live musical gatherings in *Second Life* may enable us to uncover the contemporary equivalents of the mods and rockers, the punks, the grebbs, the townies, the baggies as the processes of digitalization continue to reconfigure the relations and organization of music culture. The focus of this research might take the spatiality of these gatherings to map out the geography of these movements and events within the virtual world of *Second Life*. The question of locality might be of importance here, both in the physical and virtual spaces in which they are organized. For instance, we may need to consider how geographical location becomes more or less important to contemporary cultural movements.

Whatever the approach taken in conducting this research into these user-generated spaces and virtualized cultural events, it is clear that there is a cultural movement in its emergent stages that requires sustained and creative analysis in order to understand what it is that is going on and to track its development. We would like to predict that it will not be long before this type of virtualized musical event becomes more common (although not necessarily in *Second Life* or in the form that *Second Life* currently takes). We are imagining here the famous Glastonbury festival in the United Kingdom overcoming the restrictions of the now famous security wall, size of the fields, sanitation, health and safety, and so on., to increase its capacity into virtual worlds like *Second Life*, where tickets may be purchased for the online version. This virtual version of the music festival would enable tickets for Glastonbury, which currently now sell out within hours of release, to be sold many times over (a possibility that is sure to be attractive to the commercially minded). Indeed, in the examples outlined here and elsewhere, major music festivals are now finding their way into such virtual worlds as a way of exploiting the marketing potentials of these spaces.

Having said all this, we would like to conclude by suggesting that putting *Second Life* into context is the most important step in understanding the scale of its implications. As we have mentioned, because of its spectacular veneer *Second Life* has received disproportionate attention when we consider the impact of other user-driven web applications. The social networking sites MySpace and Facebook, for example, both have far greater and more active memberships. Doubts have even been raised about the number of residents of *Second Life* who actually play an active part, with some suggesting that it only has around 100,000 residents who regularly participate (Johnson, 2006). The difference between *Second Life* and these other social networking sites is that *Second Life* concentrates less on the mundane stories, images, and perceptions taken from people's everyday lives and focuses more centrally upon an approximation of the user that is far more detached from their everyday existence. That is to say that the profiles used in these

other social networking sites, which tell us often in detail all about the user, are replaced with the 3-D avatar, which in fact reveals very little. The problem for *Second Life*, it seems to us, is that the *sociological tendency* in the Web 2.0 user (Beer & Burrows, 2007)—illustrated by their desire to find out about other people and their friendship connections—is frustrated by the 3-D imagery of *Second Life*. Indeed, this would suggest that *Second Life* is something else and does not necessarily fit with the kind of social networking sites with which it is often associated. It is closer perhaps to the game play of the Sims games or Grand Theft Auto (or an interactive form of radio as we have described above). This similarity between *Second Life* and the type of 3-D worlds found in these games suggests that it is important that we attempt to begin to understand it in terms of what Atkinson and Willis (2007) describe as the "ludodrome". This requires us to understand how the *Second Life* "ludodrome," the mediated simulation of concrete urban space, comes to have implications for the lives of its users.

In the case of music the implications of being able to go onto MySpace to access music, videos, or even to make friends and communicate with pop stars seems of far greater significance than the 3-D gig (at least at the moment of writing this seems to be the case). This is not to say that *Second Life* is an irrelevance, the articles in this edited volume clearly suggest otherwise, it is instead to suggest that we perhaps need to separate *Second Life* from the social networking phenomenon and, in the case of music culture, look toward creating more nuanced understandings across a range of different Web 2.0 applications. The challenge will be to develop research strategies that allow us to study the types of events we have described in this chapter. In some cases this might require us to hang out at gigs so as to allow us to rock with the avatars, constructing ethnographic reports on what is happening, but more significantly it will require us to keep a handle on the bigger picture as we consider more generally the place of culture in a Web 2.0 context.

Postscript: A Note on Writing This Chapter in the Context of Cultural Speedup

Whilst putting this chapter together we began to reflect upon how it would be possible for us to say something that may hold some relevance for readers who may come to read it over the years to come. It occurred to us that the nature of the material we were writing about, for publication in a printed book, meant that it was entirely possible that the descriptive aspects of the chapter could even be outdated by the time the book was published. In fact *Second Life* is already starting to look a bit "old hat" in relative terms. The problem here is one of "social and cultural speed-up," an issue

described in some detail recently by Nick Gane (2006). As Gane pointed out, the problem of cultural speed-up, illustrated by the rapid movements of web cultures over recent years, is that analysis lags behind as we attempt to describe things that are constantly on the move and/or accelerating (see also Beer & Burrows, 2007).

In the end, faced with the problem of writing about what may possibly be an ephemeral moment of transition, we decided to give up with our endeavor to write something that may endure. That is to say that we have opted instead for a descriptive account of the phenomenon, with some theoretical interventions, that will more than likely serve merely as a historical document that readers may choose to use as a point of reference in understanding the next stages in these transitions. This piece then is intended to fit in with a movement toward a "descriptive sociology" suggested, in relation to this type of problem, in a recent article by Mike Savage and Roger Burrows (2007). We suspect that by the time of publication of this volume *Second Life*, and the other online phenomena discussed in this chapter and elsewhere in this volume, will have changed or been usurped by the next "fad." Phenomena like *Second Life* can move with startling speed from appearing to be established cultural happenings to being "so last year." What is clear, considering the wider context, is that there will have been changes by the time you have come to find this piece; we hope that you will take this chapter as an attempt to grapple with the moment as we try to keep up with some quite radical changes in how people use the Internet. More detailed conceptualizations will only follow as these transformations bed in a little more and as we have the luxury of time to reflect.

References

Adams, T. (2006). Goodbye, cruel world. … *The Observer*, Review, October 29, pp. 8–9.

Adorno, T. W. (2002). The Radio Symphony: An experiment in theory. In R. Leppert (Ed.), *Essays on Music* (pp. 251–269). California: University of California Press.

Andrews, R. (2006, August 15). Second Life rocks (literally). *Wired.news*. Retrieved March 5, 2007, from http://www.wired.com/news/technology/internet/1,71593–0.html

Atkinson, R., & Willis, P. (2007). Charting the ludodrome: The mediation of urban and simulated space and the rise of the *flâneur electronique*. *Information, Communication & Society, 10*(6), pp. 818–845.

Barthes, R. (1977). *Image, music, text*. New York: Hill and Wang.

Beer, D. (2006). The pop-pickers have picked decentralized media: The fall of Top of the Pops and the rise of the Second Media Age. *Sociological Research Online, 11*(3). http://www.socresonline.org.uk/11/3/beer.html

Beer, D. (2007). Tune out: Music, soundscapes and the urban mise-en-scène. *Information, Communication & Society, 10*(6), pp. 846–866.

Beer, D., & Burrows, R. (2007) Sociology and, of and in Web 2.0: Some initial considerations. *Sociological Research Online, 12*(5), http://www.socresonline.org.uk/12/5/17.html

Brecht, B. (1932, July). Radio as a communication apparatus. Retrieved February 8, 2007, from http://www.tonisant.com/class/2001/fall/brechtradio.htm

Cadioli, M. (2006, June). Music in Second Life. *Digimag*. Retrieved January 11, 2007, from http://www.digicult.it/digimag/article.asp?id=601

Dahlen, C. (2006, April 21). The show must go online. *Pitchforkmedia.com*. Retrieved January 11, 2007, from http://www.pitchforkmedia.com/article/feature/31242/Column_Column_Get_That_Out_of_Your_Mouth_24

Debord, G. (2004). *The society of the spectacle*. New York: Zone books.

DeNora, T. (2003). *After Adorno: Rethinking music sociology*. Cambridge: Cambridge University Press.

Fildes, J. (2006, May 12). BBC starts to rock online world. *BBC News*. Retrieved March 5, 2007, from http://news.bbc.co.uk/go/pr/fr/-/1/hi/technology/4766755.stm

Gane, N. (2006). Speed up or slow down? social theory in the information age. *Information, Communication & Society*, *9*(1), pp. 20–38.

Gibson, O. (2007, January 16). A blag or a steal? New rules put unsigned punk band in top 40. *Guardian*. Retrieved March 5, 2007, from http://www.guardian.co.uk/uk_news/story/0,,1991104,00.html

Graham, S., & Thrift, N. (2007). Out of order: Understanding repair and maintenance. *Theory, Culture & Society*, *24*(3), pp. 1–25.

Johnson, B. (2006). Are there really two million people using Second Life? Technology Guardian, *The Guardian*, December 21, p. 2.

Keen, A. (2007) *The Cult of the Amateur: How Today's Internet Is Killing Our Culture and Assaulting Our Economy*. London: Nicholas Brealey Publishing.

Lash, S., & Lury, C. (2007). *Global culture industry: The mediation of things*. Cambridge: Polity Press.

O'Reilly, T. (2005). What is Web 2.0: Design patterns and business models for the next generation of software. *O'Reilly*. Retrieved December 7, 2006, from http://oreillynet.com/1pt/a/6228

Poster, M. (1995). *The second media age*. Cambridge: Polity Press.

Robinson, J. (2006). Mister Space Man. *Observer Music Monthly*, no. 20, December 2006.

Savage, M., Bagnall, G., & Longhurst, B. (2005). *Globalization and belonging*. London: Sage.

Savage, M., & Burrows, R. (2007) The coming crisis of empirical sociology. *Sociology*, *41*(5), pp. 885–899.

Semuels, A. (2007, February 22). Virtual loses its virtues. *Latimes.com*. Retrieved February 25, 2007, from http://www.latimes.com/entertainment/news/la-fi-second22feb22,1,4841916,full.story?coll=la-headlines-entnews

Thrift, N. (2005). *Knowing capitalism*. London: Sage.

Totilo, S. (2006, June 26). Are virtual U2 concerts even better than the real thing? *Mtv.com*. Retrieved January 11, 2007, from http://www.mtv.com/news/articles/1535128/20060626/u2.jhtml?headlines=true#

Urry, J. (2003). *Global complexity*. London: Sage.

Wallenstein, A. (2007, February 13). Hollywood hot for Second Life, but are virtual worlds for real?. *Hollywood Reporter*. Retrieved February 25, 2007, from http://www.hollywoodreporter.com/hr/index.jsp

Whiteley, S., Bennett, A., & Hawkins, S. (Eds.) (2004). *Music, space and place: Popular music and cultural identity*. Aldershot: Ashgate.

YouTube video montage of U2 in SL live performance. www.youtube.com/watch?v=Mro9Qzv–k8

Part III Identity in Virtual Worlds

7. Identity and Reality: What Does It Mean to Live Virtually?

Don Heider

Upon entering a virtual three-dimensional (3-D) world for the first time, it's normal to be a bit overwhelmed. There are so many questions. How do I move? How do I speak? What are those objects? What do those objects do? Where can I get help? Often your initial hours in the place are spent bumping into things and trying to orient yourself to the new surroundings.

Yet, in most worlds, *Second Life* included, you are asked to make a profound decision very early on. The way you negotiate through these places is with an avatar, a virtual human that serves as your substitute in the virtual realm. So the big decision is what to do with the appearance of your avatar. Male or female? Short or tall? Fat or thin? Skin color? Facial features? Hair length and color? Virtual realms like There.com and *Second Life* offer a variety of prototype avatars that make these decisions for you; you can alter them later. At There.com if you choose female you can select from the Blonde Dancer, the Cocoa Halle, or Espresso Bob, referring to hair style; for males it's the David Blonde, the V Coca or the Joey Espresso. At *Second Life*, prototype avatars are girl or boy next door, city chic male or female, harajuku male or female, cybergoth male or female, furry male or female, and nightclub male or female. Harajuku apparently refers to young people who gather in the fashion district in Tokyo near Harajuku Station. But you can also choose the most basic of avatars, a sort of generic form of human.

No matter what your choice is, you can make dozens of decisions to alter the basic form. You can easily change the height, weight, size, and shape of the avatar as well as alter hair length and color, eye shape and color, lip size and shape, the list goes on and on. For those who have never

created a new virtual being, the choices can seem a bit daunting. But this is just the tip of the iceberg. Once out of *Second Life*'s orientation area and in the larger virtual world, you discover quickly that simply using the customizing function provided by the world's developers is quite passé. Most residents also purchase enhancements from the many sellers in *Second Life*. People with sophisticated skills have created a huge cadre of choices you can add, for a price. For instance, no matter what you do to your skin color and tone with the world's built-in tools, the avatar lacks subtle shading. So graphic artists have created "skins" outside of *Second Life* with sophisticated art and photo programs and then imported these skins into the world. These skins are much more lifelike with subtle shading and more makeup choices. You can pay from 300 Lindens (the *Second Life* Currency; about $1.50 U.S.) to 8000 Lindens($30.50 U.S.) for a skin. If you are willing to spend more for a custom skin, you contract with a skin-maker to design a skin that looks like you or, perhaps, your favorite celebrity.

Obtaining more realistic looking, more sophisticated hair is also a very common behavior in *Second Life*, as in real life you might want to change your hair style, length, color etc. on a regular basis, so multiple sets of hair might be necessary. Better hair in general costs much less than a good skin, and there are many products to choose from. Add to this clothing, makeup, accessories, etc. and you see quickly there are many, many options when it comes to forming your appearance in this virtual realm. Free things are also available, but it's not uncommon to spend $2,000 to 10,000 Lindens (about $8-$40 U.S.) to achieve a more sophisticated and stylish look.

Thus far I have discussed primarily the human forms you may choose from in *Second Life*, but there are more choices as well. You can choose a more fanciful humanistic form, that is elf, vampire etc., or you can choose to live in this world as an animal (known in-world as furries), or even as an object. That being said, the vast majority of residents select a human form.

After several years in *Second Life*, I am only beginning to try to answer an important question: Given the opportunity to live in a virtual world and take on one of many, many forms, why do people make the choices they do? This is more than an issue of aesthetic choice. This strikes at a very foundational question inside of virtual worlds and that is the question of identity.

Identity in a virtual world is a complex matter. It is complex because the very question of human identity is complex. As Baumeister put it in 1986, "An identity is a definition, an interpretation of the self" (p. 4). The idea of the self is foundational in philosophy and has been seriously studied by social scientists since William James discussed it in his 1890 classic "The Principles of Psychology." After over 120 years of study, not much has been settled regarding the idea of the self and identity, including definitions for those terms. Some have looked at how we define our own identity, others have focused on how society or our culture shapes our sense of self.

Many have agreed that the self we present to others, the so-called "social self," is multifaceted. James wrote that a person "has as many social selves as there are individuals who recognize him" (1890, p. 294). This idea, in different forms, has been repeated and refined many times, perhaps most famously by Erving Goffman (1959). Goffman argued for a dramaturgical approach in seeing the self, wherein we are being reshaped by each interaction with an audience for whom we perform.

Modos

I have spent three years in *Second Life* as a participant observer. The learning curve for me was quite steep, as I had not previously participated in an online community or environment. So, I had to not only learn the particulars of this 3-D world, but of operating and communicating in an online environment. I had to ask people things like what does AFK or ROFL mean (**a**way **f**rom **k**eyboard & **r**olling **o**n the **f**loor **l**aughing). I intentionally did no reading, scholarly or otherwise, about virtual worlds or virtual communities. I wanted to avoid letting previous research influence my ideas and impressions. I had no idea what I was going to research, but I realized from my first few hours in SL, that this was an interesting and unique environment with many opportunities for research. I had stumbled upon the place after reading a short piece about it in the local paper. I had no previous conceptions, and I was a complete novice to online environments. In some ways *Second Life* (SL) provided for me the ideal place for ethnography.

I also relatively quickly made a decision about a fairly serious ethical dilemma. I decided not to identify myself to people initially as a researcher. Within my first eight weeks in the world I saw that residents had very strong and very negative impressions about researchers who had entered SL. People felt that residents were being treated as guinea pigs; being frequently poked and prodded for information. When, at first, I identified myself as researcher to several people, the reaction was obvious. I decided it was going to be very difficult to get information I needed unless I kept my research identity to myself.

This meant not giving people the chance to choose to participate or not participate in my study. People I came in contact with were all included unknowingly. I felt I could justify this decision by ensuring a relatively strong level of anonymity to people I interviewed. First, people in SL never use their real names. When you register a new account, you select your avatar's last name from a list of around 100 rotating preselected names. Then you are invited to compose your own first name. I decided I would not identify anyone even by this avatar name. Instead, by using pseudonyms for the avatars, I could offer at least two layers of protection for informants.

RL and SL

My early days in *Second Life* were spent exploring. The place is full of lots to see: interesting buildings, beautiful beaches, exotic forests, and mall after mall after mall. I spent much time at a hangout for new people called the Shelter. People come there to dance (with the help of animations) and talk. It is staffed with veterans of the world who offer advice and help to new folks. Built by a computer whiz who appeared only in an avatar that was a close cousin of Snoopy, it is a repository of both information and free clothing and gadgets.

After learning how not to run into objects, walls, or other avatars, the next task at hand was to see what people were doing in SL. As I got to know people and talk to them about their interests and reasons for spending time in this virtual world, one thing quickly became apparent. That is the fact that people spending time in *Second Life* treated the place very much as an actual, not a virtual, place. One early example of this emerged when a friend of mine had a problem with her *Second Life* residence. People often do not have a SL home. They merely roam about when online. But for many residents, owning or leasing virtual land and establishing a home is an appealing alternative. My friend Monica Kanto had land and a nice cabin. An angry neighbor had covered his land with giant purple phalluses, which Monica could clearly see from her house. She was very upset and angry by this turn of events. I had a hard time understanding and relating to how she was feeling. This wasn't her real house; after all, everything was just pixels on a hard drive somewhere. But for Monica, who spent four or more hours a day in *Second Life*, it was a serious matter. She paid a contractor (in Lindens) to come remove a picture window from her home so the view of the offending objects would be much less noticeable.

Another informant told me about a long-term (six month) relationship she had had with a man in *Second Life*. They eventually split because he was cheating; she told me that, as a result, she was so upset she experienced a long bout of depression; she missed work and even had taken antidepressants. I asked her whether she had ever met or spoken to the man outside of *Second Life* and she answered she had not.

Both of these examples demonstrated that various dimensions of this virtual world are as "real" as anything we might experience in our day-to-day "real" lives. Virtual objects can hold the same meaning for people as real objects. Relationships formed in a virtual world, even when they stay virtual, can have emotional impact on people quite similar to the impact of relationships in the flesh.

Thus material things, objects, even in a virtual world, can have value to people. Consider material objects around your home: some have more value to you than others. Things have value according to what importance

and meaning we attach to those objects. The value is most often socially created. A photograph is valuable because of the meaning we attach to it. A favorite shirt, a piece of jewelry, your lucky underwear; each has meaning because of what you associate with those material objects. To others those same objects may have no particular value and certainly not the same value you ascribe to them. So too, in a virtual world, objects can be ascribed with the same kinds of meanings. It's not the reality or unreality in the physical world that gives many objects value; instead it is the meaning we assign to each object.

The same holds with human interaction. The fact that it takes place in a virtual environment does not diminish its value or meaning. In daily life we may have trivial or meaningful contact with people in a variety of settings. It is not the surroundings that define the relationship or exchange, it is the meaning *we ascribe* to these relationships and exchanges that define their relative value and importance to us.

It's not uncommon for the first few weeks in *Second Life* to struggle with the question of living in a world made of pixels. But in relatively short order, the unreality of the place fades. I think it does so for several reasons. First, avatars represent real people: this means real kinds of interactions. Likes and dislikes, real emotions, real connections all occur. Next, there is a physical reality to the place—the ground, the sky, clouds, even a breeze. There is a geography with maps that point out architecture, landmarks, real estate. There is day and night. So, you become acclimated to places, just as you might when moving to a new neighborhood or city.

As well, there is an economic reality. People have jobs, there is real commerce; real money goes in and comes out of the world. After a time the differences between real life and *Second Life* are no longer so significant. We already live in a world full of symbolic reality: money, social institutions, rituals. So the hard clean lines between the real and symbolic aren't so hard and clean anymore in a postmodern world; *Second Life* can be seen as the next step in the blurring of those lines.

Identity and Reality

This brings us back to the question of identity. As outlined earlier, people have a number of choices when they enter a virtual world in general and *Second Life* in particular. One of the most basic choices is that of identity. Social scientists have emphasized several factors as important as we develop our own sense of self-identity. One is appearance. In life we are born with certain characteristics predetermined by genetics: height, body type, hair color, eye color, facial type, abundance or lack of hair and much more. As medical and cosmetic technology become both more sophisticated and

more accessible and affordable, we can control some things about our appearance. But in a virtual world, it is under our control almost completely. Given these endless opportunities, what do people look like in *Second Life* and why? I spent a large amount of time asking people in the world about their avatars. As often happens with research, the results were surprising, yet ultimately made sense.

Lots of different subgroups have formed in *Second Life*, such as elves, furries, technopunk, neko (human/cat like creatures), goth, etc. These are not the subject of the study at hand. Although these groups can be somewhat popular in their own right, the majority of people I encountered in the world were not primarily devoted to such groups. These subgroups would be worthy of study by themselves. But the majority of people I observed and interviewed in SL were people not living in a particular sect. This is an important caveat, because often these subgroups have their own set of norms for appearance, identity, and role definition (furries take on animal shapes and skins, elves assume fantasy shapes and skins, etc.).

In doing hundreds of interviews with residents in the mainstream part of *Second Life*, I learned that people generally created avatars that look much as they do in real life. This result was fairly surprising to me initially. As mentioned before, this is a place where you can appear as almost anything—from things like a set of whirling silver orbs to a tiny teddy bear or a giant robot. Yet, people overwhelmingly not only choose human forms, they choose human forms that resemble what they report they look like in the real world. One SL resident, Waterspurt Effingham said, "I love my avie as she is a representation of my human self." Or rather, residents slightly improve their appearance in the virtual world. I'll call this phenomenon, the Replicant effect, borrowing the term from the 1982 sci-fi film *Blade Runner*. In that film, replicants were bioengineered robots that looked almost exactly like humans, but were better (physiologically superior). Likewise, people in *Second Life* often build their avatars to look similar to their real-life appearance, only better. They give themselves trimmer waists, bigger pecs, a more ample bustline, or that blonde hair they always wanted. They make alterations often to look like how they looked when they were younger, or perhaps to meet those ideal body types seen in mass media.

I asked one informant, Janie Biziou, if her avatar looked like her real-life appearance:

> Janie Biziou: sorta but better
> Me: better how for you?
> Janie Biziou: i think everyone does that
> Me: of course
> Janie Biziou: well i don't have blonde hair
> Janie Biziou: and I'm older and fatter

Over all, in the mainstream of *Second Life* you rarely see ugly avatars. If you go to a dance club, live music event, or a shopping center, you generally see attractive human avatars. The accepted "look" seems to be well-dressed, good hair, good skin, and physically fit. Think of people you see in TV commercials. Yet most of the people interviewed reported that their avatar resembled, in some ways, their real-life appearance.

Appearance is only one aspect of someone's identity, however. When it comes to interacting with people in *Second Life*, what do you find?

Typologies

Once you've selected what you'll look like in this new virtual world, another interesting question is, how will you act or how will you behave? A number of social scientists argue persuasively that without social context, there is no sense of identity. The argument is, we define ourselves depending upon our social circumstances, and things like mores, norms, and the expectations of others help us define who we are.

My own experience in *Second Life* bears this out. In my first days, weeks and months into the world, I was in SL who I am anywhere else. There is a core of who I am that remained consistent. My surroundings did somewhat define me, however. Since I am so new to online communities and completely new to 3-D virtual worlds, I am much quieter than I might be in real life. In my interactions with others, at first I mainly ask questions. But once I found someone to talk to and began a conversation, what came out is who I am, whether I intended that or not.

The interactions are different than real-life meetings. Think of a time in normal life when you met someone. You have a lot of sensory input; what they look like, how they smell, how they hold themselves, what their facial expressions are, how they dress, how do they speak, what their voice sounds like, whether they have an accent, how they phrase the words they say, whether their speech is forthright or halting, what words they emphasize, whether they make eye contact, how they touch you or shake your hand, and what mannerisms they have. In SL, you have almost none of this input. You see an avatar, which is somewhat of a visual representation of a person, but most avatars have the same posture, and avatars do not speak or emote. You can, with some extra effort make your avatar smile or frown or salute or wave, but the extra effort often precludes it from happening. Communication in SL primarily happens through keyboarding. Even though parts of the world are now voice-enabled, residents rarely choose to use a microphone and headset to speak in the world. So when you interact with someone, you have the words they type and little more. Indeed, you might think of this as communication stripped down to some of its most basic elements, words

written on a screen. But words can be rich and descriptive. So with each interaction, you decide what words to type; what to disclose about yourself and what not to disclose about yourself. In day-to-day life, where people may meet you because of where you work or who you know or where you live, all those things (work, social networks, locales) probably give people some information about you, whether you intend that or not. Things are different in *Second Life*. In SL you choose what information to give. Some things may come out inadvertently as you speak, but most information, especially about yourself, you make a conscious effort to provide. This gives people, more than in normal circumstances, an opportunity to control that information, or even fabricate it.

In dealings with people in *Second Life*, I observed, broadly, four typologies when it came to people's choices to revealing themselves: truth-tellers, embellishers, role-players, and liars. Truth-tellers often see *Second Life* as they might any other communication technology, like a telephone. It is simply another way to interact. These people are transparent, open, and direct. And although they may keep details about their real lives private because of security concerns, they will tell you many things about themselves. In fact, in some ways, the layer of anonymity can foster a level of openness and sharing not often found in normal interactions. In other words, it's difficult to share uncomfortable personal details with your office mate, knowing she will see you every day and may tell your coworkers or your boss. The same would hold true with neighbors. But in SL friendships, people often share very personal details about their lives fairly rapidly. In my first months in the world, I was struck at the things people told me about their lives, their spouses, their backgrounds, their personal issues. Part of this may be because, although there are lots of activities in *Second Life*, the primary activity is communicating. How do you know whether or not people are telling the truth? Much as you would outside of SL. Is what they tell you internally and externally consistent? In other words, does the information they give remain consistent day after day with no conflicts (internally consistent)? And, does it hold true and check out with verifiable facts outside of *Second Life* (externally consistent)? I found the majority of people I met in *Second Life* to be forthright and direct, friendly and open. These were the truth-tellers.

Embellishers are people who mostly tell the truth, but, like people who exaggerate a bit on their resume, they might improve on a fact or two. One example was an avatar called Randolph Birge. Randolph typically wore military flight suits in SL, complete with insignia. His profile mentioned flying. But when you questioned him further, you discovered he was recently out of the Air Force and had never "flown" anything. He wasn't outright lying. He was in the Air Force. He did work in airplanes. He just was not a pilot. Embellishers will take a kernel of truth and add to

it, often to make themselves appear a bit more interesting than they are in real life.

Role-players are people who come to *Second Life* or other virtual worlds for very specific reasons, to play a character or live in a virtual world as a particular role. These people have migrated to *Second Life* from Role-Playing Games (or RPGs) and can be found in areas (or sims, the term used for an area in SL) where specific role-playing rules or guidelines have been set. These role-playing areas are wide-ranging, from sci-fi/cyberpunk role-playing sims, to vampires, to elves. People go to these sims to be part of what you might think of as a work of fiction in progress, but instead of reading a novel or watching a movie, they themselves are the characters and can influence how a story might be shaped. In *Second Life*, people often identify themselves as role-players, and even distinguish when they are in and out of role. Role-players also often create elaborate back stories for the characters they play.

Liars are people who come into *Second Life* deliberately to deceive people. Unlike role-players, they do not identify with the fiction they are creating through their words and actions. They will instead tell people a series of fictitious details about their real-life identity. So, for instance, men or women who are married in real life tell people they are single, and even pursue romantic relationships in the world without revealing their real-life marital status. Another common form of lying in *Second Life* concerns gender. Men live as women, women live as men.

In *Second Life* you have the opportunity to write information about yourself or your avatar in a profile section, which has different sections—one titled 2nd Life, another titled 1st Life. People can view your profile by simply clicking on your avatar. People can choose to write briefly about their avatars or themselves in these sections, and even offer a photograph. Few people in *Second Life* offer much information from their so-called 1st life, and only a very small percentage offer a 1st life photograph of themselves. However, profiles provide a place for people to say something about what they are doing in *Second Life*, such as living cross-gender. In other words, these profiles provide residents a fairly simple way of letting other residents know whether they are role playing or are different in *Second Life* from what they are in first life. Liars are people who do not reveal accurate information in their profiles, but also might deliberately offer false information and even a picture not of themselves.

An example of a liar can found in the story of an avatar called Amari Godernot. Amari entered *Second Life* and was a quick study. She had some computer scripting skills because of her background as a graduate student in a computer sciences program at an American university. She had a lot of experience also in gaming and in online communities. She joined one of the elf groups in SL and quickly climbed the ranks as a helpful and useful

member. She met another member of the elf group, they fell in love, got engaged, and had a very large and very public *Second Life* wedding. She gave her friends and partner a number of details about her real life, including details about her sexual awakening as a woman, her former boyfriends, and even a fiancé. She and her SL partner eventually split because of his real-life circumstances; he was able to spend less and less time in *Second Life*. A few weeks later it came as a considerable shock to the elf group when Armani entered the lands no longer as a female, but as a male. People were surprised and Amari's former *Second Life* husband was very angry. Amari was largely unapologetic for the switch, and in some cases expressed amusement, even though he had told a remarkable amount of lies during a long, extended time in *Second Life*. He did acknowledge an error in judgment:

> Amari Godernot: I'm a person whose real mistake was role-playing a female in a relationship.
> Me: and how many lies had to go into that?
> Amari Godernot: I expect quite a few.

A liar must invest a lot of time and energy into constructing and maintaining a fabricated existence. In Amari's case, he had already thought through a decision to come into SL cross-gender. He picked a gender neutral name, and to friends and associates, he had composed an elaborate series of lies about his life as a woman. He even told stories of the discrimination he had faced as a woman pursuing a computer sciences graduate degree in a largely male world. When, because he had a crush on a woman in the elf lands, he decided to flip to a male identity, the switch for him was a simple matter. But he hadn't anticipated the impact of his actions upon others. His former partner in-world was angry and hurt, and for a time Amari had to give up his leadership post in the elf group. Eventually his former partner was banned from the group for his unwillingness to let the incident go, and some others who knew Amari reported they would never completely trust Amari again. Even given this, Amari was able to find new romance in SL, this time with female companions, even though they knew his background of deceit.

This wasn't the most grievous case I witnessed or heard about in my time in *Second Life*. There were also cases where people would use alternative accounts, two different avatars with different names on the same account, to deceive people. In one case, a man first romanced a woman in-world as a man, broke it off, and then romanced her as a woman engaging in a virtual lesbian relationship. In another, a person talked an in-world lover into giving his/her account password, and then promptly cleaned out the account assets, totaling several hundred real-world dollars. Liars and swindlers exist

outside of virtual worlds as well of course, but anonymity does provide an opportunity for those interested in deception.

Simulacra

What might be the most interesting question about identity in virtual worlds, is the question of what does the act of creating an avatar mean ultimately? Jean Baudrillard wrote about simulacra and simulation (1994). He was playing with the idea of one thing that is created to represent another, whether it's a map (can a map ever be an exact replica of the terrain?), a behavior (if one feigns illness and displays all the symptoms, isn't she de facto ill?), or an icon (can not a religious icon become imbued with the power of the divine if it's meaningful to a believer?). In light of this, what exactly is an avatar? Is it a map of a person, a symbol for a real existence? Another way of putting it might be, by creating an avatar, is a new reality created?

Using Baudrillard's framework for thinking about images and what they represent may provide a insightful framework for thinking about avatars. He describes a scale ranging from a representation to a simulation:

> Such would be the successive phase of the image:
>
> it is the reflection of a profound reality;
> it masks and denatures a profound reality;
> it masks the absence of a profound reality;
> it has no relation to any reality whatsoever: it is its own pure simulacrum.

In the study at hand I found cases where the avatar was a close representation of a human, its creator. It looked like the real-life person and the person used the avatar to be their almost exact replica in a virtual world. In these cases the avatar is a reflection of the reality of the person's identity. In other cases the avatar and its behavior masked the human behind the avatar. In these cases an avatar masks the reality of the identity of the person. In *Second Life* bots are rare (a bot is something that appears as an avatar but actually has no human behind it, it is merely a computer program written in a way to respond as a human might). But I would argue bots represent the third condition, that of masking the absence of a real person. Baudrillard's fourth description—that of no relation to reality, I regard as not possible. Even in the case of people who are serious role-players or pathological liars, I would argue that what they say or do is in some way a reflection of who they are, what is inside their heads, no matter how distant it may seem from the actual person.

Let's return for a moment to the idea that an avatar is a reflection of reality. Baudrillard uses the term *profound* reality. As I have already observed, many people who come to *Second Life* choose to reveal a good bit of

themselves through their appearance and behavior in this simulated world. The word profound denotes the idea of more depth, or the chance to see much more below the surface. Because of some of the characteristics of the virtual world, such as anonymity, people may offer a *more* profound knowledge of themselves than they might in normal, everyday circumstances. People often share more, they share more deeply and more quickly than most real-life encounters with people. *Second Life* has interesting things to do and see, but ultimately *Second Life* is mostly about communication or social interaction. Those hours and hours of interaction often result in deeper levels of sharing information, ideas, and emotions. Thus in some ways *Second Life* does not reflect the real, it exceeds the real. Ironically then, a virtual world may be a place where we can experience a more profound sense of a person's identity than we might under normal nonvirtual circumstances.

Final Thoughts

To people who participate in a virtual world such as *Second Life*, what does it mean to create an avatar? What does an avatar represent? Is it someone's idealized version of themselves? Is it someone's idealized version of what a human could or should be? This raises a larger question: if an avatar is a representation of self, then who am I? How do I define myself? What is my essence? In normal everyday life we define ourselves in light of a life context—that is to say, how we were raised, what we were taught, who our parents are, what we do for a living, what neighborhood we live in, what our racial/ethnic background is, what, if any, religious beliefs we hold, etc. When creating an identity in *Second Life*, if people are new to the world, they are almost creating an identity initially without social context. In other words, they don't know yet the norms, values, and expectations of the virtual world. As they are socialized into the world, their avatars' appearance and identity might change, but I would argue that in this first phase of avatar creation, people are often challenged to spend a bit of time considering their satisfaction or dissatisfaction with their real-world identity. This might drive decisions about how they then might live in a virtual world. Free of some of these encumbrances and with the chance to define one's self, will we see a more profound self in a virtual world?

What I found in interviewing people overall, is that in a place where there is opportunity for a radical redefinition of self, few in SL radically redefine themselves. This brings us back to that question of what are the differences between the real world and a virtual world. In a postmodern world where so many things have shifted from the concrete to the abstract, where so many things in our day-to-day lives are symbolic, worlds like *Second*

Life further blur the distinctions between the real and symbolic to the extent that, in some cases, it is rendered no longer important. In the case of identity, a virtual world may even provide the opportunity to see a more acute and profound version of a person's identity, even without ever knowing that person's real name. This may be one of a host of unintended and unexpected consequences of these new realms we are now only beginning to explore.

References

Baudrillard, J. (1994). *Simulcra and simulation*, trans. Sheila Furia Glaser. Ann Arbor: University of Michigan press.

Baumeister, R. F. (1986). *Identity; cultural change and the struggle for self.* New York: Oxford University Press.

Goffman, E. (1959). *The presentation of self in everyday life.* Garden City, MY: Doubleday.

James, W. (1890). *Principles of psychology.* New York: Holt.

8. *Identity and Gender In Second Life*

JAIME LOKE

Introduction

We live in a culture where the modifications of appearances grow increasingly easier, if not more acceptable and even at times expected in our daily lives. From the relatively mundane daily application of makeup to the more invasive procedures of cosmetic surgery, the task of altering one's image to fit individuals' expectations and desires is becoming more of a social norm.

For instance, plastic surgery has gained more popularity and acceptance in the recent years. According to the statistics published by the American Society of Plastic Surgeons, there were 11 million cosmetic procedures performed in 2006—an increase of 7 percent from 2004. The same statistics data reported that 90 percent of all cosmetic surgery patients are women. The top five female cosmetic procedures are breast augmentation, liposuction, nose reshaping, eyelid surgery, and tummy tucks.

The real-world stereotypes of beauty drive women to go under the knife for bigger breasts, flatter stomachs, and fewer wrinkles all for the price of being beautiful and the ever unconquerable quest of staying ageless. The arguments are endless as to the real reasons women go through such invasive procedures but there is still no concrete evidence today that can determine if the majority of women go under the knife because they succumb to beauty stereotypes, do it purely for personal desire, or a combination of the two reasons.

According to an article titled "Becoming the Other Woman," author Virginia Blum wrote that contemporary western culture consists of "female rivalry (that) extends from competition for men in the heterosexual marketplace to beauty contests to a ceaseless entanglement with the beautiful bodies and faces of fashion models, television stars and screen idols" (p. 107). However on the other hand several women complain incessantly that there is a lack of representation of diverse looks and body types distributed across the media. Organizations like the NOW (National Organization for Women) Foundation publish facts on the media's portrayal of stereotypical beauty standards. But when women are given a choice to become what they want to look like, do they practice what they preach in desiring and appreciating more diverse looks or do they secretly wish they looked like what the stereotypical beauty standards are?

One telling sign is indicated in the virtual world of Second Life. Second Life offers players the opportunity to morph into almost anything or anyone they desire but it is shown here that women choose to adhere to the stereotypical beauty standards of reality. This fantasyland is actually an extension of real-world physical aspirations to solidify stereotypes that would be much harder to achieve in reality. Women may say they would like more diverse images displayed but a glimpse into this virtual world that somewhat mirrors reality tells of a different tale. Not only do women players in Second Life adhere to stereotypical beauty standards, but they too believe in the notion perpetrated endlessly in advertisements that only beautiful people are able to find love, make friends, and be happy.

In Second Life, the opportunities to alter one's avatar are practically endless. Second Life noted "using over 150 unique sliders, they can change everything from their foot size to their eye color to the cut of their shirt" (Linden Labs, 2006). Even if one had an indispensable amount of money in real life, it would still be a challenge to alter for example one's foot size with cosmetic surgery. Second Life offers a much easier alternative. With "an unparalleled opportunity to play with one's identity and to try out new ones," what do female players try to experiment with in this virtual community? (Turkle, 1994). Apparently not very much. This is all very disconcerting because the female players often admit that their avatars are much more attractive compared to their real self in reality, and they start to associate the avatars' success in Second Life in finding happiness, friendship, and/or love, because their avatars are simply more attractive. The female players' beliefs are reinforced that only beautiful women lead fulfilling lives. Further down, this chapter will reveal the interviews with the several female players who conform to stereotypical beauty standards and who believe that beauty buys happiness, friendship, and love.

Second Life

In the preliminary step of selecting an initial avatar, there are six options or six looks per gender. For the female avatars, there are

1. Girl Next Door
 She is tanned, slender and has long brown hair. She is dressed in a tight purple sweater, short enough to expose her midriff, with slim jeans and looks around twenty to twenty-five years old.
2. City Chic
 She is the shortest of all the avatars and possesses somewhat of an East Asian look. She is extremely skinny and has black hair. She easily passes for a young teen with pigtails, a red top over a white t-shirt with her grey knee-length tights.
3. Harajuku
 Harajuku is actually a shopping and entertainment district in Tokyo that has gained popularity because Japan's most fashion flamboyant teens gather there to hang out. The avatar mimics the outlandish outfit Harajuku is known for with her blue hair, a hat that has two black antlers protruding from the sides, black gloves, purple pants tie-dyed with black and knee-high boots that have thick heel wedges. The Harajuku looks young, skinny and can easily pass for a teenager as well.
4. Cybergoth
 The cybergoth is very tall and skinny dressed in an all black, body-hugging one-piece suit. Her skin is pale white and she is wearing a headpiece with two feather-like accessories pointing outwards from each side in a scissor-pattern fashion. Her eyes are dark and it is hard to tell how old she looks like, although she would not pass for a woman over the age of forty.
5. Furry
 The avatar has a cat face with a human body. She has large eyes, with long eyelashes and a pink nose. She has a big raccoon tail behind her tight-fitting white pants and her striped blue polo shirt is short enough to reveal her tiny waist.
6. Nightclub
 This avatar is scantily clad with very large breasts. Her flat stomach is exposed as she wears a bikini top with what looks like a thin, short-cropped jacket and tight jeans. She has short brown hair and is wearing something that looks like a ski cap. She too looks young but more matured than the rest of the avatars.

On the superficial level, there are deceptively numerous variations offered for avatar selections but the two constants across all these avatars are youth

and slenderness. It might be possible to argue that the avatars are all presented as young because they are intended to mirror the age group that dominates Second Lifers—but the average age of Second Lifers is 32 years and all the avatars look anywhere from young teens to the early twenties only.

All the avatars in this initial step are also very thin. There are definitely more body variations in real life than what is offered at the beginning stage in Second Life. Of course this is only the preliminary round and once players proceed further, there are ample opportunities to change, but just by focusing on the initial portrayals, real-world stereotypes that plague women have already permeated into this virtual world, and players have not even begun their own image construction yet.

Second Life challenges the traditional boundaries of reality and of the imagination. The avatar is given a name, a face, an identity and is able to live a life in this virtual world based on whatever scenarios or whomever the individual chooses. The process of altering the avatar's appearance can take lots of time. If players decide to invest in more elaborate outfits and physical features, then there is more time and effort on the players' part to go in search for the more attractive costumes. More often than not real-life money is exchanged to buy these better-looking clothes, hair, skin, and other accessories.

The intricacies of the avatar features are phenomenal. From the height of the avatar's forehead to the size of the calves, the initial makeup of the avatar draws players in by having players created an individual they desire. By the time an attractive avatar is constructed, players usually have invested a lot of time and money into the process and it would be safe to assume that players cannot help but feel personally vested in their avatars based on the time, effort, and money placed into the construction of this new virtual identity.

In Yee and Bailenson's research, The Proteus Effect, they found out that the communities formed in Second Life interact with you based on whom you decide to be in Second Life (2007). The study also found that the lines of separating oneself from one's avatar are blurred as avatars self-representation influenced their behaviors as well. Second Life is not simply a game where players, detached from their avatars, control the avatars for pure entertainment but instead it affects something as personal as one's behavior. "An avatar is not simply a uniform that is worn, the avatar is our entire self-representation. If perceived only as a uniform, then it will belong to one of many identity cues but the avatar is the primary identity cue in online environments" (Yee & Bailenson, 2007).

This chapter concentrates on female players because research has shown that female players more so than male players in Second Life view their avatars as an idealized version of themselves (Yee, 2003). Female players were also less likely to think of their avatars as just pawns in a game, which translates to the notion that female players have a stronger association to their avatars as an extension of their real self rather than a commodity that they

control in a make-believe world. It is because female players associate so much more with the avatars they created, it allows a wealth of information about the female players in examining how the avatars are created, perceived, and controlled in Second Life. In this world where the limits are almost endless, it is surprising to find the lack of diverse images amongst female players.

I Am My Avatar

As mentioned above, female players have demonstrated that they associate much more with their avatars compared to male players. During my observation in Second Life, the strong personal association with the avatar was reinforced in the several interactions I had with female players. As a participant observer in Second Life, I would start a conversation with a female avatar by approaching her and complimenting her on something she has on. (All names have been changed to protect the individuals' privacy.) An example of a typical conversation would begin like this:

> Me: I really like your hair!
> Leelin: * **blushes** * thanks hun

Numerous respondents included the "* blushes *" in their response which meant to convey an action on their part. Instead of just a thank you response followed by a detached disclosure of where she had gotten the hair from or how much she paid for it, the response showed that she is attached to her avatar and emotionally invested in it as well. Most conversations are followed with the reasons they had picked the hair/shoes/skirt and it is often because it goes best with their skin color/pants/hair style.

The virtual world is seemingly less woven from fantasy but something players start to associate with on a very personal level. In a recent article in *Financial Times* titled, "Get a (second) life," James Harkin (2006) wrote an article about this virtual world and briefly included some of his personal experiences on it.

He wrote,

> Don't make the mistake, however, of telling a Second Life aficionado that this is all a game. Gamers on Second Life believe that this virtual world is their reality. The value of Second Life, he told me, was that it offered a space "in which you can utterly control every aspect of your Second Life." When I wondered aloud about the difference between his Second Life character and the real him, he got a little shirty. "What do you mean?" he said. "The character . . . he's really me. It would take an awful lot of effort to maintain a full extra persona."

In another instance of blurring the lines between fantasy and reality, I had the opportunity to interact with this female player, Cici, on Second Life

who spends many hours in this virtual community. Due to her physical limitations, she is no longer able to work and for much of her day, she is confined to her home. Cici is on Second Life a lot because it helps make her day go by faster. Her husband works from home too and they both share the same home office. He too spends many hours *in Second Life*.

Cici revealed to me that her relationship with her husband has been suffering because of Second Life. She accuses him (his avatar) of dating other avatars in Second Life. She complained that in Second Life, he goes off on dates with other women often to private places and he ignores her avatar in Second Life. These complaints are coming from a woman whose computer is right across the room from her husband's computer. Cici can physically see, talk, and touch her husband but yet she yearns for him to "take her out" in Second Life and she is going through severe emotional trauma because his avatar online is taking other female avatars out for a movie. Cici said, "he'll go and take other girls to the movies but completely ignores me while I'm here. Hey, it's not like he needs to hang around me all the time but don't completely ignore me. Take me out once in a while."

There very well could be underlying issues in their marital relationship to cause this strife other than "infidelity" in Second Life but that is beside the point. The fact remains that she is jealous and is affected by her husband's avatar's attention to other women because she deems it as genuine infidelity. Cici is unable to separate the division between the fantasy world and the real world.

For Aquarius Mabelon, one of the main attractions of Second Life is that she gets to "see" her daughter. In real life, Aquarius lives very far from her daughter. According to Aquarius, she does not get to visit very often and her daughter is often too busy to talk to her on the phone. However, Aquarius and her daughter are both players in Second Life and Aquarius comes online to be able to "see" her daughter, and on good nights, be able to chat a little while with her daughter. Below is part of a conversation I had with Aquarius on Second Life:

> Aquarius: my daughter just came on.
> Me: you wanna go talk to her? (long pause)
> Aquarius: she's too busy tonite. Not a surprise.
> Me: what is she doing?
> Aquarius: dunno. But I don't get to see or talk to her often so at least here in sl, I get to see her. That's good enough for me, to see her here. She looks good.

How can Aquarius tell that her daughter looks good from her avatar in Second Life? However it is this transference of fantasy into the real world that is allowing Aquarius this false sense of closeness to her daughter because she is able to see her daughter's avatar online and on nights that she is lucky, be able to chat with her daughter for a little while.

This overlapping of real and make-believe is seemingly affecting women more than men. When asked in an interview what Lucy Lowe, a female player in Second Life, would want to see added to Second Life, Lucy Lowe said that she would actually want instead to see Second Life features incorporated into real life (Talamasca, 2007a). Ancora Quintus another female player in Second Life, had a similar request when asked what she would like to see added to Second Life. She wrote, "I want a motion capture suit that I can plug into my computer so my avatar can mimic my movements" (Talamasca, 2007b).

The Perfect Image

This blurring of the two worlds is seen to affect women on very personal levels. On the one hand, there are women who live in Second Life like it is reality, and on the other hand, there are women who want to bring Second Life into their real lives. These women instead want to import their real-life movements into the virtual world. For women and this virtual world, it is becoming a convoluted ping-pong effect of going back and forth between the real and unreal that could result in complications.

According to Krotoski's article, "Where are the ugly avatars?" there is no denying that this element of fantasy in this virtual world allows for players to emerge in the form of an ideal self, which more often than not means a very attractive outer shell. In the same article, she wrote, "Your avatar is your public clothing, acting as a visual mnemonic for others who want to know who you are in the online space." Her article also included a response to a similar question posed and answered by bloggers: "Sometimes they are true sometimes they are not. People love to have a dream image. It's not bad it just doesn't reflect who you are."

But Krotoski poses the same question this chapter is asking as well—is it really not that bad when your avatar is this stunning persona that does not reflect the players' true physical identity? She said, "Surely beyond the self-esteem issues of creating a particularly stunning online self there are psychological elements of oneself in the characterization you choose" (2006). And that is because we already saw the merging of the real and unreal amongst the female players in terms of personal relationships.

As a participant observer in Second Life, I interviewed fifty female avatars to gauge their choices and reasons in creating their avatars. The fifty female avatars had to acknowledge that they were also female in reality. Those who told me that they were actually male in real life were not included in the interview count or analyses.

In the interviews, I did find that women do feel that their avatars need to be or look a certain way in Second Life. Female players are convinced, just like in real life, they have to look a certain way and portray this sexy

persona to be able to be popular in Second Life. However the female players are not forced to look any certain way, they chose to look this way. Their avatar is how they wished they looked in real life and this is as close as they can get to re-creating their image.

According to Cadence Knopfil (not her real name), a female player, being beautiful is important in Second Life. She said, "It makes life easier in Second Life." When I asked her to explain what she meant by easier, she did not elaborate. She simply replied, "You'll see."

Women players on Second Life do view their avatars as an idealized image of themselves. During the interviews with the female players, I initially pose the question if women do try and model their avatars like their real self or if they look like the avatars in real life. More than half of the female players will quickly respond with an "Of course I do." However, after chatting for a while more, several of them admit that they are actually not that tall, or that skinny, or that their breasts may not necessarily be this large in real life.

Out of the fifty female players I chatted with, only two came outright and admitted that they looked nothing like their avatars. Regardless of whether they looked like their avatars or not in real life, they all said that they wished they did. The paragraphs below document some of the exchanges I had with several female avatars as a participant observer in Second Life.

Cadence Knopfil mentioned above is an attractive, black woman in Second Life. Dressed in skintight jeans with diamond sparkles, high heels, and a white bikini top, she is tall, slender and looks like she belongs in her late twenties. Her hair, which she claimed to have paid a lot of real money for, is a very striking afro. I met her in a dance club as Cadence was dancing away and struck a conversation with her. After chatting a while, I asked Cadence if she looked like her avatar in real life.

> Me: does your avatar look like you in rl?
> Cadence: yes of course
> Me: cool. You must be a model in rl!
> Cadence: **blushes** well ... most part I look like my avi in rl, some parts no
> Me: like what?
> Cadence: I wish I had the same hair
> Me: just the hair?
> Cadence: I'm also not this skinny in rl. I'm older in rl. I think I look more like my avi maybe ten years ago! lol

When female avatars start to gradually acknowledge that they are not a mirror image of their avatars in real life, they often begin by declaring that their hair is different. Either the color, the length, or the style is unlike their own but more often than not, the hair is first revealed as the difference. Of

all the physical changes we could perform to ourselves today, hair is probably one of the most accepted and likely the cheapest form of change. From a simple haircut to a permanent dye job, changing one's hair will hardly raise eyebrows nowadays. It seems that female Second Lifers begin the admission by discussing their hair because it is culturally accepted, maybe even expected, to experiment different hair colors and styles, and this change is not deemed as personal as one's eyes, lips or skin color.

Another female Second Lifer I interviewed was Shiki Allen. I met Shiki Allen in the welcome center when I had first arrived in Second Life. Wearing a hot pink strapless dress with heels that seem to go on forever, Shiki Allen was at the welcome center recruiting avatars to her dance club. Her bleached blond hair swayed gracefully side to side whenever she moved and her skin was tanned to a golden brown. When I asked Shiki if her avatar looked like her in real life, like most others, she initially responded with a quick yes. After a while, she admitted that she was not a blond in real life, she weighed more and was not that tall. But Shiki said of all the physical attributes that her avatar possesses, she wishes most that she in real life, like her avatar, "was that young again."

However not all Second Lifers felt that youth was enough to satisfy their image desires. Tessa Longoria, a blond, blue-eyed avatar with a supermodel's body was quick to admit that her avatar is definitely more attractive than her real self. Upon checking her profile where she had placed a real photo of herself, I discovered that Tessa is actually a very attractive 19 year-old. During my interview with Tessa, she said "I'm ugly in real life. My avi is much, much prettier."

Though it is true that her avatar possesses the beauty standards that are as close to the stereotypical beauty standards as the computer mouse would allow her to create, she is definitely not an unattractive girl in reality by any means. Unfortunately, she does feel that she is ugly.

Like Tessa, a few Second Lifers that I interviewed had their real life picture up on their profile so I could compare the difference between their avatars and their real self. Sandra Keenan is one Second Lifer that I interviewed who also had a real picture up. Before I looked up Sandra's real-life picture under her profile, I asked Sandra if she looked like her avatar in real life. She said, "Um ... we have the same hair." After I prodded further, Sandra said, "I look younger here and a little thinner but overall everything is the same." Sandra Keenan on Second Life looks like she is in her early twenties, weighs about 100 pounds lighter than her real-life picture, and the only characteristic that could possibly mirror her avatar is the color of her hair. Sandra's avatar has long brown hair tied in a braid while her real picture shows a woman who has very short-cropped brown hair.

Sandra and I chatted over a period of several days and not long after our initial conversations, she shared this:

> Sandra: There's a reason I'm married in sl but not in rl. In rl, just me and my cat.
> Me: What's the reason?
> Sandra: you've seen my picture on my profile. That's why. I'm waaaay hotter in sl

Sandra is an example of one of the many female players who believe that to be in love, one has to look a certain way. Sandra attributes her lack of success in finding a partner because of the way she looks. She does not even begin to consider other possibilities that may hinder her from finding a partner. For example the vast amount of time Sandra spends at home instead of mingling outside with others could be one of the reasons why she does not have a husband in real life.

Cici, the woman mentioned at the beginning who is expecting marital strife with her real-life husband because he ignores her on Second Life initially claimed that she looked like her avatar in real life. Cici is tall, with long, straight red hair, large breasts, very thin and she looks at most in her early twenties. After conversing with Cici for several hours, she took me to her house in Second Life and it was there when she revealed more personal issues.

After talking about problems with her husband, she said that she is actually not as young as her avatar is. Cici is actually in her early fifties and has nine children. She also said that she wishes her body looked the same as her avatar's did but like Cadence, she said, "I WISH I was this young again!"

It is disappointing to note that women seemed to have fallen into the stereotypical beauty demands, and what is unobtainable in the real world they seem to quickly grasp on to in the virtual world where virtual money can buy one better hair to bigger genitals, and one does not even need virtual or real money to look young.

The Only Road to Love, Friendship, and Happiness

It is far more disturbing to realize that these female players believe that conforming to a certain type of look is the only way to guarantee finding love, friendship, and happiness—in reality or in Second Life. Out of the fifty female players interviewed, all of them have claimed their successes in Second Life because of their attractive avatar but more importantly also their unhappiness in real life because of how they look in reality.

Success discussed here is based on how satisfied the female player is with her relationships to other avatars in Second Life, if she is happy with her online persona, and if she is overall satisfied with her online life. The

following paragraphs document a few exchanges between female Second Lifers and me about the differences between their real life and their virtual life.

Tessa Longoria, the 19 year-old Second Lifer who claimed to be ugly in real life, said that she has a sugar daddy in Second Life who buys her whatever she wants. Tessa said, "if I looked like that in rl, I would have a sugar daddy too."

Sandra Keenan also shared as discussed in the earlier section how in reality, she lives alone with her cat. In Second Life, she has what she calls a great marriage and is very popular with other Second Lifers. Sandra said that the reason she is married in Second Life, but not in real life, is simply because she has a far more attractive avatar as opposed to her real physical image. Sandra seemed to have surrendered to the notion that the only reason she cannot find love in real life is because she is not attractive.

In real life, Raewyn Chalet lives by herself and drives a bus in Alaska. She hardly leaves her house if she does not need to go to work and leads a very quiet life. In Second Life, she is happily dating her boyfriend and she is also a business owner with a lot of friends. Her avatar is a slender, tall, and tanned girl that likes to wear mini-skirts and strapless tops that show off her cleavage. With her short brown hair, full perfect lips, and catlike eyes, Raewyn claims that her avatar is oftentimes the life of any party in Second Life. "It is perfect here. My boyfriend and I go on dates all the time. We have a very special connection," said Raewyn.

But in real life, Raewyn moved to Alaska, in her own words, to "escape her past." When I prodded her further, she did not want to reveal much except to say "nobody happy moves to Alaska." During my conversations with her, Raewyn did admit that she wanted to start anew in Alaska, hoped to settle down, and start a family. However she blames her lack of desirability in real life due to her shyness and unattractiveness. She said, "Who would want to go out with a trout?" (A trout is a pejorative term for an unattractive woman.) She went further to say, "even in sl, nobody would want to be dating someone who looks like ass."

Fefa Barthelmess is a platinum blond with big blue eyes and full red lips. She too is very thin and tall. Her legs are elongated further with the black high-heeled boots that she dons on. In Second Life, she usually just hangs out with her friends and they like to hop from dance club to dance club to meet more people. In the virtual world, she is currently dating a few different men. In reality, she claims to be a young actress who is trying to "make it big":

Fefa: acting is tuff, but its my thing and i luv it
Me: Have you gotten any big breaks recently?
Fefa: not yet but soon. i'm saving up for a boob job

Me: Why?
Fefa: easier to get jobs that way.
Me: Acting jobs?
Fefa: yes. gotta look good. Once I get the boob job, i'll save some more for other stuff.
Me: Like what?
Fefa: eyes and lips will be next. Then I'll really hit it big! Lol
Fefa: right now, i dun look as good yet. maybe one day i can look like my avi!
Me: Why don't you think you look good?
Fefa: you ask a lot of questions.
Me: Just want to get to know you better.
Fefa: i'm not ugly in rl but not as gorgeous as I am in sl. Look at me here! This is why I can date so many different people in sl but not in rl.

Fefa hopes that one day her acting career will take off but in the mean time, she is focused on altering her real life looks as she feels that plastic surgery will help her career. She does not believe that the way she currently looks will be enough to generate success in her acting career and she even hopes to one day mirror her Second Life avatar. There must be a connection Fefa is seeing between her avatar's image and the success she has in Second Life. She's dating more than one man in Second Life and she attributes her ability to do this to her avatar's image. Her experience in the virtual world has either influenced or reinforced her believes that in order to be successful and date the way she wants to date, Fefa has to look a certain way.

Looking Like a Porn Star

Another pattern, which I noticed across all female avatars that I spoke to, and several others that I did not speak to, was that the avatars are often scantily dressed. From tight revealing tops to skirts so short the underwear is visible, these female players are donning on very skimpy outfits. It is more of an oddity to see a female avatar dressed modestly than it is to see one who is almost naked. Female avatars are using sexuality too as part of the idealized image about themselves as they equate sexy with beautiful.

Petii Armene is a petite, dark-haired, and tanned avatar in Second Life. She's dressed in a tank top that shows off what looks like a six-pack abs, a very tight miniskirt that shows off her white underwear when she bends down low and knee-length high-heeled boots. Petii is a lesbian in Second Life because according to her, it excites a lot of men when they watch her kissing another girl. She has the name "Pornstar" tattooed on her lower back. When I asked her why she got that tattoo, she replied:

Petii: cause of I have a reputation in sl
Me: What kind of a reputation?

Petii: well, lets just say this guy once said that I'm the only thing that gets into knickers quicker than a butt
Petii: I have a weakness for dancers ;-)

Petii says she is heterosexual in real life and currently does not have a boyfriend. Her job as a photographer does not allow her the time to date anyone for long "before they get tired your schedule and leave." Chatting with Petii a while longer, I learn that her avatar's physique does not mirror her real-life body as she is not as physically fit in reality and she usually does not wear so much makeup.

Second Life XXX

Sex has always been a fascinating subject and women have long been the targets of sex symbol stereotypes. In the media today, women's sexuality is used to sell anything and everything from tennis balls to car window tint. According to an article in *Wired News* by Annalee Newitz (2006), there is an estimated 30 percent of commerce in Second Life that is somehow related to sexual activity. Linden Lab programmer Aaron Brashears said, "We didn't plan it that way at all, but people love the novelty of it. You can be whatever you want—a dragon or a fox or a dominatrix. There's no formula and the possibilities are endless" (Newitz, 2006).

Though the possibilities are endless, there definitely is a lack of diverse avatar images in Second Life. Women argue all the time about being objectified by men; however when presented with an opportunity to choose (as they do in Second Life), most still opt for the porn star look anyway. As a participant observer, I have seen a tremendous number of female avatars with exaggerated, sexualized body parts.

However on the other hand, how far can we hold women responsible for conforming to the stereotypical beauty standards? I observed a very hostile exchange between a female avatar and a male avatar simply because the female avatar was not the "typical" beauty found in *Second Life*.

Male: what's wrong with you? You look like a troll
Female: did you just call me a troll??
Male: yes you, you're so ugly! Go away you disgusting little thing
Female: fuck off asshole!!
Male: you fuck off ugly troll

She proceeded to try and push him off the edge of the wall where they were both standing but he teleported himself away and so she was not able to "avenge" him calling her a troll. I conversed with her a little after her confrontation and she said that she had tried to model her avatar after her real-life image. She was quick to let me know that she is actually much more

attractive than her avatar, and she was by no means a dwarf in real life even though her avatar is unusually short.

I have no way to compare her real-life image and her virtual image but it was interesting that after the hostile exchange to which she knew I had been a witness, she felt compelled to stress to me that she is actually more attractive in real life, not as heavy and taller than her avatar. I never initiated any queries about her avatar's image or her real-life image, but still it seemed that she had been scarred by the incident and needed to reassure herself that she does not actually look like that, it was just her avatar.

Conclusion

The concern here is not that these female players do not mirror their real-life image. After all, Second Life is a virtual world that offers the opportunity to create and change as much as one desires to—and what fun would it be if players did not experiment with all the different possibilities? The troubling part is that most female players who "experiment" with looks end up conforming to the stereotypical beauty standards that plague this society in real life and this is now extending its influence into the virtual world. There is hardly a wide spectrum in the variation of images amongst female avatars. Almost every female avatar is young, attractive, and thin. To look anything different from those characteristics would be to deviate from the norm, and from observing the world of Second Life, not many dare to.

It is human nature to want to be attractive; however, attributes of what constitutes beauty should be personalized and different across the many walks of life. To each his own and it ought to resonate more so on the scale of attractiveness as it should be individualized—not conform to the stereotypical beauty standards one is so often bombarded with on television, magazines, advertisements, and every other possible outlet. Second Life is a virtual reality whose membership extends across national borders. Of the Second Lifers 25 percent are from outside the United States but there is still no genuine diversity amongst the images of female avatars (Walsh, 2006).

Due to the fact that women are far often subjected to beauty standards, and research has consistently shown that women place more importance in physical attributes when evaluating their self-worth, this chapter examined primarily female Second Lifers and the images of their female avatars. Women are bringing into Second Life what they are unable to achieve in real life. They are projecting this idealized image that they wish they could actually be in real life.

What are the repercussions of this exchange? Yearning to be someone you can never be and so instead opting to live in a virtual world to convince

oneself that the unreal is almost real? It can be argued that it is unhealthy because Second Life to many female players when interviewed has grown to become something in their lives that exceeds just a game. The case of the wife accusing her husband of infidelity over the virtual world is an example of a strong indication that the lines between reality and make-believe are becoming much more blurred.

So for female Second Lifers with their supermodel-like avatars who form relationships, get married, have sexual exchanges, and other kinds of bonds but are not forming the same kinds of relationships in real life, it inevitably reinforces the cultural standards of beauty and also the notion that if you want to be loved and be popular, you have to look a certain way. This can be very detrimental to the female players who admittedly revealed in the interviews that they are not as attractive in real life. They may be resorting to being "ugly" and feel that the only place they can find happiness is in this Second Life where with the click of a mouse almost everything is possible—everything unreal. And as previously mentioned above, research has shown that female players are the ones who are more apt to have their avatars be an idealized version of themselves.

But though some may argue that Second Life is more than just a game, bottom line is that it can never ever replace reality. Real-life relationships do not function through instant messaging, and meaningful relationships are not built on a fake image of oneself. Real-life relationships are much more complicated and harder to cultivate but also can be much more rewarding. In Second Life, no matter how much an avatar claims to love her husband or his wife, it can never be replaced by a real-life marriage.

Some will argue strongly that there is intimacy in relationships in Second Life and to an extent maybe there is, but the intimacy is generated through the security of anonymity. Without the mask of the computer screen, how many of these relationships will function in reality? Maybe some will argue that in a way relationships in Second Life is better because it has no strings attached and it is a constantly happy relationship unlike real-life ones which come with real-life struggles but that brings us back to the question—how real is that? Perfection itself is unreal.

Many women battle daily to end this culture of objectifying women, to spread the fact that beauty comes in all shapes and sizes and to fight for women to be recognized as a whole people not just sexualized body parts. But what is Second Life culture telling us especially about the female players? It is telling us that if women had the chance to choose, they would change their appearances because right now, they do not look good enough. The players who admitted that they believe they are married in Second Life because of their good looks and that they are single in reality because they consider themselves unattractive have fallen into the belief that good looks equals happiness.

Although this chapter concentrated primarily on female players and the lack of diverse images of their female avatars, it was not necessarily any different for male avatars. No interviews were conducted with male players, hence there are no description from the responses to the creation of these male avatars; but it was evident that just by taking an informal survey around Second Life, there were overwhelming numbers of male avatars who mirrored supermodels as well. There seemed no lack of bulging biceps, six-pack abs, and chisel jaw lines. Have men fallen into the similar demands of beauty that usually plague women in this virtual world?

If it is true that men are now being subjected to the same demands of beauty, then it has become a vicious cycle of expectations. But are men in the same situation as women in Second Life? Men, unlike women, do not see their avatars as an idealized image of themselves. They are likelier to view their avatars as pawns in a game (as much as 45.5 percent compared to only 22.5 percent of women in the 29–35 year age group) and not so much an extension of their identity (Yee, 2003). It may be that women have a harder time disassociating themselves with their online identity and there lies the problem.

A virtual world is relatively harmless to escape to as long as the borders between the fantasy world and the real world are clearly understood. But if instead the fantasy world has evolved to become a substitute for the real world, then this "game" is not so much a momentary escape but a complete denial of the truth. The consequences of living a lie not only affects one on a personal level but becomes entangled in a web of complicated consequences that affect society on a larger scale. When women live in an existence that reinforces the belief that one's worth is measured by how attractive one is, it is detrimental to self-esteem and condones the stereotypical acts that objectify women. The fight to eradicate the objectification of women and the fight to recognize that beauty does come in different bodies, skin color, and sizes have been fought too long and too hard for a backlash in this virtual world to sweep it all way. It must start with women to recognize that genuine feminine beauty comes in myriad of shapes, sizes, and colors—even in the make-believe world.

References

American Society of Plastic Surgeons. (2006). 2000/2004/2005 National Plastic Surgery Statistics: Cosmetic and Reconstructive Procedure Trends. Retrieved January 10, 2007, from http://www.plasticsurgery.org/media/statistics/loader.cfm?url=/commonspot/security/getfile.cfm&PageID=17870

Harkin, J. (2006). Get a (second) life [Electronic version]. *Financial Times*. Retrieved March 1, 2007; from http://www.ft.com/cms/s/cf9b81c2-753a-11db-aea1-0000779e2340.html

Krotoski, A. (2006). Where are the ugly avatars? Retrieved February 25, 2007, from http://blogs.guardian.co.uk/games/archives/2006/05/05/where_are_the_ugly_avatars.html

Linden Labs (2006). What is Second Life? Retrieved January 10, 2007, from lindenlab.com/ProductFactSheet.pdf

Newitz, A. (2006). Scoring with XXX Games. *Wired News*. Retrieved March 1, 2007, from http://www.wired.com/news/culture/0,71135-1.html?tw=wn_story_page_next1

Talamasca, A. (2007a). Resident snapshot: Lucy Lowe. *Second Life Insider*. Retrieved March 14, 2007, from http://www.secondlifeinsider.com/category/resident-snapshot/

Talamasca, A. (2007b). Resident snapshot: Ancora Quintus. *Second Life Insider*. Retrieved March 14, 2007, from http://www.secondlifeinsider.com/category/resident-snapshot/

Turkle, S. (1994). Constructions and reconstructions of self in virtual reality. *Mind, Culture, and Activity, 1*(3), Summer 1994. (Reprinted in Timothy Druckrey (Ed.), *Electronic Culture: Technology and Visual Representation*, Aperture Foundation, 1996 and in Sara Kiesler (Ed.), *Culture of the Internet*, Hilldale, NJ: Lawrence Erlbaum Associates, 1997).

Walsh, T. (2006). "Second Life" stats expanded: Early 2006. *Clickable Culture*. Retrieved March 3, 2007, from http://www.secretlair.com/index.php?/clickableculture/entry/second_life_stats_expanded_early_2006/

Yee, N. (2003). Identity projection. The Daedalus project. Retrieved February 10, 2007, from http:www.nickyee.com/daedalus/archives/000431.php?page=3

Yee, N., & Bailenson, J. N. (2007). The Proteus effect: The effect of transformed self-Representation on behavior. *Human Communication Research, 33*, 271–290.

Yee, N., Bailenson, J. N., Urbanek, M., Chang, F., & Merget, D. (2007). The unbearable likeness of being digital: The persistence of nonverbal social norms in online virtual environments. *Cyber Psychology & Behavior, 10*, 1.

Part IV The Business and Economy of Virtual Worlds

9. Virtual World Economies: A Case Study of the Economics of Arden

EDWARD CASTRONOVA, JAMES J. CUMMINGS, WILL EMIGH,
MICHAEL FATTEN, NATHAN MISHLER, TRAVIS ROSS, WILL RYAN,
MARK W. BELL AND MATHEW FALK

Synthetic World Economies

Synthetic worlds (or "virtual worlds," we will use the terms interchangeably) are persistent online 3-D spaces that replicate many of the features of the real world. One negotiates them using a virtual body, much like a video game character, known as an avatar, and many thousands of people can be in the world at the same time, making the environments much like a real place, socially speaking. The worlds have a sort of fantastical yet logical reality to them, such that people can fly, but only if their avatars have wings, a flying spell, or happen to be birds to begin with. The economies of synthetic worlds also have this fantastic-yet-logical flavor to them. Our goal is to do economic experiential research in virtual worlds. To do that, we must find the best virtual world to do experiments in.

Like the economies of nations, virtual world economies can be defined on the basis of their structural characteristics. One such characteristic is the openness of the economy. National economies can be described as open or closed in relation to the global economy. If a country allows trade with other countries it is an "open" economy, if it does not it can be described as "closed." Applying this model to virtual worlds we can describe virtual world economies as "open" or "closed" depending on if they allow trade with the "real" world. For instance, Second Life, a virtual world created by Linden Lab, allows currency transactions on their Lindex between the in-world

currency (Linden dollars) and U.S. dollars. Second Life would be an "open" virtual world economy. Blizzard's World of Warcraft (WoW) has no such official exchange of currency and so would be a "closed" world. There are several ways the economy of WoW leaks into the "real" world economy, mostly via the exchange of currency between the virtual and the "real" and vice versa. This, however, violates the Terms of Service of the game. Closed worlds offer the best model for a researcher hoping to run experiments in virtual worlds. If money was being passed through the membrane between the virtual and "real" worlds it may contaminate the experimental results.

One must view how much control over the economy a virtual researcher might have. This control would be over the cost of items, money in the system, and the ability to transfer it back and forth from the "real" world. Most virtual worlds, especially ones run by third-parties offer a researcher little or no control. This does not remove any of the validity of the study of their economies but it does make them difficult to run controlled experimentation in. To run controlled experiments on the economies of virtual worlds, it is essential for the researcher to control the economy as best as they can. In the case of WoW, the world is "closed" but it gives the researcher no mechanisms for control so it is not a good candidate. Dr. Castronova, therefore, made the decision to create a virtual world of his own; this would allow the authors to control the economy of a closed virtual world. This provides an excellent candidate for doing economic experimental research. The first step of this process was to design an economy.

The Economics of Arden

Previous research into synthetic economies (and synthetic societies more generally) has focused exclusively on what they look like from the *outside*, that is, how we might understand them as *users*. Here, we report on our experience as *builders*. The authors represent an element of the design team for *Arden: The World of William Shakespeare*, which has been conceived as a massive game world that will serve the University's dual missions of teaching and research. Arden's teaching function is served by immersing its users in the language, plots, and historical contexts of Shakespeare's plays. The research function is served by conducting controlled experiments on the genuine human social structures that will emerge within the world.

One structure that will certainly emerge is the market, and thus we will be in a position to conduct experiments on market dynamics. Yet the market can emerge in various ways. If we simply put items into the world and allow people to trade them, there will be economic activity: people will trade things they don't want for things they do want. Trade will happen at a more intense level to the extent that we create specialization, that is, to the extent

that we make different people have different endowments of goods and services. As an example, we could make a world where people can ride horses, and everyone also is a rancher, saddler, and blacksmith. In that world, everyone would use their own ranch to raise a horse, their own saddling skills to make a saddle, and their own smithing skills to shoe the horse. Alternatively, we could make a world where everyone must choose one of these occupations and "skill up" in it, that is, devote time to improving their character's ability to produce quality items. In this alternative world, there would be ranchers with many horses but no saddles and no shoes; saddlers with many saddles but no horses and no shoes; and smiths with many shoes but no horses and no saddles. To get all of these people on horses and riding, trade must occur. And the point is that there would be far more trade in the latter world than in the former. It is something that we can design into the game, or not, depending on our objectives. If our objective involves research on market dynamics, and it does, we would want a thriving economy to exist in our world.

This chapter lays out our approach to building a thriving economy. First we will describe in more detail just how we can create supply and demand in a completely synthetic environment. Second, we give an overview of the kinds of items and production technologies we plan to have in Arden. Third, we talk about the way markets will work in our world: how players will trade and where the money comes from. Fourth, we describe some of our policy tools. And lastly, we discuss the kinds of social experiments we expect to be able to do with the economy we have built.

Sources of Demand and Supply

What Drives an MMOG Economy?

Video games in general, and MMOGs (Massively Multiplayer Online Games) in particular, start players with only a fraction of the game play options and abilities that they will have at the end of the game. A newly created player character starts with the most rudimentary abilities and will later gain additional advancements through exploring the world and accomplishing various tasks. One type of character advancement is the acquiring of "innate" abilities—abilities that allow the character to attack in a certain way, heal other characters, or accomplish any number of actions in the world. These innate abilities cannot be transferred from character to character. The second type of advancement is the acquiring of items more "external" to the player character—armor, weapons, and tools that enhance a character's innate abilities. These items can be transferred from character to character, and are what form a MMOG's source of demand.

Within a given virtual game world there is a demand for "finished" items, such as weapons that allow a character to hit harder, armor that allows a character to withstand more blows from a weapon, or potions that give them temporary benefits. Players usually demand these better weapons and equipment because it assists their survival while venturing into new areas of the world; innate abilities are not always enough to ensure save passage. Further, new equipment also usually bestows a new appearance on the wearer and functions as a status symbol. Anyone who sees a character with that equipment knows that they spent the time and energy to go through the necessary steps to obtain it.

Finished items can usually be obtained in two ways. The first way is for a character to venture out in the world and discover an item, either through completing a specific task or defeating an enemy. The second method is similar to the first, but instead of obtaining finished items, characters obtain item components which then must be taken to a character that is skilled in item creation. This crafting character can turn the components into a finished, useable item. The components have no innate use: they do nothing but take up space until a crafter turns them into something useful.

This leads us to the demand for components. Not all items can be directly obtained through killing monsters and completing quests. Often, the best items (those that allow for the greatest character advancements) can only be made by player crafters. However, crafters cannot create items out of thin air; they require components that are gathered in dangerous areas or obtained through defeating monsters.

There is an obvious link of supply and demand between crafters and people who venture out into the world to kill monsters. Monster killing adventurers need items and crafters need raw materials to create items. In addition, crafters are also often bound to each other through supply and demand: most finished materials require items made by crafters of various different specialties. For example, a blacksmith might need a leather strap produced by another crafter in order to create the hilt for a sword.

What Makes These Items Scarce and Valuable?

There are three main reasons that items are valuable: some items, such as arrows or food, are constantly being used up and need to be replaced; other items are made valuable by the amount that they increase a character's abilities; and other items are valuable simply because they are hard to obtain and anyone who acquires the item gains social prestige with the other players.

Most MMOGs attempt to enforce value through rarity. Less-powerful finished items and raw materials are allowed into the world on a frequent

basis but the truly powerful and valuable finished items and raw materials are much more difficult to collect. For instance, the valuable raw materials might only appear one out of every hundred times a character collects raw materials from the ground. Likewise, the monster that drops the "Sword of Magic" might only drop the sword once every hundred times he is defeated, or the monster may only appear once a day, or the route to the monster might require the cooperation of multiple characters in order to gain passage.

Further, most MMOGs do not institute a system of decay on their items. In those games, once an item is created it never leaves the world unless a player destroys it on purpose. Items are generally made permanent because most games make it hard to get the rare items. Players do not want to feel that their hard work has been wasted. A problem that arises from this system is that rarity is not enforceable over a long period of time. People play MMOGs for months, if not years, and no matter how difficult it is to obtain an item, eventually it will start to appear in the economy with such a frequency as to seem common to the players. In turn, the less-powerful items that were originally "common" will begin to look like nothing more than rubbish, and the "rare" items will go from being considered prestigious to being viewed as the new baseline. Players who do not have the "rare" items are then considered to be lower class.

There have been many thoughts on how to enforce scarcity, such as having all items, even the powerful ones, decaying over time, and needing to be replaced. That solution can fix the problem of a market getting flooded with "rares" to the point that they are considered common, but that does not address the dissatisfaction of a player having to replace an item that they spent twenty hours to acquire. The other major solution to the rarity problem is to create additions to the world that contains different, more powerful items, and so the rare items in the new areas become valuable until the cycle repeats itself and the new rare items are then perceived as common.

An MMOG can combine supply and demand with a decay system, requiring that all items need to be replaced on a regular basis. However, care must be taken to ensure that a player does not think that their hard work or time spent in game has been wasted. In many MMOGs a player may spend twenty hours acquiring an item that gives him or her a boost of power and is visually impressive, signaling the significant time investment. If that item breaks, the player will feel that the game itself is disrespecting the time and effort that they put into the game, and they may leave.

A game that requires every single item to decay can still have tasks that are hard or take twenty hours to accomplish, but they must result in

permanent, non item-centric rewards. For instance, any player that slays the ancient red dragon might gain a title to put after their name, so that everyone can see they put in the time and effort. If we wish to give the character an ability reward, we can give them a new intrinsic ability. They fought a dragon, so they now do slightly more damage when fighting this type of dragon.

The above scenario does not contain any items at all. But we do not want to have a world bereft of items: such a world has no economy. So, we introduce items that enable the use of the dragon-slaying ability that our character has achieved. These items will surely break over time, but the player has not lost their hard work. They merely need to procure a new stock of the enabling item, a task that will surely take time, but not nearly the time that the dragon-slaying task required.

Arden will make use of a system similar to the broad ideas outlined above. It will have a constant turnover of items that need to be replaced, but players will retain abilities and mementos that show the rest of the player base what they have achieved. The function of rare items will be taken up by abilities and titles, and the common items will be used as enablers that allow a character to use the abilities that they have obtained.

Resources and Production

Raw Inputs

The most basic type of components for crafting is raw resources. The resources present in Arden will be based on those found in the British Isles during the fourteenth and fifteenth centuries. These resources can be harvested by the players from resource nodes, which are three dimensional graphical representations of a specific resource type (tree, bush, ore, etc.). Resource nodes will appear on a predetermined coordinate of the virtual world map, with the location and rarity of the node based on the tier level of the resources contained within (see display below). When harvested, most nodes will yield a "common resource," but occasionally a node will yield a "rare resource." In order for rare resources to remain so, the chance a rare resource will be harvested from a node will be set to one out of every five hundred harvests. In addition, each resource will also yield a rare byproduct: when five hundred units of the rare byproduct of a particular resource are combined, the aggregate will yield an associated rare resource. This system ensures that players who have an unlucky streak can continue to harvest rare resources at a rate of one rare for every five hundred resources harvested.

In our design, each node hosts twenty-one nodules, which will spawn over an extended period of time. A node can have up to five simultaneously active nodules available for harvest. Nodes will spawn with three active nodules, and additional nodules will continue to spawn at a predetermined rate until the upper limit of five active nodules is reached for the node. Resources can be harvested from a node by accessing one of its nodules. Nodules will individually disappear once harvested by a player and be replaced if any of the twenty-one remains. Once twenty-one consecutive nodules have been harvested the node will despawn and subsequently respawn in a new location based on a predetermined algorithm. Our economy design and its purposes call for resources to strike balances between being continuously available or randomly available, as well as predictably located or randomly located. Thus, the numbers and rates used here were chosen to strike a compromise in which (1) a node may be in any one of several predictable locations, and (2) the node could be either fruitful or not fruitful at a given time, especially given the predicted activities of the rest of the player base.

In order to support player advancement, resources will be grouped within a tier based system. A tier based system permits players to advance from working with lower tiered rudimentary materials (such as tin for metal crafting) to working with more higher tiered advanced materials (like steel) through an investment of time. Higher tiered resources will appear in more remote locations requiring a larger time investment from the player to achieve and maintain a high crafting level. Higher tier resources represent goods superior to those at lower tiers, and by having incrementally longer production processes for higher tier goods only a marginal cost is added into the production model for superior goods. Extended time investment is preferable to a cost model based solely on entry-barriers (i.e., the cost of achieving high enough level to work with the new materials) in that it still allows for a tier system yet does not implement barriers that may seem overly arduous or arbitrarily restrictive to players.

The initial version of Arden will implement five different crafting professions: metal worker, wood worker, provisioner, apothecary, and tailor. Each crafting type will use resources from the resource tables listed below. Metal workers will deal primarily with metals, stones, and gems, while wood workers, tailors, apothecaries, and provisioners will be involved primarily with animal and plant byproducts. However, the resource utilization of the crafting professions will not be mutually exclusive; for example, a metalworker might need bronze to fashion a spearhead, but also require a hardwood, such as yew, to complete the shaft.

Tables 9.1 and 9.2 on the following pages list two types of resources available: Stones, Metals, and Gems, and Plants.

Table 9.1 Stone, metal, and gems used in the world of Arden

		Stones, metals, and gems			
Ore	Type	Common	Rare	Tier	Byproduct
Sphalerite	Softmetal	Zinc	Electrum	1	Electrum dust
Sphalerite	Gemstone	Sphalerite	Calamine	1	Electrum dust
Cassiterite	Hardmetal	Tin	Wolframite	1	Wolframite dust
Cassiterite	Gemstone	Tourmaline	Indicolite	1	Wolframite dust
Chalk	Stone	Chalk	Travertine	1	Travertine aggregate
Chalk	Gemstone	Rubellite	Spodumene	1	Travertine aggregate
Beckerite	Clay	Earthenware	Stoneware	1	Stoneware dust
Beckerite	Gemstone	Amber	Copal	1	Stoneware dust
Galena	Softmetal	Lead	Silver	2	Silver dust
Galena	Gemstone	Flourite	Pyromorphite	2	Silver dust
Malachite	Hardmetal	Copper	Goethite	2	Goethite dust
Malachite	Gemstone	Malachite	Azurite	2	Goethite dust
Dolomite	Stone	Dolomite	Shale	2	Shale aggregate
Dolomite	Gemstone	Amethyst	Prasiolite	2	Shale aggregate
Limonite	Clay	Terra Cotta	Bentonite	2	Bentonite dust
Limonite	Gemstone	Turquoise	Sunstone	2	Bentonite dust
Hematite	Hardmetal	Iron	Marcasite	3	Marcasite dust
Hematite	Gemstone	Hematite	Onyx	3	Marcasite dust
Pyrite	Softmetal	Pyrite	Gold	3	Gold dust
Pyrite	Gemstone	Peridot	Lapis Lazuli	3	Gold dust
Sandstone	Stone	Sandstone	Slate	3	Slate aggregate
Sandstone	Gemstone	Agate	Chrysoprase	3	Slate aggregate
Kaolinite	Clay	Kaolin	Porcelain	3	Porcelain dust
Kaolinite	Gemstone	Carnelian	Jasper	3	Porcelain dust
Niccolite	Hardmetal	Nickel-Cobalt	Meteoric Steel	4	Meteorite dust
Niccolite	Gemstone	Skutterudite	Sodalite	4	Meteorite dust
Sperrylite	Softmetal	Palladium	Platinum	4	Platinum dust
Sperrylite	Gemstone	Rutilite	Amazonite	4	Platinum dust
Limestone	Stone	Limestone	Marble	4	Marble aggregate
Limestone	Gemstone	Serpentine	Chaorite	4	Marble aggregate
Staurolite	Clay	Beidellite	Antigore	4	Antigore dust
Staurolite	Gemstone	Diopside	Andalusite	4	Antigore dust

Production Technologies

The production technologies of Arden will allow us to expand the economic interdependence of the various crafting professions, as well as increase the fun quality by importing a measured dose of realism. To illustrate the interplay of

Table 9.2 Plants used in the Arden economy

Node	Type	Plants Common	Plants Rare	Tier
Varies	Fiber	Talaw	Raffia	1
Varies	Fiber	Flax	Jute	2
Varies	Fiber	Cotton	Ramie	3
Varies	Fiber	Spruceroot	Sissal	4
Bush	Berry	Blueberry	Blackberry	1
Bush	Berry	Loganberry	Raspberry	2
Bush	Berry	Red grapes	White grapes	3
Bush	Berry	Strawberry	Elderberry	4
Tree	Fruit	Persimmon		1
Tree	Fruit	Pear		2
Tree	Fruit	Cherry		3
Tree	Fruit	Apple		4
Bush	Vegetable	Cabbage	Spinach	1
Bush	Vegetable	Carrot	Beets	2
Bush	Vegetable	Broccoli	Cucumber	3
Bush	Vegetable	Beans	Peas	4
Tree	Nut	Peanut		1
Tree	Nut	Chestnut		2
Tree	Nut	Almond		3
Tree	Nut	Walnut		4
Grass	Grain	Millet		1
Grass	Grain	Barley		2
Grass	Grain	Wheat		3
Grass	Grain	Oats		4
Bush	Spice	Ginger	Fennel	1
Buah	Spice	Coriander	Nutmeg	2
Bush	Spice	Sage	Pepper	3
Bush	Spice	Parsley	Basil	4
Grass	Aromatic	Celery		1
Grass	Aromatic	Onion		2
Grass	Aromatic	Garlic		1
Grass	Aromatic	Leeks		2
Varies	Sweetener	Maple syrup		3
Varies	Sweetener	Beet sugar		4
Tree	Hardwood	Maple	Sycamore	1
Tree	Hardwood	Hickory	Black. locust	2
Tree	Hardwood	Ash	Yew	3
Tree	Hardwood	Walnut	Oak	4
Tree	Softwood	Poplar	Spruce	1
Tree	Softwood	Chestnut	Mahogany	2
Tree	Softwood	Cherry	Rosewood	3
Tree	Softwood	Cedar	Rowan	4

the economic interdependence that permeates crafting, we offer both a general summary of production technologies and a detailed example of how metals are harvested, extracted, refined, and processed into finished goods.

Synthetic worlds often represent progression in a crafting profession by introducing a tiered level system for raw materials. Tiered systems are easy to model with game mechanics and also happen to mirror reality well. Historically humans did work with copper before working with more difficult alloys such as bronze, and subsequently iron, and steel. In video games we often see a reflection of this system in which players produce finished goods using a variety of fantasy and real-world analog materials. This current convention has provided us with the essential foundation, upon which we wish to continue to expand.

In designing Arden, we are using the works of Shakespeare to limit our scope of potential crafting materials; we will rely on real-world analog materials, specifically those resource materials which were possibly available in the British Isles during the fourteenth and fifteenth centuries. As mentioned above, we have grouped materials into tiers, and their use will mark achievement in a player's chosen trade. Further, and notably, the design of Arden deviates in four different areas from current conventions of most synthetic worlds. Firstly, not all trade skills will represent an equal investment of time from the player. This is positive because not all players visiting synthetic world wish to devote an equal amount of time to crafting. By being made aware of this difference the players can choose a craft that suits their anticipated time investment. This does require a balancing of investment with return, and this balance must take into account the individual demands of the craft, the balancing of the rewards of one craft versus another, and the rewards of crafting compared to other achievement methods. For example, historically metal workers were highly valued crafts persons due to the difficultly of the profession; similarly, metalworking in Arden will be a crafting profession which requires a higher investment of time.

Secondly, those synthetic worlds which typically implement tier based systems encourage linear consumption of game content. Tier 1 resources are located in areas with tier 1 mobs, tier 2 resources are located with tier 2 mobs, and so on up through the tier structure at a rate predicable to the developer and the player. This system produces a negative effect of segregating players into groups based on tiers, diminishing their social interactions and shrinking the visible player base for a given player. In Arden the system will be slightly different, as metalworkers, for example, will progress through tiers 1 and 2 relatively quickly and spend a much longer time using the tier 3 resources, with some high achievers occasionally requiring tier 4 materials. This also mirrors reality well, for by the fifteenth century apprentices and journeymen were widely skilled in tin, copper, and bronze-smithing, while the current material of the craft is ironwork, and

only the most accomplished craftsmen have the advanced knowledge and ability to work with steel. Other crafting groups will have similarly structured, but different progression paces. Such a design will limit the tier based social segregation of players through an overlapping of different crafters at different points in tier progression.

Thirdly, resource materials from lower tiers will still remain valuable to players once they have moved beyond that resource tier. This deviation from convention is required by the previous deviation; however it is also useful in its own right as it further reduces the tier based segregation. There will be incentive for a craftsperson to use materials which are below his tier level because, as different crafts will advance at various rates, other crafting professions will still require goods based on these lower level materials. This system thus also makes possible the fourth and most important improvement on convention: that players engaging in a crafting profession must have a system of interdependency with other crafting professions.

In order to measure inflation or any other economic indicator within a synthetic world there must be high levels of trade. By having a large number of goods that players want, with only a small number which they can create themselves, high levels of trade can be induced in a crafting system. In this system a player will create a large quantity of one particular item and then trade those particular items for items which are desired but cannot be made by that player. By deconstructing the barriers between resource and production tiers, we have created interdependency between crafting professions and increased the proportion of the player base that any given crafter can count on as their customers or suppliers. In aggregate, these four refinements enable us to more accurately measure the marketplace economy of Arden. Additionally, the system will promote interaction between players, limit the frustration of depending on a set fraction of players for advancement, and reduce the tedium of repetitive crafting. Fun, interdependence, realism, and our academic study are all served by these refinements, which we will now reference while explaining the production of metal objects within Arden.

Metalworkers in Arden will comprise a large category of crafts persons. These will include several variations on jewelers and ornamentalists and a large number of specialists in the blacksmithing crafts who make the weapons, armor, tools, or other gear needed by a late medieval society. Each tier of materials will contain a hard metal generally used by the blacksmithing crafts and a soft metal used by the jewelry-oriented crafts. For all crafts professions in Arden, there will be four basic components to the production of any material: the workstation where a task is done, the tool(s) used in that step of the process, any reagent that is consumed during that step, and a byproduct produced in that step which may or may not be valuable to any craftsperson.

The workstations for metalworking will include a simple fire pit, the anvil, the furnace, the forge, and the steeping tank. A fire pit is to be used when only a low amount of heat is needed to treat the metal in the step. They are the cheapest and most often encountered machine. When fires aren't sufficient for the task, forges can be used to generate stronger heat. Anvils are shaped large metal objects used as the workspace on which metal is hammered into shape. Furnaces are machines where strong heat is generated but the combustible materials are kept separate from the worked metal. Anvils and furnaces can be of varying types relative to the material being worked. Steeping tanks are places where the metal being worked is treated with a liquid. Any metal being worked in Arden will use a combination of these workstations specific to the metal being worked.

Tools are objects that the metal worker needs for the step, but which are not consumed by that step. They are finished goods produced either by the metalworker himself, in conjunction with another craftsperson, or solely by another craftsperson. Metalworking tools will include smelting tongs, pans and shears, the mining pick, and smithy hammer (which would require the assistance of a woodworker to supply the wooden handle), as well as ceramic bowls and moulds and stone crucibles produced by potters and masons respectively.

Reagents are materials which are consumed during the productive step. These will include the fuel that feeds the fire, and this ranges from wood to charcoal to coal as the heat needed increases (again all wood products need to be supplied by a woodworker). Chemicals may sometimes be needed as reagents; these may range from as simple as salt water to as complex as ammonia and cyanide (which were produced in medieval times by specific processes for treating urine and plant extracts, processes that players pursuing the alchemist and apothecary crafts will learn). Disposable objects will also be occasionally needed. For example "cupell" is a Middle English term for a ceramic bowl which is used in refining certain metals instead of a crucible because the impurities in the metal are attracted to the cupell, purifying the metal but destroying the effectiveness of the cupell in the process. A potter will often be called on to replenish a silversmith's stock of cupells.

Byproducts are new materials leftover from the crafting process. Byproducts of the metalworking process (in addition to a large quantity of ash and slag) will include arsenic, sulfur, and cobalt dye, each of which will have uses for other craftspeople. As a game-native mechanic, whenever a common-grade resource is refined, one byproduct is a residual amount of rare-grade resource, as explained earlier.

Within Arden player characters learn specific crafting processes and recipes as they progress through trade professions. It will be a positive side-effect if the players themselves learn somewhat of metallurgy and materials science along with their characters, though the realism imported into the

processes is there to promote fun and game story first, as well as serve the economic needs of the simulation. What follows is a detailed account of how metal resources in particular may be used in Arden's craft production.

The first tier of metal resources listed above shows materials generally available in pre-Roman Britain. In our design, Sphalerite (softmetal) and Cassiterite (hardmetal) ore is mined from separate, named resource nodes and the raw ore then taken to a workstation. Sphalerite can be taken to a wood fire, with the resulting Zinc metal hammered into purity and shape, then quenched with salt water. Cassiterite must be taken to a wood furnace where the Tin metal drips out of the ore into the crucible. When it solidifies it is also hammered on the anvil.

In reality, pure Zinc metal was not used during the fifteenth century. The production method described here would lead to Zinc highly contaminated with silicates and other metals, which would actually constitute a low-grade pewter. However, in the Arden simulation, this is still referred to as Zinc in reference to the early jewelry components made from it, using recipes taught by the crafts trainers. Tin metal was used extensively for plates and eating utensils, and somewhat for weaponry such as daggers and arrowheads, either as stand-alone metal objects or as covering on wooden objects. Due to the limited nature of these materials on their own, players will tend to progress through the first tier of metalworking very quickly. Rarely, Electrum may be found in Sphalerite, either as a whole unit or as the byproduct mentioned. In the case of the unit of ore or the aggregation of a sufficient quantity of byproduct, Electrum is melted and cast in a ceramic bowl over an open fire prior to being hammered and shaped into a premium-grade class of jewelry objects. Similarly, Wolframite is rarely found in association with Cassiterite, and is used for a premium-grade of early tools and weapons.

The second tier of metal resources dates to the Roman era in Britain. It is easily noticeable that tier 2 production will be less basic relative to that of tier 1. Galena and Malachite ore can be mined from resource nodes and taken back to a workstation. Galena ore must be crushed (hammer tool) before it is mixed with charcoal (reagent) and placed in a tin pan (tool). The next step is heating this pan over a wood fire. This step produces white pellets and black pellets. The white pellets are arsenic (byproduct) and the black pellets are taken to the next step, where they are mixed with lard (reagent) and burned in a ceramic bowl (tool). The resulting chunk of lead metal in the bowl can then be hammered and shaped like normal, producing jewelry, drinking vessels, roof tiles, and other objects from learned recipes. Malachite ore must be roasted in a charcoal fire before it is taken to the furnace where again the metal, this time Copper, drips out into the crucible. Unlike Tin, Copper is poured into moulds (ceramic reagent) instead of being hammered into sheets. Even though Copper is only a tier 2 material

it will always be in demand from the food-preparation classes for its use in making containers and tools such as mixing bowls. In addition, Copper can be used in its own right for weapons, tools, and implements. Here though it is also the first example of cross-tier production. Zinc, Tin, Copper, and Lead make a foursome of metals more useful than each individual. Tin (tier 1) and Copper (tier 2) combine to make Bronze, a better metal for weapons and tools than either metal alone. Zinc (tier 1) and Copper combine to make Brass, a much more useful ornamental metal for jewelry and household objects. Zinc and Lead (tier 2) and Tin combine to make true pewter, useful for drinking vessels and other ornamental objects. Beyond this, Silver is a minor component of Galena, so in the game world Silver ore is a rare harvest from Galena nodes, as well as being a byproduct of Lead production. Silver is put through the same production process as Electrum, but the ceramic bowl is consumed in the process, making it a reagent rather than a tool. Silver then would become a premium-grade jewelry material. Goethite is an ore found rarely among Cassiterite, and it is basically low-grade Iron. It would be put through the same process listed below for Iron, but in light of tier level, players get to use it earlier.

Tier 3, as mentioned earlier, is where the majority of metalworkers will spend most of their time. This tier includes Pyrite and Hematite ores, which are harvested from resource nodes and taken to workstations. When Pyrite is wanted for making jewelry and ornamental objects, it is not heat treated in any way, as any heating, oxidizing, or even watering produces sulfuric acid. Rather, it is simply cold-hammered unless sulfuric acid is wanted. Gold is the rare softmetal associated with Pyrite, extracted and handled the same way Silver is from Galena. At tier 3, metalworkers may also get a recipe to separate electrum into silver and gold, increasing the achievement-life span of that tier 1 harvest. Hematite must be pulverized like Galena, but then set into a steeping bucket with Limonite clay (reagent [tier 2 pottery]) to separate the [sinking] Iron oxide from the [floating] slag. If the rare tier 2 clay Bentonite is used, it can be re-used, though Limonite must be discarded after use. The Iron oxide is then mixed with charcoal in a crucible and put into the furnace. If the crucible is made from common clay or stone, it is a reagent that needs to be replaced. If it is made from rare Wolframite (tier 1 rare metal), then it is reusable. Within the crucible is a solid Iron bloom which is then taken to the forge and anvil to produce wrought Iron. Iron will be the most popularly used metal material in Arden, as it was in the medieval age. It was used to make everything in the metalworker's own trade such as armor, weapons, and tools, as well as interim products for other trades—such as nails, horse spurs, pots and pans, scissors, and masonry joiners (all of which a metalworker in Arden may learn to make by learning individual recipes). The rare hard metal at this tier is called Marcasite because historically iron was alternately harvested from meteor crashes,

in which case it was often already alloyed with nickel and other metals, increasing its strength. Occasionally when nickel impurities were found in terrestrial iron, these portions of ore were saved and accumulated as well. In Arden, low-grade steel of this sort is taken directly to the forge and worked on the anvil.

The fourth tier of materials represents the leading edge of metalworking technology in the fifteenth century. Metalworking goods and crafts up through those produced with Iron fill all marketplace needs; however, tier 4 materials (even the common resources) represent premium goods. Rare tier 4 materials are as rare as it gets in Arden. Further, the production processes for these materials will require a relatively large time investment. Sperrylite is the softmetal ore, and after being pulverized it is cooked in a bath of ammonia and cyanide. The resulting cake is heated in a furnace in a crucible to form Palladium metal, which can then be worked by the forge and the anvil. Palladium is the common metal for tier 4, but when used on its own is superior to Electrum and roughly equal to Silver, and only slightly inferior to Gold (the rare resources from earlier tiers). Palladium can be alloyed with Silver or Gold to create a premium range of jewelry better than that derived from either of those metals alone, again preserving the value of early-tier resources. Platinum is also associated with Sperrylite ores, and constitutes the rarest soft metal in Arden. Melting Platinum was actually beyond the technology of the fifteenth century so we are well within our creative license to make the production process extremely difficult in terms of game mechanics. The process will mirror other rare precious metals, except that the furnace is used, with a disposable cupell, and there is a very high chance that the Platinum ore will emerge unchanged. Niccolite ore is pulverized and roasted in a furnace within a crucible containing coal dust. The resultant pellets are immersed in another crucible with liquid Lead (tier 2), and the whole mass is heated to melting and then allowed to solidify as a block. The block is then gradually heated until the lead runs off, carrying the impurities with it and leaving Nickel pellets and Cobalt crystals (byproduct) in the crucible. The Cobalt is pulverized before being traded to glaziers, potters, alchemists, and many others as an ingredient in blue dyes and glazes. This step also produces Platinum dust by product. The Nickel pellets are sent back to the furnace to be heated in a sealed crucible with charcoal. After the Nickel is isolated and purified, it is put into a fresh crucible in the furnace with refined Iron, and crushed Limestone (tier 4 stone from Masons) and charcoal, yielding low-grade (but still fantastic for the medieval period) Steel. As an extremely rare event, high-grade Steel can be the random result of this process (additionally, Meteoric Steel would be an extremely rare harvest). Like Platinum jewelry, Steel weaponry and armor would be the rarest of the rare items.

Markets

Money

Richard III ruled England for a two-year period beginning in 1483. The money of Shakespeare's day was mostly introduced shortly after Richard's reign, particularly the sovereign (worth 1£). To mirror the currency of the England of Richard's era as much as possible, Arden will use the most common currency available in England in the late 1400s.

The basic units of value at the time were the pound (£), the shilling (s), and pence (d). The abbreviations are derived from the Latin units of currency, librae, solidi, and denarii. Unlike the British currency today, pounds, shillings, and pence did not follow a decimal progression. Each pound was worth 20 shillings and 240 pence, with each shilling therefore worth 12 pence.

Coins like the Rose Noble (worth 15 shillings) and Florin (worth 6/8) were not commonly used and so are not included in Arden's system of currency. The currency of Arden is given below in Table 9.3

In Richard's day, the highest value coin was worth less than half a pound, so most commerce was conducted using only shillings and pence. Prices were thus given as combinations of shillings and pence. For example, two shillings and six pence would be written as "2s 6d" or "2/6" and pronounced "two and six." Two shillings alone would be written "2/-".

Players will carry coins around in their inventory as they would any other item. Coins will "stack" in groups of 10, meaning that each slot in the inventory will carry 10 of a particular type of coin. The eleventh coin must be put in a separate slot. Players will be able to evaluate their coins'

Table 9.3 Examples of the currency used in Arden

Unit of Currency	Value	Value (in pence)
Noble	6/8	80d
Half Noble	3/4	40d
Quarter Noble	1/8	20d
Groat	4d	4d
Half Groat	2d	2d
Penny	1d	1d
Halfpenny	0.5d	0.5d
Farthing	0.25d	0.25d

worth (in pence) by hovering their cursor over a group of coins, which will allow them to quickly evaluate the difference between the types of coins.

To convert between denominations, players will have to visit the King's Market, where the King's Merchants will trade denominations freely. However, the Marketplace will convert between currencies automatically, so most users will have to exchange currency infrequently. Players may find foreign coins during play (e.g., by completing a quest for a foreigner), but these coins will act like normal inventory items and cannot be directly converted to British currency.

The Market Interface

Arden has two separate market interfaces. The Marketplace proper can be accessed anywhere in the world and facilitates buying and selling between players. The King's Market is a physical location in the central town with satellite locations in the nearby villages. At the King's Market, players can convert currency and possibly buy or sell with the Crown. In other respects, the two markets are very similar.

The King's Market

For players, the primary purposes of the King's Market are to convert currency and to pick up items and money from buying and selling through the Marketplace. In addition, the King's Market functions as a tool with which researchers and the design team may regulate the money supply of Arden.

If at a given point there is not enough money in the economy for researchers to implement a particular economic study, the Crown will purchase basic crafting materials from players for more than the market rate. Similarly, if there is too much money in the economy, the Crown will sell crafting materials for less than the market rate in order to regulate the world's money supply.

To buy or sell items through the King's Market (i.e., when the King's Market is buying or selling goods), players must travel to one of the Warehouses scattered across the kingdom. In these Warehouses, talking to the King's Merchants will bring up a simple interface that indicates the current items available and the prices per unit.

The Marketplace

Unlike most games, Arden does not have computer-governed merchants to sell basic equipment. To gain improved items, players must complete quests,

craft items, or (primarily) buy them in the Marketplace. Similarly, players cannot sell most items to computer-controlled characters. The only way to gain money is to sell items on the Marketplace.

For this reason, the Marketplace is central to the player experience. At any time and any place in the world, players may open the Marketplace interface to buy or sell items. To buy items, players may search through current listings for items. Items are listed with a quantity, price, and seller and in ascending order by price per unit. Players can buy portions of an entire lot at the given price per unit. Once a purchase has been made, the appropriate coins will be removed from the player's inventory and the items bought (and change, if necessary) will then be available for pick up from any King's Merchant.

To sell an item or items, players can open the Marketplace and place the items from their inventory into the Marketplace. They must also set a price per unit in pounds, shillings, and pence. Once confirmed, these items will be placed on the marketplace immediately. When an item is sold, the player will receive their money in the largest denominations possible from any King's Merchant. Eventually, Arden will include a "dutch auction" type of system where players can indicate a maximum and minimum selling price. Their items will be listed with the maximum price for the first week and steadily lowering prices in later weeks until the minimum price is met. At that point, the items will be returned to the player through the King's Merchants.

In the future, players will also be able to access the Marketplace in order to request an item. This will be very similar to the interface for selling in that they will select an item, a quantity, and a price per unit. Other players will then be able to fulfill a portion of the order directly through the Marketplace.

Economic Policy Tools

Policy administration is a vital aspect to the sustainability of the Ardenian economy. Unlike many synthetic worlds of its class, Arden is a closed economy where all money within the system is accounted for by the system administrators. The system will always conserve the amount of money in the system (e.g., it will never just "sink" out of the system). The administrators will, then, need tools to circulate this money amongst the denizens of Arden. By controlling the money supply, administrators should also be able to affect aggregate demand in the system as well as inflation just like any other fully functioning closed economy.

The two approaches administrators will have to alter economic policies will be through monetary and fiscal policies. From the approach of this

synthetic world, the monetary policy should be of greater value. Each of these policies, though, offers strategies for affecting the dynamics of the economy: monetary policy for actual currency issues and fiscal policy for taxation and government aid. There is an interface to administer each of these policies. In addition to these tools, there are three key indicators of economic activity in Arden that will be discussed.

Monetary Policy

The general approach taken for the development of these tools is one of monetarism. Monetarism revolves around the principle of the quantity theory of money. Patinkin (1969) contrasts two approaches to monetarism. The first is called the Chicago oral tradition from Milton Friedman, who described the quantity theory as a theory about the demand of money. This demand for money depends on "(1) the total wealth to be held in various forms, (2) the price of and return on this form of wealth and alternative forms, and (3) the tastes and preference of wealth-owning units" (p. 48). This view is put in contrast with the other Chicago tradition. This tradition states that the quantity theory is not about the demand for money but rather the money supply's relation to aggregate demand, price, and output. The changes necessary in the money supply can develop as a result of open market operations or fiscal policy deficits.

This system will blend these two traditions together. We will focus on the quantity theory of money ($Mv = PQ$) in terms of its relation to aggregate demand and the affects it has on aggregated prices and produced goods. Like Friedman (1982), however, the monetary policy tools will focus on supply of money to affect this balance in the economy. With this approach, however, there are two different assumptions that must be addressed. The first is that the velocity of money, which according to Friedman is the rate at which money circulates from person to person, is a constant factor in the equation. Serrano (2003), in his discussion of economies basing their economy on a standard, discusses the "Triffen dilemma" that, among other things, states that the velocity of money can be kept constant if the currency can be tied to some standard such as gold or, in the case of Arden, a resource that most players will find of value, such as iron. Serrano takes issue with this dilemma on the grounds of the expansion of credit. The economy of Arden has no credit, and so making such an assumption seems justified. The second assumption is that by setting target money supplies for consumers, one will not also be setting interest rates. From the standpoint of credit, interest rates are not a part of the system because credit is not a part of the system. From a practical standpoint, however, the mechanism by which money enters into circulation for consumer's use functions very similarly to setting interest rates.

The actual mechanism for manipulating monetary policy, mentioned in the previous section, happens through the King's Market. At the start of every "season" of Arden, new players enter the world. At this point, there is no currency in circulation, but only resources scattered throughout the world that could be gathered. NPCs denoted as King's Merchants will then buy certain types of these resources at a price determined by administrators. This price will be higher than that of the market value for that item. While this transaction will affect the market value of that item, it is by this method that money enters into circulation from the King's Treasury. Each NPC who works as a King's Merchant will be tied to a pool of money that can be used by them to purchase these goods. When the pool dries up, then the NPCs will have no more money to buy these items. At this point, the supply of money is fixed. The same mechanism can be used when administrators feel the need to remove money from the system. NPCs will sell items of the class that they buy for a price below market value to bring money back out of circulation. This money then is deposited into a different pool, which cannot be used to buy new items by the NPCs. The actual items sold by the NPCs will not be conserved, which means that these will not be the same items that they bought from players since their preservation is not crucial for the system to function.

The interface for influencing this interaction between players and NPCs, and hence influencing the supply of money that enters into circulation, will be in the management of each pool accessible to NPCs as well as the prices of buying and selling back items. These values represent relative prices that are more or less than the market values of the items that are being bought or sold. The "buying" pool, which is used for buying items from consumers, will contain amounts of each of the different types of currency. Administrators can add to this pool, either from the "selling" pool or through the process of "minting" new money, or remove money from the pool. The "selling" pool, which is used for storing money from sold items, can only have money removed from it. Removed money will either be put into the "buying" pool and re-circulated or removed from the world entirely. The interface will also include several values that the administrators can alter that will change the buying and selling values of each of the items that are going to be sold by the King's Merchants. In between each of these pairs of values for each item, there will be the calculated market price for that item. There will also be an automatic way to set these values by choosing a relative proportion above and below market value, which will adjust each of the items values being bought and sold by the King's Merchants.

The interface for influencing this interaction between players and NPCs, and hence influencing the supply of money that enters into circulation, will be in the management of each pool accessible by NPCs as well as the prices of buying and selling back items. These values represent relative

prices that are more or less than the market values of the items that are being bought or sold. The "buying" pool, which is used for buying items from consumers, will contain amounts of each of the different types of currency. Administrators can add to this pool, either from the "selling" pool or through the process of "minting" new money, or remove money from the pool. The "selling" pool, which is used for storing money from sold items, can only have money removed from it. Removed money will either be put into the "buying" pool and re-circulated or removed from the world entirely. The interface will also include several values that the administrators can alter that will change the buying and selling values of each of the items that are going to be sold by the King's Merchants. In between each of these pairs of values for each item, there will be the calculated market price for that item. There will also be an automatic way to set these values by choosing a relative proportion above and below market value, which will adjust each of the items values being bought and sold by the King's Merchants.

Fiscal Policy

From a monetarist approach such as the one that we are planning this economy from, fiscal policy is not as important toward affecting aggregate demand and inflation. This distinction comes out most succinctly in the difference between the Monetarist tradition and the New Keynesian tradition. Whereas monetarists argue that price is determined by the supply of money and hence a strong monetary policy is more important, New Keynesians argue that prices do not change in the short run, but only in the long run (De Long, 2000). This is due largely to price stickiness and menu costs. New Keynesians believe much more enthusiastically in using fiscal policy to affect long-term prices.

While the monetarist tradition does not see fiscal policy as contributing greatly to aggregate demand or inflation, they do not view it as harmful to the activities of monetary policy. Given this, fiscal policy does also provide a convenient mechanism to encourage or discourage certain types of behaviors in the world. Due to the imbalance of time that various people will inevitably spend exploring and interacting with the world, fiscal policy could be used to ensure that all players, regardless of how active or casual they are, have a fun experience playing the game (and not becoming hopelessly destitute).

The way most normal governments administer fiscal policy is through generating funds and expenditures. Generating funds can be accomplished through taxation, minting money, or borrowing from the public (e.g., using T-bills). Administrators can apply these funds to various spending programs through their expenditure. The important difference between a real-world

government and the King's Government of Arden is that with respect to the actual economy of Arden, operating costs for maintaining this government are 0 percent. Administrators of Arden have taxation at their disposal as a fiscal policy mechanism. Minting money, another fiscal tool, can be a part of the monetary policy. It is not however necessary to maintain the fiscal policy. Finally, a procedure for borrowing from the public, which can increase funds, will also not be implemented in the world. After those funds have been collected they need to be spent. There are very few ways of spending these funds that have meaning to the world. One way would be on general welfare of needy Ardenians and the other would be reinserting funds raised and putting them into the "buying" pool.

Taxation in Arden will be used to promote the sorts of behaviors and activities that we feel players should follow. One possible tax is a hoarding tax, which could be construed as a modified wealth tax. If hoarding is getting out of control in the space, this tax could be levied to take a percentage of the total monetary wealth that a player has. This would encourage players to spend their money and continue circulating it in the system. The interface for this tax will allow players to make this progressive or not, if they wanted people who are hoarding more to be charged higher rates, and also the value at each level of hoarded wealth. Just as hoarding wealth by individuals will be taxed; hoarding property by "Houses" of players will be taxed. A similar interface can be used to manage this tax as well. Likewise, if players are engaging in behaviors that pollute or otherwise damage the environment for other players in the space, taxes could be collected on the amount of damage or pollution caused. This tax would be levied when any production process that, as a bi-product, produces waste or pollution is completed. The player will be notified that they are being taxed for this activity. The interface for this tax will be a rate per unit pollution. The final tax that could be levied is a future concept for the design of Arden. In this future design, it has been proposed to draw up contracts between individuals who are providing services for each other. To encourage use of this contract system, we proposed a tax that punishes those who do not use the contract system. This tax would use an interface for setting a fixed rate for such behavior.

That which comes into government must also be spent. Expenditures going to welfare can be used to help players who play more infrequently and are having a difficult time getting into the economy. This could occur through automatic messages being sent to players who have low amounts of wealth and items. If the player requests aid, a portion of the funds raised could be used to help these players. Alternatively, the remainder could be re-circulated into the economy through the "buying" pool. This will require an interface that allows administrators to transfer money to player's accounts by selecting them from a list and specifying an amount. There

will also be a portion of this interface to specify the amount going back into the "buying" pool.

Indicators of Economic Activity

In order to manage policy, there are several key economic indicators that are necessary for understanding the economic growth of Arden:

- CPI
- Inflation
- GDP
- (Q) Quantity of goods produced
- (P) Price of goods
- (M) Supply of money in circulation

The CPI is useful for discovering the "costs of living" in Arden. To calculate CPI, we will construct a list of the percentage of each finished item in the economy that an individual owns. This list will be manually selected for the first season of Arden and will be automatically calculated from previous season's data for every season after that. The amount obtained will then be divided by the base season's percentage of items, which will be the first season. Inflation can be calculated using CPI by dividing any two seasons by each other.

The GDP is essentially the PQ side of the quantity theory of money. It is calculated by looking at the decomposition of the components that make up a finished good and each timestamp of when they are made. Starting from the last calculation of GDP, the system will increase the quantities of each component that occurred in this time period and also add the value-added price for each price. The value-added price will be obtained by subtracting out prices that come from components that were made in previous calculations of GDP.

The final step, then, is to calculate M which is the supply of money in circulation at a given time. This value can be retrieved by a simple aggregation of all funds that any of the players have in the game.

Conclusion

Possible Experiments

The economy of Arden has been designed to be rich, deep, persistent, complex, nuanced, and rigorous. It is not an exact analog of a contemporary economy; indeed, it is not an exact analog of the economies on which it is

based, those of medieval England. Yet a wooden maze is not an exact analog of any real puzzle that humans face on a day to day basis, and a rat's mind is not an exact analog of a human's. We can learn something about how humans act by examining the behavior of rats in wooden mazes. Our claim is that we can learn something about how societies of humans act by examining the behavior of human societies in synthetic worlds. Any experimental environment can be relevant to questions about the real world, if the questions are posed at the proper level of abstraction. The questions we would like to pose to the economy of Arden involve very general issues of market dynamics, at the macroeconomic level.

One general question, for example, involves the relationship of the money supply to the price level. It is believed that increases in money, unless accompanied by increases in trade, will lead to increases in the price level, that is, inflation. Questions posed at that level of abstraction can indeed be studied within Arden, because Arden contains genuine, real instances of all of the items being queried: it has money, it has trade, it has a price level, and it has inflation.

Thus one can imagine the following sort of experiment. Set up two versions of Arden, exactly alike. Allocate players to the two versions randomly. In one, we set the money supply at an arbitrary level, say £1,000. In the other, we set the money supply at £2,000. We would predict that the price level ought to be higher in the latter world. If not, we would have to examine the environment and see whether the result is replicable. If robust, such a finding would serve as an empirical challenge to some fairly fundamental notions in macroeconomics.

This strategy of random assignment to controlled environments satisfies the "all else equal" requirement often stated in economic theories (and many other social theories as well). Indeed, this requirement is exceedingly difficult to meet under any of the contemporary methodologies now available. A great deal of processor power and econometric theorizing is spilled attempting to control for the various influences that get in the way of the independent variable's effect on the dependent variable. As the unit of observation becomes a larger and larger aggregate (families, towns, provinces, nations), it becomes harder to adequately model the structure of influences. Causation is difficult to establish with any confidence at all. Yet with this simple macro-level random-assignment experimental method, causation is established beyond a reasonable doubt. In a synthetic world experiment, all else is, indeed, held constant.

Broader Scope

Creating a closed controlled virtual world served the purposes of the authors to do economic experiments. Not all researchers have the same goals and

creating a virtual world in itself is an undertaking which requires not only time and resources, but support from others in the way of programming. Some of the worlds that don't give the researcher the level of control the authors had with *Arden: The World of William Shakespeare* are still valid subjects of research. This research can even compare and contrast the controllability or openness of multiple virtual worlds. The virtual world *Second Life* has a robust economy that offers a wealth of opportunities for study even though it may not be able to be controlled by researchers. The MMORPG *WoW* equally offers many research possibilities. What is needed to research virtual world economies though is a complete understanding of how the economies work, the mechanics of economic exchange, and the interaction with the real world. This understanding is gained through more than a passing glance at the economies and other structures and mechanics of interaction within these spaces. If a researcher is planning on studying these virtual worlds, he must take the time to learn about the worlds and their residents firsthand before proceeding.

References

De Long, J. B. (2000). The triumph of monetarism? *The Journal of Economic Perspectives, 14*(1), 83–94.

Friedman, M. (1982). Monetary policy: Theory and practice. *Journal of Money, Credit, and Banking, 14*(1), 98–118.

Patinkin, D. (1969). The Chicago tradition, the quantity theory, and Friedman. *Journal of Money, Credit, and Banking, 1*(1), 46–70.

Serrano, F. (2003). From "Static" gold to the floating dollar. *Contributions to Political Economy, 22*, 87–102.

10. Real Business and Real Competition in the Unreal World

J. Sonia Huang

Introduction

The emergence of virtual worlds and the Web 3-D changes the way of doing business. Web 3-D is the synonym for Internet based virtual worlds, where people can create their own 3-D virtual personalities. One of the popular virtual worlds is Second Life. The creator of Second life is Linden Lab founded in 1999 by Philip Rosedale, who is the former CTO of RealNetworks, where he pioneered the deployment of streaming media technologies. Linden Lab is based in San Francisco and employs a senior development team consisting of experts in physics, 3-D graphics, and networking. The development is undergoing an evolution similar to that of the Internet in the mid-nineties and it may profoundly impact the way people cooperate, communicate, collaborate, and conduct business.

The influx of companies such as Toyota, American Apparel, Nissan, Adidas in Second Life is the first indication of the upcoming role for the next generation of conducting business online. However, how real are the businesses in Second Life? In this chapter, I will (1) provide a firsthand look at the demand and supply of the Second Life economy, (2) apply a market structure analysis from real world to the virtual realm, and (3) suggest generic strategies for business owners to achieve above-average performance in this virtual market.

Second Life Economy

Statistics

Second Life (SL), a literal opposition to real life (RL), is a 3-D virtual world built and owned by its residents. A resident is a uniquely named avatar[1] with the right to log into SL, to trade Linden Dollars,[2] and to visit the Community pages. Since opening to the public in 2003, SL has grown fast and inhabited by more than 14 million residents from around the globe (Linden Lab, 2008). The number may be inflated due to the rapid spread of onetime users who never return but are still included in the resident census. Therefore, several other statistics give a more accurate portrayal compared to the number of total residents (see Table 10.1). As of June 30th, 2008, roughly 825,000 residents, basic and premium,[3] have logged into SL at least once in last 30 days. The number of premium residents has reached 87,867 from 5,000 at the start of 2005. The average concurrency in-world is 50, 104; that is, whenever you log in SL, there are around 50,000 residents interacting with each other.

Different from combat-based online games (e.g., World of Warcraft or EverQuest), SL is a place for residents to live there, work there, and consume

Table 10.1 Statistics of Second Life*

Population	
Total residents	14,166,823
Log in last 30 days	825,100
Premium residents	87,867
Estimated in-world suppliers**	57,821
Average concurrency	50,104
Currency	
Total supply	L$ 5,190,596,970
Average exchange rate	L$267.4/US$1
Land	
Resident-owned island (mainland and island)	19,977
Resident-owned land (millions of square meters)	1,577

* Last Updated: June 30, 2008.
** Unique users with positive monthly Linden dollar flow.
Source: Linden Lab. (2008, July 1). Economic Statistics (Raw Data Files). Retrieved July 20, 2008, from http://secondlife.com/whatis/economy-data.php

there, just as they do in real life. Following this logic, SL should have its own demand and supply system. But, how does it work? Here, I offer a firsthand look at the residents, the customs, and especially the economy of this virtual world.

Demand

When I landed in SL for the first time in fall 2005, all I had was an avatar wearing a purple shirt and a pair of jeans. I soon realized I would require many goods and services. First, to attend different events, I needed different clothes, shoes, hair styles, etc. According to SLboutique.com, a full outfit costs from nothing (e.g., freebies) to L$4K. The price difference is mostly dependent on designers' talent and users' rating. Second, I noticed that a basic avatar had very limited movements (i.e., walk, run, fly, and sit down). If I wanted my avatar to hug, dance, or express and emotion, I would have had to purchase so-called "scripted attachments" or "animation overridders," which then would allow my avatar to be more humanized in SL. For example, a dance pack which allows my avatar to possess several dance moves, could cost as much as L$1,500. Since there are millions of residents in SL, demand for these categories (e.g., clothes, footwear, hairs, skins, and poses) should be substantial. Lastly, a large portion of my demand consists of entertainment. I have liked to sit in a club watching other people dancing or to play slot machines in a casino. Looking at the most popular places, I figure that other residents also regarded SL as a virtual hangout place, filled with clubs, beaches, and casinos.

Besides the individual demands, land and business owners need goods and services as well. A business owner, Roy, reported that he spent L$50K to build a club because everything was built from scratch. For example, a Sakura tree used for landscaping may cost L$2K if owners do not know how to design and created it themselves. Even if owners do know how to create a place, they still need many basic building blocks known as "primitives or prims," sold together with land. An art gallery owner, Dirk, complained that he ran out of prims to build a gallery but to buy more prims means to buy more lands.

Supply

Where there is demand, there are suppliers. Unlike other virtual worlds where game creators are also the main suppliers of in-world goods and services, SL's technology allows residents to build anything imaginable—from clothes, vehicles, houses, to buildings. Most importantly, SL residents retain full ownership of their virtual creations. In other words, they are free to buy and sell anything

they own in SL. The inception of property rights in SL contributed to the thriving market economy (Hof, 2006). Table 10.1 shows that 19,977 islands, which is equivalent to 1,577 millions of square meters in size, are owned by residents as of June 2008; and the number of estimated in-world suppliers has reached 57,000. The suppliers can be categorized into three common types: business owners, land owners, and labor force providers. At the end of 2006, Anshe Chung, virtual real estate developer, became what is claimed to be the world's first virtual millionaire (Second Life Herald, 2006). Chung had accumulated the equivalent of over one million U.S. dollars of assets in SL.

However, the classic tale of entrepreneurship reaping profits does not represent the situation of most business owners in SL. During a "land owner 101" meeting, two owners shared with me that their businesses were not as profitable as outsiders thought. One owner had not yet broken even in his club business, and another said she earned about L$60K a month but was always very busy in creating clothes. Apart from operating businesses on their lands, some owners chose instead to develop the land and either to resell it or to lease units for profits. One example is land owner, Katie, who had built a large shopping mall and was leasing out individual stores for L$300 per month. Compared to the business or land owners, being an event host or a designer may be a good alternative to making money as they do not have to worry about any overhead costs. These part-time jobs' pay range from several Linden dollars to several hundred Linden dollars per hour. For example, a designer, Tigerlilly, built a dance club for a friend and earned L$5K for that single project. Thus, if a resident is talented and full of creative ideas, SL can be a place to make quick money without much capital.

A new type of supplier is emerging in SL. They are backed by RL companies or organizations such as Adidas, Toyota, AOL, and Reuters. For example, Adidas had sold over 21, 000 virtual shoes to streetwise SL residents (Guardian.co.uk, 2006); Toyota created a futuristic urban island, Scion City, with a dealership that sells virtual cars and has a racetrack where residents can take cars for virtual test drives; AOL launched an interactive mall dubbed AOL Pointe, where residents can buy clothes for their avatars, skate in a park, and watch videos together (AFX News Limited, 2007). In October 2006, Reuters, one of the oldest existing news agencies in real life, chose to station a full-time reporter in SL to disseminate its real world news feeds to residents, hoping in the process to find a new audience (Terdiman, 2006). In addition, IBM announced a joint initiative with Circuit City to explore virtual business models in SL because they know that behind each avatar is a real human being. Companies have always targeted their presence in areas where they are able to maximize consumer attention. Since there is an increasing growth of consumers moving into virtual worlds, it is only logical that this becomes real life companies' next frontier.

Although SL is full of business opportunities, what does the in-world market look like? What kind of market structure can business owners anticipate? What are the businesses doing? To answer these questions, a real world economic analysis is necessary. In the following section, I will introduce an analysis of market structure to study the SL market and Porter's generic strategies to evaluate the competitive advantage of SL businesses.

Theoretical Statements

Market Structure

Since SL is a distinct territory with buyers and sellers, a place like this has an economy (Castronova, 2001, 2005). Market is one of the key components in a capitalist economy, whereas market structure describes the state of a market with respect to competition. In other words, market structure is determined by the level of competition or concentration in a market. There are four kinds of market structures that are usually discussed in real world in decreasing order of competition: (1) perfect competition, (2) monopolistic competition, (3) oligopoly, and (4) monopoly (Bain, 1959; Scherer & Ross, 1990; Carlton & Perloff, 2005). As a rule of sum, perfect competition is characterized as "highly competitive," on the other hand, monopoly is described as "highly concentrated."

Perfect competition. In perfect competition, there are several sellers and buyers but none of whom possesses the market power to influence prices. For example, the agriculture industry, with a large amount of sellers, and almost perfectly substitutable products, has an approximation to the perfect competition structure. According to Albarran (2002), no media industries (i.e., newspaper, magazine, book, radio, Internet and TV industries) fall in this category.

Monopolistic competition. Quite a few people confuse monopolistic competition with monopoly. A monopolistic competitive structure is defined as several firms selling somewhat different products in a market as opposed to a monopoly structure where only one firm dominates the market. Monopolistic competition is similar to a perfectly competitive market except for the differentiated products. A typical industry in this category is restaurants. Each restaurant with its unique location, service, and menu has more power on what price they can charge. On the other hand, if two homogenous restaurants open next to each other, both of them are price-takers. Media industries such as books, magazines, and radio are monopolistic competitive (Hoskins, McFadyen, & Finn, 2004).

Oligopoly. An oligopoly differs from monopolistic competition in that this type of structure features a small number of sellers. Firms in an oligopoly are mutually interdependent because the behavior of any given firm solely depends on the behavior of the other firms. The major tool of analysis for an oligopoly market is game theory, modeling as if each firm is playing a game with its rivals in order to do the best it can (Young, 2000). In media, the oligopoly market structure is best represented by the network television industry (Albarran, 2002).

Monopoly. As mentioned earlier, a monopoly market has only one seller who is the only provider of a kind of product or service in a given market. In microeconomics, monopolists are regarded as price maker or price setter, whereas buyers only decide whether or not to purchase. Local utility companies are all monopolists. Also, most local newspapers are considered as local monopolists.

Concentration Ratio

To determine which market structure SL belongs to, the concentration ratio has to be determined. Common measures are four-firm concentration ratio (CR4), eight-firm concentration ratio (CR8), the Lorenz Curve, and the Herfindahl-Hirschman Index (HHI) (Carlton & Perloff, 2005). For this study, the CR4/CR8 is a better measure because the largest four and the largest eight businesses are identifiable. Other measures such as HHI, requiring the market share data of all firms in a given market, are almost impossible to utilize because the number of businesses in SL is so vast and is ever increasing daily.

The CR4/CR8 represents the market share, as a percentage, of the four/eight largest firms in the industry. Market share can be measured in various ways, but in media industries revenue (sales) or audience (circulation or rating data) concentration prevails (Albarran, 2002). Since sales revenue of each SL business is not accessible, this study examines audience concentration instead. To calculate audience concentration of the largest 4 and the largest 8 businesses, audience traffic of those businesses will be divided by the total traffic of SL. The rule of sum is that a market is highly concentrated if CR4≥50 percent (CR8≥75%), moderately concentrated if CR4 between 34 percent and 49 percent, and lowly concentrated if CR4≤33 percent (CR8≤50%) (Hoskins et al., 2004).

Generic Strategies

There are many ways to evaluate a business strategies (e.g., Miles & Snow, 1978; Kotha & Orne, 1989), but the three primary generic strategies that

most companies follow in order to gain competitive advantage are Porter's (1980) cost leadership, differentiation, and focus.

Cost leadership. Cost leadership is a strategy adopted by a firm which sets out to become the low-cost producer in its industry. A typical low-cost producer sells a standard product and places considerable emphasis on reaping scale or absolute cost advantage from all sources. However, the strategic logic of cost leadership usually requires one firm for this position in one industry. This means that there is only one cost-leader in a specific market. Thus, cost leadership is a strategy particularly dependent on preemption, not pursuable for every firm.

Differentiation. The second generic strategy is differentiation, usually adopted by a firm which seeks to be unique in its industry along some dimensions that are widely valued by buyers. Differentiation can be based on product itself, the delivery system, the marketing approach, and so on. For instance, few people thought of news as a product that could be differentiated, but with clever framing (Reese, 2001), cable all-news networks (e.g., CNN and Fox) showed news indeed could be differentiated products (Bae, 2000). In contrast to cost leadership, Porter (1985) emphasized that there can be more than one successful differentiation strategy in one industry. A good example is the case of Internet access: some firms provide dial-up service which is cheap but slow; others offer fast but more expensive cable and ADSL services. Both types of firms are profitable and have their loyal customers because of product differentiation.

Focus. The third generic strategy, focus, is quite different from the others because it rests on the choice of a target segment within an industry. For example, instead of serving the general public like *USA Today* does, *Wall Street Journal* presents a focus strategy to meet the special needs of business people. The focus strategy has two variants: a cost-focus firm seeks a cost advantage in its target segment; while a differentiation-focus firm seeks differentiation in its target segment.

Stuck in the middle. Porter's (1980) contention is that viable businesses must seek a low cost, a differentiation, or a focus strategy; a firm that is stuck in the middle will compete at a disadvantage. Empirical studies also found that superior performance was achieved through the adoption of a single strategy (cost leadership or differentiation or focus) not a combination of strategies (e.g., Parnell & Hershey, 2005). With these basic rules in mind, this chapter attempts to evaluate the way SL largest businesses position themselves and to suggest a guideline for achieving above-average performance.

In short, this chapter investigates the following research questions:

RQ1: What is the concentration ratio of largest businesses in SL?
RQ2: What is the market share of RL-backed businesses in SL?
RQ3: Do the largest businesses in SL have any obvious strategy?

Method

To evaluate the level of audience concentration, I randomly sampled daily traffic of a constructive week from Q1 2007 in SL for the largest SL businesses and the RL-back businesses in SL. Daily traffic, reflecting data as of midnight the previous day, was reported by Linden Lab in-world. Linden Lab calculated traffic for each parcel based on the number of residents visiting and the amount of time residents spent on that parcel in a 24-hour period (SL History Wiki, 2005). For example, if I was online for 1 hour and spent 20 minutes on resident A's parcel and 40 minutes on resident B's parcel, resident A would get 33 percent of my points and resident B would get 66 percent. Alternately, if I only spent 10 minutes online and spent all of it on resident A's parcel, resident A would receive all of my traffic points. The formula to calculate daily traffic for each parcel in-world is as follows:[4]

$$DT = cons \tan t \left(\sum_{i=1}^{n} \frac{Y_i}{X_i} \right),$$

where *DT* represents the daily traffic of a parcel, constant is the total traffic points each resident can bestow each day,

X is the total minutes a resident spent in-world,

Y is the total minutes a resident spent on the parcel and *Y* must be more than five sequential minutes,

i represents the number of residents who visited the parcel.

Although traffic report of each parcel is available in-world the next day, Linden Lab is reluctant to disclose either the total traffic of SL or the total traffic points each resident can bestow each day (i.e., the constant). However, an experiment done by an in-world resident, Charlton (2006), who placed 4 avatars online for 24 hours in her private parcel, obtained a traffic report the next day as 3200+. From this experiment, I am able to estimate the constant is around 800, which is echoed by another resident, Granville (2006), who claimed "788 points [are] awarded for a single resident managing to be on a parcel for 24 straight hours."

Since SL defines "separate parcels owned by the resident or group are counted as if they were the same parcel," this chapter treats each parcel as an individual- or group-owned business. Therefore, a parcel is termed as a business unit hereafter.

To evaluate strategies of the largest businesses in SL, I collected data from the short introduction in the search box provided by each business owner. For residents who perform a search for a business either by entering keywords or by parcel names, the short-text introduction is usually the first impression residents receive of the kind of businesses being conducted. The short-text introduction usually includes different activities (e.g., dance, escorts, free money) a business provides.

Results

Largest Businesses in SL

The measure of CR4 and CR8 revealed that SL was a lowly concentrated market. Throughout Q1 2007, the CR4 was around 2.4 percent and CR8 was slightly above 4.5 percent (see Table 10.2). As aforementioned, if CR4≤33 percent (CR8≤50%), the market is considered lowly concentrated. In fact, the percentages are way below the cutting points, which fits the definition of a "nearly perfect competition." This type of market structure represents many small businesses producing a homogeneous product and an entry or exit of a business has no discernible effect on the market. In real life, a market comparable to SL is the agriculture market where the CR4 is less than 5 percent (Wikipedia.org, 2007).

Table 10.2 Estimated market share of largest businesses in SL

Largest SL Business	Average Traffic per Day	Estimated Market Share (%)
ELEMENTS	119,749	0.71
! NUDE BEACH	99,369	0.59
Neva Naughty	97,647	0.58
ParrotHead Gamers	92,908	0.55
CLUB ARSHEBA	90,547	0.53
A VIRTUAL FESTIVAL	90,250	0.53
! SEXY LAND	88,149	0.52
! South Beach Miami	87,159	0.51
Total Traffic of SL	16,970,400	100.00
CR4	409,673	2.41
CR8	765,778	4.51

* Since the average concurrency per day in Q1 2007 is 21,213; and the estimated traffic points per person is 800, the estimated total traffic in-world is 16,970,400.

In terms of market share, the largest business, ELEMENTS, generated 119,749 traffic points or .71 percent of total traffic. The second largest, ! NUDE BEACH, generated 99,369 or .59 percent, followed by Neva Naughty which generated 97,647 or .58 percent. The fourth largest, ParrotHead Gamers, generated 92,908 or .55 percent (see Table 10.2). In sum, this study found that the market structure of SL was lowly concentrated, a nearly perfect competitive market.

Great Turnover in SL

There is another piece of evidence that may reinforce the fact that SL businesses are operating in a nearly perfect competitive market with free entry and exit. Table 10.3 shows a turnover ratio of 100 percent between 2005 and 2007. Compared with 2007, none of the largest businesses in 2005 remained the same; and two (i.e., Night Mountain and Spinnaker Gaming) had even dropped out of the SL market. The businesses still operating in 2007 were no longer the largest. For example, the largest business in 2005, Luskwood, could only generate one sixth of ELEMENTS's traffic per day. Other large businesses in 2005 such as Club Cherry Charming and Moonshine Casino had received just several hundred traffic points each day. In terms of business segments, casinos and gaming occupied half of the largest businesses in 2005, whereas clubs represented the majority of largest businesses in 2007. Later I will discuss in detail about the kind of services each of the largest businesses provides and will examine its competitive advantage. In sum, the title of "largest businesses in SL" is transient and unstable.

Table 10.3 Great turnover of largest businesses in SL

Largest Businesses in 2005*	Traffic in 2007	Largest Businesses in 2007	Traffic in 2007
Luskwood	19,011	ELEMENTS	119,749
Heisenberg Casino	16,052	! NUDE BEACH	99,369
Chaos Theory Gaming	6,802	Neva Naughty	97,647
Textures Unlimited	2,886	ParrotHead Gamers	92,908
Club Cherry Charming	701	CLUB ARSHEBA	90,547
Moonshine Casino	282	A VIRTUAL FESTIVAL	90,250
Night Mountain	—	! SEXY LAND	88,149
Spinnaker Gaming	—	! South Beach Miami	87,159

* Data collected in October 2005.

Table 10.4 Estimated Market Share of Largest RL-backed Businesses in SL

RL-backed Business in SL	RL Company	Average Traffic per Day	Estimated Market Share (%)
The L Word in Second Life	Showtime	12,101	0.07
Mercedes Benz Island	Mercedes Benz	5,326	0.03
Nissan Sentra	Nissan	4,904	0.03
Sheep Island	The Electric Sheep Co.	4,271	0.03
Fairgrounds Speedway	Pontiac	3,635	0.02
Sun Pavilion	Sun Microsystems	2,175	0.01
Toyota Scion City	Toyota	2,074	0.01
**NETg Training	Cisco, Microsoft, and others	1,837	0.01
Reuters	Reuters	1,631	0.01
AOL Pointe	AOL	1,437	0.00
Total Traffic of SL		16,970,400	100.00

RL-backed Businesses in SL

Referring to Table 10.2, every single one of the businesses is resident-run despite the presence of so many real life companies and organizations in this virtual world. However, the RL-backed businesses are gaining attention (see Table 10.4). Among them, The L Word in SL,[5] backed by Showtime Networks, had an average traffic of 12,101 per day, outperforming other RL-backed businesses by more than 127 percent. As of Q1 2007, auto companies such as Mercedes Benz, Nissan, Pontiac, and Toyota, were performing relatively better than other tech companies like Sun, Cisco, and Microsoft in terms of traffic concentration. As for market share, even the ten largest RL-backed businesses as a whole, sharing 0.22 percent of total traffic, were having fractional impact on the SL market during Q1 2007. Nonetheless, it is too soon to draw any conclusions from Table 10.4 because there will certainly be more real life companies joining this virtual economy.

Generic Strategies in Nearly Perfect Competition

Once the market structure of SL is identified, the next question is: "Do the largest businesses in SL have any obvious strategy and how would it be possible to create and sustain a competitive advantage for these businesses in a perfect competitive market?" In microeconomics, if the SL market is diagnosed as nearly perfect competition, it may produce two outcomes: (1) SL business

owners make no attempt to brand their products or services, and (2) SL residents are unaware whether they go to ! NUDE BEACH or ! South Beach Miami because of their homogeneity (Hoskins et al., 2004). This implies that market structure has a determinative power on the conduct and performance of all businesses in a market so owners should choose to adapt to existing condition rather than attempt to influence them. In strategic management, however, scholars believe a well-positioned company can still earn above-industry-average profits. According to Porter (1985), "A firm that can position itself well may earn high rates of return even though industry structure is unfavorable and the average profitability of the industry is therefore modest" (p. 11). For a holistic understanding of the SL market, I made a strategy evaluation of the largest businesses in addition to the market structure analysis.

Table 10.5 shows the parcel size of and services provided by the eight largest businesses in SL. I found that seven out of eight businesses operated on land that encompassed over 60,000 square meters to maintain which Linden Lab charged its owners up to US$295 each month. However, ! NUDE BEACH, which only consisted of one fifth the size of other large businesses, kept its monthly maintenance fee down to only US$75. Based on an equivalent amount of traffic other businesses were generating, ! NUDE BEACH presented a cost leadership strategy if other input costs were all equal.

To evaluate differentiation, the services uniquely provided by one of the eight largest businesses are underlined and totaled in Table 10.5. I found ! SEXY LAND (14 unique services), ! NUDE BEACH (10 unique services), and ParrotHead (9 unique services) Gamers were relatively better service differentiators. Based on the services provided, ! SEXY LAND mostly specialized in shopping; ! NUDE BEACH mainly sold itself as a place to relax; ParrotHead Gamers was more unique in its various games. On the other hand, ELEMENTS (2 unique services) and A VIRTUAL FESTIVAL (3 unique services) provided services which overlapped much with others. According to Porter (1980), a business that can not achieve and sustain differentiation will be a below-average performer in its market. However, the reason why ELEMENTS is able to be low in differentiation but high in traffic is likely because of its leader advantage. For example, if a resident wants to find a place to dance, he/she can type "dance" in the search box, a list of businesses sorted by traffic from high to low will be displayed, and ELEMENTS will be the first one on the list. Nonetheless, the leader position may not be sustainable because of the perfect competitive market structure, so ELEMENTS risks getting demoted from being the first on the list if it is not creating unique services for residents.

Lastly, it is not clear whether any of the eight largest businesses in SL selects a segment in the market and tailors its strategy to serving them to the

Table 10.5 Services provided by the largest businesses in SL

Largest SL Business	Parcel Size (m²)	Services*	Number of Unique Services
ELEMENTS	65,536	The Best Looking Club in SL, Escorts, Girls, Music, Dance, Sex, Adult, Women, DJ, Erotic, XXX Fun, Nude Events, Money, Contest, Free Prizes, Sploder	2
! NUDE BEACH	13,248	Martin Mounier, FKK, Nacktbaden, Cosy, Skinny-Dipping, Laguna Nude Beach, Nudity, Waves, Romantic Place, Sunset, Relax, Strand, Laguna Bay Nude Beach	10
Neva Naughty	65,040	Free Sex Orgy Room, Free Movie Theater, Multimenu, Sex, Furniture, Sex Animations, Sex Attachments, XXX, BDSM, Outdoor Furniture	6
ParrotHead Gamers	65,520	Bingo, Slingo, Solo, DmC, Devil May, Pizza, Greedy, Camping, YarTsee, Free Money, Money Tree, Slots, Air Hockey, Games, Black Jack	9
CLUB ARSHEBA	65,536	Hot Sexy Girls, Sex, Exotic, Erotic, Dancers, Escorts, Girls, Women, Lesbian, Slingo, Stripper, Nude Jobs, Lap dance, Adult, Free Money, Hot Prizes, Sploder	5
A VIRTUAL FESTIVAL	63,584	Festival Island, Psytrance Rave Party, Dancing Bungee Club, Camping Money, Chairs, Spots	3
! SEXY LAND	65,536	free sex, orgy, nude, XXX, FKK, France, Italia, BDSM hot beach, girls, dungeon, dance, bondage, Deutsch, camping, shopping mall, silks, lingerie, shoes, jewelry, boots, clothes, shop, fuck, fun	14
! South Beach Miami	65,536	Strip Club, Casino, Beach, Hippie, Pay Music, Dancing, Dance Gambling, DJ, Free Money, Sex, Nude, Erotic, Escorts, Girls, Women, Adult, Blackjack, Slots, Sportsbook, Bet, Bingo	6

* The underlined letters are unique services provided by the respective business. Also, several terms may be unfamiliar to those who are not well versed with SL lingo. For example, "Slingo" means a place that welcomes new SL residents; "Martin Mounier, FKK, Nacktbaden, Cosy" are names of residents, usually VIPs of a parcel.

exclusion of others. According to Porter (1985), focus involves deliberately limiting potential sales volume, so a focus strategy, by its conception, is more applicable to smaller businesses. However, Table 10.5 did show that some businesses were providing services that only target on certain residents. For example, CLUB ARSHEBA attempted to appeal lesbians; ! SEXY LAND seemed European friendly; and ! South Beach Miami provided some activities for sports fans, but it was not conclusive whether the focus strategy or the differentiation strategy results in popularity.

Conclusion

Virtual worlds are flourishing and their growth seems likely to continue. These days youngsters spend a lot of time in 2-D social networks such as MySpace, Facebook, and Bebo; others have joined up in Habbo, Zwinktopia, Webkinz, Gaia Online, and the like. It's likely that several belonging to this generation will migrate to the more sophisticated systems that Second Life and other virtual realities require in the future. These virtual worlds already represent an area of e-commerce that is booming when other sectors are having difficulty surviving. According to a study conducted by Parks Associates, online gaming which was a $1.1 billion industry in 2005 will escalate to a $4.4 billion industry by 2010 in North America (Show Initiative LLC, 2006).

This chapter has attempted to describe some of the unique features of microeconomics in a virtual world known as Second Life (SL). I applied a market structure analysis to the SL market and evaluated competitive advantage of the SL businesses. The analysis using CR4/CR8 ratios demonstrated the SL market was structured in a manner consistent with a nearly perfect competition. As a result, each business represented an insignificant portion of the market; and businesses, large or small, risked great turnover. Although the reason why the two largest businesses in 2005 are no longer operating is unknown, a basic guideline for current business owners is: as long as the revenue earned from the business is more than the incurred variable costs, the business should keep running rather than shutting down. However, a piece of advice for potential entrants is that the SL market may not be as profitable as outsiders thought because of its nearly perfect competitive market structure.

An evaluation of largest businesses in SL indicated that some owners were learning the ropes of how to do business in a virtual world but there is more room left for sustainable strategies in the SL market. Strategic management scholars suggest that business owners must make a choice about the type and the scope of strategies they desire. That is, as Porter (1985) stated, being "all things to all people" (p. 12) or "stuck in the middle" (p. 16) is a sign for below-average performance. For example, if cost

leadership is the goal, in addition to a low monthly maintenance fee, ! NUDE BEACH should find and exploit all sources of cost advantage, including designing, marketing, and innovating, to become the low-cost producer. As for product differentiation, most of the largest businesses provide a wide range of services or products which are unique to its competitors, but this strategy does not lead to above-average performance unless it is sustainable compared to competitors. One way to be sustainable is for a business to possess some barriers that make imitation of a strategy difficult. For instance, if ParrotHead Gamers chooses to specialize in gaming, it has to develop all sorts of games that many SL residents perceive as creative and fun and then uniquely position itself to meet those needs. Another way to be sustainable is through advertising (Carlton & Perloff, 2005), which I did not find any of the largest businesses in SL were doing. Conversely, many smaller businesses were taking advantage of the SL classifieds. Although these smaller businesses are not able to get on the list of popular places, placing an ad is a differentiation strategy for a business to create business visibility or brand loyalty, as long as its profits rise more than the advertising expenditures. Another generic strategy worth pursuing is the focus strategy. In SL, there is often room for a new service or product that serves a different buyer's need or a different optimal production or delivery system. For example, given that Neva Naughty's "furniture" makes it on the top of a keyword search list, the furniture retail is a good candidate of a focus strategy for Neva Naughty to pursue.

The in-world market changes everyday. Any big investment, especially from RL companies, can change the entire market climate. Although I found that the RL-backed businesses as a whole have fractional impact on the SL market during Q1 2007, resident-run business owners should not overlook the economic impact of RL-backed businesses in the future. Some may believe that RL companies arrive in SL only for a presence or self-promotion, but others predict a number of them will eventually understand the nature of SL and succeed as part of the virtual economy. A notable example is IBM, which had sent 1,000 employees spending time in SL and three executives working full-time on SL projects (Cane, 2007).

There are at least two limitations of the study, however, each of which also connotes a direction for future research. The first limitation is my estimation of total traffic in SL. I have requested the number from Linden Lab for several times, but their responses cited the volume of academic requests in rejecting access to data (personal communication, January 29, 2007; February 4, 2007; February 20, 2007; March 9, 2007). Since Linden Lab records the traffic points for each parcel and they must have total traffic points for all the parcels, I anticipate a more research-friendly Linden Lab in the future. Second, it is not sufficient to conclude the type of market structure SL is without monitoring it for a long period of time given the

changing nature of businesses in the virtual world. If diversity is the goal of SL economy, the current environment is competitive and healthy in nurturing differentiation. On the other hand, if the in-world market becomes more dominated by several large businesses, the governing authority in SL may have to decide whether it is in the residents' best interest.

Notes

1. Avatar is a resident's representation of himself or herself.
2. Linden Dollar (L$) is a virtual user-to-user currency which residents use to buy and sell virtual or real goods and services in SL. The latest exchange rate is one US dollar to 267.4 Linden dollars (see Table 10.1).
3. A basic account is free and includes access to events, shopping, building, and scripting. A premium account, which requires a monthly membership fee, allows a member to own land on which the member can build, display, entertain, and live.
4. The formula is developed by the author based on the text description of traffic by Linden Lab.
5. "The L Word in Second Life" is a virtual world experience for fans of the Showtime television show. L Word fans can track community events and explore beautiful virtual settings taken from show locations.

References

AFX News Limited. (2007). Virtual designers busy in online worlds [Electronic Version]. *AFX International Focus.* Retrieved February 26, 2007 from http://www.lexisnexis.com/us/lnacademic/home/home.do?rand=0.5358514149031219.

Albarran, A. B. (2002). *Media economics: Understanding markets, industries, and concepts* (2nd ed.). Ames, IO: Iowa State Press.

Bae, H.-s. (2000). Product differentiation in national TV newscasts: A comparison of the cable all-news networks and the broadcast networks. *Journal of Broadcasting & Electronic Media, 44*(1), 62–77.

Bain, J. S. (1959). *Industrial organization.* New York: John Wiley & Sons.

Cane, A. (2007, January 24). Surely, they cannot be serious. *Financial Times,* p. 1.

Carlton, D. W., & Perloff, J. M. (2005). *Modern industrial organization* (4th ed.). Reading, MA: Addison-Wesley.

Castronova, E. (2001, December). *Virtual worlds: A first-hand account of market and society on the cyberian frontier.* Retrieved January 12, 2007, from http://www.geog.psu.edu/courses/geog497b/Readings/Virtual%20World%20Real%20Economy.pdf

Castronova, E. (2005). *Synthetic worlds: The business and culture of online games.* Chicago: University of Chicago Press.

Charlton, C. (2006, September 3). *Is the traffic system broke?* Retrieved March 22, 2007, from http://forums.secondlife.com/showthread.php?t=134595&highlight=traffic

Granville, C. (2006, September 2). *Proposal: Changes to popular places.* Retrieved February 27, 2007, from http://forums.secondlife.com/showthread.php?t=134428&highlight=proposal+traffic

Guardian.co.uk. (2006). The profits of virtual insanity [Electronic Version]. *Guardian Unlimited.* Retrieved December 8, 2006 from http://www.guardian.co.uk/technology/2006/dec/08/comment.business.

Hof, R. D. (2006). Online extra: Virtual worlds, virtual economies [Electronic Version]. *BusinessWeek.* Retrieved May 1, 2006 from http://www.businessweek.com/magazine/content/06_18/b3982010.htm?chan=search.

Hoskins, C., McFadyen, S., & Finn, A. (2004). *Media economics: Applying economics to new and traditional media.* Thousand Oaks, CA: Sage Publications.

Kotha, S., & Orne, D. (1989). Generic manufacturing strategies: A conceptual synthesis. *Strategic Management Journal, 10,* 211–231.

Linden Lab. (2008). Economic Statistics (Raw Data Files) [Electronic Version]. Retrieved July 1, 2008, from http://secondlife.com/whatis/economy-data.php.

Linden, Z. (2007, February 9). *State of the virtual world - Key metrics, January 2007.* Retrieved March 13, 2007, from http://blog.secondlife.com/2007/02/09/state-of-the-virtual-world-%e2%80%93-key-metrics-january-2007/

Miles, R. E., & Snow, C. C. (1978). *Organization strategy, structure, and process.* New York: West.

Parnell, J. A., & Hershey, L. (2005). The strategy-performance relationship revised: The blessing and course of the combination strategy. *International Journal of Commerce and Management, 15*(1), 17–33.

Porter, M. E. (1980). *Competitive strategy: Techniques for analyzing industries and competitors.* New York: The Free Press.

Porter, M. E. (1985). *Competitive advantage: Creating and sustaining superior performance.* New York: Free Press.

Reese, S. D. (2001). Framing public life: A bridging model for media research. In S. D. Reese, O. Gandy, & A. Grant (Eds.), *Framing public life: Perspectives on media and our understanding of the social world.* Mahwah, NJ: Lawrence Erlbaum Associates.

Scherer, F. M., & Ross, D. (1990). *Industrial market structure and economic performance* (3rd ed.). Boston: Houghton Mifflin Company.

Second Life Herald. (2006, November 24). *Herald exclusive: It's official - Anshe Chung is a millionaire! [Updated].* Retrieved March 22, 2007, from http://www.secondlifeherald.com/slh/2006/11/its_official_an.html

Show Initiative LLC. (2006, August 29). *Online game market to grow to $4.4 billion in North America in three years.* Retrieved February 18, 2007, from http://www.showinitiative.com/media/8-29-2006.html

SL History Wiki. (2005, January 12). *Traffic.* Retrieved March 22, 2007, from http://slhistory.org/index.php/Traffic

Terdiman, D. (2006, October 26). *Newsmaker: Reuters' "Second Life" reporter talks shop.* Retrieved January 18, 2007, from http://news.com.com/Reuters+Second+Life+reporter+talks+shop/2008-1043_3-6129335.html

Wikipedia.org. (2007). *Concentration ratio.* Retrieved March 12, 2007, from http://en.wikipedia.org/wiki/Concentration_ratio

Young, D. P. T. (2000). Modeling media markets: How important is market structure? *Journal of Media Economics, 13*(1), 27–27.

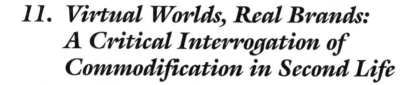

11. Virtual Worlds, Real Brands: A Critical Interrogation of Commodification in Second Life

Jia Dai

The recent phenomenon of the 3-D online digital world Second Life represents an important emergent form of online communication. With its vast digital lands, diversified communities, various life experiences, and opportunities developed and consumed by creative residents, it has grown explosively into a virtual world in which "the only limits are imagination" (Second Life, 2006d). At the same time, this enormous power of creation and consumption signifies a new commerce potential to the real-world business, which is always alert to any possibility in extending and maximizing its market.

This commerce potential is represented by emergence of a new breed of agencies that are breaking new ground in bridging businesses into virtual worlds, such as Millions of Us and Rivers Run Red. For example, Millions of Us presents itself as "a company dedicated to helping businesses understand and harness the power of virtual worlds" (Millions of Us, 2006a). Likewise, Rivers Run Red is "an immersive spaces company, working to develop virtual worlds as a new channel to engage in communities, reach consumers and build brand experiences" (Rivers Run Red, 2006).

The effort in helping businesses to control consumerist power of the virtual world brings about the questions of commodification of Second Life—the process through which use-value is transformed into exchange-value (Mosco, 1996). In particular, how the use-values of Second Life (its ability to meet individual and social needs such as exploring an imaginary

world, practicing diversified identities and social networking, etc.) is transformed into exchangeable value that is determined by what they can bring in the marketplace (e.g., to allure advertisers and make profits). This chapter takes a close look at the process of commodification of Second Life by examining the strategies taken by the marketing agency Millions of Us that gear the content and residents' activities of Second Life toward business desire. Discussed are the commodification of (1) user generated virtual content and environment in Second Life; (2) residents' consumption behavior cultivated by corporations' relationship marketing and brand immersion strategies, and (3) residents' labor—working as product testers and open source participants in the service of brands building. The chapter posits that commodification orients Second Life from a world of imagination and creativity toward a world of real business, one that not only sets the boundary for imagination, but also impairs residents' power as both residents and consumers in Second Life.

Commodity Forms in Mass Communication

Marx defines commodity as an external object that satisfies human needs and is then exchanged for something else. The physical property of the commodity is the Use-value, and the value by which the commodity is compared to other objects on the market is the Exchange-Value. While the exchange-value takes the form of money, it is eventually determined by the real equivalent behind the exchange: the quantities of congealed labor-time (Marx, 1906). In the light of this Marxian notion, Mosco (1996) points out that the process of commodification is the process through which use-value is transformed into exchange-value. Commodification occurs in mass communication, for example, when media production, distribution, and consumption aim to realize the exchange-value (to generate monetary benefits in the market) rather than use-value (to inform and communicate). A Marxian analysis on commodity leads to the disclosure of *social relations* that hide behind the appearance of commodity. The political economy study of communication, for example, examines how political and monetary power influence media content and in return, how media "reinforce, challenge, or influence existing class and social relations" (McChesney, 2004, p. 43).

Mosco (1996) summarizes three commodity forms in communication: content commodity, audience commodity, and labor commodity. First, media content is a commodity in two senses: in a direct sense, the "pay-per" conception (Mosco, 1988) reveals the fact that information can be exchanged between the producer and the consumer through money (i.e., pay per view); In an indirect sense, media make profits by selling advertising time or space based on the extent of its popularity. Because of the dual

modes, Garnham suggests one address mass media as "economic entities with both a direct economic role as creators of surplus value through commodity production and exchange and indirect role, through advertising, in creation of surplus value within other sectors of commodity production" (Garnham, 1979, p. 132, as cited in Mosco, 1996, p. 147). Second, the notion of "audience commodity" (Smythe, 1981) suggests that audience is an object being exchanged among media and advertisers. Moreover, because audience works *spontaneously* to be a commodity (e.g., training themselves for brand recognition), "leisure time for most people is work time" (Smythe, 1981, p. 247). Finally, labor commodity includes both labor of producers and the use of communication systems and technologies. The former produces media content that possesses use-value and the latter expands its exchange-value by "increasing the flexibility and control available to employers" (Mosco, 1996, p. 157). For example, media synergy helps to use various products to sell one another (e.g., film, toy, and video game) so as to maximize their exchange-value.

Commodification in Digitized Media and the Web

Digitized media environment further deepened and complicated the three commodity forms of communication. Investigating the "mutually constitutive" relationship between digitalization and commodification, Mosco (Smythe, 1981) identifies three ways in which digitalization assists the implement of media commodification.

First, "Digitization expands the commodification of *content* by extending the opportunity to measure and monitor, package and repackage entertainment and information" (Mosco, 2004, p. 216). In the "Fordist" information delivering system, general messages are delivered to a mass audience that was marketed to advertisers with a rough estimate of the amount of consumer: for a price per thousand TV viewers or per thousand newspapers readers. "This system did not account for different use of the medium, nor did it make any clear connection between viewing and purchasing" (p. 216). The "post-Fordist" digitized media, however, provide a flexible system that better measures and monitors information delivery and consumption (i.e., read-on-demand). Also, repackaging of information changes the irreversibility of information delivering: now media content could be sold in multiple ways—pay per view, or with multiple endings and customized versions—that effectively maximize the market of media content.

Moreover, the recursive nature of digital systems accelerates the commodification of *audience*, as it helps to "refine the process of delivering according to both audiences' actual purchases and their demographic

characteristics" (Mosco, 2004, p. 216). Advertisers do not need to buy the undistinguished audience package from media anymore; instead, they are now able to investing only on specific sectors of audience whom they track through electronic records such as credit card information. Likewise, Schiller (2004) discusses that interactivity of the Internet communication helps to realize a more complex marketing due to its "unparalleled abilities to target well-heeled consumers' interests and tastes, to provide 'depth' to brand-related interactions, to offer transactional services, and to audit audience behavior ..." (p. 133). The online/digital environment, therefore, makes it possible to improve the one-off interaction between a producer and a consumer (e.g., physical buying behavior) to an ongoing conversation that nurtures consumers' brands recognition, appreciation, and loyalty—that is, media consumers' "relationship" with businesses. In recent years, this refining process is further reinforced by leading online shopping websites such as Amazon.com through a strategy of colligation—to recommend to subsequent customers the buying choices of the early customer based on the common choice among them.

In the mean time, media convergence provides an environment in which audience is more likely to be shared and exchanged among advertisers. As Jenkins (2006) notes, "In the world of media convergence, every important story gets told, every brand gets sold, and every consumer gets courted across multiple media platforms" (p. 3). With consumers being exchanged across multiple media platforms, either of their own free will (e.g., an earnest reader of *The Da Vinci Code* is allured to watch the movie, to rent the DVD, or vice versa), or unconsciously sold by media (e.g., personal information gathered by media companies when you rent a DVD online), audience commodities are more comprehensively exploited by mass media.

The third way in which digitization assists the implement of commodification is the "ability to *eliminate labor, combine it to perform multiple tasks,* and *shift labor to unpaid consumers*" (Mosco, 2004, p. 216). The high cost of digital systems leads to the pressure to reach and maintain a high audience rating—only through this way can media attract advertisers. The result is that labor (of human and machinery) gets more exchange-value-oriented than before: it is devoted to produce and transmit content that is more sellable in the market. For example, labor is increasingly organized under the principle of multiplicity and "intertextuability" (e.g., same content fits various media formats).

Paralleling producers' labor commodification is the shift of labor to unpaid consumers. Mosco notes that companies now sell software undebugged (to shorten the time in production) on the understanding that there are chances of remedy (in the form of updates) and that customers "will report errors, download and install updates, and figure out how to work

around problems" (p. 217). The "participatory culture" (2006) made possible by increased accessibility to various hard- and software for computers and involves collaborative problem-solving is a telling evidence of this trend. Similarly, Benkler (2006) observes a shift "from the highly constrained roles of the employee and consumer in the industrial society to the flexible, self-authored roles of user and peer participant in cooperative ventures" (p. 175). These phenomena show that the boundary between producers and consumers is merging, supporting that what Toffler (1980) calls as "prosumer"—a combination of producer and consumer—has come into being.

Digital play spaces further blurred the boundary between producer and consumer. Kline et al. (2003) identify five aspects to illustrate in detail how in game media people play games while working for the benefits of the industry—a fashion they all as "play as work": "the marriage of gaming with market research; the 'laboratory' model of interactive entertainment centers; the use of game testers and expert gamers by major manufacturers; the use of shareware and player editing to add value to games; and the role of gaming culture as a training-and-recruitment arena for the industry" (p. 202). Being incorporated as either a tester or a contributive editor, players' "play" is increasingly blurred with the "work" for others' commercial benefits.

How do these ideas about commodification in mass media, especially digital media, relate to Second Life? As a new form of mass communication, would an examination of Second Life offer new evidence of commodification? The following sections analyze how the three forms of commodification as discussed above is further developed and present new characters in Second Life.

Launching Real Brands in Second Life

With a logo of "your world, your imagination," Second Life delivers an image of socially spontaneous, participatory, egalitarian, and creative space that encourages and protects individual creativity. In *The Wealth of Networks*, Benkler (2006, pp. 74–75; 136) uses Second Life as a primary example of the grassroots power being unleashed through peer production and sharing. Arguing in favor of the democratizing and egalitarian nature of the "decentralized nonmarket productions" such as Second Life, he writes about the participants as

> substantially more engaged participants, both in defining the terms of their productive activity and in defining what they consume and how they consume it. In these two great domains of life—production and consumption, work and play—the networked information economy promises to enrich individual autonomy substantively by creating an environment built less around control and more around facilitating action. (pp. 138–139)

While Benkler's optimistic view indeed reflects some truth of this virtual world, it is nevertheless challenged by the marketing ambition of real-world business now. To what extent do residents in Second Life have autonomy and freedom in defining what they consume and how they consume it, if real-world monopoly companies see Second Life as a gold mine and seek to build a same powerful status in it as they do in real world?

Already, there are major companies that have established a presence in Second Life such as IBM Corp., Dell Inc., and Adidas. Entrepreneurs also found promising career in helping companies of monopolies to realize their ambitions in Second Life. A recent *Fortune* article reports that there are 65 companies that have sprung up inside Second Life to serve real-world business customers, and there are at least $10 million worth of such projects underway ("It's not a game," *Fortune*, February 5, 2007).

Among them is Millions of Us, which has helped companies such as General Motors Corp., Sun Microsystems Inc., Warner Bros. Records, Microsoft Corp., among others, to launch their brand names and project their ads in Second Life. In a recent interview, Reuben Steiger, the CEO of Millions of Us describes the job of his company as thus:

> We bring real world companies into the virtual world. We help them translate what their brands and their products are about, and manifest those in the virtual environment. I think a lot of companies look at this as a great stage to get in, and ran some early experiments and see what they can do in environments like these. (2006a)

Introducing these mega-brands and monopoly corporations into the virtual world signifies a process of commodification of Second Life. The use-values of Second Life as a realm of egalitarian individualism, social network, and creativity is now gradually transformed into exchangeable values—its potential to engender consumers' desire in consumption of big brand products, and to perform as a test-bed for evaluating the market of new products.

Collecting the Evidence

This study focuses on the work of Millions of Us as the subject in analyzing the commodification of Second Life based on two reasons. First, Millions of Us was a company that sprung up as a ramification of Second Life, founded by a former manager of Business Development for Linden Lab who owns Second Life. This inherited relation makes Millions of Us an agency that may better understand the virtual world than other similar companies do, and develop strategies of brands building that more appropriately utilize the virtual environment. Second, as a leading company in the field, Millions of Us has effectively helped dozens of big name corporations launching

into Second Life; thus examining its strategy in various launching events would be revealing of how it manages the virtual environment to meet advertiser's needs.

On its website millionsofus.com, Millions of Us archived various information that documented in detail how it is helping real businesses understand and harness the power of virtual world, including the portfolios containing each large-scale launching case, CEO Reuben Steiger's own blogs, news reports about its work, videos of interviews with Reuben Steiger, leaders of client companies, and programmers in charge of launching design. These enormous documents enable the researcher reconstruct past and ongoing events that are not directly observable in-world. They also provide a comprehensive and real-time accounts of brands building in Second Life, including how Millions of Us evaluates the potential of Second Life in product marketing, how it tracks residents' response and activities, communicates with clients, and reflects on its own performance. By analyzing all relevant documents, the researcher was able to assess related evidence, and to interpret its influence in brands development of Second Life.

In addition to the information about Millions of Us, also reviewed are published documents, press reports, and proceedings of media forums and symposiums that covered business development in Second Life. For example, major news media such as CNN, CBS, *New York Times, Economist,* and *Fortune* all had discussion about the real-business entry and their impact in Second Life. Their coverage may not be representative of brands launching at large, yet they reveal much about the social responses to the new phenomenon in general.

Also, to gauge the actual effect of the launching events, and the response of residents, participant observation is conducted in the virtual sites where the brand names reside.

Analysis

Reconstructing the Virtual Environment to Accommodate Real Brands

When making a decision as to where and how to enter the virtual world, a key factor that advertisers and Millions of Us have to think about is the "location"—a fitting place that is in agreement with the characteristic of the brand or product, and will be beneficial to its future development and management. The original environment of Second Life, however, doesn't fit this realistic purpose well due to three reasons. (1) as a virtual space, Second Life encourages imagination and creation of a never experienced world, demanding a transcendency of an earthly touch; (2) Second Life is a self-sufficient

world, and residents' needs is satisfied by creations and productions in-world, making out-world resources unnecessary; and (3) Many virtual consumers already have favorites among Second Life's established product creators, such as avatar designer Fallingwater Cellardoor and Pixel Dolls. As Reuben Steiger points out, for real-world brands the critical question is how to avoid tension with the "indigenous culture" of Second Life entrepreneurs (Steiger, 2006a).

How, then, to project a real brand into the world where there seems no need of it? The resolution is to create a lifelike replica of certain real-world goods and make it indispensable to virtual life. This means to reorient or reconstruct the existent virtual environment so as to accommodates to the demand of real brands consumption. **The launching process of** Toyota **Scion** XB into Second Life illustrated how the environment in Second Life was reconstructed by Millions of Us to make room for the needs of "driving." On August 20, 2006 at the Second Life Community Convention in San Francisco, after a real-world **Scion** took a turn at a street corner and disappeared, it enters into the virtual world—a "real-virtual" connected design by Millions of Us. For the vehicle to run along in Second Life space, Millions of Us designed a road system around the Scion City (Scion headquarter in Second Life), one that is a simulacra of real road systems with zebra crossing, yellow double lanes, traffic lights and so on (as shown in Figure 11.1). Similarly, Nissan in Second Life set up an air obstacle course for its virtual drivers to have fun with.

Figure 11.1 Scion City in Second Life—virtual vehicles and road system

Source: http://millionsofus.com/blog/archives/104

Apparently, in Second Life where everybody flies, and where traveling across different places is just a click away through "teleport," road system is good for nothing. Yet in order to accommodate the introduction of automobiles, it has to be a part of the infrastructure. This reconstruction of the Second Life environment demonstrates a trend that pulls Second Life from an imagined world back to the real one, resulting in, arguably, a discouragement of imagination and creativity. Through the pre- "real auto" history in Second Life, neither do automobiles need roads (they have wings), nor the linden roads ever technically could support driving scripts—you would drive a short distance and then hit a patch where your car would fall through the road. Such an absence of a ready-made transportation system forces residents to invent alternative tools such as jet air pump. With the launch of Toyota and Nissan, however, the virtual becomes real—flying autos are back to the ground, and fancy indigenous transportation tools are edged out by "real autos" of big brands.

Removing objectionable content is another way to maintain a congenial environment to real business in Second Life. When the Second Life Liberation Army (SLLA) staged a protest against the American Apparel store in Second Life by shooting potential customers and knocking them out of the area, as a gesture to prevent consumption of corporate brands, the owner of the store quickly disabled the scripts that allowed the attack to occur (Walker, 2006). Since the "Second Life Community Standards" sets out six behaviors such as intolerance and harassment that will result in suspension or expulsion (Second Life, 2006b), a resistant protest or attack is most likely to be punished. In fact, in a response to the attack, SLLA Liaison Solidad Sugarbeet expressed a concern of residents' rights in the community when Linden Labs started selling chunks of the virtual lands to IBM, Sony, and Warner Brothers. He emphasized that SLLA's resistance to corporate control will continue (Second Life, 2006a). However, with the normal tension between real business and the indigenous culture of Second Life, it is reasonable to expect that real-world business will enhance their capability in surveillance and control in order to press "objectionable" contents.

Relationship Marketing and Brand Immersion Experience

While the entry of a brand into Second Life could be easily realized by well-designed launching events, the maintaining of it requires a long-term relationship building that embeds a brand into consumers' day-to-day experience. Traditional mass media commercial such as categorized ads in newspaper or TV commercial could not achieve such a relationship building due to a lack of interactivity between consumers and the brands. In other words, brand information is pushed to the audience without a

consideration of the audience's wants and needs, or feedback after purchasing. Digitized media do a better job in the sense that they incorporate a surveillance environment, a feedback loop, and capability of repackaging brands information to fit in multiple media to increase cross selling. Digitized media, however, do not necessarily encourage the development of a sustainable producer-customer relationship.

The uniqueness of a virtual world like Second Life provides an ideal environment to achieve this long-term relationship goal because it enables advertisers to not only monitor consumers' buying behavior, but also to comprehend their daily activity, their needs, taste, preference, and expectation in consumption that are revealed in the time streaming of everyday "life" in-world. As Justin Bovington, the CEO of London brand consultant Rivers Run Red comments, "whenever something takes 'time', in this case the time absorption taken into VW [Virtual World, note added], companies will know that the time spent is valuable and a commodity of trade. In short, the VW experience is the brand immersion experience" (Ketstugo, 2007).

The virtual environment also makes the demographics of residents in Second Life more traceable and evaluable to advertisers. For example, Razor Rinkitink, the Director of Web Services of American Apparel sees a strong overlap between Second Life users and his targeted customers: "They are sophisticated, educated, have money to spend, and fall into our target age range" (Brands-in-Games, 2006). This traceability and evaluability of Second Life users and consumers enables brands to make "accurate adjustment" to deliver their product information to those consumers who have most needs and affordability. Also contributing is 3-D online interactivity that is supported by technology such as 3-D streaming and Scalable Distributed Simulation. For example, MetaAdverse—a network of billboards placed throughout the Second Life world in high-traffic areas such as malls and clubs, could precisely measure potential customers and their behaviors: it tells how many virtual people (/resident/avatar) have faced the sign directly, for how long and from what angle and distance (Vedrashko, 2006).

Other examples illustrate how advertisers manage to engage Second Life community into the dedication to brands consumption. First strategy is to initiate social gatherings where residents that share a common interest would party for the celebration of a brand. When Warner Brothers Records promoted their artist Regina Spektor prior to the real-world launch of her new album on June 14, 2006, Millions of Us created a location in SL which "looks like an uber-hip East Village loft space," and "perfectly matched to the aspirations of the artist's core demographic—urban hipsters" (Brands-in-Games, 2006). In other words, Warner Brothers' promotion has gone beyond the traditional information-telling model to a construction of a fan community by creating an atmosphere of intimacy wherein consumers share a group identity—in this case, fan of Regina Spektor or urban hipsters—and exchange comments (as shown in Figure 11.2). Selling a product is now

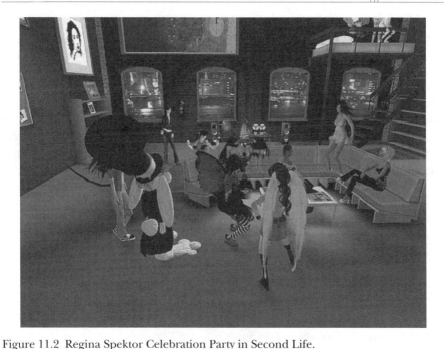

Figure 11.2 Regina Spektor Celebration Party in Second Life.

Source: http://flickr.com/photos/pathfinderlinden/163797727/in/set-72157
594160823434/

executed by selling a "sense of community" that increases brand awareness
and spreads the brand awareness through self-replicating viral processes. As
Millions of Us documented, "people who visited the location began inviting
their friends and spending hours and hours hanging out there, allowing the
project to become both popular and viral" (Millions of Us, 2006b). Another
example is the launch campaign of *Wired* magazine's virtual headquarters in
Second Life that was composed by two parts: *Wired*'s Editor-in-Chief Chris
Anderson's Second Life lecture on "The Long Tail," and a launch party
designed to resemble a giant computer motherboard (Millions of Us, 2006b).
In the magazines' headquarter, free food and drinks are provided—just like
what would be provided at a reception desk in real life.

Content creating goes hand-in-hand with building the long-term
relationship to give "props" for people to add value to their Second Life
experience that is eventually geared toward brands consumption. Pontiac
collaborates with Second Life residents who are interested in creating
content around cars to form a community of interest in the hope "to open
a conversation with Linden Lab about what it would take to improve the
physics/technical specifications behind driving/creating cars in Second
Life" (Millions of Us, 2006c). Nissan is giving away autos for free, a "bait"
that attracts consumers to use a car vending machine dispenses Sentras, a
double loop racing road, and driving sims, and so on.

How do the efforts in relationship building and immersive experience creation benefit brand name corporations? Certainly there is no instant effects for product selling in the real-world sense. But for those who can't afford a real brand such as Nissan in real world, Nissan strategy in Second Life seems to be attractive. A Nissan Santra user mentioned two nice features of this virtual infrastructure: "you can see through the windshield when in first-person view (not always true of Second Life cars), and you can actually shift gears, which I've never seen on an Second Life car before" (Millions of Us, 2007). Such a favoritism to a brand could develop into brand loyalty and stickiness in real sense, eventually exert influence when real-world consumption occurs. That is why Millions of Us devotes to cultivate a *car-culture* in a "self-expression, customization and fashion sense" (Wallace, 2006), a culture "in ways that are part of the existing culture" in Second Life (Millions of Us, 2007). In this perspective, what Eric Kintz, Vice President of Global Marketing Strategy & Excellence for HP writes about marketing in Second Life is revealing: "The bottom line is—If a brand does not understand what it takes to interact with an on-line community today, it will not have the luxury of wondering how that relationship will scale over time" (Steiger, 2006b).

Relationship building and maintaining involves enormous financial investment on programming, designing, and hiring ad agency, etc. This investment, of course, will be returned by residents' product consumption. With monetary power in hand, brand companies tend to exert strong control both in shaping virtual content and in developing relationship with customers. As Schiller (Kintz, 2007) notes, "When advertisers foot an appreciable proportion of overall media costs, they come to dominate that medium's workaday self-consciousness, one effect of which is also to place determining pressures and limits on its relationship with audiences" (p. 124).

Work by Playing: Residents' Laboring in the Service of Brands

The interactivity and immersive brand experience in Second Life indicates a reinforcement of consumer laboring in service of the interests of brand name companies. According to Kline et al. (2003), consumers' pure, free play is being encroached upon by a very un-free regime from marketers— "playing" itself is being commodified. That is, like producing labor, it becomes salable and purchasable in the market. Adopting Kline et al.'s framework in explaining the phenomenon of work by playing, the following section is devoted to the discussion as to how residents' laboring in Second Life is in the service of brands.

Recruiting Second Life talents for industry: Many talented people live in Second Life. "You walk around this place and the jaw drops 10 times a day at the genius," says John Jainschigg, director of online technology and new business development for *Dr. Dobb's Journal* (Wagner, 2007). Now genius is found to be incorporated or recruited into the brand corporations through multiple ways. Francis Chung, an in-world-grown creator of the famed Dominus Shade cars in Second Life, was commissioned by Millions of Us as the lead car creator, taking charge of developing the Scion XB as well as its customization system. A Steiger's response to a blog post about Scion reveals how the synchro operation among the brand company, the agency of Millions of Us, and Chung worked:

> We got the green light from Scion 2 weeks ago on the project and they wanted an initial version to coincide with their August 20th National Dealers' Meeting. So Francis Chung worked basically around the clock to make the silver Scion XB that we could use in a film clip for that meeting ... Scion's really really into customization—we're going to try to push that envelope as far as we can with the official launch, which will involve a dealership, the cars and some pretty sweet musical entertainment. (Hebdige, 1979)

Now a member of the Scion team, Francis Chung's *play* in-world is transformed from a self-expression and personal interest into a *work* for Scion. What does this transformation mean in the sense of commodification? First it reduces the training cost for the brand company, since the skills demanded for complicated design and creation has been obtained by the player spending his own leisure time. As Francis Chung admits, during the making of Dominus Shadow 2.0 which helped him get attention from Millions of Us, "Lots of late nights and hair pulling over the bugs and design weaknesses in Second Life, uncountable number of hours wasted on tests and experiments" (Steiger, 2006b). Residents' own play like this would obviously shorten the process of the research and development and reduce the cost for the company. Second, the established reputation of the talent contributes to the popularity of the product he is now engaged with. In Francis Chung's case, for example, Chung's fans kept paying attention to his new series of products that are now branded as Scion. Finally, a potential talent repertoire in Second Life makes possible a flexible mode of employment. Less office and less physical presence will be needed in the real world when Second Life work solves problems. Contracts will be made on project base rather than time base, leaving flexibility for brand advertisers to respond to the rise and fall of in-world trends and hotspots.

Using expert players as testers: While being recruited is a formal way through which a resident's labor is purchased by advertisers, most residents' work is taken advantage by industry through a covert way: as testers and contributors for the refining or improvement of their products—without being paid.

Scion and Nissan in Second Life have been giving out auto copies as a teaser—in the hope that residents will try them out and give constructive feedback for future improvement. In this sense, the live and experienceable characteristic of Second Life creates a "laboratory" model of interactive environment that conduce to the updating of brand products.

Open source to add value: Linden Lab defines open source as "means making the source code available for copying, and explicitly allowing users to modify their copy, and share their modified version with their friends, their customers, or the rest of the world" (Chung, 2006). However it sounds beneficial to residents, it in fact lends substantial support for corporations that turn this open technology into monetary advantage. For example, the "Nissan Altima" sim gives away some open source motion contraptions in the expectation that increasing numbers of people participating in making consumerized autos will eventually benefit brand recognition and consumption.

Conclusion and Discussion

Employing the Marxist notion of commodification—the process through which use-value is transformed into exchange-value, this chapter examines how Second Life is being commodified while advertisement agencies advance brand name corporations into the virtual world. Mosco's discussion on three forms of media commodity—content, audience, and labor in the digital environment—provides a framework for the analysis of the commodification process. The study shows that (1) user-generated virtual content and environment in Second Life is being reconstructed to accommodate brands consumption; (2) residents in Second Life are targeted by corporations' relationship marketing and brand immersion strategies that are geared toward stimulating consumption and brand loyalty, and (3) residents in Second Life, while playing on their freewill, are nevertheless at the same time laboring in the service of brands building as product testers and experiment participants.

By turning content, residents, and residents' labor in Second Life into commodity, brands advertisement and management emphasize on market interests that Second Life could bring (the exchange-value), while ignoring its function as a social network, as a platform of communication, creation, and art (the use-value). The market-driven intent and effect, as Schiller notes, "doesn't mean they can not sometimes eventuate in true artistry but rather that art itself is generally placed in harness to a narrow and exclusionary social purpose: selling" (Second Life, 2006c). One can easily imagine, for example, that with real-world business thriving and dominating in Second Life, the alternative, indigenous brands run by individual owners in-world are likely to be marginalized or eliminated—a replicate of "Big fish

eat little fish" principle of the real world. Ready-made brand products tend to encourage habitual and established life style, holding back the residents' needs and motive to imagine and create things of unrestrained fancy. Moreover, the phenomenon of "talent hunt" tips the power balance between corporations and average residents: when a talented resident is recruited by industry, his alternative, spontaneous expression stops and pursuit of massive popularity begins. Once a promising model of egalitarian social and peer production (1999, p. 128), Second Life could degenerate into an unimaginative, homogenous, and mediocre world wherein the needs of the dominant are priority—simply another real world.

Linden Lab does not show great concern about this probability of degeneration. The founder Philip Rosedale discusses how brand corporations in Second Life would not develop into monopolies like the ones in real world. His argument is that first, in Second Life there is not such a thing as land scarcity in the real-world sense, so if one patch did become homogenous, residents would exploit others; second, economies of scale which lends advantages to brand companies over average artisans simply does not work in Second Life, because there is no manufacturing cost to minimize (Benkler, 2006). In short, Rosedale suggests that real brand business in-world does not impair average people's rights and interests of their virtual adventure; rather, one has enough space to develop his own career in Second Life in a free, unconstrained way.

Rosedale's argument could easily be refuted, however. The logic of capitalistic market determines that any space that is trafficked and eyeball-intensive is bound to be sought after and exploited by corporations. However unlimited the virtual world is, corporations' influence could be as much extensive and pervasive. Also, the argument that "in Second Life there is no manufacturing cost to minimize" is misleading in that it only sees the manufacturing cost as the cost of reproducing, without taking into account the cost of designing and marketing. An average resident could create a product with a zero cost, but to popularize the invention may require finance-intensive, technologically sophisticated and professional-demanded labor—advantages for brand corporations, but disadvantages for average residents.

The result of brands dominance in Second Life, therefore, is the recurrence of the power law—a "predictable imbalance" with a small portion of well-known brands holding a large portion of the wealth and resources (e.g., attention, popularity, etc.) in the free virtual world. Second Life's recent plan to sell real names has signaled this trend. CNET reports that Linden Lab has decided to charge a $100 setup fee and a $50-a-year maintenance fee on individuals who want a real last name, and a $1,000 setup fee (unlimited accounts) and $500 a year on companies to keep their corporate name. That means companies like Sun would populating the world with last

names like "SunMicrosystems" rather than random names selected from a defined list (The *Economist*, 2006). Although the original intention of the real name system is reportedly to encourage more famous people such as executives, political candidates "to use Second Life as a virtual soap box" (CNET News Blog, 2006), brand corporations seem to be the big winner. A real name will automatically transform brand popularity and recognition from real world to Second Life, leaving the indigenous small business owners and producers disadvantaged. The $1,000 setup fee and $500 year maintenance fee may put small start-ups in-world under economic pressure; even if not so, with a stronger payment power, brand companies may receive better service and encourage Linden Lab to develop a hierarchical service system (e.g., VIP member) that further benefits the wealthy. One can also imagine, if brand companies cooperate with Linden Lab to develop some complicated scripts or tools that are beyond average residents' grasp, then there will be less participants and more onlookers in Second Life. In the mean time, the fact that following a real brand is less cognitively challenging than digging up a new one among countless brands in-world speaks a favoritism toward established brands on the consumers' side.

In summary, the analysis of commodification of Second Life presented in this chapter maintains that Second Life (its overall virtual environment, residents, and residents' labor) is sold as a commodity, through advertisement agencies, to brand corporations, in the service of their market benefits. The result of the "selling" is an infringement of residents' rights in pursuing virtual life in a fair and egalitarian environment, and damage to a rich, imaginative, and creative virtual culture.

Media's adaptation to the needs and values of those in power in society is not a new topic. It is often deemed as traditional, natural and is taken for granted. One would question, for example, what's wrong with companies getting more presence in Second Life? What's wrong with the principle of survival of the fittest in Second Life? After all, it seems to have worked well in real life.

It is the very notion that what exists does so because it is natural and good that this study rejects and criticizes. What exists seems natural and good because media has left out controversial issues to comply with commercial interests. In the case of Second Life, marketing strategies taken by corporations such as reconstructing the virtual environment, promoting immersive brand experience, and exploiting residents' labor all seem not to be problematic, because they are under the disguise of Second Life's open and fair appearance. As Linden Lab claims, Second Life is a "bourgeoning online society, shaped entirely by its residents … with potential only limited by their imaginations" (Turner, 2007). Also as Benkler (2006) notes, "in the world of Second Life, the individual is treated as a fundamentally active, creative human being, capable of building his or her own fantasies, alone and

in affiliation with others" (p. 136). This study shows, however, that residents' imaginative and creative behavior is actually limited—real business does not want you to imagine or create anything that would not benefit their market interests; and if you do, it will stop it with capital leverage. O'Brien's (2007) comment insightfully points out that Second Life's framework "reflects the real world capitalist society in which Linden Lab exists. Second life as a cultural institution of the superstructure expresses and legitimizes its capitalist base." This comment attests to what Kline et al. (2003) described about the fate of pure, free play in a digitized environment: Once socially spontaneous, participatory and intimate, free play nevertheless "has been encroached upon by a very un-free regime of invitations, pressures, surveillance, and solicitation from marketers" (p. 245).

This study does not deny the progressive force and character that is represented by Second Life, as has been commended amply as an example of ideal new media of "social production" by Benkler (2006); yet given what has been found here, it is also reasonable to not believe that Second Life or any other online digital world is imbued with inherent advancement that excels other media. Hopefully this study alerts people of the danger of the commodification of Second Life, and drives away any social conformism (2003) that reinforces acceptance of what exists but avoids raising basic questions of social structure of power. Conforming to the commodification in Second Life, one will not ask question as to whether it deviates from its original liberal intention: "Your world, your imagination." If Second Life is going to amount to what it is claimed or believed to be, it is going to require collective residents who are sensitive to the commodification trend and willing to take effective actions against it.

Acknowledgement

The author thanks Dr. Don Heider and Dr. Sharon Strover for the depth and generosity of their comments.

References

Benkler, Y. (2006). *The wealth of networks : how social production transforms markets and freedom.* New Haven, CT: Yale University Press.

Brands in Games. (2006). Panel on marketing to virtual avatars, Part 2. Retrieved August 01, 2006, from http://www.vedrashko.com/advertising/2006/06/panel-on-marketing-to-virtual-avatars_23.html

Chung, F. (2006). Dominus Shadow 2.0 now available! Retrieved August 3, 2006, from http://www.nafii.com/DoMoCo/?p=42

CNET-News-Blog. (2006). "Second Life" to begin selling real names. Retrieved July 20, 2006, from http://news.com.com/2061-10797_3-6125932.html

Hebdige, D. (1979). Subculture: The unnatural break. In *Subculture: The meaning of style*. London: Methuen; Routledge.

Jenkins, H. (2006). *Convergence culture: where old and new media collide*. New York: New York University Press.

Ketstugo, K. (2007). *Second Life Liberation Army rally and protest*. Retrieved January 03, 2007, from http://slla.blogspot.com/2007/03/second-life-liberation-army-rally-and.html

Kintz, E. (2007). *Marketing in Second Life*. Retrieved April 09, 2007, from http://millionsofus.com/blog/archives/198

Kline, S., Dyer-Witheford, N., & Peuter, G. D. (2003). *Digital play: The interaction of technology, culture, and marketing*. Montreal: London McGill-Queen's University Press.

Linden Lab. (2007). *Join Second Life now*. Retrieved June 07, 2007, from http://lindenlab.com/

Marx, K. (1906). *Capital: A critique of political economy* (S. Moore & E. Aveling, Trans.). New York: Modern Library.

McChesney, R. (2004). Making a molehill out of a mountain: The sad state of political economy in U.S. media studies. In A. Calabrese & C. Sparks (Eds.), *Toward a political economy of culture : Capitalism and communication in the twenty-first century* (pp. 41–64). Lanham, Md: Rowman & Littlefield.

Millions of Us. (2006a). *About us: Overview*. Retrieved July 02, 2006, from http://www.millionsofus.com/about.php

Millions of Us. (2006b). *Case study: Warner Brothers records*. Retrieved July 02, 2006, from http://www.millionsofus.com/case_warner.php

Millions of Us. (2006c). Case study: *Wired* magazine. Retrieved July 02, 2006, from http://www.millionsofus.com/case_wired.php

Millions of Us. (2007). *Archive for the "car culture" category*. Retrieved July 03, 2007, from http://www.millionsofus.com/blog/archives/category/car-culture/

Mosco, V. (1988). Introduction: Information in the pay-per society. In V. Mosco & J. Wasko (Eds.), *The political economy of information* (pp. 3–26). Madison, WI: University of Wisconsin Press.

Mosco, V. (1996). *The political economy of communication: Rethinking and renewal*. London and Thousand Oaks, CA: SAGE Publications.

Mosco, V. (2004). Capitalism's Chernobyl? From Ground Zero to cyberspace and back again. In A. Calabrese & C. Sparks (Eds.), *Toward a political economy of culture: Capitalism and communication in the twenty-first century*. Lanham, MD: Rowman & Littlefield.

O'Brien, E. (2007). *Response to Jenkins' "A Second Look at Second Life."* Retrieved February 09, 2007, from http://www.henryjenkins.org/2007/01/a_second_look_at_second_life.html.

Rivers Run Red. (2006). *Key facts*. Retrieved April 03, 2007, from http://www.riversrunred.com/mission.php

Schiller, D. (1999). *Digital capitalism: Networking the global market system*. Cambridge, MA: MIT Press.

Second Life. (2006a). Community standards. Retrieved January 2, 2007, from http://secondlife.com/corporate/cs.php

Second Life. (2006b). *Exclusive interview with Second Life Liberation Army Leader (SLLA)*. Retrieved December 04, 2006, from http://www.revenews.com/wayneporter/archives/002508.html

Second Life. (2006c). *Open Source: Frequently asked questions.* Retrieved August 14, 2006, from http://secondlife.com/developers/opensource/faq

Second Life. (2006d). *What is Second Life?* Retrieved August 13, 2006, from http://secondlife.com/whatis/

Smythe, D. W. (1981). On the audience commodity and its work. In M. G. Durham & D. M. Kellner (Eds.), *Media and cultural studies: keyworks* (pp. 230–256). Malden, MA: Blackwell Publishers.

Steiger, R. (2006a). Interview with Millions of Us CEO Reuben Steiger. Retrieved December 07, 2006, from http://www.millionsofus.com/index.html

Steiger, R. (2006b). Responses to "The VR/SL Scion." Retrieved December 07, 2006, from http://blog.rebang.com/?p=972

The *Economist.* (2006). Virtual online worlds. Retrieved December 09, 2006, from http://www.economist.com/displaystory.cfm?story_id=7963538

Toffler, A. (1980). *The third wave.* New York: Morrow.

Turner, A. (2007). *Second Life charges for real names, increases identity theft risk.* Retrieved April 09, 2007, from http://www.itwire.com.au/content/view/11110/1085/

Vedrashko, I. (2006). *Advertising in Computer Games.* Massachusetts Institute of Technology, Cambridge, MA.

Wagner, M. (2007). *Dr. Dobb's launches developer resources in Second Life.* Retrieved May 09, 2007, from http://www.informationweek.com/software/showArticle.jhtml?articleID=197801114&subSection=Development

Walker, R. (2006, October 1). Selling to avatars. *The New York Times* Magazine.

Wallace, M. (2006). *Nissan, Pontiac drive into Second Life.* Retrieved December 08, 2006, from http://www.3pointd.com/20061024/nissan-pontiac-drive-into-second-life/

Part V Living in a Virtual World

12. Towards a Democratic Theory of Synthetic Worlds

PETER SPANGLER AND JAMES MORGAN

Introduction

The structure, activity, and numbers of people involved in Massively Multi-player Online environments (MMO) is similar to that of small nation-states. As these communities evolve and grow in size the government that is imposed from outside the environment becomes increasingly restrictive and there is a need for separation and revolution. Democratic governance in synthetic worlds is not only viable but also necessary for the further development of these spaces. This revolution is necessary as the current de-facto governing bodies neither adhere to nor endorse such basic documents as the Universal Declaration of Human Rights, thereby denying "residents" of these spaces any possibility of self-determinacy. In fact outside rule is frequently totalitarian and despotic.

The purpose of this chapter is to consider self-governance in synthetic worlds. To date there have been few examples of democratic organization and governance, but the examples that do exist though are worth investigation. We are interested in both the necessity and practicality of democratic governance and what self-governance could make possible. We hope to show that democratic governance in synthetic worlds is not only viable but also necessary for the further development of these spaces. Furthermore, in extending the logic of governance of these spaces the line of authority begins to blur between the computer-mediated synthetic worlds and the terrestrial reality. This is a phenomenon we term "trans-instance government." Making this argument obliges us to address what the problems and limitations of the current governance structures are, why the concept of democratic government can and should be applied in a synthetic world,

and why trans-instance governments form an important foundation of democratic theory in synthetic worlds.

The subject matter we are concerned with in this work are "games," the term should not minimize the significance of these simulated spaces. As Baudrillard has argued, simulation has the power to be more than it initially appears to be (Baudrillard, 1995). The millions of people around the world collectively engaged in different gaming environments often for a not inconsiderable investment of their time, energy, and their own money demand serious consideration. In this context we are talking about the inherent rights of a community to govern itself. More specifically we are talking about trans-instance governance with a much greater fluidity due to the ability to enter into a given community but also to exit it. The fundamental question here is, does the community have a right to be self-determined and self-governed, and what does that mean?. What are the costs and benefits of self self-governance and what needs to happen to permit this?

As an additional observation, MMO's exist in more than one place or space. These different spaces may be individual nations or may merely involve separate intellectual zones (thematic or organizational). The question of governance becomes more difficult as each "instance" of law is examined. The nearest physical analog which expresses this difficulty is international law; however international law does not deal with the trans-instantial nature of MMO spaces. International law has the advantage of only looking at one location, that of the physical body in order to determine primacy. This does not easily translate to a synthetic environment that does not exist in a physical locale.

Another form of governance is required, one that acknowledges the sovereignty of each space and attempts to make a synthesis and extension of law. This is nearly impossible as most certainly each country in which a player lives will see that their legal system clearly rules over their player. Dividing the pie up this way denies the collective trans-instance community. That is a point of interest. Voluntary communities need to be governed in a way that permits them to scale. Synthetic communities require the voluntary participation of their members (lest they exit).

Rights must be guaranteed and responsibilities must be spelled out. They must be given unto mechanisms that permit them to adapt to and react to the needs of the people and the external intersecting body of laws (the laws that govern the bodies represented by avatars). In the United States, this is the position that the constitution fills for citizens (providing overarching principles). Other democratic structures have different ways of addressing the meta-laws of the land; however, it is essential that as the rules of the environment(s) shift the meta-laws remain consistent. The laws must represent a set of guidelines, tests, and methods for redress in order to be fair. It is not possible for the law to predict or address future adaptations of

the coded environment, so it must be adept at providing means of intelligent analysis and proper popular judgment.

Fundamentally and primarily the law must acknowledge the rights of the people. To this end the Universal Declaration of Human Rights (UDHR) provides a good foundation: "every individual and every organ of society, keeping this Declaration constantly in mind, shall strive by teaching and education to promote respect for these rights and freedoms and by progressive measures, national and international, to secure their universal and effective recognition and observance, both among the peoples of Member States themselves and among the peoples of territories under their jurisdiction." Every member of civil society is responsible to that society to observe, educate, and participate in the construction of the society's system of laws.

To understand how these rights apply to a synthetic world is not a trivial translation and is in fact a good exercise. Does the right to work and social security extend into what might be considered a recreational activity? What happens if the activities in the synthetic world begin to support the person in real life, does this change the rights of the individual to "continue in business" or give the business operator any preference over the casual "player?" What is the relationship between synthetic and terrestrial world?

Assumedly no distinction can be permitted and every synthetic world entity has to be afforded the same "right to exist" as another. There is a difference when there is a cost to participation, whether a monthly fee, cost for ISP, cost for equipment, availability of free time, and on and on. This consideration is headed down the same path as trans-instantial primacy.

For the UDHR to have relevance it has to be applied both universally and explicitly locally (within each instance). That is to say that one set of rights do not trump another. *This* is the nature of trans-instance government. *This* is the necessity of scalability within instances. And finally *this* is what retains value and fairness for the individual player.

But what is the necessity of democracy in the UDHR? With the multitude of successful real-world governments, and corporate structures that do not embrace democracy one is faced with the question "Is something fundamentally different here that requires a democratic structure?" That leads to our thesis, yes, synthetic worlds provide an environment that requires democracy. It is required for player investment (as opposed to player exit), and further community involvement is necessary for scalability.

We feel that the UDHR is above all fair, but entirely biased towards democratic governance. This is an evolution, but one that may not as easily be felt, leveraged, or demanded in terrestrial space. At the time of this writing synthetic worlds are not necessary, but if it can be assumed that they will follow a similar development arc to that of the iInternet and the wWorld wWide wWeb; we can expect that within five or ten years they will become functional in the lives of first worlders, and in twenty years will become an

important part of daily life. We will not speculate about them ever becoming necessary, and that may be a fault. Given the One Laptop Per Child (OLPC) initiative it is possible that the digital divide will close in a worldwide way and that there may be a universal equalization of technology (and subsequent shift in standards of living particularly as relates to technology skills/labor). It may come to pass that synthetic worlds become part of the medium of business and recreation in this new world, but that is far from the necessity of food and oxygen or the embedded desire for art.

Extending the logic of governance of these spaces the line begins to blur between the computer-mediated synthetic worlds and the terrestrial reality. This is part of the "trans-instance" phenomenon.

Authority and the Consumer-Oriented Paradigm

Corporate

Corporate governance is founded by lawyers in contract law and is a take it or leave it proposition. This represents the classic producer and consumer relationship and the essential freedom involved is that of exit,; if you don't like the rules don't participate. This form of governance is represented in Terms of Service (ToS), End User License Agreement (EULA), Customer Service Representatives (CSR), and functions to keep the operating organization free of liability for any decisions they make. Typically the ToS and EULA are huge documents that no player reads, but essentially they say that the company running the "game" has full rights to do whatever they want whether intentionally or unintentionally and that the player has no recourse, frequently further stating that the player does not in fact own any aspect of the game experience, character, equipment, image, anything. These documents are not written for people, and frequently intentionally take advantage of the fact that no one reads them. There is no mystery here, if you want to play you say yes. The consumer is not expected to read or understand these rules but they essentially provide legal recourse in case the environment is interrupted/ceases to function or someone is ejected for no reason. These documents shield the corporation from liability based on their own actions, the actions of others, or acts of god. The CSR's are frequently the administrators of justice based on these documents, and realize that the limit to their authority is the limit of the system, with the possible exception of extending copyright litigation to the end user. This is to say that the reach of the CSR extends only to the log-in, but the reach of the document may go beyond to that of a corporate lawyer. Thus once someone is booted from the environment they essentially become free from this form of governance.

Designed

Designed governance is built into the structure of the game. Many games include a set of functions for facilitating an associational, in-game life. The guilding, friends and grouping systems in World of Warcraft are examples. The support mechanism of internal hierarchies and the display of tabards form internal communication and are functional aspects of game-play. This structure is voluntary in that one can play or not play regardless of whether one is a member of the guild or has any friends. Another secondary example is the grouping used in Warcraft. Groups can be formed through built-in chat channels or other mechanisms for finding interested people. Groups are usually more short-lived though they often feed into the friending system which allows users to track other players. The functionality to have a satisfying experience exists completely within the design of the game engine; though governance is not strong this is a coded form of association and communication.

Consumers

Synthetic worlds have adopted a consumer/producer paradigm. That is, these are services that are owned and operated by a company for the entertainment benefit of players. These companies clearly have an interest in producing high quality, engaging games—not only for profit but also in many cases for a genuine interest in creating new innovative spaces. In the past ten years or so a number of companies and projects within larger companies have come and gone that have tried to create sustainable business models for synthetic worlds. More recently the gaming companies devoted the resources and talent to create the infrastructure to support very large user populations in very large persistent worlds. This paradigm has therefore guided how massively multiplayer worlds are presented and relationships defined.

Police

In general, companies have approached the problem of managing their worlds with a particular perspective and a set of assumptions based on the producer-consumer paradigm. Some of these assumptions are reflected in the Terms of Service (ToS) and the End User License Agreement (EULA). This is why they behave, as Castronova discusses in "Synthetic Worlds," as a kind of "strange government" being effectively despotisms and somewhat aloof entities at that. Companies are accustomed to shielding themselves from liability and trying to protect their assets. This is true of game companies running massively multiplayer worlds. They therefore issue the ToS and

EULA that users must click through (people who do not study these documents rarely read them). These instruments are not created in the interests of the participants of these games but rather of stating the position of the company should a dispute occur and the rights that the company is explicitly retaining in those disputes. In turn the company has a certain number of support staff available to triage a multitude of issues from players and direct their support resources accordingly. Invariably only a fraction of the requests are ever handled.

These companies have done a great deal of work to make the software running the world scale but they have not been able to scale in terms of their ability to provide customer support. They have provided tools to allow users to control different aspects of their interactions with others, such as blocking messages from other users, in the case of Second Life being able to eject people from property a user owns, creating groups (or guilds, as in games like World of Warcraft or A Tale in the Desert.) But most problems are difficult to provide automated tools to address. What we have is a set of guidelines for some user interface controls in the game, but larger scale controls are unlikely to be readily addressed through software. For the human support staff, not only are they called upon to take up the roles of police, judge, and company representative in the world but they have to do that bearing in mind that part of their responsibility is to shield the company from liability. While the ToS/EULA invariably reserves the right to administer the world as the company sees fit, there is still an inherent conflict of interest that companies have when acting as a judicial authority within the world. What further complicates matters is that the transnational nature of synthetic worlds brings with it questions of whose standards of behavior apply. Invariably the standard will be the one that the relevant employees of the company are most familiar with, particularly the customer support staff who are called upon to make judgment calls.

Other categories of problems have emerged related to the increased capabilities of online worlds. A more perfect example of this is in Second Life's granting of property rights within the game. This has led to a blossoming of economic activity—the type of activity only possible in a 3-D virtual world. The downside of this has been the problems of dealing with the added complexity of a world with private property and markets. Other problems emerge as well, such as issues with what constitutes acceptable behavior in the space. Free speech issues are but one example of a category of hypothetic situations that raise potential legal issues. The transnational nature of online worlds also leaves them potentially dealing with multiple legal systems from different countries, such as the case that a French court brought against Yahoo over Nazi artifacts being available on their auction site.(InfoWorld, January, 12 2006).

This situation is if anything growing more complex as gaming companies add new features to their games that take advantage of more powerful

hardware. Synthetic worlds have so far been constructed based on the premise that the world itself was a service offered by a separate corporate entity. However, if we consider these spaces as primarily communal space in which social institutions can arise, then that changes how we might approach interacting in, constructing and operating institutions in these worlds. Companies can and should still be in the business of creating innovative software to run these worlds but many of the problems of managing these worlds—which are largely not technical matters but social matters—are potentially better handled by the players in the world.

Government in trans-Instantial spaces

A fundamental part of our argument has to do with the fact that people can now occupy more than one space, obviously not physically but in an intellectual and communicative sense. This was not possible until the creation of networked computers and particularly types of software that create distinct spaces. Prior major technological innovations—the telegraph, telephone, and television—did not have the necessary characteristics to do this. Many of the common observations about the nature of the Internet and massively multiplayer games, such as the transnational character of these spaces, derive from this. More particularly, people can and do have a presence in the real world as well as in multiple online spaces. That is, their existence is already spanning multiple instances of reality—hence many of us are already living in trans-instantial mode of existence. Government itself is a social construct regardless of where it is found. We must consider how these trans-instance, massively multiplayer spaces impact the creation of government there.

Locative/Terrestrial

The first area that we can identify has to do with jurisdictional boundaries. People live on earth, servers are housed in buildings, and EULA's have a jurisdiction. The governments of earth touch all MMO's in some fashion. Arguably there is restricted speech that could be prosecuted terrestrially if exposed in an MMO. Hence any chat medium is susceptible to this sort of liability. Speech is the most obvious example, because it is easy enough to disparage another person in text, which could even violate our beloved UDHR.

Content-Based

The second area has to do with the manifestations of government—content creates governance as well. By content we are specifically referring to player

content which is generated by the player in the act of playing the game. Much content comes in the form of association; a guild or clan has rules, rules for promotion, rules for raiding, meetings, and recruitment. Decisions have to be made, whether it is by one person at the top of the chain or by an oligarchy or otherwise.

Player-Driven

Finally we cross the magic circle of the game once more when we deal with the player in the equation. Ventrilo and teamspeak let us chat, websites help us recruit and explicate our rules, forums let us keep records of our discussions. Inside all of these structures the full flavor of governance takes place too even if it is the most basic netiquette.

Trans-Instance

In order to thrive and prosper an environment has to embrace and address all of these areas of governance. To ignore one merely means that it will arise of its own accord and potentially disrupt the power structure. The governance of an MMO is a coalition of many governances, a collection of instances of government that have to work in harmony or risk alienating players. In the end it is people who are governed, by choice in this case, and through the acceptance of the rights of others and their responsibilities and the responsibilities of their government.

Finally, a strong democratic government is self-healing and can survive the departure of its founders, or perhaps even a migration from one game to another. The departure of founding members is one metric for measuring the health of a democracy. Political scientists describe a healthy democracy as being "consolidated," meaning that there are regular, free elections. Different groups come to hold political power through the mechanisms specified in the constitution, and no major group resorts to extra-constitutional means to attain power. For a government to be operative it must govern the people independently of their environment, yet understand that it only has power in certain instances. For this reason laws can be very specific, defining griefing for example, that do not apply elsewhere but that reflect an aspect of the UDHR and the right of the individual to expression until it prevents another individual from doing so.

It is hard to talk about democratic consolidation without getting into a theoretical discussion, so let me start with a few brief attempts at a definition or framing argument.

A consolidated democracy has passed into a position of stability in which it is difficult for the government to be usurped by another form. There are generally considered to be several conditions which contribute to or are

necessary for a democracy to be consolidated. Linz and Stephan (1996) list the following:

1. the state has to exist to support the polity, free elections, winners' ability to exercise legitimate force, and rule of law.
2. transition to democracy must be completed, the government must be invested with the power to determine policy.
3. the rulers must govern democratically.

Functionally it seems that many of these requirements demand a test or some manner of verification. Our contention is that once the democracy is consolidated it is capable of withstanding the departure of its founders.

Interlude 1: A Brief Tale of Neualtenburg

This is the case of Neualtenburg (which later became Neufreistadt), a loose collection of residents in Second Life that culled together form a grand experiment in collectivism and democracy. This discussion is not about the founders per se, but about the resilience of their creation.

The original collective was formed after Ulrika Zugzwang won a contest proposal in which the goal was to find a way to preserve the original snow simulators in Second Life. Residents had been ignoring the frigid landscape and just building what they felt. In response to this Linden Labs held a contest to create a sustainable build that fit the snow sim. The winning proposal was based on a Bavarian city and a great part of the end result was the intent to create sustainability through an elected government. It seems that there were always a certain amount of personality clashes and lively discussions as one might expect to find in any group of people. But the city survived and thrived with a purported membership as high as 200 at its peak.

In May of 2005 the group moved from the Anzere with the expiration of the lease and perhaps a desire to expand. The new sim was a private island, Neualtenburg.

In 2006 personality conflicts rose to a fevered pitch and Ulrika withdrew from the island sim's democracy. This created a great deal of difficulty as the following things were brought before the citizens.

1. Ulrika claimed ownership of buildings (and removed them);
2. Ulrika claimed ownership of images used in other builds;
3. Ulrika claimed ownership of the name Neualtenburg;

A lengthy campaign was launched in the Second Life Forums, the apparent purpose of which was to extract recompense for the first claims.

At this point there were sympathetic voices on the Representative Assembly, but the institution was faced with a significant challenge. After many hours of discussion, offers, counter offers Claude Desmoulins was able to broker a deal which included a one-time payment and the change of the Simulator name.

It is perhaps ironic that what started out as an exercise in sustainability (to be able to survive the departure of its founders) ended up being wildly successful.

Foundations of Democracy in Synthetic Worlds

Synthetic worlds are a kind of laboratory where we can watch politics "happen." While many of the inhabitants no doubt have strong opinions about real-world political issues, synthetic worlds are largely isolated from those issues, which therefore makes them a relatively "cleaner slate" to examine how individuals form political structures. We can expect that in the near future we will be able to examine the development of political cultures, concepts, and structures in these spaces. A large body of theoretical and practical knowledge in this regard already exists though, and we can use that knowledge to inform not only our assumptions about what may happen but also what should happen for the benefit of the communities that are emerging in synthetic environments.

The history of democratic theory consists of the development and contribution of particular concepts and abstractions by different thinkers in history, notably during the British, French, and American Enlightenments of the eighteenth century. Theoretical models exploring how a group of individuals can be organized into a society and a state goes back at least to Plato's Republic. Although this history goes back to the ancient world the key ideas about modern democracies have been developed starting in the sixteenth century. Our purpose here is not to review the history of political philosophy but rather to draw on it selectively to see how democratic governance applies to the inhabitants of synthetic worlds. Given that these spaces already have specific groups (i.e., primarily for-profit companies) operating these worlds we first look at the issue of authority. After that we address what it means for a group of individuals to come together to form a more formal association; we might call this the foundation for the democratic society. Finally, although the focus of this work is on arguing for democratic governance in general and not for any particular arrangement of political power, we comment on aspects of the institutionalization of government in synthetic worlds.

Authority in Synthetic Worlds

Authority

Political authority is a function claimed by the state to which the citizens, residents, and visitors defer. The citizens may or may not have actively invested this power. In other words political authority is sovereignt—the ability to make its own laws and control its own resources. Political authority is a form of force that the state is permitted to exercise over its resources, the ability to govern. Another way of thinking of this is that the state is the vehicle through which political authority is manifested and directed toward different ends. As with many of the definitions used in this chapter, this is one that can apply to conventional modern states as well as states in synthetic worlds.

Hobbes/Leviathan—Absence of Political Authority

There are a number of reasons why a centralized political authority is desirable. Life without a political authority can be hazardous, as Hobbes puts forward in "Leviathan" (1651). Life would, says Hobbes, be much more subject to competition with one's neighbors for necessities. Without a central authority to enforce order there is little compelling reason to expect members of a society to cooperate. People live in fear and have to plan accordingly. Hobbes has been criticized based on his assumptions about human nature; in particular the role of altruistic behavior is not taken into account. Political authority can provide the ability to manage and coordinate the resources of a population to provide for security, services for all the citizens, and a system of justice or problem resolution. The existence of a system of justice provides a stronger reason to enter into contracts with others, since there is recourse in the event that the other party does not live up to the agreement. These are commonly cited reasons and in addition, we might also add that with this is a foundation for continuity and even upon which civil society can grow.

Political Authority in Synthetic Worlds

Political authority in synthetic worlds presents a number of issues that do not exist for real-world governments. The bar is set higher for trans-instance governments to justify their own existence. What is the added value that the political authority brings? Historically, providing for the security of the country has been a large part of this added value. Obviously there is no

significant threat of being killed in a virtual world—it may in fact be part of the game. The exception, of course, would be a trans-instance government in which one sphere of influence happens to be the territory in the real world.

Consider four possibly overlapping groups: individuals in the game, a player-run government, a corporations that own and operate the synthetic environments that the player-run government occupies, and a terrestrial institution. A trans-instance government would sit between the other groups, tasked with representing the interests of the individual in the game, or perhaps only a subset of them. The corporation has defined its role with respect to the individual players via the ToS and EULA, and is more concerned with deferring to the terrestrial world authority to which they are accommodating a player-run government. The player-run government would have the task of representing the interests of the players. This is a difficult enough situation when these are all distinct groups, but when they overlap—say when a player is also a member of a real-world government—then things can potentially become more complicated since the participants may differ, and have potentially conflicting, institutional roles. In cases of a conflict, it is likely that the rules a person will obey will be the rules that would cause the greatest consequences not to. This is likely not the player-run government.

We cannot provide a complete formula for resolving the myriad of possibilities that exist here. In such cases arbitration rules are negotiated or evolve in some other fashion. In general though, a player-run government—which we argue has to be democratic in nature—is vested with political authority in order to represent the interests of the community. Those interests will have an internal dimension and an external dimension. The added value that such an authority brings is related to how well it manages the resources of the different instances that it occupies to serve the community.

Coded Authority

The question of whether any political authority is needed or even desirable in a synthetic world is a moot point. A true anarchistic arrangement in a synthetic world is simply not possible. Consider that the servers that run the digital world and the company that owns and operates them reside in one country or another. There are already two levels of political authority at work: one is the company operating the world that is a de-facto authority, but the second is the real-world government in which the company operating the game is located and therefore subject to the laws thereof. That real-world political authority is the source of the ToS and EULA which have already been discussed earlier. As discussed earlier, those are instruments to protect the company, and not the players. While no doubt companies do

want to provide some level of service to their players who are their customers, they face the problem of scaling to serve their needs and making profit. At a certain point the hosting company can no longer be fair to or aware of all of its players. The majority of players will never experience this unfairness—or at least at a level that they consider it more than an annoyance—but some players will be penalized with no recourse.

Necessity of Authority

What can an in-world authority that is implemented by players add that would make it worth the effort? For many players, government in-world is unnecessary or even anathema. This perspective argues that multi-player games are not broken and there is no need to invest authority in a player-run government. Some also argue that adding government might be fun for those directly involved in the government but this might prove somewhat less than fun—and therefore self-defeating—for other players (Doctorow, 2007). Given that many companies are not very involved with their users it is understandable that users like the level of autonomy they have. However, by accepting this argument we would just be agreeing to the status quo. We would be leaving other options on the table and acknowledging the company running the synthetic world as the ultimate authority, with both the benefits and the problems that the benign neglect of a company brings. This is evidenced in a massively multiplayer environment like Second Life that is decidedly free-form and gives a great deal of capabilities to users; the "game" is no longer just a game. There is broad range of activity—particularly economic activity—that is starting to take place in Second Life and other worlds. Although it may be possible for things to progress as they are, it is unlikely that this will be sustainable without a more responsive authority than is currently being provided by the companies running these worlds, or can be provided by them.

This on its own does not entirely substantiate the need to create in-world governments with terrestrial authority. Another perspective is that synthetic worlds need to fit into existing real-world sociopolitical institutions, and similarly that those institutions need to adapt to accommodate them. Stephen Kobrin expresses this type of view (2001). Kobrin does not address massively multiplayer worlds specifically but rather discusses the Internet and cyberspace more generally. While asserting the transnational character of the Internet he nevertheless argues that it cannot exist apart from the traditional social order and argues for embedding Internet-based structures in existing social institutions (Kobrin, p. 689). He further posits that there "cannot be two different sets of rules for the real and virtual worlds." (p. 690) Jack M. Balkin took a different approach to this problem. His view was that in-world activities can have real-world consequences and therefore

real-world governments will come to have a compelling interest in what happens in these synthetic environments (Balkin, 2004, p. 2046). In both of these cases the issues have to deal with where player's rights lie. There seems to be little disagreement that synthetic worlds are distinct spaces that will have transnational communities with their own norms. What is in question is whose authority and whose laws apply to the synthetic world?

In contrast, a "pro-in-world government" view can be found in Lastowka and Hunter (2004), who argued that virtual worlds constitute distinct jurisdictions and therefore should be administered from within those worlds. If democratic government is about providing for the collective good of the community, then the participants in these online worlds need a presence within the world that is capable of representing them. Game companies in themselves are by their nature not well positioned to play this role, nor are many of them interested in that. Participants in online spaces are currently a bit like foreigners in an undefined country. We have to recognize that the people who spend part of their time in these spaces enjoy a right of association, a right to participate in the cultural life therein, and a duty to those communities consistent with the UN Universal Declaration of Human Rights. That these communities are made manifest by means of computer hardware and software, and that the inhabitants coexist between the real world and virtual worlds is not a sufficient basis for disregarding them. Ultimately the main reason for players in synthetic worlds for investing in the creation of an in-world authority is to assert and represent their rights.

The Public Sphere

Once we have established the need for a political authority in synthetic worlds, the next logical step is in analyzing how such a political authority could be formed that is consistent with democratic principles. This process of forming a collective is in many ways the classic problem in social contract theory. Hobbes, Locke, and Rousseau all started with similar premises about humanity in the state of nature and the need to form a collective. Given similar starting points they nevertheless arrived at different conclusions. Although some of their perspectives may be useful there is one major difference we need to bear in mind when comparing with real-world populations. Namely, participation in an online community is entirely voluntary—whereas you do need to live ' "somewhere" in the real world, you don't have to live somewhere online. People participate in online worlds because the members find value in them. There is therefore an added fragility to establishing an in-world government. Even though it may be in the interests of the members to create a more perfect union, as it were, it needs to be done is such a way that the positive characteristics of the community

are preserved. Such a government has to not only provide some added value and benefits but also do it in an acceptable manner, lest the members simply leave. The state therefore has an interest in being sensitive and responsive to the will of the community. The de-facto dictatorial governance of the companies operating massively multiplayer worlds derives from their role in the development and operation of the technology that enables MMOs. Setting that aside for the moment, the only form of governance that can successfully bind a community in a synthetic world are democratic forms of government. Fostering the development of a democracy is a difficult enough in real life, and virtually never proceeds in the same way. Regardless of the space though, it is important to have a cultural medium for the community to raise issues, discuss them, and form a consensus. We find the appropriate vehicle in the concept of the public sphere.

Origins of the Modern Concept of the Public Sphere

The modern concept of the public sphere as developed by Jürgen Habermas and others addresses this problem of providing a suitable basis for a democratic society. Habermas developed the idea of the public sphere in *The Structural Transformation of the Public Sphere* (1962) and since then much of his work has elaborated and further developed aspects of the public sphere.

The public sphere is an associational space lying between civil society and the formal apparatus of the state (Habermas, 1962, p. 30). Within this space individuals discuss and debate critical issues of society. This point about debate is critical to understanding the dynamic of the public sphere. By way of comparison, Rousseau's social contract and general will explicitly asserted the need for a community to be largely in sync on issues. For any problem Rousseau assumes that a sufficiently informed populace will tend to converge on one course of action despite the differences in the interests of individuals. Sharper differences of opinion within a population do not fill well in this model. As anybody in any organization can attest however, people tend to fall into different camps with different opinions. A society needs a mechanism that recognizes this, and this is what is an inherent part of the public sphere. The public sphere does not set aside conflict but rather accepts it and provides a forum for the discussion of different views in a society. Participation in these discussions is based on reasoned arguments instead of, for example, the social status of participants. The use of reason in evaluating the merit of arguments tends to produce better conclusions. This does not mean that an incorrect view is never reached; in a debate there may be a lack of key pieces of information, for example. This deliberative aspect of the public sphere is what Habermas has argued makes it desirable as a basis for a democratic system of government (Habermas,

1992, p. 446) Through shaping public opinion and being shaped by public interaction, and through an institutional interface, the public sphere has the potential to influence and monitor state authority for the better.

The public sphere can exist wherever there is open communication. This is to say that the participants in the public sphere need only be able to discuss issues for it to function as such. This communication can be seen in chat, blog, and their counterparts in MMO's. Public, open communication is necessary though not sufficient for the public sphere. The conversation has to be reasoned and the participants have to have equal voices. This is a focal point for democracy in the instances that form around MMO's.

Characterizing the Space—Multiple Public Spheres

The public sphere is not, however, a formal institution. In fact it exhibits a remarkable flexibility. This associational space exists whenever two people in the same community get together and talk about an issue of local importance, or when a member of the community organizes a discussion group. One general feature of the nature of the discourse is that the potential audience referred to is indefinite (Bohman, 2004). That is, even when two people are talking or a small group is being addressed, the implied audience is the broader community. The public sphere is also not strictly bound to synchronous communication as in a meeting. Asynchronous forms of communication such as newspapers, magazines, pamphlets, personal letters, and more recent developments likes blogs and wikis are significant vehicles for facilitating discourse.

The venue in which people meet to discuss issues does not have to be specifically a public venue either. In *Structural Transformation* Habermas examined French salons in the latter eighteenth century, among other venues, as the physical space in which the public sphere manifested itself. Salons were a particular type of room in the bourgeois household in which a small circle of friends would gather to discuss a range of topics, including politics (Habermas, pp. 33–34, 45) The rooms and the homes they were in were private, but that did not mean that the discussions held within did not relate to issues of public concern. The critical factor for creating the public sphere does not reside in the allocation of physical space, or in the artificial designation of public or private, but through a cultural trait that values intellectual discourse and a concern for the welfare for the community.

Finally, we see the public sphere as not being a monolithic entity. There are different perspectives on this and Habermas can be read to mean that there is a single public sphere. However, other studies reflect a more complex situation with multiple public spheres (e.g. Nancy Fraser, chapter 5 in Calhoun, & Todd Estes, 1992). A society consists of multiple "layered" public spheres, out of which a broader, more general public sphere is

articulated. Even that metaphor is too ordered however. The public sphere by its nature is intended to accommodate a variety of opinions, many of which will be mutually exclusive. The nature of the discourse produces a dynamic effect in which issues and opinions change and much of the time a prevailing view emerges. This does not mean that dissenting views are eliminated—they will persist and become the minority view that the majority needs to take into consideration.

The Synthetic World Public Sphere as a Distinct Category

What we are trying to do here is to sketch out the framework for a synthetic world public sphere. Just as the bourgeois public sphere was a particular type, or category, of public sphere, so too do we assert that the synthetic world public sphere would be a distinct type.

All of these venues for the manifestation of the public sphere that have been mentioned above—newspapers, forums, etc.—have a corresponding representation in synthetic worlds. In addition, there are other forms of communication available within the gaming worlds specifically and the Internet more generally, such as group-chatting features and the ability to post transcripts of in-world discussions. The fact that there exist multiple modes of communication is not only beneficial but critical for the health of a democracy. This observation is not necessarily new—Bohman makes a similar argument in looking at the Internet and the public sphere, though he did not address synthetic worlds specifically (Bohman, 2004, pp. 139–140).

Currently there are few instances of what we may call a political public sphere in any MMOs. However, we can identify activities that are occurring now that would qualify as proto-public spheres. For example, the "Discussion" category event postings in Second Life lists a number of scheduled meetings. Sometimes these have a very specific scope while others are more general. Among these events there are various groups that meet regularly to address general philosophical, scientific, or literary topics. One specific example of this is a regularly scheduled discussion session called the Socrates Cafe.

"Socrates Cafe" is a term created by Christopher Phillips for an informal gathering of people to discuss philosophical questions (http://www.philosopher.org/). Although Phillips has been traveling the world fostering the creation of these meetings for several years, The Socrates Cafe has been a relative newcomer to Second Life. The host, whose name in Second Life is Verum Vacirca, started these meetings in November 2006 based on her experience with a Socrates Cafe in the city she was living in at the time. "Someone there began having meetings at a coffee house I went to regularly. ...When I purchased land [in Second Life] I decided to open a small coffee shop for the Yanguella neighborhood and wanted to share the space I had. I wanted it to

be a community space people would feel comfortable in, ... " (Interview with Verum Vacirca). In these discussion sessions the topics are selected by the participants. The choice of topic is very open, although the idea is to select a general philosophical question that everybody can relate to. Instead of having two designated "sides" as in a typical debate format, all of the participants are free to add their comments on the topic to the discussion, introduce questions, and agree or disagree with others. In practice the thread of the discussion does tend to wander into other topics, but this can also lead to interesting connections being made between topics. The purpose of creating this venue was to, as Verum says, "... inspire people from all walks of life to think about the bigger ideas of life. ... It's a great thing when someone can inspire others to think about consequences of choices, the bigger picture or where we're going in life." There are also some "regulars" but often the mix of participants varies. It is therefore not surprising that the participants do not often know the other people in any given meeting that well either. What this amounts to is that the discussion is what the participants make of it.

Within Second Life "residents" can own land, and in fact there is little to no land that is really "public" land. Verum owns the land that the Socrates Cafe takes place in but aside from that she participates as any other member of the discussion. This point is worth highlighting—the skills that make for a good facilitator are the same skills that make for a good participant in a discussion. Verum is aware of the possible influence her presence might have as well. "I respect the Socrates Cafe and in that, if my presence is inhibiting others or disruptive, I will stay away." In Second Life the owner of a plot of land can eject others, and when it comes to discussion sessions it is not unknown for the owner to eject others when their views start to conflict too much with those of the owner. In the Socrates Cafe Verum has only rarely had to eject somebody. There is an ethic involved here—ejecting somebody because they disagree with one's views would be a fast way to destroy a forum such as this.

We can draw a parallel between the Socrates Cafe and the literary clubs and salons of England, France, and Germany which contributed to the development of the public sphere in those countries in the seventeenth and eighteenth centuries (Habermas, 1991, pp. 32–35). In both cases we can identify a venue, existing in a private space, but being opened by the owners for others to participate in. The public sphere does not require an officially public location to take place in. The venues themselves exist due to a belief in the virtue of the forum to exist; people themselves create this associational space. It does not hurt, however, to have a location set aside for public discussion as with the well-known Speaker's Corner in Hyde Park in London.

Within Second Life we might conjecture that as the number of inhabitants grows and become more invested in the synthetic world their existing shared associational life will form the basis for more discussion of

political issues of common interest. The forums, being relatively few as they are now, nevertheless form an important element of the culture in MMOs. These cultural elements provide the necessary foundation for associations with a distinct political character to form.

Nevertheless we should exercise caution in how we expect the public sphere—or spheres—that emerge in synthetic worlds to replicate the public spheres in the past or present. So far there are no truly large-scale self-governing entities in any synthetic world. We can point to smaller instances though, such as the example of Neufreistadt (or Neualtenburg). For the most part though what we see are cases of what "may" develop into instances of the synthetic world public sphere we are detailing here. In addition, there is still developing a kind of civil society in these various worlds, the progress of which will likely be closely connected with the developing of the public sphere.

Interlude: 2: Barrens Chat as The Public Sphere

World of Warcraft has a built-in coded division between characters known as "factions." This division is part of the story and prevents communication between the player groups. The factions are The Horde, and The Alliance, and whereas neither is considered good nor evil each has their own racial aims. The nature of the Horde (undead, orcs, trolls etc.) lends itself to a traditionally darker perspective. These factions are prevented from communicating, that is to say that languages are different per faction and the environment separates and transmogrifies text between the factions preventing direct communication. So even if everyone on the Alliance side is speaking English to other members of the Alliance, English speaking Horde members will see in their chat windows a gibberish version of their words. Barrens Chat is perhaps the wildest and most open, most useless of all channels in World of Warcraft. As such it is also one of the most open of fora. It is our contention that this meets the basic needs of the public sphere. Membership is open within a single faction,; communication is free and voluntary.

If there were to arise a general public will within any one faction, it could easily then be hashed out in the barrens. The difficulty of course would be sifting through the Chuck Norris jokes to find the political speech.

Institutionalization of Democratic Government

Thus far we have addressed the basis for individuals to establish a political authority in a synthetic world and have discussed issues with how individuals come together to do that and provide for a public sphere to mediate between the state and society. The last theoretical issue that we address is

that of the institutionalization of a democratic government. This topic is broad and could easily constitute a chapter in and of itself, but it may be sufficient to say that the development of a culture of democracy is necessary for stability. The character and structure of the formal apparatus is not as important as the underlying intent of blind justice and equality.

Constitution

Where a constitution exists and serves as the primary repository for governmental authority in the real world, they tend to be lengthy, complex documents. The United States Constitution, in contrast, is remarkably brief and has been a very effective document for over two hundred years. As Dahl notes, "a well-designed constitution might help democratic institutions to survive, whereas a badly designed constitution might contribute to the breakdown of democratic institutions." A large part of the strength of the U.S. Constitution is that it is largely a document that specifies how the government is to operate and less concerned with particular laws. The U.S. Constitution is a meta document describing the governmental structure itself and the relationship within governmental branches and between the government and the citizens. For a government in a synthetic world, and particularly a trans-instance government that spans more than one game or even a portion of the real world, this is a key feature for creating a usable structure that can function over the long term. Democracies that have regular elections through which different groups come to power, the rule of law guarantees freedoms and provides for justice, and no major groups within the state feel compelled to go outside of the means prescribed by the constitution to achieve their ends are said to be consolidated. To achieve this, a constitution has to be structured in such a way that it is flexible enough for future citizens to adapt to changing needs, yet provides continuity in the basic ideals on which it is based.

Given that there are a number of different possibilities for the shape of a constitution for a democratic government, there are also areas that need careful consideration if the health of a democracy is to be maintained—be it in the real world or in a synthetic environment. In the corporeal world a less-than-friendly state could use police and military forces to break up public gatherings where people meet to discuss issues or to take part in demonstrations; in the synthetic world this perhaps more difficult to arrange depending on the particular rules of the environment, but there are other ways for the state to impinge on the public sphere. Recognizing that we are discussing the player-run state in this case, and not the company running the game per se, what would constitute a breach of the freedom of association? Members could certainly meet elsewhere to discuss issues, in another gaming world that the state has a presence in (or not) and in venues such as

shared wikis and forums. Members of the state might seek to bar entry to other areas under the administration of the state, or to remove the ability to participate in the aforementioned forums. The extent to which a state pursues blocking off such avenues though can lead to the disfranchisement of a subset of the population. Not only is this most likely a breach of the rights of the citizens of the in-world state, but also a breach of the public sphere by the state. In order for the public sphere to have meaning it has to have the ability to form and be secure from intrusion. The freedom of association recognizes the right of people in a society to gather together, which provides the basis for them to discuss issues of public importance.

The final note about constitutions is that whatever form they take they need to provide for a system of voting that is fair, open, and auditable. Voting is a primary means by which the citizens exercise their will. In particular, voting is where the deliberations of the public sphere make themselves manifest to direct and change the composition of the state. To picture it another way, since the public sphere is located within civil society, the mechanism of voting is the institutional interface connecting the public sphere to the state. In any large government there is the potential for abuse and manipulation when it comes to voting, which is why this demands careful consideration of how this will be implemented. In a relatively small citizen population, say fifty members, this is less problematic since the members are likely to have some sense of how the consensus of debates takes place, simply from being able to know all the other members of the community better. This is a situation reminiscent of Rousseau's arguments for small-scale communities. In a much larger system however this level of familiarity is simply not possible. This is in fact where neutral, third-party companies, universities, and non-profit organizations that provide voting services can provide a good solution. However, this can also be implemented and operated by the state provided there are appropriate checks in place. In many modern states the actual mechanisms of handling elections is done by a paid civil service and the same could be done in an in-world government. At a finer level of granularity voting is typically limited to full citizens of a government.

We have argued that it is possible to have a democratic state span more than one synthetic world and even to occupy a portion of the real world. We have termed such a state a trans-instance state to denote that the government has jurisdiction in multiple spaces. The implications of this for constructing a constitution are that the constitution needs to be applicable to all spaces. The key point here is that the constitution, as a meta document, is general enough to define a system that can administer multiple spaces. The more specific laws that are applicable in those different spaces will likely differ. This is not very different from a traditional city government

defining residential and commercial zones, or in a state defining some regions as protected parklands in which development is not allowed.

Citizenship

Citizenship in synthetic worlds differs considerably from real-world models. Citizens of a state in a synthetic world are all naturalized. Citizenship has an institutional status. Rights, benefits, and duties of this institution are created at the pleasure of the government. In a democratic society this would of course mean that the people determine these factors. The possibilities are open ended, but some possible benefits include legal standing, the right to participate in the government through voting and other means, virtual property ownership, elevated status with respect to the policing authority, reputation within community, and direct participation in the government and influencing sphere. Obligations may include service (including policing or military), participation in electoral processes, or even payment of taxes. Only nonplayer characters can be born into such a state. An important historical factor affecting government stability in online games is the fluctuation of their populations. Typically massively multiplayer games have waxed and waned in popularity, often around the release of features and new content. Individual players typically play a game for a certain amount of time—a few months to a couple of years say—and then move on to another game. However this begs the question: "Would a greater investment, citizenship for example, affect this?" This fluctuation contrasts with real-world countries where both applying for citizenship and leaving are long, complex processes. Further the most active and persistent player is not present 100 percent of the time. This means that citizens are only citizens part-time. Being a citizen of a country means being able to derive some benefits from that association as well as committing to a set of obligations. What all of this amounts to is a challenge for a state in a synthetic world is to be able to withstand fluctuations in population, as well as to be able to gracefully shut down when there is no longer a compelling reason to maintain the state.

Conclusion and Final Thoughts

The populations inhabiting synthetic worlds are not being served by the companies that operate them;, in fact it is absurd to think that they would. Without a change in the status quo the potential of these environments will not be fulfilled. What is required is a revolution to change the paradigm of corporate control of these worlds and replace it with a system more responsive to the people. We have argued that this can only be realized through

the creation of participatory systems of governance—in short, democratic governance.

We have addressed the problems inherent in many of the current systems. With a few notable exceptions, most synthetic worlds are embedded in a producer-consumer paradigm in which the availability of a particular environment is a service offered to subscribers. In this autocratic paradigm the instruments of the ToS and EULA contractually define this relationship. However, these instruments exist for the protection of the interests of the company and their investors. This situation has also placed these companies in the role of being the de-facto government in that they must answer or be the gatekeeper for legal actions. This is a role that they are ill-suited to play for a number of reasons. Corporations are notoriously conservative when it comes to dealing with the law, and are presented with limited resources for dealing with customer satisfaction. A better solution to this situation—both for the people inhabiting these worlds as well as the companies that are currently operating them—is to crowd-source the customer service through in-world governance and to cede in-world sovereignty to this new player government. However this still leaves the issue of legal responsibility.

The people in these spaces have a right to self-determination and self-government. Synthetic communities only exist based on voluntary participation on the part of individuals. These communities need to be governed in a way that allows them to scale and is responsive to both the wants and needs of all of their members. Establishing a democratic form of government is difficult and involves as much of a revolution in culture as in institutions. The concept of the public sphere that was discussed here is one aspect of a democratic society that we consider foundational for a healthy democratic society. This involves people coming together to rationally discuss issues of general public concern. The consensus reached becomes manifest through the institutions of democratic governance.

There is also evidence of an interest in developing this kind of rational communal organizations. The examples of Neufreistadt, where a small group of individuals has been running an island democratically, as well as the Socrates Cafe in Second Life and Barrens Chat in World of Warcraft which provide venues for discussion highlight this. To be sure there are problems as well to overcome—incentives to active participation over the long term and avoid degeneration into something other than a vehicle for communal organization. This, however, is true of conventional democracies in the real world as well.

This has not been an especially technical discussion, but as a final note we might make the observation that most of the software running today's virtual worlds has a traditional centralized architecture: you run your client application to connect to a server (or set of servers) which maintain the state of the synthetic environments. Communication passes through these servers

before filtering out to other participants connected to the system. This architecture by its very nature privileges whoever controls the servers and traditionally serves a useful function. By way of analogy, Napster was ultimately a centralized service because it required a central server to keep track of who was online and the content they were making available on their individual systems. So despite using peer-to-peer communication for the actual file copying used by the participants it was still possible to shut the service down at the center, which is what ultimately happened. Napster's world wide network was closed because it had a single "choke" point that ultimately succumbed to the local law. In the wake of Napster differently architectured software systems were developed to avoid the trap that Napster had fallen into. Gnutella and BitTorrent are both more decentralized systems and because of this are more difficult, if not impossible, to exert complete control over. Extending this logic to synthetic worlds, we can imagine a more decentralized architecture that allows peers to set up a space that is then part of a network of similar systems allowing people to travel between them. Further the environment could be constructed in such a way as to share processor resources across and through a common environment. This blended world would be trans-instantial by nature and considering that supporting systems could be in separate jurisdictions a foundation for a new type of space would be created. Since there is no single central control the resulting effective political power and responsibility is similarly distributed.

At a more technical level what this might look like would be a more openly available server application that any individual or group can install, operate, and share contributing to the pool of resources in much the same way that SETI users contribute excess cpu cycles. The increasing commodification of server space for outside parties to run whatever service they want makes this more viable. We can imagine individuals coming together to create a shared virtual space which happens to run on a shared service. The final topology of such a service might resemble something like Second Life with a huge diverse landscape or World of Warcraft with multiple parallel instances that promote a tighter group orientation.

For democracy to be successful in the synthetic environment the environment must support or be formed in a democratic manner. This is not to say that the proto-democracies that are springing up in SL and elsewhere will not be successful, but to say that they will not be truly sovereign until their underlying architecture removes them from the jurisdiction of a single nation, corporation, or power.

References

Balkin, Jack M. (2004). Virtual liberty: Freedom to design and freedom to play in virtual world. *Virginia Law Review, 90*(8) (December. 2004), pp. 2043–2098.

Baudrillard, Jean. (1995) *Simulation and simulacra.* Ann Arbor, MI: University of Michigan Press.

Bohman, James. (2004). Expanding dialogue: The Internet, the public sphere and prospects for transnational democracy. In Nick Crossley & John Michael Roberts (Eds.), *After Habermas: New perspectives on the public sphere.* Oxford and Malden, MA: Blackwell Publishing.

Dahl, Robert A. (2000). *On democracy.* New Haven, CT and London: Yale University Press.

Doctorow, Cory. (2007, April 16). Why online games are dictatorships. *Information Week.* Retrieved April 20, 2007 from http://www.informationweek.com/news/showArticle. jhtml?articleID=199100026. Accessed April 20, 2007.

Estes, Todd. (2000). Shaping the politics of public opinion: federalists and the jay treaty debate". *Journal of the Early Republic, 20,* (3) (Autumn 2000), pp. 393–422.

Fraser, Nancy. (1992). Rethinking the public sphere: A contribution to the critique of actually existing democracy. In Craig Calhoun (Ed.), *Habermas and the public sphere,* Cambridge, MA: MIT Press.

Habermas, Jürgen. (1974). The public sphere: An encyclopedia article (1964; Sara Lennox & Frank Lennox, Tans.). *New German Critique,* 3 (Autumn), pp. 49–55.

Habermas, Jürgen. (1991). *'The structural transformation of the public sphere: An inquiry into a category of bourgeois society"* (Thomas Burger, Trans.) Cambridge, MA: MIT Press.

Habermas, Jürgen. (1992). Further reflections on the public sphere, (Thomas Burger, Trans.). In Craig Calhoun (Ed.), *Habermas and the public sphere.* Cambridge, MA: MIT Press, 1992

Kobrin, Stephen J. (2001, 4th Qtr.). Territoriality and the governance of cyberspace. *Journal of International Business Studies, 32*(4), pp. 687–704.

Lastowka, F. Gregory, & Dan Hunter. (2004). The laws of the virtual worlds. *California Law Review, 92*(1), Rev. 1, 73.

Linz, Juan J. and Stepan, Alfred C. (1996, April) Toward Consolidated Democracies. *Journal of Democracy,* 7(2), pp. 14–33

Perez, Juan Carlos. (2006, January 12). Court throws out Yahoo appeal in Nazi memorabilia case. *InfoWorld.* Retrieved June 12, 2007, from http://www.infoworld.com/article/06/01/12/73881_HNcourtyahoo_1.html. Accessed June 12, 2007.

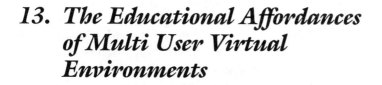

13. The Educational Affordances of Multi User Virtual Environments

PAUL HOLLINS AND SARAH ROBBINS

Introduction

The emergence of the synthetic world or Multi User Virtual Environment (MUVE) offers educators, and those engaged in the business of teaching and training, not only an exciting new tool with which to interact with their students but moreover; a tool which could be part of a much wider challenge to the established pedagogic practice of existing formal education.

Based on their empirical experience, as tutors, researchers, long-term residents of Second Life and players of other massive multi player online role playing games (MMPORPG) including *World of Warcraft, Lineage,* and *Halo,* the authors present a coherent view of what, they term, the educational affordances of this new technology are and provide a summary and context of the educational activities currently being undertaken and what could potentially be possible in formal educational settings.

They have identified five key affordances of MUVE; being those of Identity, Space, Activity, Tools, and Community and present examples of each.

However recognizing the established formal processes of education they also look at how MUVE can be integrated with the existing legacy technology of education such as learning environments and address some of the concerns being expressed by some in education as to the suitability of using MUVE in education in order to improve the educational experience and effectiveness for today's students.

A Caveat

"Extreme positions are not succeeded by moderate ones, but by contrary extreme positions" Nietzsche (1968). Throughout recent history, education theory and policy has swung from one extreme to another, with questions such as: is it better to expose students to regimented learning where expectations and the anticipated learning outcomes are clear ? alternatively is it better to allow them the freedom to explore their own interests with the risk of undefined failure? With the emergence and application of new disruptive technologies, those which challenge the established norms of technological and educational provision for learning, the debate continues unabated. Is it better to use mechanical training through games and simulation that structure learning into achievable, measurable levels with clear goals or to place learners in open, creative environments where the responsibility to learn is firmly assumed, upon their own shoulders and where teachers act more in the role of a facilitator and coach as opposed to being merely dispensers, or oracles, of all knowledge. As Reeves (2002) argues "in the main, technology is not being used innovatively in education. It is both [a] strength and a weakness that technology can sit quite comfortably within current approaches to education; it is a strength that we can stay with those educational practices we are most used to, but this is also its weakness."

Our observations of Multi User Virtual Environments (MUVE) indicate that they can indeed support, effectively, a full and diverse variety and range of educational approaches. These range from: the highly structured approach, as advocated by behaviorists and empiricists such as Locke and Thorndike, who assert that knowledge is based on experience and that human behavior and response is entirely predictable. The rationalist approach as advocated by the like of Paiget and Descartes who argue that cognition is a mediating factor in the relationship between the learner and the environment. That behavior is deemed as being unpredictable in the social constructivist perspectives of Dewey and Vygotsky who assume that knowledge is distributed amongst communities, that there is a "collective" knowledge to supplement that of the individual. The authors argue that the affordances of MUVE provide educators with a real opportunity not only to challenge existing pedagogic practice but develop new pedagogies aligned to the preferences of their students who may be comfortable in their relationship with digital technologies.

In this chapter the authors will focus more on the rationalist and constructivist approaches in presenting an unequivocal and unapologetic position in support of student driven learning facilitated through MUVE.

The authors consider the current systems predominant in education an extreme position to which we must respond to in extreme ways. Freire

(2000) warned us against following, what he described as the dreaded "banking model;" the industrial method of education in which students are passive recipients of information "deposited" there by educators rather than engaging in material and being part of their own learning process. The "banking model" emphasizes memorization, testing on facts rather than synthesis, and does not allow for critical thinking.

Freedom to construct one's own learning experience is of critical importance and we suggest that MUVEs are an incredibly powerful tool in the educator's current arsenal. We'll make an argument for the use of MUVEs in the classroom as environments where students are in control, where students decide how they learn, and where students assume more responsibility for their own, personalized, learning opportunities. We realize that this pendulum swing from standardized behaviorist knowledge transfer distribution model to knowledge making models is a jarring one for many educators. We also realize that advocating a decentralized learning model that, as Illich (2007) describes it, "deschools" the school won't be challenging to educators and perhaps students alike but perhaps, as Nietzsche (1968) put it, "sometimes one extreme position requires an equal and opposite extreme position." Our hope is that this dichotomy of positions will encourage a reflective discussion by both and result in a new model of education where the student's needs are more considered and valued over the bureaucracy or artificial standards.

Now that you have read our caveat, we'll make a case for using MUVEs to facilitate a rationalist, constructivist approach to radical student-centered learning. We will endeavor to lay out why MUVEs could be extremely important in encouraging this change and what it is about MUVEs that is uniquely powerful for learning. We will focus on Second Life as the currently most adopted MUVE tool, amongst educators though we concede that there are other, including open source alternative environments in use such as *Croquet* and Open sim and two dimensional environments such as Habo Hotel emerging that could, in the near future, offer a greater choice of technology to educators. We will focus primarily on the use of MUVE in formal education settings and recognize the exciting unstructured informal learning that occurs in this environment as a matter of every day living for residents of virtual worlds.

A History of MUVEs and Education

The roots and emergence of MUVE are subjects covered in great detail within other chapters of this book; it is, however, worth providing some context in respect of the development of the educational applications of MUVE posited within the wider subject of digital games based learning.

A number of authors have recently addressed themes around the educational use of digital games in learning, most notably Prensky and Gee. Prensky (2001) suggests that a new generation of "digital natives" are emerging; students who are comfortable with digital technologies, especially digital games, students who have ability to think and act at , what he terms, as twitch speed, students for whom the existing paradigms of the delivery and passive absorption of information are not engaging. Whilst, undoubtedly, younger people have very personal and individual relationships with technology the issue of a new generation of learners with highly developed digital skills was placed firmly on the educational agenda. Beck and Wade (2006) argue that this "new generation" dramatically different in terms of their attitude, expectations, and abilities will have a profound impact on the future of business.

MUVE such as Second Life and Habo Hotel can claim residency levels, internationally, into the millions appealing to very broad demographic and massive multiple role playing games such as World of Warcraft, which can boast an even greater number of players. Without any doubt society is engaging with synthetic environments in ever-increasing numbers. Steinkuhler (2004) asserts that the sophistication of interaction, collaboration, and organization of lineage in World of Warcraft players presents clear evidence of the informal learning that is occurring in these game playing experiences. This notion of higher order skills development is further highlighted by Gee where, in the context of semiotics, he suggests a series of thirty-six learning process embedded within digital games. Although his work was done largely in the context of single player games, and before interconnectivity was such that Massive multi player online role playing games had emerged as a significant genre of gaming, he had clearly identified the potential of digital games as educational tools. MUVEs offer much more than the highly structured narrative and experience of digital games and whilst unarguably the experience is playful in nature MUVE should not be categorized as merely games.

So how, pragmatically could MUVE help us face the challenges of educating this new generation? Are they another example of a solution seeking a problem?

The challenges facing the embedding of technology-enhanced Learning in formal education are well documented. The wide scale adoption and significant investment by schools and universities in learning content management systems or virtual learning environments such as Blackboard and Web CT has clearly not resulted in the kind of transformation required. Britain and Liber (1999) concluded that the systems currently employed by educational institutions were mainly geared toward content structuring and presentation, conforming to a transmission model of education. They were concerned that discussion and dialogue were somehow "hived off" to a

separate discussion place not integrated with or more importantly driving the sequence of content. The authority and control of the systems was vested to teachers and administrators with emphasis on tool development to support this to the detriment of the development of student tools. There was a complete lack of student self-organization or presentation tools, and that once started courses were inflexible and not easily adopted to student or teacher learning preferences.

The Application of MUVE Could Help Redress This Balance

Many times as we look out onto our classrooms, our students tucked into their uncomfortable desks we've often wished we could just snap our fingers and turn the sterile environment into a cozy coffee shop, a ring of soft bean bag chairs, or a dramatic movie theater. Any space other than the pre-scribed, structured spaces with the instructor in front so often created as educational spaces in schools. At the suggestion of changing the space we are sure our students would offer up designs we can't even imagine. Over our life times we learn far more outside the classroom than we ever do inside of one. We try to prepare our students to be life-long learners not just classroom learners so why not use a virtual space to allow them to learn in a limitless variety of nonclassroom spaces? Second Life's flexible environments allow educators to not just defy the rules of the classroom but to engage students in doing the same. But flexible spaces are just one benefit of learning in a MUVE. We've observed five distinct affordances in these spaces that are conducive to student-centered learning: Identity, Space, Activity, Tools, and Community. The categories should not be considered in isolation or as being somehow mutually exclusive, but more as a framework to consider affordances.

The Educational Affordances

Identity

Learning changes us. There can be no doubt that when we truly learn we become a new person whose experiences and knowledge become newly fil-tered by learning. Certainly, inspirationally, a large part of the higher education experience should be maturation and personal growth. When this learning occurs within the context of a learning community it takes on a deeper social relevance. Allowing students to experiment with their identity as they learn affords an opportunity to see new learning from new angles. MUVEs such as Second Life allow learners to experiment with identity in safer ways than they might be able to on an average campus. For

example, assigning students to change their skin color, gender, or even species and take on those social and communicative roles as they interact can be enlightening if they're also allowed to reflect on how their new identity influenced their perception of events, concepts, and explorations.

Recent research (Fetscherin & Latteman, 2007) suggests that "people are using Second Life not to change their identity, but rather to explore and visit new places and people;" the environments do afford the potential to examine issues of, fluid, identity. However, we cannot underestimate the importance of fluid identity on the learning process. The "slippage" between persona and self affords a reflective process that encourages self-awareness, examination, and growth (Turkle, 1995, p. 185). In addition; we know that the ability to experiment with one's own identity increases tolerance for the identity of others who might be different (Turkle, p. 261).

Learning may involve students developing and playing with identity affording real choice in creating a virtual identity and the opportunity to mediate multiple identities. These identities can, but not necessarily, be independent or extensions of real world persona. The more we interact with others, the greater our reach in a community, the more identities we develop (Wolf & Perron, 2003, p. 93) and these instances of identity become "drafts" of ourselves with which we are able to develop a greater understanding of the effects of learning and thereby a great appreciation for how learning enhances us. We also begin to see ourselves, not as our institutions label us, but as independent beings (Wolf & Perron, p. 100).

MUVEs also afford residents or learners the relative protection of pseudonymity; the learner's physical real-world appearance need not be exposed. Avatars evolve levels of trust from their peer residents in world, and develop value sets and cultural models. Krotoski (2005) argues that residents learn from trust and the reputation, described as social capital, that virtual communities operate in very similar ways to other communities both on and offline. The psychosocial moratorium (Gee, 2007) where virtual world actions are free of real-world consequences, described in relation to digital games, applies to a lesser extent in virtual communities; actions can and do have consequences both virtual and real. However, given the immersive qualities of MUVEs, it's possible to create simulations in which learners can convincingly become, even if they are the only ones who are convinced, different people or different iterations of themselves

Learners are free to explore issues relating to gender, race, creed, and culture as teachers, guru, artisan testing hypothesis by assuming identity and positions with great transience. Breaking the artificial boundaries created in traditional classrooms between student and teacher is invaluable toward creating a real sense of community and imbuing trust between student and instructor.

As we discuss identity we should not limit ourselves to the potential benefits to the individual. Communities of learners can greatly benefit from flexible identities as well. Gee's (2007) theory of affinity groups (pp. 27, 59) reminds us that when users are in a shared space they also begin to share a set of values that measure success in the space. Though this may represent a carry-over from the brick and mortar world of "fitting in" it also allows learners to redefine what success is rather than adhering to the standards set by institutions.

Space

The space in virtual environment affords residents and educators the potential to explore and create a variety of spaces including recreations, fluid space, student-created and as metaphors for interaction thought made (virtually) real.

There are numerous examples "in-world" virtual recreations of "inaccessible" spaces such as the court of Henry VIII, where residents can interact within the Tudor court; Paris 1900, a simulation of turn-of-the-century Paris, 1900 including the Paris metro, in all its art nouveau glory and the decadent space of the Moulin rouge; one can visit Ancient Egypt in immersive archaeology, view the finerery of Da Vinci's work in the Sistine chapel or replicas of Saturn rockets at the NASA Space Flight Center. Not all of the spaces highlighted here could be described as "authentic."

Conventional educational space is well represented in world with countless campus buildings, classrooms, and facilities; there is, however, a trend we have observed amongst educators, or rather educational institutions understandably, to merely replicate their "bricks and mortar" real-world presence in virtual worlds, an example of this being Harvard's Berkman Center's faithful recreation of Austin Hall, and whilst this may have some use for virtual conferences, hosting video and podcasting and undoubtedly for marketing purposes, it is an example of the replication of existing institutional policy and practice in a new medium. Or could this be institutions marking the virtual territory to maintain the status quo of the existing educational system?

But MUVEs offer much more than simulating real-world space without the restrictions of the boundaries of real-world limitation. MUVEs offer much more; think about the potential to interoperate, visualize, model, and create "thought space." Hitherto impossible to represent in real-world scenarios.

"Enter hell this way" is the sign that greets the casual visitor to the virtual, albeit a subjective, representation of the text of Dante's Inferno in Second Life. The visitor can walk through, or better still fly, over this impressive creation of "thought space" including blazing torrents,

sculptures, and mud in all its glory before "abandoning all hope" at the gates of hell. Yes, the interpretation is entirely subjective, but imagine if our literature students were encouraged to create their own infernos, their own representations, and digital literacy to a new level?

Another popular creation in Second Life is the virtual representation of the hallucinatory experiences of schizophrenia; created in order to educate and raise awareness of the disease amongst those who wish to visit.

Undoubtedly more of this kind of innovative creation and use of virtual space will emerge as educators become comfortable with modeling the environment and reaching the plateau of productivity.

Activity

Consistent with all forms of educational technology the "quality" of the resulting educational experience, or pedagogy, will ultimately determine the usefulness of MUVE. Suffice to say MUVEs seem to support a wide variety of pedagogic approaches. Activities include the SCHOME (not school not home) project in the teen grid of Second Life (Teen grid is a restricted area within Second Life with access restricted to under eighteens and "vetted" individuals) developed by the United Kingdom's Open University led by Dr Peter Twining and funded by the British Educational Communications and technology agency. SCHOME is an acronym for "not home not school" with activities pitched somewhere between the two. The SCHOME demographic at present consists of identified "gifted and talented" students with an intention to broaden the community in time.

SCHOME, described as the education system for the information age, has a significant presence and has created and established SCHOME Park. One of the key ambitions of the Park is to encourage young people to take ownership, control, and responsibility for the development of the island and more importantly the activities undertaken on it. The Open University has provided only a basic infrastructure. Students encouraged and supported by the SCHOME team have built and developed a sky lounge, physics simulations and areas for business studies, largely self-directed but supported by Dr. Twining and his staff. There have been governance issues, mainly concerned with students being too creative and attempting to build too much and nearly exceeding prim counts; but current diverse activities undertaken include archaeology, artificial intelligence, ethics and philosophy, physics, language lovers, readers and writers, and research. One specific example of a SCHOME activity, a student-initiated project, is detailed below.

One of the students suggested looking at the potential for game making in Second Life. A meeting was arranged between five students virtually at "SCHOMEHenge" in Second Life, moderated virtually, where a free-ranging discussion of students' favorite games occurred, and high level "essential"

qualities of games were identified; these included action, unpredictability, strong characters, good narrative, multiple paths, progressive difficulty, and immersive environment. They then considered if Second Life would be a suitable environment for game development identifying potential limitation of the technology and environment. Whilst it should be recognized that these were gifted and talented children I would have been equally pleased with the outcomes had it been produced by postgraduate games design students. Design proposals were then discussed to construct a skill-based assault course, which is now under construction.

The pedagogic approach is consistent with established educational theory; in this case Laurillard's (1993) conversational model, detailed in rethinking university teaching. In this particular instance, the teacher or facilitator set a very broad task, came up with a good idea about something you need or like to learn. Learners are then empowered to achieve the task, in this example through community consultation and negotiation of the learning tasks. The facilitator then provided intrinsic feedback on the actions and in discussions through forums. The students then modified their actions given the feedback and the limitations, both technological and pedagogical, of the environment. The students then modified their actions given the teachers input feedback and the learners description. The students then reflected on their new redefined (re)description of the activity, and subsequently the facilitator can reflect on the students' re-described model

In summary; the students are engaged in the goal-oriented behavior of trying to master a self-chosen educational activity; the facilitator has provided the experiential environment to allow this to occur without formal constraints, supporting the interaction with resources embracing social, cultural, and the learning perspectives and preferences of the students.

While this interaction is occurring facilitator and students are engaged in a deep level conversation, reflecting and adapting to the others' perspective. In this instance the technology has supported constructivist learning. The established roles and boundaries between tutor and student are blurred.

Building on our understanding of how hypertexts (nonlinear, branching, ergodic texts) can be useful teaching tools, and accepting that MOOs and MUDs are surely a form of collaborative hypertext, then can MUVEs be far behind? By applying what we've learned about using hypertext for education we can begin to view how MUVEs are a merely a more graphically intense extension. Manovich points out, in a snarky and yet absolutely correct way, that calling digital text spaces "interactive" is redundant. After all, *all* computer use is interactive. This is an important point because as educators it's often easy for us to confuse digital learning with truly interactive learning. Education on screen, even in a space as stimulating as Second Life, can still be made sadly passive. It's not enough

to be digital and flashy. Our educational activities must be truly interactive meaning that they engage learners in active ways that facilitate critical thinking, interrogation, and reflection–interactive in a meaningful way that implies collaboration, community, and choice. The construction of spaces in Second Life is very much like the construction of a shared text and is surely tightly related to the shared narratives created by communities in both the real world and virtual world.

We know that true learners create their own narratives (Atkinson, 1990, p. 148; Landow, 2001, p. 225) and MUVEs give us concrete spaces in which to visualize and interact with those narratives. The question becomes how do we, as educators, initiate and nurture those narratives? By becoming travel guides of sorts instead of lecturers we can instigate situations in which intellectual curiosity can be fostered. In MUVE spaces, as in other hypertextual spaces, the instructor becomes more of a coach than a lecturer (Landow, p. 222). If the instructor is a coach, then the learners become a team, a learning community with a shared, constructed space.

The affordances of MUVEs give instructors tools with which these kinds of interrogative activities can be easily undertaken. For example, in a recent semester my students revealed to me that they had blatant gender stereotypes, which were inhibiting their ethnographic studies of communities. Assumptions about how men and women translate events and identities were acting as a lens through which the students looked at things, and the outcomes were almost offensive. So how to break these students out of the Midwestern American stereotypes and give them the tools they needed to become more objective in their observations? Second Life provided the answer. Without telling the students why we were doing it, I asked them to switch genders for a night in Second Life. We met at our normal class time and location on our Second Life island and each student was given a box of mixed gender clothes, asked to go to their virtual dorm rooms, change gender, and come back to the common area. After a few minutes the students started to emerge from their rooms. The transformations were discussion provoking to say the least. Male students took on stereotypical, over-feminized bikini-clad avatars with exaggerated female bodies complete with small waists, large breasts, and flowing long hair. Female students emerged dressed as firemen, policemen, and other muscle-bound male stereotypes. As I stood to the side observing the students they spontaneously engaged in a discussion about the fallacies of their assumptions. The female students were aghast at the male's assumptions about female beauty and frailty. The men were insulted that the women thought only of men by their profession or role in a male-based society. The discussion went on for nearly an hour with nary a word from me. The students were in the driver's seat. This is one example of an activity that was directly facilitated by the flexibility of the MUVE space as well as its collaborative and community-based spaces.

Tools

Second Life affords a variety of tools for use by educators not least the scripting language itself. The Linden Scripting Language (LSL) is a relatively straight forward tool to learn and use for the manipulation of primitive objects (prims) to construct complex 3-D structures. This affords the building of objects at a reasonable resource cost, fast prototyping with effective modeling and programming tools; it is not, however, a full programming language. The simplicity of LSL is both beneficial and problematic in equal measures if used to support the teaching of programming skills. The provision of chat and audio facilities provide students with an authentic experience of digital communication and the search facilities of accessing information.

Other tools include the economic and fiscal structure of the MUVE itself and the virtual currency Linden Dollars (with a real-world exchange rate!), "in-world;" this could be applied in the testing of economic and financial models and hypothesis. Castronova (2006) provides an in-depth discussion of the economies of Second Life and other MUVE.

Community

The use of MUVE for collaborative and community development activities is probably the affordance that has been thus far most researched and exploited .In a recent survey (Fetscherin & Latteman, 2007) learning was cited by 86 percent of those interviewed as motivation to use Second Life. There is a vast social network of communities reflecting the diversity of interest in the real world; a quick "search" type edit in the toolbar will reveal that any number of residents may join communities of practice, of location, or of interest. To those interested in education and research The Second Life educators community (SLED) is a particularly active group both in-world and the affinity group fora and mailing lists, and certainly worth monitoring.

The SLED community is a good example of how organized "communities of practice" (Wenger, 1999) can play a crucial part in the professional development of educators resident in this space. Others suggest a more formal approach to professional development advocating continuous professional development courses.

Virtual spaces can encourage community formation among students as well. Environments that engender a sense of experiment and play, such as Second Life, allow students to bond without the barriers that face-to-face interactions often introduce. The screen reduces the feeling of risk or vulnerability that may prevent students from trusting each other and relying on each other in collaborative exercises. Classes in Second Life developed

all of the typical traits of community: traditions, meaningful shared spaces, artifacts, lingo, and shared jokes. Overtime, the students showed evidence of levels of bonding we had never seen in face-to-face classes. Granted, the activities we observed among students outside of class time may exist in face-to-face classes but are not observable because they occur in offline private spaces. However, it's also important to note that as education researchers, the opportunity to observe relationships formed around class exercises and materials are critical to our understanding of community in education whether the course is taught on or off line.

Combining SL with Other Systems and Tools

Given the very real constraints of the existing educational system is it possible to ingrate the application of MUVE into practice?

Second Life, common with other examples of MUVE, is proprietary software with closed interfaces; for some involved in education this is of concern. In the United Kingdom for example, there is a positive drive in Higher Education, to move toward open source applications within a service-orientated approach. One of the key drivers of this approach has been the desire to move institutions away from "monolithic" closed software applications which could be, in the case of Learning Content Management Systems or Virtual Learning Environments (the legacy systems currently used in education to deliver teaching and learning), considered as technologically deterministic in pedagogic approaches. Whilst earlier in the chapter we argued that MUVE can support a variety of pedagogic approaches there is real danger that MUVE could be considered in isolation as yet another "monolithic" system. Linden Labs have recently made, at least at the user end, Second Life open source with an announced intention to follow this shortly with the release at the server end; this will require Linden Labs to develop an entirely, well not entirely, new business model but will allay the fears of many of the open source fundamentalist educationists.

There remains, however, concern regarding the interoperability of MUVE and institutional systems and perhaps more significantly of MUVE and other social software applications. One of the first attempts to integrate Second Life with an institutional system is the Sloodle project. The aim of the project is to integrate the functions of both. The first example of this is the integration of Second Life and Moodle, an open source learning environment popular with academic institutions; instigators of the project, Kemp and Livingstone, argue that the applications present complimentary affordances that can be used in an integrated way, in their words, "which promises to bring a bit of pedagogy to 3-D immersive environments." Blocks in Moodle become objects in Second Life. Chat logs, etc. in Second Life become "contributions to the Moodle classroom."

Early adopters have successfully integrated social software applications into MUVE; formerly in the absence of audio communications in Second Life many residents opt to use the open API SKYPE software, Teamchat, or other applications. The recent introduction by Linden Labs of incorporated voice communication in Second Life has caused considerable debate. There are those in-world that were totally opposed to this; arguing that it fundamentally changed the nature of interactions in world, that residents' pseudonymity could be exposed and that those who require voice functions could easily use VOIP applications "in-world" should they desire, whilst others argue that the provision of voice was essential if mainstream adoption is to occur within educational institutions. These are still questions that remain largely unanswered.

Sled community discussion is often focused on the integration of digital assets such as presentations in power point, photographs, and video into Second Life and this is now occurring with increasing success. With open API it can not be too long until your Facebook account is fully interoperable and accessible within a MUVE, perhaps we should even be thinking about avatar interoperability across MUVE and MMPORPG, now there is a thought!

Conclusion

Pay any attention to media, education, gaming, even politics and you can't help but notice the massive infiltration of technology in mainstream culture. From MySpace to Facebook to iPhones to World of Warcraft, our free time and our work time are becoming increasingly technology dependant. Whether you're a teacher, a parent, an employer, or just a consumer, it's unwise to adopt technologies without a critical eye.

Second Life is surrounded by skeptics who question the escapism and anonymity allowed in the space. It's true that there are seedy sides to Second Life. It's also true that the hardware required to run Second Life is above a typical bargain computer. It's also true that the immersion Second Life offers may be distracting to less than motivated students.

On the flipside though, it's true that technology becomes more affordable every day that some unmotivated students are engaged by the creativity and fun of the virtual space. We can't ignore the influence that social technology has on our students and the ways they learn.

Second Life is one technology, a MUVE that we simply cannot ignore.

References

Atkinson, P. (1990). *The ethnographic imagination: Textual constructions of reality.* New York: Routledge.

Beck, John C., & Wade, Mitchell. (2006). *The kids are alright: How the gamer generation is changing the workplace.* Boston: Harvard Business School Press.

Britain, S., & Liber, O. (1999). *A framework for pedagogical evaluation of virtual learning environments.* JTAP.

Castronova, Edward. (2006). *Synthetic worlds: The business and culture of online games.* Chicago: University of Chicago Press.

Fetscherin, M., & Latteman, C. (2007, June). User acceptance of virtual worlds. An explorative study about Second Life. Retrieved September 30, 2007, from http://www.fetscherin.com/UserAcceptanceVirtualWorlds.htm

Freire, Paulo. (2000). *Pedagogy of the oppressed.* New York: Continuum.

Gee, James Paul. (2007). *What video games have to teach us about learning and literacy* 2nd ed. New York: Palgrave Macmillan.

Illich, Ivan. (2007). Deschooling society: Essay 1971. Retrieved September 30, 2007, from http://philosophy.la.psu.edu/illich/deschool/ accessed 09/30/07

Krotoski, A. (2005). The social life of virtual worlds. *Intersection: Journal of Contemporary Screen Studies.*

Landow, George. (2001). Hypertext and critical theory. In David Trend (Ed.), *Reading digital culture.* New York: Blackwell.

Laurillard, D. (1993). *Rethinking university teaching.* London: Routledge Falmer.

Nietzsche, Friedrich. (1968). *Will to power.* New York: Vintage.

Prensky, Marc. (2001). *Digital game-based learning.* New York: Paragon House.

Reeves, T. (2002). What really matters in computer based education. Retrieved September 30, 2007, from http://www.medicine.mcgill.ca/ibroedu/review/Reeves%20Evaluating%20What%20Really%20Matters%20in%20Computer-Based%20Education.htm

Steinkuhler, Constance. (2004). Learning in massively multiplayer online games. http://www.academiccolab.org/resources/documents/steinkuehlerICLS2004.pfd

Turkle, Sherry. (1995). *Life on screen: Identity in the age of the Internet.* New York: Simon and Schuster.

Wenger, Etienne. (1999). *Communities of practice: Learning, meaning, and identity.* Cambridge: Cambridge University Press.

Wolf, Mark J. P. & Perron, Bernard. (2003). *The video game theory reader.* New York: Routledge.

14. Virtual Journalism and Second Life

DUSTIN HARP

The rapidly increasing technological innovations during recent years have had a significant impact on the ways citizens of technology-based societies go about their everyday living. These advances have changed the way individuals conduct their personal lives and, more broadly, are impacting cultures, citizenship, and corporations. One of the more recent technological trends is Second Life, a massively multiplayer online role-playing game that simulates real-world living. Of interest in this chapter is the intersection of this new world with journalism—the real, the virtual, and the conjunction of these two worlds. A focus on journalism in this new world is an especially interesting endeavor for two key reasons, the first being the many real-world changes within the field of journalism, including a mass exodus of readers to online and digital journalism sources, a steadily increasing decline in traditional newspaper readership, and the explosion of the blogosphere as a mass mediated citizen voice (and what some term a form of citizen journalism). The second reason for such a focus is the growing abundance of journalistic products within Second Life, including organically developed journalistic products and the entrance of "real" newspaper organizations into the game. Considering these intersections, this essay explores journalism within Second Life, with the goal of understanding more about the place and practice of journalism in virtual worlds, and its relationships with community building, citizenship, and the "real" world.

Launched in 1999 by a privately owned San Francisco-based company called Linden Labs, Second Life is an animated, 3-D cyberworld. People with access to a computer and high-speed Internet connection can enter this world as a resident—creating a fictional character known as an avatar. A March 2007 report noted that about 3.3 million people had already joined and more were entering Second Life every day (Ward, 2007). Second Life fits into the computer game genre known as MMORPG, which is an acronym for massively multiplayer online role-playing game. Three major differences, however, ren-

der Second Life different from MMORPGs. First, the goal of play is much different and less defined. Residents are not there to participate in such activities as slaying dragons but everyday and sometimes more mundane life tasks like shopping, setting up living spaces, chatting with friends in a local bar, and listening to "live" music. Further, those in game, not the game designers, govern activities in Second Life and residents not only create content in game but they legally own the content they create. This leads to a third major difference: residents in game can earn Lindens (the official in-game currency) by selling their created content (and in some cases themselves for sex play) and then exchanging those Lindens for U.S. dollars. This has resulted in an economy mirroring the real world and one that breaks down the dichotomy of real and virtual, as reports indicate that a fair number of people are earning real dollars via Second Life play (*USA Today*, 2006).

A rich, mediated discursive space related to Second Life exists outside of the game, ranging from coverage in mainstream news publications to MySpace pages and personal blogs (or weblogs, which are websites typically written in a diary form). To grasp the range of this discussion one only needs to do a quick search on Google using the phrase "Second Life" and "blogs." Within 17 seconds the search engine offers 35,000,000 hits on one particular July day. On the same day a LexisNexis search of "Second Life" in major U.S. newspapers during the previous two years renders 699 hits. Along with a discussion about the who, what, when, why, and how of this new kind of game play, exists a full examination of Second Life's relationship to real-life money and business. This dialogue is fed by the fact that not only are real-life private citizens entering into and making money in Second Life, a number of real-life corporations and businesses are crossing this virtual threshold with profit motives in mind (Reena, 2006). Adidas, American Apparel, Best Buy Co., Dell Computer, Toyota, and Sears Holdings Corp. are among the major corporations to have entered into the virtual world of Second Life in hopes of reaching consumers and driving up sales of their products. Although these companies offer potential customers a look at manufactured goods that they might in turn purchase in the real world, some argue that so far the investment of time and money does not seem to have paid off (Semuels, 2007).

Along with the multitude of businesses in Second Life that are hoping to reach potential customers and sell products, there are media companies with a less tangible product—information. Second Life has enticed a number of these businesses into its virtual environment. Most talked about may be Reuters, the world's largest international multimedia news agency, which has set up a news bureau in Second Life with a bureau chief named Adam Reuter. The result of the news bureau and in-game presence is a website (Reuters Second Life News Center) with daily stories about Second Life and charts indicating the Linden to U.S. dollar exchange rate and U.S.

dollars spent in Second Life during a previous 24-hour period. The stories on the Reuters' website tend to bridge the virtual world of Second Life with the real world. Some recent headlines include: "SL businesses sue for copyright infringement," "Amsterdam sims resold to Dutch media firm," "Protecting real brand names in a virtual world," and "The price of tying the virtual knot." Adam Reuter also conducts regular interviews that are presented on the website, either as audio files or often as videos that display avatars in Second Life. Some recent interviews include one with *New York Times* editor Bill Keller and another with Archbishop Desmond Tutu in Cape Town, South Africa. This Second Life interview includes the Reuters' in-game bureau chief sitting across from an avatar resembling Tutu. The interview begins with Adam Reuter asking Tutu if he is happy with his avatar and Tutu quietly laughing in response. The video, however, also shows real footage of the real journalist behind the Reuters' avatar—Adam Pasick—speaking to the real Tutu (Reuters staff, 2007). This illustrates another example of the blurred line between the real and the virtual world and the role of journalism in this phenomenon.

Other real-world media companies are present in Second Life as well though it is difficult on any day to determine the exact number. Part of the reason for this is because of the many ways these businesses enter into and present themselves in Second Life. For example, the Bakersfield newspaper set up a virtual Bakersfield with hopes of creating an online space for citizen engagement. Although a staff member at the newspaper company created and maintains this space, it has been partially funded by the paper. This link between the newspaper company and the Second Life space, however, is not obvious to the casual visitor (Pacheco, 2006). Other relationships between real media organizations and the virtual world are clearer. For example, the in-game presence of the Sundance Channel is through a Second Life island named after the media outlet. On the Sundance Channel Island "Green Meetings" are held in which avatars are invited for a question and answer session with Simran Sethi, a top environmental journalist. The series of scheduled meetings are taped and also shown on the Sundance Channel's website, which houses a blog specifically about Second Life (http://www.sundancechannel.com/blogs/secondlife). *Wired*, another real-world magazine, maintains a blog about Second Life on its website as well as an in-game headquarters, and Playboy Enterprises Inc., an international multimedia company, has recently established an island in the game too.

The environment in Second Life changes in such a way that at any moment a company, media or other, can appear. And how each company proceeds to occupy its space and time in Second Life is open and varied though the above examples offer some explanations. What is more clear and important within this chapter is simply that these media corporations

have created a presence in Second Life, which indicates that real-life journalists and business executives see this virtual world as relevant and important to their real-world work. A few explanations for this journey into the virtual world exist. The obvious reason is that this offers media companies and journalists a way to reach more people. But perhaps more importantly, this is an especially desirable demographic—those early adopters of new technologies who are of a relatively younger generation. In other words, these are the future consumers of news and information products. And these corporations producing news and information are using the latest digital tools in an attempt to stay abreast of and understand the latest technologies in a rapidly transforming media age.

Along with the established real-life media corporations, another form of journalism exists within Second Life. These are magazines and newspapers that have grown organically from the game—some backed by larger media corporations but many by individuals. An avatar does not have to travel far in Second Life to find virtual news boxes placed outside of virtual storefronts. A quick click on the box offers Second Life residents the latest news—fashion, art, or general news—mostly all about the virtual world and the avatars that occupy it. Unlike those news organizations that start on the outside and move into the game, these are news products developed in Second Life. They typically focus on the avatars and happenings in Second Life—as if Second Life is a first and only life—and less often touch on real life. This type of in-game news media product is often in the form of PDFs that can be downloaded and printed, but typically these publications have a website as well. These newspapers and magazines illustrate the organic formation of mass media products in a new community—albeit a virtual community—and are a ripe means for research into journalism's functions in our modern world. It is these newspapers and magazines, many that are mimicking the real-life print media environment, this chapter focuses on. Broadly this research seeks clarity regarding journalism in Second Life. Asking a series of overarching questions I hope to better understand the intersection of journalism in the real and virtual world and what Second Life journalism can tell us about journalism, community, and citizenship in the digital age. I do this by addressing the following questions: What journalism products exist in Second Life? How does this journalism resemble or differ from real-life journalism products? What functions might Second Life journalism play in people's real and virtual lives? Why are people practicing journalism in Second Life? And what can we learn about Second Life journalism that might inform our real-world journalistic life and practices? Ultimately, my goal is to discover what we might know about journalism and our contemporary digital world through an examination of journalism in Second Life?

To understand the journalistic environment in Second Life I proceeded with this project in two steps. First, through Second Life play and multiple

online searches, I examined the presence of journalistic products in the Second Life community—those journalism products that mimic real-world newspaper and magazine models that I think of as organic or original to Second Life and the various other forms I noted earlier, including those journalistic products extending from real-life media companies and the variety of blogs and websites devoted to Second Life. Second, I conducted interviews with Second Life journalists, which included publishers, editors, and reporters of a variety of Second Life newspapers and magazines. The goal of the two-tier approach was to understand the landscape of journalism in the Second Life community and then to better grasp the why and how of this realm of virtual world journalism.

I have explored as a resident in Second Life sporadically for about two years though I have not been a regular in the game for a variety of reasons, mostly because of the amount of time a Second Life entails. More recently, however, I began to spend more time in Second Life, including daily visits, as I explored the world of journalism in this virtual environment. I also read various websites and blogs about Second Life. The virtual network of Second Life residents is extensive and spans the Internet in many ways, particularly in how residents of Second Life link their avatars and in-game experiences to other social networks like MySpace, Flickr, and blogs. I have explored the broader network of the Second Life community in this way to better grasp the world of Second Life. In many ways I believe these products can be seen as a form of community-based journalism for a virtual world, similar to the way that real-world political bloggers are sometimes seen as citizen journalists and become part of a broader mainstream media discourse.

Along with exploration of the spaces within Second Life as a means of encountering journalism, I also utilized the in-game search capabilities. This allowed me to both grasp the numbers of newspapers and magazines produced in and about Second Life and contact avatars and visit spaces associated with these products. Through this process I identified a number of publications and even more journalists writing for these newspapers and magazines. I sent emails and instant messages to many of these journalists— reporters, publishers, and editors—and then during a two-week period conducted interviews with those who responded.

In this second step I used Instant Messaging in game and email out of the game to chat with and interview fifteen Second Life journalists. I approached my research from a feminist methodological perspective; a less formal form of interviewing that strives to treat my interviewees with mutual respect. This meant that I treated my contacts as equals in a conversation that was of mutual interest and not as though they were subjects available for my use. The interviews were guided by a set of open-ended questions and varied in length dependent on the direction of the discussion. Following

the idea behind feminist research, I wanted these to be conversations that allowed me to discover what was important rather than interviews in which I steered the discussion based on what I thought I needed to know. Most of those I interviewed seemed very interested in talking about the topic, and most invited me to feel free to ask more questions whenever I wanted. This phenomenon of openness to converse seems typical of my experience in Second Life and reiterates the social networking nature of the game.

In the process of conducting my interviews, I identified myself originally as a researcher at a major U.S. university but those I actually chatted with and interviewed typically asked me about my work. In those cases, I answered honestly about my whereabouts, sent them links to my University website, and said that I was interested in understanding journalism in Second Life.

In addition to my interviews, I have also read a number of Second Life newspapers and magazines to get a better understanding of the types of stories and writing styles within these publications. I draw from this aspect of my exploration to enhance the knowledge I gained through interviews and the game itself.

Journalism in and about Second Life—the Landscape

Through Internet and Second Life searching and exploration, I discovered many journalistic publications and digital spaces for and about Second Life—those connected to the real world (discussed earlier) and those newspapers and magazines that have sprung up from within Second Life. While there are many blogs related to Second Life, I focus on what we think of as traditional print journalism—newspapers and magazines—of which there are a few that are quite popular. These are particularly interesting journalistic products because as a society we are moving from a paper to a digital culture. Yet, in this new digital world, news and information products are being modeled after the traditional print form. In fact, it almost seems a contradiction that citizens in this new digital world would model their journalism creations on the traditional paper form. To offer context about the numbers of these publications, I searched the term "magazine" under the search heading "groups" within Second Life. The search rendered more than 100 hits while the term "newspaper" delivered 28 matches. This is not to say that each of these hits indicated a unique publication but illustrates at some level the relevance and existence of magazine and newspaper publications in Second Life. Examples of some of the titles include: Metaverse Messenger, SL Newspaper, AvaStar, Second Style Magazine, Second Life Herald, PrimPerfect Magazine, SL Enquirer, Pixel Pulse Magazine, 2Life Magazine,

Italian Lifestyle Magazine, 2Litalia World, and Berliner Journalism Medienhaus. These numbers and titles of Second Life publications must be, however, understood within the context of the varied lifespan and popularity of these publications. While some are established publications with regular editions, others are published sporadically or only a couple of times before disappearing. I talked with several Second Life journalists that are associated with the relatively long-lived publications that are fairly well known amongst a population of residence in Second Life. Most of the Second Life publications modeled on traditional paper forms also have websites or an Internet presence outside of the gaming environment. Even with an online site, however, many of these publications are created to be printed and read like the typical real-life printed newspaper or magazine. And even when they are not, the websites are often designed in a way that mimics print-style story presentation (including story columns, lead photos with smaller-font captions, etc.). While I cannot say with certainty that there is a cause and effect relationship, these publications with the option to print are among the most popular in Second Life. What follows are descriptions of some of the Second Life publications along with details about those publications from the publishers, editors, and writers who create them. Next, I use themes that emerged from my chats with these journalists to consider the questions posed earlier in the chapter. Finally I discuss communication theory that might be useful in helping to understand this virtual world of journalism.

First, however, a note about whom I interviewed in Second Life. In the ever-changing and malleable world of Second Life it is nearly impossible to offer a representative sample of the journalists there. My goal then was to get a better understanding of who works as a journalist in this virtual environment and then to grasp the how and why. While I ended up chatting with 15 journalists, nine of which were female avatars, in reality I chatted with five people who identified themselves as women in the real world. Interestingly, I did not interview any male avatar journalists controlled by real-life women, four of the female avatars I chatted with were manned (literally) by men. The ages of the 15 real people ranged from 25 to 65, though nine of them were in their 30s. Most of these had joined Second Life during 2006, which meant they had been in the game for at least a year, though four have been participating in Second Life since 2005 and one person had joined only a couple of months before we talked. Six of the 15 had real-life professional journalism experience, ranging from working on their college newspaper to a career in television news. The real-life jobs of these people have great range. For example, while one person retired from ABC Network News another has been a journalism professor for more than 20 years; another told me her career in real life was "mother." I also talked with a software developer, an IT software trainer, an SL content creator, an

"SL entrepreneur," a commercial manager, a community development manager, and five people who were artists, writers, and/or photographers.

The Real Virtual News

One of the most well-established in-game newspapers, which fits closely with our real-world professional idea of a newspaper, is the Metaverse Messenger. In design and journalistic ideals, this newspaper seems to most closely mimic or attempt to mimic a real-world newspaper. Katt Kongo, in the real world a trained journalist and 38-year-old woman named Kristan, started the newspaper in August of 2005. She now earns about $1,200 a month publishing the newspaper and recently celebrated the publication's hundredth issue. The M2 as the newspaper is called, has published nearly every week since it started and currently has 13 people listed as staff. Under the newspaper's title reads the newspaper's catch phrase: "A real newspaper for a virtual world." Kristan, who worked at a college newspaper for five years and then a local paper for another two, has been unable to get a reporting job in real life. She explained during a recent chat, "I live in a rural area, and job opportunities here are limited, especially in journalism." Further, she said she is unwilling to uproot her children for a career in journalism. The weekly Metaverse Messenger looks like a real newspaper in nearly every design detail, including typical story layout, a front-page index box, and sections that mirror the real-world content divisions of newspapers.

The Second Life Herald, with the tagline "Always fairly unbalanced," is another well-established newspaper in the game since June 24, 2004—though the history of the publication dates back further. The paper was founded on October 23, 2003 by a philosophy professor named Peter Ludlow (http://www.secondlifeherald.com/slh/about.html), though it was originally titled The Alaphiville Herald and served the Sims Online world. Different from many of the Second Life newspapers, the SL Herald only publishes in blog form and does not mimic the real world of print media in layout. However, the link to the real world of journalism is not lost, as the current editor Walker Spaight, is real-life journalist Mark Wallace. As a real-life journalist, Wallace's writings on virtual worlds, video games, and other topics have been published in *The New York Times*, the *Financial Times*, *Wired*, *GQ*, and many other publications. Wallace also hosts podcasts related to SL, on a website titled RezNation, which began offering podcasts in February 2006. Podcasts seem to be a growing means for offering news and information in SL. The about section of the SLHerald website describes the publication as a muckracking tabloid that takes "a good, close, often snarky look at the online worlds that are becoming a more and more important part of everyone's offline lives" (http://www.secondlifeherald.com/slh/about.html).

SL Newspaper, a newer addition to Second Life, is offered in blog form on the web and described on the website as "a newspaper on the Internet that reports about events and happenings in Second Life." Avatar JamesT Juno began the newspaper in October of 2006. The newspaper covers everything from financial news to events and gossip. Currently there are eight reporters working for the publication and Juno, who refused to give his RL name, said all profits go toward paying rent for the virtual office and saving toward a RL meeting with the newspaper's writers. Juno, who does not have RL journalism experience, is a commercial manager somewhere in Europe.

The AvaStar, with the tagline "Your world. Your voice," is another easily found and relatively popular in-game newspaper. A recent edition, number 31, lists 28 names in its staff box. Issues are typically about 14 pages offered in PDF form on the publication's website. Described on its website as "a professional tabloid newspaper for the residents of Second Life," it is published by Bild T-Online.de, Germany's leading print-based general interest website, which is the online edition of the BILD newspaper, described as "Europe's largest tabloid newspaper" (http://www.the-avastar.com/slife/jsp/microsite/pages/about.jsp). The look of the newspaper, like others that offer a printed version, mimics the typical paper version of a tabloid.

A relatively recent addition to the Second Life publication world is Second Style magazine. The slick design and high advertising to editorial content ratio reminds one of reading a real-life fashion magazine. The monthly magazine, which first appeared in April of 2006, covers "the best of Second Life clothing, hair, skins, accessories and more" (http://www.secondstyle.com/index.htm). Second Style's website includes a blog titled Fashionista, and then at the beginning of each month readers can download a magazine of about 40 pages. The design style and look of the magazine is very similar to one of its genre in the real world. Although Celebrity Trollop, the publisher and editor of the magazine, made about $25 with the first issue, Trollop is earning closer to $300 per issue, after about six months. The success of the magazine and blog has also inspired expansion and beginning in September 2007, the magazine will produce weekly podcasts of five to seven minutes.

Along with the general audience newspapers and magazines, niche market publications are among the journalism products within Second Life. For example, there is SLART magazine, which covers the Second Life art world. A relatively new addition to the virtual environment, the SLART website offers "a critical review and journal of the arts in Second Life" (http://slartmagazine.com/). The publication includes a blog and articles designed in print magazine form (web pages that look nearly identical to a magazine page). This magazine seems to have filled a true need in the community as it has become fairly popular in a short time. Richard Minsky,

who wears both female and male avatars, started the magazine and says he
plans for it to become a RL publication.

 Another of the niche market publications is 2Life, a magazine for
Second Life's Jewish community. The magazine has published five editions
that can be downloaded as PDFs from the publication website. Along with
two editorial board members, the July 2007 issue lists eleven other writers
and contributors in its staff box. At 21 pages, it resembles a real-life maga-
zine in design and layout except that this magazine appears to be advertise-
ment free. The advertising-free nature of the magazine makes it unusual
compared to most of those in the game. The story of 2Life magazine is also
a bit unusual. Real-life artist Julian Voloj first learned about Second Life
through friend Adam Pasick (a.k.a. Adam Reuters). Voloj joined the game
and first began blogging about SL in general. Soon he was involved in the
Jewish community in Second Life. He explains: "As a RL artist, I explore
Jewish identity and heritage in my work. Fascinated by Jewish community in
SL, I wrote a few RL articles on this topic." One of these articles was
published in Tachles, a Switzerland-based publication. Voloj explained, "In
April (2007), the Jewish Media Corporation Switzerland, owner of Tachles
magazine, approached me with the idea of dedicating a magazine to Jewish
arts and culture in SL. Since April I am now editor-in-chief of this maga-
zine." The story both illustrates the way in which RL media corporations are
sponsoring media in SL and also the small world connectedness of journal-
ists in SL.

 This discussion of Second Life newspapers and magazines offers a
glimpse of the varied publications in Second Life. One commonality among
them is how much they mimic real-world publications in form. For those
familiar with Second Life, this could come as no surprise considering the
many ways Second Life in general mirrors the real world. At the same time,
Second Life and the digital tools used to construct it offer journalists in this
world the opportunity to create new and innovative forms of journalism. So
far, however, journalism in Second Life seems to be mimicking the real
world more often than offering new ways to think about it.

Understanding Why People Practice Journalism in Second Life

As Metaverse Messenger publisher Hall said that she is an SL journalist sim-
ply because of her circumstances. She explained: "It [her income] is one
sufficient only for the low cost of living area I'm in." But the rewards from
publishing her newspaper in Second Life come in forms other than money.
She explained that the work has opened many doors for her professional
life. Along with several contracts to work in Second Life, Hall has also been

offered a book deal. Hall's living wage earned through working in Second Life, though, comes at a price. She said she spends more than 80 hours per week in SL. But she said she is motivated by the networking and social aspect of Second Life: "I love people, talking to them, and writing about what they are doing, or what concerns them." Most of the SL journalists I talked to made none or very few Lindens for their work as journalists. And I heard one story about losing money. Avatar Ninette Newall founded Looks Magazine but after a few months ceased publication. While she said she learned a lot, she also lost 100,000 lindens in the process, mostly on wages and advertising. Not a journalist in real life. She explained that she has not pursued a real-life career in journalism because it is "Too hard competition I guess. And I think the printed media is being replaced more and more with Internet media. And I have the feeling that tutoring education is winning more and more over written education. Its about contact with people more in our modern world than about sitting and reading big thick books." In her case, the in-game competition proved tough.

Motivations for participating in the production of Second Life journalism were similar for many of the journalists I interviewed—making connections with people and participating in community building. But the motivations often went beyond simply meeting people. For example, Roslin Pention, a journalist writing for a style magazine said, "I thought it would be a nice way to get to know people in the fashion community and I felt the need to make my mark in SL, 'do' something. Everyone in SL who spends some time eventually starts to have the same desires they do in rl ... needing a purpose is one," (Roslin Pention). Another journalist, who wished not to be identified by name because he is a RL man playing a female avatar, said "The connections with other people is the best part, but being able to escape into a persona that is 180 degrees away from what you do for your main job is a really liberating and enjoyable experience."

Some of the journalists, rather than making a mark, however, hope to make money from their venture either now or in the future and believe they are getting involved in what just might be the next big thing in journalism. For example, avatar Aphris Juran an M2 journalist, who is actually a 65-year-old who recently retired as a senior producer for ABC Network News, said that after retiring from the news business he discovered Second Life less than a year ago and has two motivations for participating: "First, I think this is the future ... and I want to help shape and guide it. I think we are making history and they will write books about these early years. Second I think that there is indeed, a huge money making opportunity here."

One of the M2 staff writers, avatar Dagmar Kojishi, in real life college professor and writer Donnell King, has a particularly interesting motivation and use for his involvement in Second Life journalism. When asked what motivates him, he explained how Second Life journalism offers flexibility

for journalists with complicated modern lives. His answer is worth quoting in detail:

> Two things: I started working at a newspaper when I was 14 (I am now 51), and worked in the industry for a number of years. After leaving staff work, I continued to freelance for magazines up until about three years ago. At that time, my daughter was finally diagnosed with an extremely rare chromosomal disorder (she is now 4). I practically quit writing, for lack of time and for lack of "juice" (honestly, it was the first time in my life I experienced writer's block—I just had nothing to say, I was so drained all the time). Because of Hannah's frequent hospitalizations, I started teaching mostly or (some semesters) exclusively online, since I could take a laptop to the hospital with me. (At this point, I've been at Pellissippi State for 16 years, teaching some journalism classes, but mostly speech classes.) Online teaching was a lifesaver, but I got even more isolated from everyday life, which doesn't feed writing. When I discovered SL and realized that it was truly an online community, I realized there must be media covering it, and found the M2. It doesn't pay much, but it feeds my writing habit, and since I can conduct interviews virtually, it enabled me to practice my craft without having to be away from home.
> I also bring student journalists to the M2. Ours is a non-residential campus. That means that student journalists often have trouble finding enough to cover on campus (nothing much happens here, since people don't actually live here), and also have the challenge of being able to cover what DOES go on (events, club meetings, etc.) since they tend to be single parents working 20 hours or more a week and going to school fulltime—they're not on campus to cover things when they DO happen. In other words, they have many of the same challenges that brought me to online teaching. Because of SL, they have the option of working for the M2 and covering SL events for their writing/reporting requirements, gaining many of the same benefits as interning for real world publications while able to work from home, perhaps even in the middle of the night.

The Practice of Journalism in Second Life

More diverse than the motivation for practicing journalism in Second Life is the journalism experience of the people writing for these publications. While some have a great deal of reporting experience, others have none. Even for those who have not worked in a newsroom or for a magazine, some have studied the subject at a university. Others have no training on the topic. The question then becomes "what kind of journalism is this?" It seems that this journalism, both guided by professional norms and values and the intuition of citizen reporting, represents the variety of journalism in the real world—from those small-town weekly community newspapers, to glossy national magazines, and the blogging that more recently is being seen by many as a new form of community journalism.

In terms of how these SL journalists get their story ideas and approach their topics, it seems very similar to journalists in the real world. Through

beats, community interaction, and personal interests, avatars in the virtual world find story ideas and meet contacts. For example, avatar Celebrity Trollop, who writes about fashion, explained, "I choose themes I think are interesting and have good content to showcase in a visually interesting format." SL journalists also get press releases from groups and avatars in Second Life.

When it comes to writing and journalistic style, however, it seems that journalists and editors are less worried about professional journalism standards and more focused on what might interest their community of readers. These points, however, vary a bit between the different publications I looked at and journalists I spoke to. Those with real-world journalism experience strive more to adhere to the traditional journalistic standards. The magazines and nonexperienced SL journalists, on the other hand, are more likely to ignore or be unaware of journalistic norms and standards. This lessening of journalistic standards seen in Second Life—also seen in the real world through citizens using technologies like the Internet, blogging, and cell phone cameras to produce news and information—may be another example of the ways in which our real-world journalism standards are transforming in a new digital age.

One person told me about her work in Second Life, "In all honesty I don't consider it REAL journalism. My journalism teacher would murder me if she saw how I write for the magazine," said Roslin Pention, a writer for Second Style magazine. The former ABC Network News producer, Harry Chittick (avatar Aphris Juran) shared a similar view of the journalism practiced in SL. Chittick explained: "I find that the M2 has met the basics needs of the populace from an info standpoint ... but is run by residents more than by professional journalists. So the internal dynamics are odd. I equate them to a good small town paper with a strong vision from only one person. I am working hard to bring them up to a more solid journalistic basis. That is to say, more emphasis on news and less on personalities and first person."

The Role of Journalism in Second Life

Tracking audiences is difficult in the real world and determining readership numbers in the virtual environment of Second Life has it own set of challenges. At the same time, because most of these publications are web-based, some of the editors and publishers offered readership data in terms of website visits. As one might imagine, the longer running publications have a higher readership. However, Celebrity Trollop, the publisher of Second Style magazine, explained "We have over 60,000 unique visitors to our web properties and we distribute 20,000 copies of the magazine, so I'd say the

answer is yes. Our readership comes pretty close to a mid-sized daily newspaper in the Midwest." Schnabel of 2Life magazine said that "nearly everyone in the SL Jewish community" reads his magazine.

When asked if a lot of people read the newspapers and magazines in SL, college professor and M2 writer Donnell King, avatar Dagmar Kojishi said: "Relative to the entire population? No. Relative to the 'powerusers?' Yes. It's common, if I have my group tag on, for SL leaders to make some comment to me about a story that was in the M2." On the other hand, BellaTheWise Jewell, who has only been practicing journalism for a couple of months as a writer for SL Newspaper, said she believes the newspaper's website gets approximately 10,000 hits on weekdays and closer to 15,000 on weekends. However she said "Considering the number of people who are said to read the paper, I personally get disappointed at the excruciatingly low number of people who comment on articles." Another SL Newspaper reporter describes the website visits as averaging 12,000 a day with 70 percent being unique hits per day.

At the same time there are those SL journalists that believe the publications in Second Life are largely ignored. Among those is avatar Ninette Newall, who started the now defunct Looks Magazine, who believes the best way to offer news and information to SL residents is video. M2's Community Relations Manager Sarg Bjornson, who lives his RL in Spain, explained "Sadly, less people than should [read SL newspapers and magazines]. Makes me wonder if the same thing happens with RL press, and if that is the reason why most of the people are inculturate mules."

Societal Functions of Mass Media

Part of each of my conversations with the 15 journalists included asking them what role they believe Second Life journalism plays in the virtual world. In thinking about their answers, I looked to long-held theories regarding mass media's function in a society. During the middle of the twentieth century, Harrold Lasswell offered three functions of mass media in a society: surveillance, correlation, and transmission (Severin & Tankard, 2001). Charles Wright noted a fourth function: entertainment. These four functions can also be dysfunctional for a society, the theorists pointed out. For example, while the first function, surveillance, explains how mass media serve to inform and provide news, warning people of disasters and informing them of essential news of the economy, on the other side, mass media reports can instill panic and apathy, and promote too much assimilation. The second function, correlation, enforces social norms, exposes deviants, and confers opinion leaders, yet also enhances conformity and perpetuates stereotypes (Severin & Tankard, 2001). Transmission, the third function,

teaches socialization and increases social cohesion, reduces the sense of estrangement while augmenting mass society and reducing the variety of subcultures and impeding cultural growth. Finally, entertainment offers a means of escapism and creates a mass culture of art and music but, at the same time, encourages escapism and a preoccupation with leisure and impedes growth. Another perspective on media's function in society is a liberal view as one in which the media is an independent mirror of society, which in the case of SL would reflect the reality of the virtual world. This is in opposition to a radical media-society relationship that views the media as a means by which the powerful social classes maintain dominance in a society (Steenveld, 2004). Thinking about these functions of mass media in relation to journalistic products in Second Life may offer insight into how mass media serve this new virtual and extended real community. It may also offer clues in terms of the future of mass media and journalism specifically in this new technological global world.

Following are explanations from SL journalists about the role they believe these SL publications play in people's second lives. In discussing their thoughts, I point to ways these notions fulfill the functions of mass media presented in the above theoretical discussion. What is important to note is how difficult it is to draw clear lines between these four functions. What becomes clear is that like in real life, journalistic publications in SL fill a variety of functions in the community. In general the journalists I talked to felt that the role of Second Life journalism in people's second lives is similar to the role news and information publications play in the real world. However, because Second Life is not a democracy and rather a world ultimately run by the rules of capitalism, not all of the functions apply equally. Most evident, however, was the liberal perspective that posits that these publications reflect SL life.

Most of the journalists believe the publications related to Second Life serve the SL community by informing them of the latest news and information—the surveillance function. Avatar Katier Reitveld, who works for M2, believes his paper "gives readers a clear accurate range of news in a clear format written in a form that people who enjoy conventional papers enjoy." SL Newspaper reporter Dana Vanmoer explains, "It helps people see the bigger picture, it's very easy to get into a group and never branch out. Newspapers help to show what is out there." Kristan Hall, the RL journalist who started M2, believes simply that SL newspapers serve the same role as RL newspapers: "people want to know what is going on, and how that will or will not affect their (second) lives."

Several of the journalists also mentioned the role these journalistic products play in business—for example informing people of existing and new businesses and also of "what's worth buying." For example, Celebrity Trollop explained: "For the most part it's one of filtering the wheat from

the chaff. There's SO much content in Second Life, it's sometimes difficult to figure out what's worth buying and what isn't. That's certainly why I follow as many blogs as I do. I'm following them almost on behalf of my readers—highlighting the best things I can find on our site—and adding my own opinion about it as well." Another journalist, SL Enquirer avatar Lanai Jarrico said she believes these publications play a major role in SL. "If there was no media here I think a lot of people would be bored with just exploring the same places on the search lists and business wouldn't be as successful," she said. This point highlights the correlation function of mass media, which notes the enforcement of social norms. Avatar Sarg Bjornson of M2 said the media serves an important role of informing people "of what is happening around the grid … both for casual and business residents, specifically for the latter, since it is very important to plan your business strategies, for example, taking into account such events as new bugs or exploits, grid attacks or simply people's fashion trends." Although the importance of SL media for businesses is talked about using the notion of media surveillance function (simply to inform), this highlights the radical function of media as a means for the powerful social (business) class to maintain dominance. Or, in the case of a newer society like SL, the media functions for those to gain dominance.

Another SL Newspaper journalist explained, "They can provide inspiration for what people can go see, since SL is a big world, can give information on issues on (e.g., the crack down on 'acceptable behavior' in SL) and can provide information in the more confusing aspects of the world." This illustrates the transmission function, which teaches socialization and increases social cohesion. An article in Second Style magazine also illustrated this function as it instructed "newbies" (people new to the game) how to dress and act in a way that would indicate time and experience in the game, so that the avatar could fit in.

For the most part, though, Roslin Pention of Second Style magazine believes that her fashion and style magazine serves as a form of entertainment to its readers. She is not alone in believing this to be a primary function of publications in the Second Life community. She explained that readers are not reading the paper "so much to be informed about SL fashion because that is something they can do easily with the blogs. It's more for the interviews, the tips, just looking at the attractive photo spreads. The BIG thing though is, I think it is in extension of what we are all comfortable with in RL extending into SL."

Several of the journalists I talked to believed these publications had very little significance in SL. Ninette Newall said that is because very few people read them. Journalism professor King agrees that their function is not significant or clear. He explained that Second Life is "not only such a huge population now, but a highly variant population." Because of this he believes

it is hard to say what function they serve. And, he points out, the definition of publications is a difficult one as websites and blogs enter into our ideas of news and information sources. "It's still very much an evolving phenomenon, and not at all clear how publications interact with Second Living," King said.

Avatar Kafka Schnabel, of the Jewish magazine, explained that the role is dependent on the publications' target audience. "I think, a magazine like 2Life has it easier because it has a clearly defined target group with an easy outreach. In general, there are many magazines, but not all have a good quality. We decided to create something that is more than a tabloid and that does treat SL as a serious medium. As we all know, there is a lot of rubbish in SL, but this is exactly what we faced in the beginning of the Internet. Within a year or maybe more, the good SL papers will survive and form an important source of information for avatars. Right now we are still far from this reality, even if many SL papers are important pieces of information and outreach," he explained.

What about Journalism and the Future?

In our contemporary digital society news and information are produced and delivered faster than ever. Newspaper companies are especially affected by changes in our technological world. The use of the Internet and newer technologies by ordinary citizens who are using them to offer similar news and information products and services has the entire journalism world in flux. That citizens are moving into traditionally held spaces as news organizations can be seen in Craigslist.com, which began with one man in the San Francisco area creating a local website that offered free classified advertisements and has spread to many areas around the country. This innovative use of the Internet has destroyed much of the profits local newspapers enjoyed at the height of their classified advertisement sections. People writing blogs have also had some affect on the products and services traditional media companies offer, forcing them to rethink their work. It is not uncommon to see major mainstream news organizations including the *New York Times* quoting citizen-run blogs.

Newspapers have struggled with a steady decline in their printed editions and are in the midst of figuring out how to offer their product—information—in the online environment. Add to this the problem of a graying workforce lacking many of the newly needed skills in the online media environment and it is clear why a crisis in journalism is occurring. The most recent decade, ultimately, has been a period of transition. What is clear is that media corporations understand the importance of the newer information technologies and are utilizing them, while at the same time trying to

figure out their potential and future. Among these latest technological advances are games like Second Life that allow users—individuals and corporations—to form communities and mass media products.

Considering these realities in the world of journalism and the presence of journalism products and corporations in Second Life, what do we know and what can we posit about the future of journalism in our advanced digital age? Can SL journalism help us to understand future media trends? And can it tell us anything about future functions of journalism in community building, citizenship, and the "real" world?

One of the most interesting aspects of Second Life journalism is the way it is replicating real-life journalism trends. This is especially evident in this notion that everyone can be a journalist. In the real world this is indicated by people's use of blogging and cell phones to enter a public journalism and information discourse. This idea of anyone being able to be a deliverer of public information is evident in the blogging of Second Life similar to the blogging in real life. But in terms of journalism in Second Life, this notion holds truth as well, as illustrated by the number of SL citizens who are practicing journalism in SL but have no experience or training in RL. What does this mean for citizenship and community building? It seems that those journalists who work in SL, whether RL journalists, became a part of the community through their work. It just may be that this illustrates what is happening or will happen as more people in the real world engage in public information and discourse and become citizen journalists.

In thinking about Second Life as a community and the function of mass media in it, it is important to remember the unique way in which this world exists. Unlike a democracy in which journalists help to create informed citizens able to make informed decisions about political issues, in SL the important information seems to be about what to buy and where to go. In many ways this may be related to the fact that SL is not a country but functions more like a company. This may mean that journalism in SL may ultimately help to establish an elite class and then help them to maintain this position. To better get out how these journalism products in SL function, however, future research could focus on the media audience.

References

Pacheco, Dan. (2006, Nov. 19). Virtual Bakersfield in Second Life. Retrieved July 22, 2007, from http://www.futureforecast.com/dansdiner/2006/11/virtual-bakersfield-in-second-life.html

Reena, Jana. (2006, Nov. 27). Second Life Lessons. *Business Week.* Issue 4011. Retrieved July 22, 2007, from http://www.businessweek.com/magazine/content/06_48/b4011413.htm

Reuters staff. (2007, June 14). Interview with Archbishop Desmond Tutu. Retrieved July 8, 2007, from http://secondlife.reuters.com/stories/2007/06/14/watch-the-desmond-tutu-interview/

Semuels, Alana. (2007, July 17). Virtual marketers have second thoughts about Second Life. *The Los Angeles Times.* Retrieved July 20, 2007 from http://www.latimes.com/business/la-fi-secondlife14jul14,1,3135510.story?ctrack=1&cset=true

Severin, Werner J. & Tankard, James W. Jr. (2001). *Communication theories: Origins, methods, and uses in the mass media.* New York: Longman.

Steenveld, L. (2004). Transforming the media: A cultural approach. *CriticalArts, 18*(1), 92–115.

USA Today. (2006, Dec. 7). There's new place to set up shop: Virtual reality. *USA Today,* B4.

Ward, Stephanie Frances. (2007). Fantasy life, Real law. *ABA Journal, 93*(3) (March), 45-47.

Interviews (identified by avatar):

Sarg Bjornson, Metaverse Messenger community relations
Voodoo Buwan, SL Newspaper manager
Lanai Jarrico, SL Enquirer founder/editor
BellaTheWise Jewell, SL Newspaper writer
JamesT Juno, SL Newspaper owner
Aphris Juran, Metaverse Messenger reporter
Dagmar Kojishi, Metaverse Messenger reporter
Katt Kongo, Metaverse Messenger publisher
Richard Minsky, SLART publisher
Ninette Newall, Looks Magazine publisher
Roslin Pention, Second Style editor
Katier Reitveld, Metaverse Messenger news manager
Kadka Schnabel, 2Life magazine editor
Celebrity Trollop, Second Style editor
Dana Vanmoer, SL Newspaper reporter

Index

General Editor: **Steve Jones**

Digital Formations is an essential source for critical, high-quality books on digital technologies and modern life. Volumes in the series break new ground by emphasizing multiple methodological and theoretical approaches to deeply probe the formation and reformation of lived experience as it is refracted through digital interaction. **Digital Formations** pushes forward our understanding of the intersections—and corresponding implications—between the digital technologies and everyday life. The series emphasizes critical studies in the context of emergent and existing digital technologies.

Other recent titles include:

Leslie Shade
Gender and Community in the Social Construction of the Internet

John T. Waisanen
Thinking Geometrically

Mia Consalvo & Susanna Paasonen
Women and Everyday Uses of the Internet

Dennis Waskul
Self-Games and Body-Play

David Myers
The Nature of Computer Games

Robert Hassan
The Chronoscopic Society

M. Johns, S. Chen, & G. Hall
Online Social Research

C. Kaha Waite
Mediation and the Communication Matrix

Jenny Sunden
Material Virtualities

Helen Nissenbaum & Monroe Price
Academy and the Internet

To order other books in this series please contact our Customer Service Department:
(800) 770-LANG (within the US)
(212) 647-7706 (outside the US)
(212) 647-7707 FAX

To find out more about the series or browse a full list of titles, please visit our website:
WWW.PETERLANG.COM